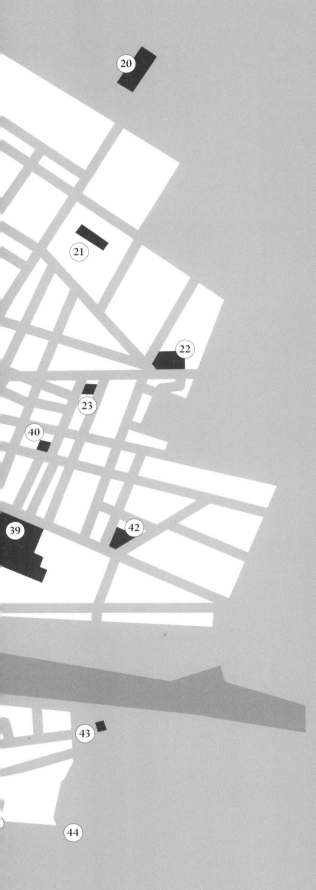

THE HEART OF THE RENAISSANCE

THE STORIES OF THE ART OF FLORENCE

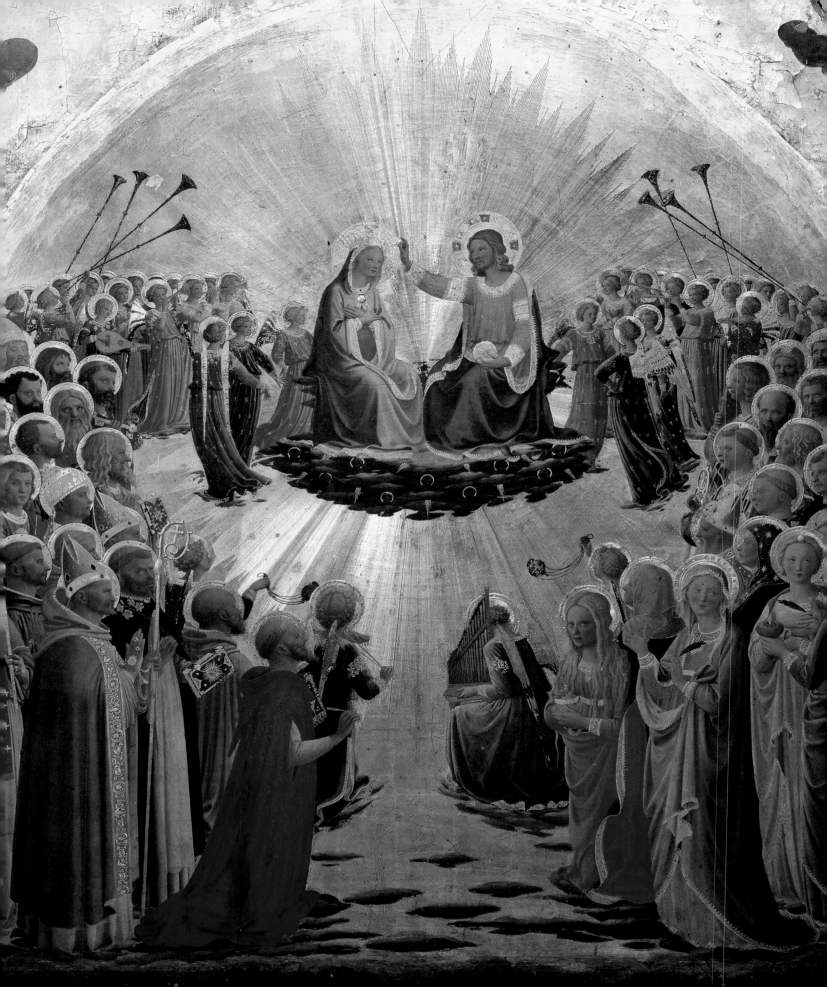

THE HEART OF THE RENAISSANCE

THE STORIES OF THE ART OF FLORENCE

RICHARD LLOYD

UNICORN

For Oliver and Elizabeth

'In essence the Renaissance was simply the green end
to one of civilization's hardest winters. It was an end to chains,
bounds, frontiers. Its device was the only device:
What is, is good.'

JOHN FOWLES

CONTENTS

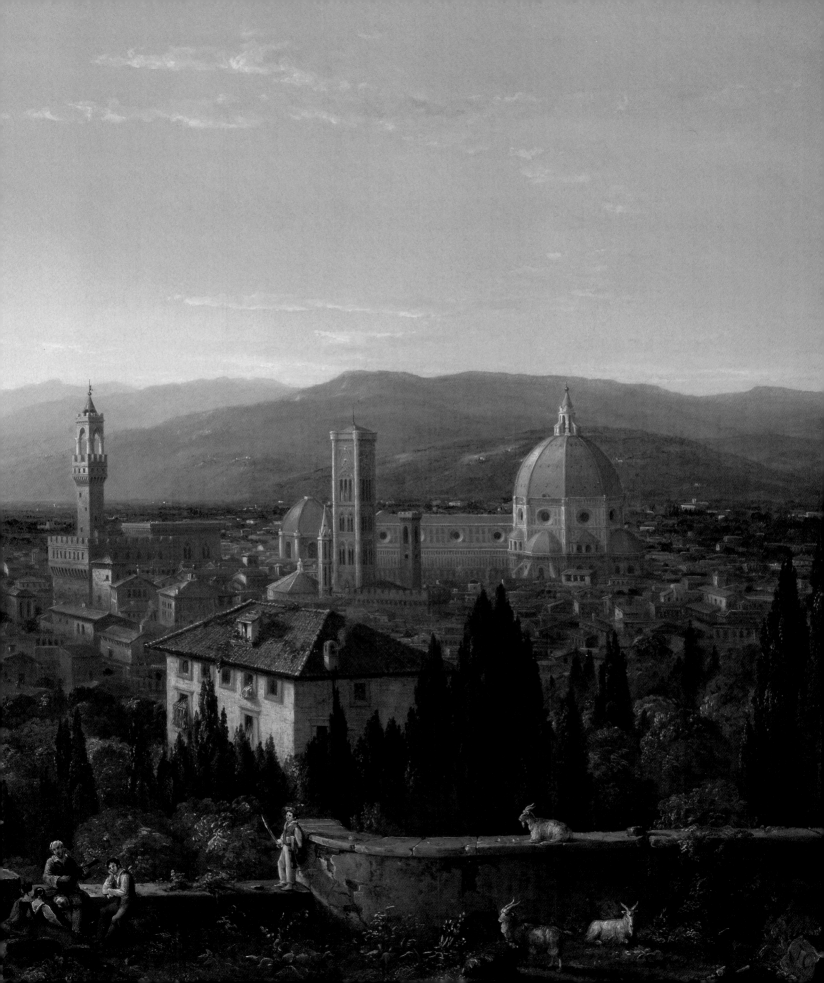

PREFACE

Florence is one of the most interesting and attractive cities to visit. As well as being peaceful with little traffic and with lots of restaurants and bars, it has many churches full of paintings and sculptures, handsome palaces, public squares, and museums and galleries with grand collections of art.

Florence's prosperity in most of the medieval age and later eras provided it with lavish funding for large amounts of art and architecture, leading to it being the centre of the development of art for several centuries and the home of some of the world's most famous artists. In the middle of the fifteenth-century the political hospitality of the Florentines to the Greeks gave rise to the revival of popularity in Italy of Greek philosophy and mythology. Combined with the Florentines' admiration for Roman architecture, this gave rise to the Renaissance, the rebirth of Classical styles and ideas, both in the designs and elements of architecture and in the subjects of paintings and sculptures.

I first visited Florence when a schoolboy in 1975 and was attracted to the city that has become of so much interest to me. The next year I took a course at the British Institute of Florence, continuing to learn the Italian language and the history of the art of Tuscany. Some ten years later I went to Florence again to visit my future wife, who had gone there to work as an *au pair* girl. Our explorations of the city revived my interest in its history and culture. In recent years I have been to Florence again several times. On my first visit with my family I felt the need to write a guide to the stories of the subjects of the paintings and sculptures, and my later visits enabled me to explore all the places that I admire.

I wrote this book in the hope that a visit to Florence would be much more stimulating if the reader knew who made the art and architecture that we see, for whom it was made and in what historical context. It is also fascinating to know the stories of the subjects of paintings and sculptures, although many of these are not immediately obvious. While much of Christian art is based on the Bible, the stories of the lives of many saints and martyrs were recorded in the *Golden Legend*, and in apocryphal gospels. There are also a startling number of local saints, whose lives are illustrated in paintings and sculptures, and a surprising number of works of art that were amazingly recorded as effecting miracles. The myths of Greek gods and their human descendants were told by Greek and Roman poets and these too need to be known to enable us to understand their representations.

I very much hope that armed with this book as a guide readers will know and enjoy the wonderful city of Florence as much as I have done, even if they do not actually go there.

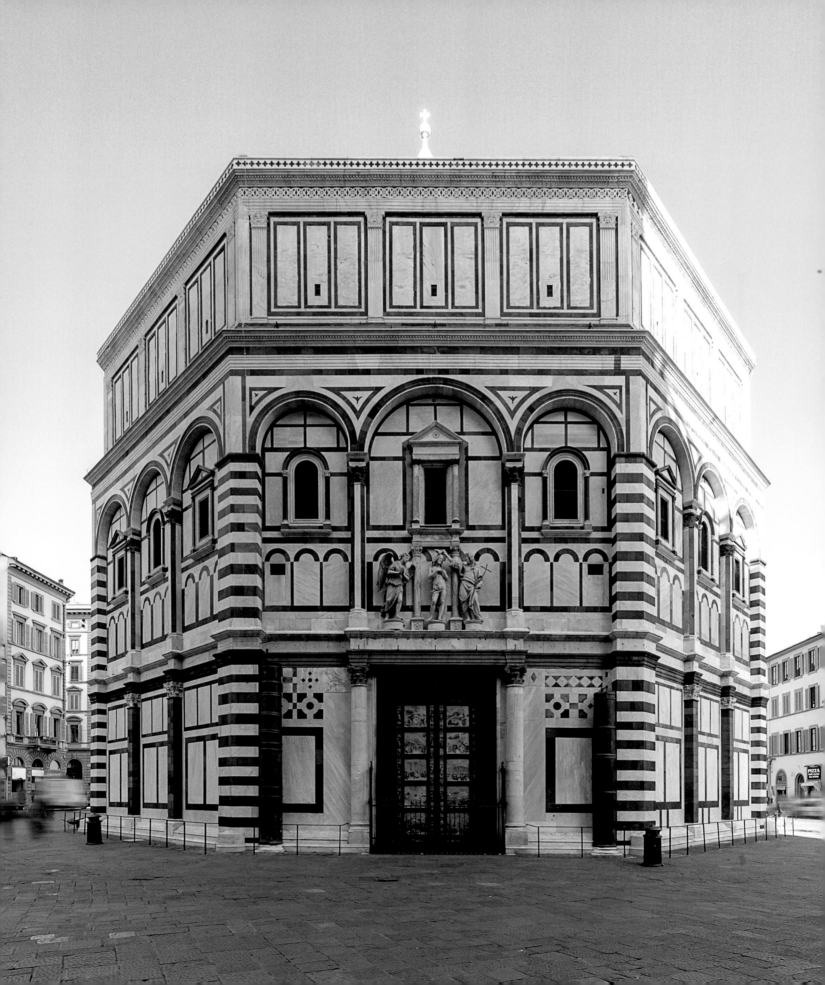

CHAPTER 1

ANCIENT ORIGINS AND BYZANTINE BEGINNINGS

L et's start our visit to Florence at the Baptistery of the Cathedral. No one knows for certain when it was built, but it is undoubtedly the oldest public building in the city, and unmistakable, with an unusual octagonal shape, and walls strikingly decorated with bold patterns in green and white marble. If it were not right in front of the highly coloured Duomo and Campanile – the Cathedral and its bell tower – the Baptistery would stand out even more sharply in a city mostly built of stuccoed brick and stone. To the Florentines, it is something of a symbol of their city and can be seen and easily recognised in many a painting from the fourteenth century onwards. Entirely covered with marble, even on its pyramid roof, it looks like a precious strongbox. On the walls, inlays of green marble quarried nearby from Prato trace out the shapes of large windows on all three storeys, but the real windows are quite small and high up on the first floor, where they are revealed by their neat frames of Classical pilasters (flat pillars) and triangular pediments alternating with rounded arches. The bold horizontal stripes on the corner piers, however much they may clash with the rest of the decorative scheme, reinforce the impression of sober strength. But there is room for a little fun too: look up at the top corners of the rectangular altar chapel which projects from the west wall, and lions glare down at us, resting their paws on the heads of bearded men.

On the lower two storeys, the columns and arches which give the building its liveliness and delicacy project out, but on the top storey the pilasters are set flush into the walls, which take a step back at that level. The middle storey is, unusually, the tallest of the three, and is finished by a stronger cornice than the rather small one at the top. At first sight, it looks as if the top storey might have been a later addition. It is not known for certain, but it might well be that it was added in the Romanesque era in the eleventh century, when the lower exterior decoration was wrapped around a much older structure.

The earliest building on this site has been dated back to the fifth century, in the last days of the Western Roman Empire. Florentine tradition has it that the Baptistery was originally built by the Romans as a temple to Mars, perhaps commemorating a victory in AD 406 over the Vandals outside the gates of the colony which had been established in the first century BC, in the days of the Roman republic, as a settlement for army veterans. Originally named Fluentia, as it lay between two rivers – the Arno to the south and the smaller Mugnone stream to the north – and later becoming Florentia, the 'Flourishing Town', the settlement followed the conventional Roman layout, divided into quarters by roads linking the gates in the rectangular enclosing walls. The site of the Baptistery is just within the northern wall of the Roman town, which stood beside the present-day Via de' Cerretani, running past the Baptistery to the Piazza del Duomo, the Cathedral Square. The Roman heritage is clear inside the Baptistery, in the square piers and massive columns made of granite brought from Sardinia. These may have been scavenged from the former Roman Capitol in Via del Campidoglio, one block to the south, or from the Roman Forum, a little further away on the site of the present Piazza della Repubblica. If there was a Temple of Mars here, even that was not the first building on this site: underneath, a Roman mosaic pavement has

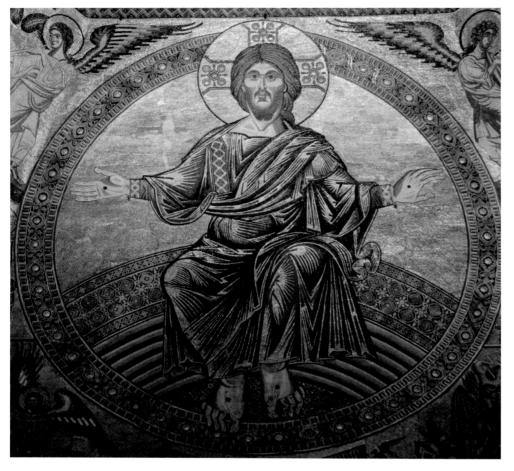

On page 12
The Baptistery

Left
Coppo di Marcovaldo: *Christ in Judgement*. Mosaic in the dome of the Baptistery

Right
Mosaics in the dome of the Baptistery

been discovered, possibly from a bathhouse or a bakery.

The Roman building was replaced or altered for use as a baptistery in the sixth century by Theodolinda, queen of the Lombards, a Germanic tribe (named after their long beards – Longo Bards) who settled in northern Italy, to commemorate her husband's conversion to Christianity. It was used as the city's cathedral until the construction in the late ninth century of the church of Santa Reparata, the remains of which now lie buried under the present Duomo across the piazza. The present building was reconsecrated by Pope Nicholas II, himself a Florentine, in 1059 and the rebuilding and exterior decoration was completed in 1128. Those stripy corners piers were added in 1293 by Arnolfo di Cambio, who was later appointed

as the first architect of the Duomo. Whoever built the Baptistery, it is a remarkable feat of construction, with massive walls strong enough to carry a dome over 80 feet across. And it is the mosaics on the inside of this dome that are the jewels in the strongbox.

Dominating the whole interior is the enormous figure, 25 feet high, of Christ in Judgement. Serene and kindly, he sits calmly on the spheres of heaven, dressed in glittering robes against a glowing golden background. His arms stretch wide, inviting the congregation to aspire to the rewards awaiting the blessed on the left and to avoid the punishments of the damned on the right. Looking straight ahead, he appears to ask, 'which way will you go?' The marks of the nails, clearly shown on his hands and feet, remind

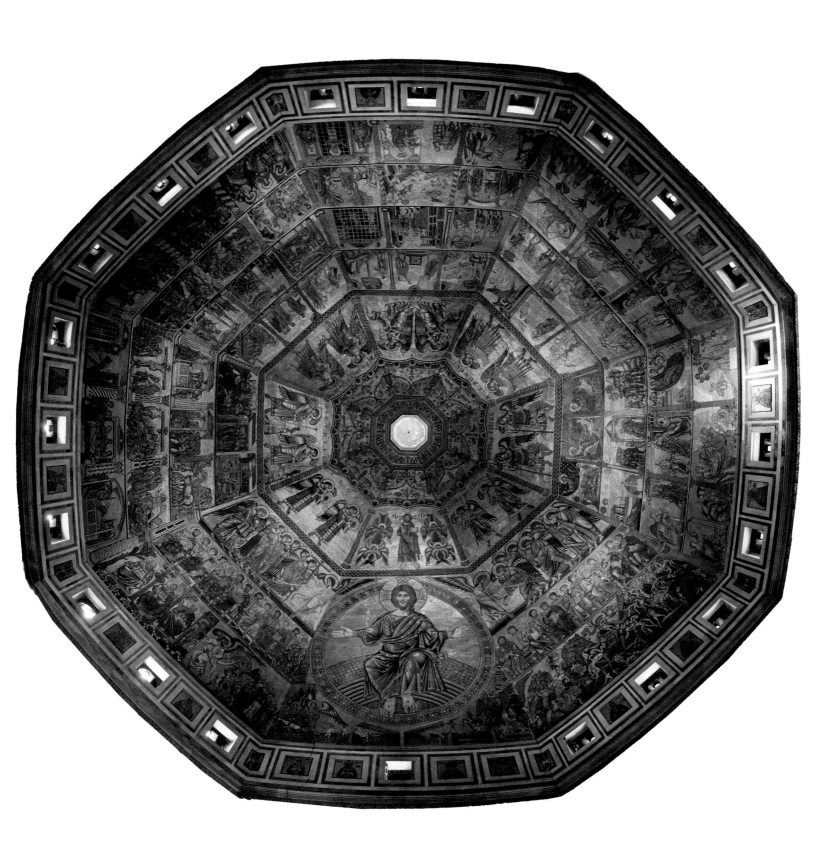

Right
Coppo di Marcovaldo: *Lucifer
devouring the Damned in Hell,*
with Virgil, in white, guiding
Dante, in black, added later
on the left. Mosaic in the dome
of the Baptistery

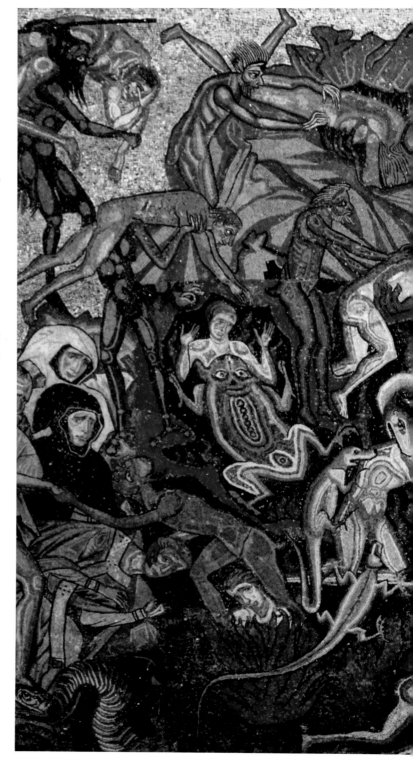

us of his crucifixion. On the left, below Christ's feet, the blessed emerge from their tombs and are guided by a pair of angels to join the eager crowd hurrying to the narrow gate of heaven, where they sit on the laps of Abraham, Isaac and Jacob in a palmy paradise. Above them, the twelve Apostles and the Virgin Mary, on the right, look on approvingly.

On the other side, the damned are rounded up by devils with bats' wings and beasts' faces, and herded off to hell with much wailing and gnashing of teeth. Lucifer sits on two giant serpents in the blazing fires of hell, all three of them gobbling up bodies. Two more serpents come out of his ears (like those of a donkey), crunching bodies in their jaws. Between his legs a monster like a giant toad bites a sinner's head, and round about, diabolic helpers cart over yet more bodies, unable to struggle, to keep the monsters fed. Bottom right, an unfortunate is being roasted on a spit.

The message is unequivocal: there is no middle road, it's either heaven or hell for us all, and there's no coming back from hell. In the days when there was a graveyard outside the Baptistery, the image of the dead climbing out of their tombs to face the Last Judgement would have had a special force. Whether rich or poor, all babies born in the city were brought here for the mass baptisms which took place twice a year, attended by huge crowds; every medieval Florentine would have this view of their fate printed on their minds. No doubt the Florentine poet Dante Alighieri remembered it well when writing his epic *Divine Comedy* in exile from the city. Dante describes Lucifer in the pit of hell much as we see him here, but as a creature with three faces, his mouths continually chewing three traitors – in Dante's view, treachery was the worst kind of sin – Judas

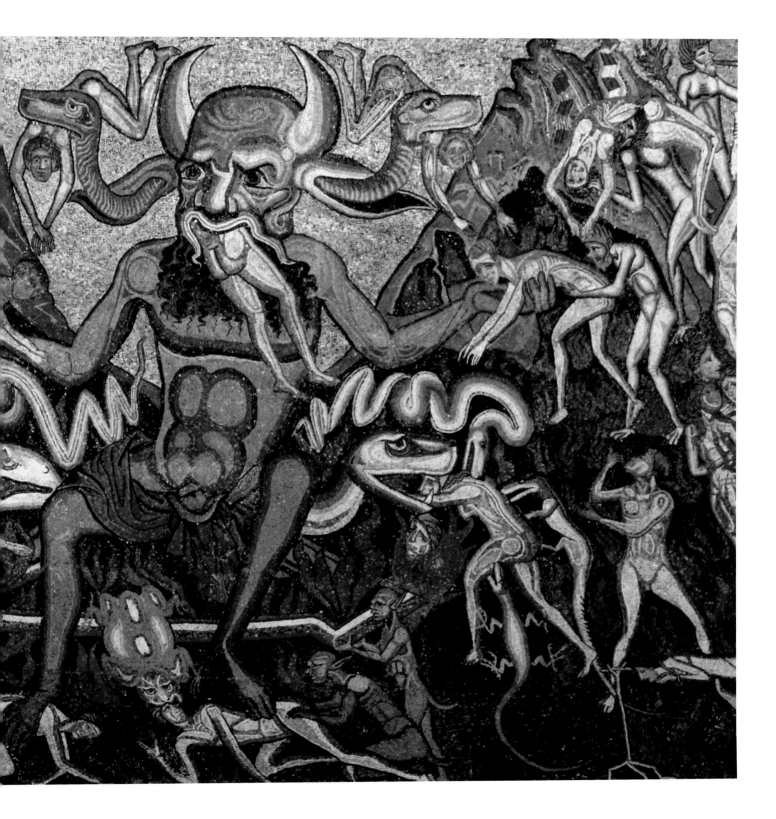

Left
The Angel Gabriel announces
to Zacharias that he will have a
son. Mosaic in the dome of the
Baptistery

announces to him that he and his wife Elizabeth, despite being very old, will have a son named John. The next scene, round to the right, shows John's birth. Then John goes off into the wilderness wearing his coat of camel skin. In the next bay, he preaches to his followers, baptises a woman, and points at Jesus who he proclaims to be the Messiah. The first scene in the east bay, in a simple symmetrical format that was already ancient, shows him baptising Jesus who stands in the river Jordan while the Spirit of the Lord, in the form of a dove, comes down out of the heavens. Then things begin to go wrong for John: he is brought before Herod, the Roman vassal king of Judea, who had been condemned by John for having an affair with his brother's wife, Herodias, and is cast into a prison not much bigger than a decorative telephone box. In the next bay of the vault, John, still wearing camel skins in prison, sends his disciples to Jesus to ask him if he is the Messiah. Jesus, busy healing the sick and raising the dead, says to the disciples: 'Go and tell John what you see and hear'. In the third scene Salome, Herodias's daughter, dances unhappily for Herod while he eats and drinks from a golden cup. The dance pleases Herod so much that he promises to give her whatever she wants. At her mother's prompting, she asks for John's head. In the last bay, Salome looks on as John is dragged from prison and beheaded. She then presents John's head on a platter to Herodias who sits beside Herod as they feast. Finally, John is buried by his followers. Deciphering these scenes with the aid of the Gospels, we can see that all the key elements of the story are here. This is a scripture lesson in mosaic, using much the same techniques as a newspaper cartoon strip – only the speech bubbles are missing.

The use of mosaic decoration had spread throughout the Roman Empire, and after the sack of Rome by the Goths in the fifth century and the collapse of the Western Empire it was continued in the Greek world of the Eastern, or Byzantine, Empire ruled from Constantinople. The mosaic tradition came back to eastern and central Italy via Ravenna, on the Adriatic coast south of Venice, which was the capital of the Byzantine Empire in Italy until it was captured by the Lombards in 751. Examples of this tradition have survived in the magnificent mosaics in the churches of Sant'Apollinare Nuovo and San Vitale – octagonal, like the Baptistery – at Ravenna, in the Cathedral of Santa Maria Assunta at Torcello in the Venetian lagoon, and on every wall and ceiling in the Cathedral of San Marco in Venice. At least some of the craftsmen who created the scenes on the Baptistery ceiling were Venetian. There are many signs of the Byzantine inheritance – the flatness of the scenes, the stylised forms and faces, the distortions of scale – but already the Italian energy is beginning to burst through, the figures jostle each other for space. For all their splendour, these mosaics show clearly that the purpose of art at this time was still firmly subordinate to the purposes of the Church – to explain the structure of the universe, to illustrate the stories of the Bible and to teach a lesson, overawing or frightening the wits out of us if need be. Good design, glittering colours, gleaming gold: these are used not merely for their beauty but because of the powerful impression they make, to reinforce the message.

Beneath the glowing golden dome, the interior walls are almost equally magnificent. The three window recesses in the arcade above the door opposite the altar are entirely

covered with mosaics, their shining surfaces reflecting light into the centre of the building. No doubt it was intended to embellish all the arcades in this way, but the others display an intriguing range of wildlife inside their window recesses: a goose pecks at a fish, ducks waddle by, cranes entangle their necks, and crossed fish make a play on the ancient symbol for Christ. (When written in Greek, the acronym of the phrase, Jesus Christ, Son of God, the Saviour, spells ἰχθύς, the Greek word for a fish.) In the corners above the chancel arch are two urns inlaid in dark marble, conveying the idea of sanctity, next to stylised suns. At ground level, the Roman columns of Sardinian granite and the square pillars with matching Corinthian capitals are perfectly proportioned. (It would be several hundred years before Florentine architects, despite their earnest study of Roman architecture, learned how to get Classical columns and capitals just right.) They make a vigorous effect, supporting the first-storey arcades in a way that is remarkably similar to the pattern of the Pantheon in Rome, unquestionably the greatest surviving Roman building. This arcade, enlivened by the light pouring through the windows behind, has a telling detail. The giant pilasters, which run the full height of the storey, have small columns on either side, supporting the arches. But while the pilasters have Corinthian capitals of stylised acanthus leaves, the columns have Ionic capitals with scrolls at either side. When later architects had studied Roman buildings carefully, this hierarchy would be much imitated.

Apart from these columns, the interior is very much all of one period. The lively marble patterns of rectangles and diamonds on the walls, behind the columns and above the

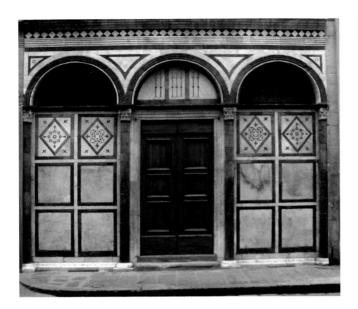

arcades are contemporary with the outside of the building, dating from the second half of the eleventh century, while the mosaic marble pavement was begun in 1209, just after the completion of the small rectangular chancel that was added to the west side in 1202.

From the middle of the eleventh century there was a zodiac wheel of astrological symbols inlaid in marble in the pavement near the north door (on the right, if you are facing the altar), where it was directly lit for only a few minutes around noon on the day of the summer solstice by the sun shining through the eye of the dome, which was at that time open, like the dome of the Pantheon. As part of the thirteenth-century renovation work, a lantern was constructed over the eye of the dome, and the zodiac wheel was relocated towards the door opposite the altar, thus losing its function as a sundial. Although very worn, it is still there today.

The twelfth and thirteenth centuries, the era of Florence's growing great prosperity, were the high point of the Romanesque style of architecture. Inevitably most of the buildings from that period have been destroyed, but some other examples of the delicate and highly decorated Florentine variant of the style survive. Indeed, we only have

to walk round the back of the Archbishop's Palace behind the Baptistery to the Piazza dell'Olio ('Oil Square') to find San Salvatore al Vescovo (which roughly translates as the 'Church of the Holy Saviour at the Bishop's Palace'). Although the church was first built in 1032, the lower half of the façade, now incorporated in the Archbishop's Palace, can be dated to 1221 and is decorated with arches and columns that are clearly inspired by the Baptistery. Down by the Arno, Santo Stefano al Ponte ('St Stephen's by the Bridge'), now a concert venue, has an interesting decorated portal which might be even earlier. While some of the decoration, such as the outer frame of little white marble squares set around the door, is familiar, the horseshoe arch above the door looks strangely Moorish.

A few hundred yards away, in Piazza del Limbo, there's another eleventh-century church, Santi Apostoli ('the Holy Apostles'). The only clue as to its origins in its façade, apart from an inscription dubiously ascribing its foundation to Charlemagne, the first Holy Roman Emperor, is to be found in the small Romanesque double window above the entrance door. Setting a precedent for many other churches in Florence, the façade is otherwise unfinished. Inside the church, which was much altered in the fifteenth and

Left
Mosaic of Christ Pantocrator
in the apse of San Miniato
al Monte

Right
Zodiac pavement in the floor
of the nave of San Miniato
al Monte

strange to find these originally pagan motifs in churches. Astrology became very popular in thirteenth-century Italy, and in the Christian thought of the time it reflected one of the mechanisms by which God exercises his power on earth. Influenced by Aristotle's notion that everything that moves must be moved by something else, this view of the universe traced all events back to God as the *primum mobile*, the first mover, and explained the varieties of human personality and behaviour as being determined by him via the movements and positions of the constellations – implicitly giving sanction to astrology. In Dante's *Divine Comedy*, when he meets his beloved Beatrice in Paradise she explains to him how the stars transmit the wisdom and love of God through the seven spheres of the planets to earth below, where it creates the virtues of mankind.

On either side of the zodiac wheel there are grids resembling large sheets of printed cloth with intricate patterns of horses, birds, lions, griffins and other mythical creatures similar to those on the façade. The origins of these designs are not known, but the creatures we see here and on the choir screen, all dated 1207, have a remarkable similarity to the northern Romanesque style of carving spread by the Normans. One suggestion is that the style, or the craftsmen, came from the Norman kingdom of Sicily. The choir screen is a fine piece of work with multicoloured marble inlays and carving inspired by plant forms. The frieze at the top of the screen is inlaid on each side of the absent central panel with marble devils confronted by griffins. These strange creatures, combining eagles and lions, are not meant to be beasts, but symbols of Christ who

combined God and man, as seen in a vision described in the Book of Daniel. The screen supports a magnificent pulpit which carries a rare example of early local sculpture. A man, perhaps a monk, dressed in a simple robe, stands on the back of a lion; in turn an eagle, supporting the lectern on its wings, stands above the man's head. The lion's very human eyes are wide open as they gaze down at us, while the man stares fixedly into space, as if entranced.

The crypt is the oldest part of the church, and its intersecting barrel vaults are supported by a marvellous assortment of re-used Roman columns and capitals. In 1341 the vaults above the altar were covered in frescoes of saints, martyrs, virgins, prophets and Evangelists by Taddeo Gaddi, pupil and godson of Giotto di Bondone, the most famous of Florence's early painters. The altar itself is said to contain the bones of St Minias.

To many, San Miniato is the most memorable of all the

Above
The crypt of San Miniato
al Monte

churches in Florence. As a building, it has an extraordinary range of stylistic origins: on the façade we have a stately Classical arcade and a correct Classical window frame, combined with bold geometric Romanesque wall decorations, a glowing Byzantine mosaic, sculptures and fantastic mythological creatures that are almost light relief. These disparate elements are tied together by the repeating patterns of the façade to produce a remarkably successful design, united by a sense of balance and proportion. Here, as inside the Baptistery, the meeting of cultures, east and west, Latin and Greek, that produced the ingredients from which distinctively Florentine art was to develop, is clearly visible.

We can see some hints of this mix of Latin and Greek in the very few paintings that have survived from this era. Giorgio Vasari, the sixteenth-century painter and architect, wrote that before the 1240s in Florence the art of painting

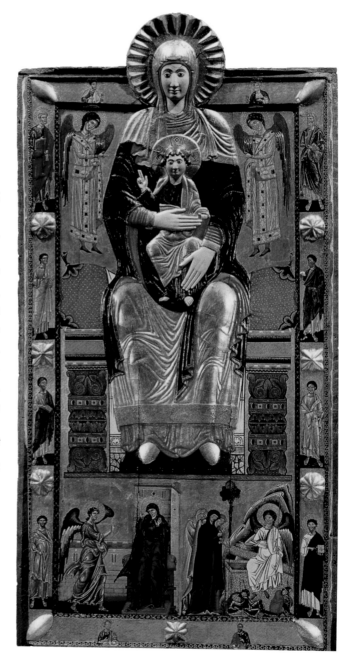

was not so much in disarray as completely lost. This may be a bit of an overstatement. Artists in the Byzantine tradition had been recruited to work in Sicily by King Roger II, where they created magnificent mosaics in the Cappella Palatina in the Palace of the Norman Kings in Palermo and in the Cathedral at Monreale nearby. Some may well have come to mainland Italy when the Norman kingdom of Sicily came to an end in 1194. Other artists may have come seeking work in Italy after the Fourth Crusade was diverted to Constantinople and the Venetians captured and plundered the city in 1204. However their influence was transmitted, the earliest paintings that survive in Florence have their origins very much in the Byzantine tradition. There is a startling example in the church of Santa Maria Maggiore (which could translate as 'Great St Mary's'), close to the Baptistery on the corner of Via dei Cerretani and Via dei Vecchietti. In the chapel to the left of the high altar, well lit, there is a panel image of the Virgin in Majesty, known as a *Maestà*, generally attributed to Coppo di Marcovaldo, the designer of the Last Judgement scenes in the Baptistery.

This wonderful image, created almost entirely of gold, scarlet and a rich dark blue, is in fact a hybrid – part painting, part sculpture. The central figures of the Virgin with Jesus on her lap are carved in shallow relief and have plaster faces with hollows which once contained relics – some of Christ's blood and a piece of the True Cross. They are painted smoothly, in quite a different way from the scenes surrounding them on the flat panel. There are angels above, saints at the sides, and, below the Virgin's throne, with its massive carved legs and a great big squashy scarlet cushion, scenes from her life. On the left there's

Below
Attributed to Coppo di
Marcovaldo: *St Francis and
Twenty Episodes from his Life*, in
the Bardi Chapel, Santa Croce

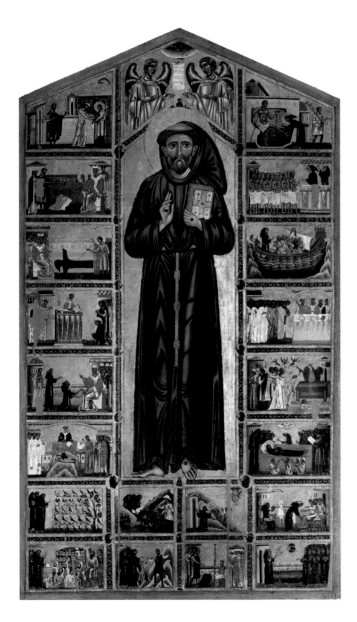

an Annunciation scene, where Mary is told by the Angel
Gabriel that she will have a child, and on the right she is
shown arriving at Jesus's tomb with Mary Magdalene, only
to find it empty, while the soldiers sleep below and an angel
dressed in white perches rather jauntily on the rim. In these
scenes the folds of the drapery are painted with contrasting
light or dark stripes, as in the Baptistery mosaics. Faces are
drawn with clear lines and strong shading. But there are no
lines painted on the Virgin's or Jesus's clothes; the carving
itself underneath creates the highlights and shadows. Their
faces too are painted in a softer, more natural way. The
whole *Maestà* has a rich glow about it, achieved by Coppo's
technique of using the purest colours, then covering them
with tinted varnishes and glazes.

Coppo is one of the earliest Florentine artists about
whom anything is known. He was born about 1225; as well
as being an artist, he served as a soldier in the war against
Siena, Florence's traditional rival and neighbour 50 miles
to the south. He was captured in 1260 and held in Siena,
but his reputation as an artist must have preceded him, for
instead of languishing in prison he painted a Madonna for
the church of the Servite friars there the next year. Later
he produced works for the nearby cities of Pistoia and
Orvieto, then returned to work on the Baptistery mosaics.
There is another painting attributed to him in Florence, a
huge altarpiece called *St Francis and Twenty Episodes from
his Life*, in the Bardi family's chapel in the Franciscans'
church of Santa Croce ('the Holy Cross'). The episodes are
like a biography: here is St Francis renouncing all earthly
goods, throwing away his clothes; here he is preaching
to the birds; here to the Muslims (rather optimistically,

Right
Cimabue: *Virgin in Majesty*
(*Maestà*) (Uffizi)

he went to Egypt hoping to convert the Sultan and end the crusades); here he receives the stigmata (the marks of Christ's wounds); here he washes the feet of lepers. While it may have been intended as a sermon in pictures, the painting has a richness and a golden glow (quite at odds with St Francis's ascetic principles) which have given it a lasting popularity. It also shows small steps towards a more expressive style in the strong highlights on St Francis's face, and towards realism in the small scenes which are no longer completely flat, but try to show receding landscapes or distant buildings. These scenes may look very stiff and unrealistic to us, but at a time when artists north of the Alps, in Germany, France and England, did not even try to make things look real and round, the Byzantine inheritance included some notions of shading, perspective and depth which helped Florence to lead the way artistically for most of the next two hundred and fifty years.

Another artist who probably worked on the mosaics in the dome of the Baptistery, Cimabue, was quite a character. His real name was Bencivieni di Pepe; Cimabue, meaning Bullhead, was his nickname. And bull-headed he must have been: according to Vasari, if he wasn't happy with his work, or if others found fault with it, he would destroy it, no matter how valuable it was. Born fifteen years after Coppo, he achieved fame in his lifetime for the greater naturalism he achieved in his work. Vasari says he learned to draw from Greek artists who had been brought in to work on the church of Santa Maria Novella ('New St Mary's'), where he went to school. His workshop was in Borgo Allegri (literally, the 'Merry District'), a street in the wool-workers' part of town, that runs north from Santa

Croce. By the time he died in 1302 he had moved to the centre and was living on Via Ricasoli, then called Via del Cocomero ('Watermelon Street'), which runs north-west from the Duomo towards the monastery of San Marco. His works are to be found in Assisi and Arezzo as well as in Florence. His surviving masterpiece is the *Maestà* that he painted for the high altar of the church of Santa Trinita ('Holy Trinity'), now in the Uffizi gallery.

This monumental painting, about 12 feet high, follows a formula in a long-established tradition. It shows the Virgin sitting on a throne with Jesus on her left knee in the conventional pose, against a golden background, as in Coppo's version. Her robes and veil are red and blue as usual, and the folds are highlighted in gold, like the mosaics at San Miniato. Her face and gesture are stylised, and everything is static. Cimabue follows the formula for a reason. The title of the picture, 'The Virgin in Majesty', itself reveals the popular devotion to Mary. She may have her baby on her knee and a tender look on her face, but she is also the timeless universal mother to whom people would appeal for assistance in times of danger or disaster. The Byzantine icons from which the formula derives were regarded as holy, as channels of communication with the saints depicted; the intention here was to create an image that would, at the least, be regarded with reverence. Such was the cult of the Virgin at the time that nearly every church had a *Maestà* on its high altar. One of the earliest to survive, the *Madonna del Popolo* ('Madonna of the People'), remains in the church of the Carmine in the Oltrarno district ('beyond the Arno') for which it was painted around 1268, having been moved only from the high altar to the Brancacci Chapel. Although painted in Italy, it follows very closely the traditional image of one of the most important Byzantine icons, the so-called *Hodegetria*, meaning 'She who shows the way', in which the Virgin points to Jesus on her knee. The original icon, of which there were many copies in Italy at this time, was believed to have been painted by St Luke.

In Cimabue's version there are some radically new elements, unlike the Byzantine precedents. The four

THE EARLY RENAISSANCE

In the thirteenth century Italy was struck by an outbreak of intense religious fervour, under the influence of two charismatic preachers. St Francis of Assisi abandoned all his worldly goods and founded his order of mendicant friars in 1209. Six years later St Dominic established rules for himself and his followers. Both orders encouraged preaching and poverty, and swept rapidly across northern Italy, gaining thousands of adherents and huge congregations. According to one tradition the two saints met in Florence in 1211, at a pilgrims' hostel in Via dei Bardi in the Oltrarno, which was later swept away by a landslide. Another tradition has the two saints meeting in Rome, each recognising the other from a dream the night before, and agreeing to work together. But their churches reveal very different outlooks on life.

The Franciscans arrived in Florence first, founding a church outside the city walls in 1210, in the marshy land to the east of the town. This soon became too small for their congregation, and was enlarged in 1252, prompting a divergence between the mainstream of the Franciscans and their spiritual wing, who saw the enlarged church as a symbol of pride. The controversy became more acute when the first church was demolished, to be replaced by the even larger present church of Santa Croce ('the Holy Cross') in 1294.

Twelve Dominican friars came to Florence from Bologna in 1219. Two years later they were assigned the oratory of Santa Maria delle Vigne ('St Mary of the Vines'), which had stood among the vineyards to the west of the town since the ninth century. This they soon replaced with the much larger church and monastery of Santa Maria Novella.

The earliest monks had departed into deserts, seeking lives of solitude and living as hermits. The monks of later generations had retreated into rural areas, living in communities and sustaining themselves through agriculture. The friars – brothers – of these new Franciscan and Dominican orders lived among the people of the expanding towns, serving their needs and surviving on their generosity. Just as in Victorian Britain and present-day China, the rapid rise of prosperity and widespread satisfaction of material needs led to a search for spiritual values. The physical result of this outbreak of religious enthusiasm was that Florence was soon surrounded by a ring of churches and monasteries.

From the eighth century the Benedictines had lived quietly following their vows in a monastery near the site of the present church of Orsanmichele on Via dei Calzaiuoli ('Shoemakers' Street'). After the turn of the millennium they lived in independent communities at the Badia Fiorentina, the ancient abbey of Florence opposite the Bargello, and up the hill at the monastery of San Miniato, which Bishop Hildebrand had endowed with episcopal properties when he founded it, to protect them from two powerful Tuscan families who had seized several properties from the bishops of Florence. The long-established Benedictines were known for the balance, moderation and reasonableness of their Rule, but these virtues were undermined by the comfort of their monasteries, not helped by Bishop Hildebrand's gifts, and could not compete with the passionate preaching of the Franciscans and Dominicans. In the middle of the thirteenth century these were followed by communities

of Augustinians, Carmelites and Umiliati, and also of Servites, the only local monastic order, founded in 1233 by seven cloth merchants from patrician Florentine families who abandoned their trade for lives of prayer and penance, becoming the 'Servants of Mary'.

The Dominicans were a strict bunch. While the Franciscans, following the example of their founder, believed that being blessed, and getting to heaven, was the reward of loving others, the Dominicans believed that it depended on having and acting on theological knowledge and understanding. Their Spanish founder, Domingo de Guzmán, was motivated at least in part by the desire to fight heresy. There was a lot of this about, one idea in particular recurring widely across Europe. That was the belief that the forces of evil are as powerful as those of good, and the two are in continual struggle in the world, which with all material things was created by the Devil, while God rules the world to come. Known to connoisseurs of heresies as Manichaeism, and derived from much older Middle-Eastern religions, it originated in third-century Babylonia and was transmitted via the Paulicians of Armenia and the Bogomils of Bulgaria and Bosnia (whose comical name means 'Friends of God') to Western Europe. St Dominic came across this heresy in southern France, where its adherents were known as Cathars. Yearning for the purity of early Christianity, the Cathars protested against what they saw as the complete corruption of the Church. They rejected all earthly contracts (including marriage!), the sacraments and the priesthood, setting up their own rival clerical hierarchy. This of course was going too far: Catharism was suppressed by a vicious twenty-year crusade launched by Pope Innocent III in 1209.

In the political disorder of Lombardy and Piedmont, Cathar ideas flourished amongst the Paterene sect. The Paterenes' fundamental view of mankind, that people are inherently so sinful that they are destined for eternal damnation unless redeemed, was not confined to the heretics, but seems to have been an extreme form of a widespread attitude that pervades much of medieval art,

in Italy and beyond. The Dominicans in particular seem to have shared this outlook, and to have had a low opinion of most of humanity other than themselves. A Dominican friar based in the monastery of Santa Maria Novella, Peter of Verona, was appointed General Inquisitor for northern Italy to root out heresy. Having been brought up as a Paterene, he was well placed to track the heretics down, setting up a dozen companies of Florentine citizens to form an anti-Paterene militia. One of these, the Cavalieri di Santa Maria (so the story goes – it is not recorded in contemporary chronicles), in 1244 slaughtered hundreds of heretics in the streets beyond the Piazza Santa Maria Novella. The massacre is marked by a granite column, the Croce del Trebbio, erected a hundred years later in the Via delle Belle Donne, the 'Street of Beautiful Ladies', whose charming name recalls that it was once Florence's red-light district.

Peter of Verona's approach to religious dissent does not appear to have dimmed the enthusiasm of the Florentines for the Dominicans' preachings of poverty, prayer and penance; two years later they began construction of an enormous church, roughly 330 feet long, big enough to accommodate a congregation of several hundred. However, it did come back to haunt Peter personally: in 1252 he was murdered by a couple of assassins hired by Milanese Cathars. The legend is that having been hit on the head with an axe he recited the Apostles' Creed and then wrote the words *Credo in Unum Deum* ('I believe in One God') on the ground in his own blood, before expiring. This tale no doubt helped him to achieve the fastest canonisation in history, becoming known as St Peter Martyr less than a year after his death. He was clearly a much venerated saint, and can be spotted, a knife implanted in his bald and bleeding head, in many a painting around town.

Santa Maria Novella was rebuilt to the design of two Dominican friars in a style which is distinctively local. The highly decorated Northern Gothic style of architecture did not catch on in Florence (with one notable exception), perhaps because of pride in the Italian Classical tradition

Left
Giotto: scenes from the lives of St John the Baptist and St John the Evangelist in the Peruzzi Chapel, Santa Croce

Left wall: top, the Angel appears to Zacharias; middle, the birth of St John the Baptist; bottom, Herod's Feast.

Right wall: top, St John the Evangelist on Patmos; middle, the raising of Drusiana; bottom, the Ascension of St John to Heaven

is more Roman than anything being built at this time.

The Peruzzi had started something. Before Giotto set to work the walls of Santa Croce were bare, and when he had finished, the Peruzzi's chapel was a striking contrast to the rest of the church. A dozen years later, Ridolfo de' Bardi commissioned Giotto to paint the chapel between the Peruzzi's and the chancel, and within another fifty years pretty well every square inch of the chancel, the transepts and their chapels were covered in fresco. So much for the ungodliness of art!

The Bardi were a noble family who also ran trading and banking businesses, and at one time owned all the houses on the Via de' Bardi in the Oltrarno, which they had redeveloped after a landslide in 1284. When Ridolfo and his brother inherited all the family banking and commercial interests in 1310, the Bardi were the wealthiest family in Florence. They too ran a network of branch offices, from Seville to Famagusta, from Bruges to Palermo. They lent money to Edward III jointly with the Peruzzi, but unwisely lent him much more, so their bank went spectacularly bust in 1345. Fortunately for us, by then Giotto had finished his work. This time the theme was the life of St Francis. Santa Croce was the Franciscans' church, so this was a natural choice, and Ridolfo's son had become a Franciscan, which added meaning to the commission. Giotto was quietly sympathetic to the Franciscans himself as well, calling one of his many sons Francesco, and a daughter Chiara, after St Clare of Assisi, one of St Francis's first followers and founder of the Poor Clares, the sister order of the Franciscans.

St Francis was born in 1181 or 1182, in Assisi, while his father, a wealthy silk and cloth merchant, was in

France on business. His French mother christened him Giovanni, but when he returned from France his father called him Francesco (the 'Frenchman'), and indeed as a youth he was fascinated by all things French, especially the troubadours, the romantic singer-songwriters of the day. He did not want to follow his father as a businessman, but dreamed of becoming a noble or a knight. In his early twenties he enlisted as a soldier when a war broke out in 1202 against the nearby city of Perugia, which resulted in him spending about a year as a prisoner of war. He then suffered a serious illness when he returned home to Assisi. These events led him to a spiritual awakening; losing his taste for worldly pleasures, he set out on a life of wandering poverty and preaching.

St Francis died in 1226, a hundred years before Giotto started work, so the events of his life had had time enough to take on a legendary quality; these pictures were inspired by, and intended to inspire, intense piety. In a city almost entirely devoted to commerce and industry, the story of the rich young man who gave it all up to embrace 'Lady Poverty' had a powerful appeal, no doubt strengthened by the concentration of enormous wealth in the hands of relatively few families. The first scene, at the top of the left wall of the chapel, shows the young Francis renouncing all his worldly goods – even his clothes – in front of the palace of the Bishop of Assisi. His supportive friend Bishop Guido of Assisi wraps him in his cloak, while his furious father has to be restrained by his anxious family from laying hands on his son. Behind the Bishop, friars look on solemnly, but in the corner a child is screaming its head off. These are very human people; Giotto has thought his way into their heads, imagining how they would react in such a situation. The second scene is at the top of the opposite wall, and shows Francis, his head shaven in obedience to the Church, kneeling with his followers in front of Pope Innocent III, seeking permission to found a new religious order based on his Rule. The next scene in order is the one below, showing Francis on his mission to the Sultan of Egypt, whom he attempted to convert to Christianity during a

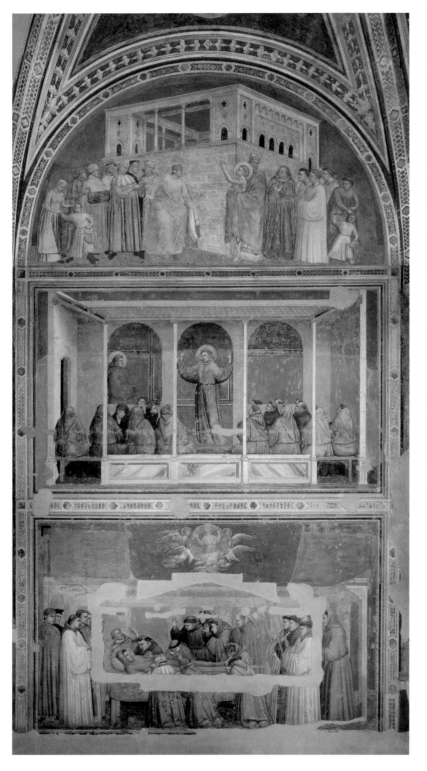

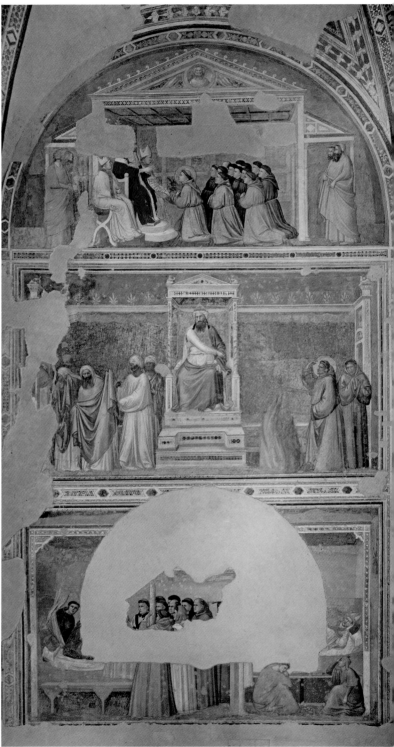

of footwear, and is still a forbidding battlemented fortress despite the ground floor being opened up for shop windows.

The beautiful bell tower of the Badia Fiorentina, dating from 1310–30, is all that remains of the remodelling of the original Romanesque abbey in the Gothic style from 1280 onwards. This work, again probably under the direction of Arnolfo di Cambio, suffered a setback in 1307 when the tower was partly demolished to punish the monks for not paying their taxes. Immediately across the Via del Proconsolo from the Bargello, the elegant and amazingly tall campanile, an unusual slim hexagonal tower with pairs of tall windows topped by a graceful Gothic spire, still soars above the roofs of the city centre. Across town, work on Santa Maria Novella was nearing completion with the construction from 1330 of a bell tower, with the classic Romanesque pattern of windows increasing in size and number on each floor, beneath a steep Gothic spire.

It wasn't just the need for security that drove tower-building: one-upmanship played a part too, so that the height of towers had to be limited by law. Some public buildings were exempt, including the new city hall, now known as the Palazzo Vecchio, which the 'Commune and People' decided to build in 1299, to accommodate the Priori. After thirty years of relative peace and plenty under the government of the Guelphs, the constitution was revised in a way that strengthened the power of the seven major guilds, the *arti maggiori*. These guilds reflected the key commercial activities of the time. The Arte dei Giudici e Notari, with a membership of eighty judges and six hundred lawyers, was at the top of the list in terms of social status, but the richest and most powerful were the Arte di Calimala and the Arte della Lana, the cloth-finishers and the wool merchants. Then came the bankers, the silk merchants, the furriers and skinners, and the doctors (of whom there were only sixty) and apothecaries. These guilds were much more than trade associations: one had to be a member of a major guild to be eligible for election as one of the Priori of the Signoria, the city's governing council. There were fourteen minor guilds as well for the artisan

trades, the *arti minori*, who were not entitled to elect their own Priori, and none for the workers, who were barred from membership and even from forming their own guilds. The guilds of thirteenth-century Florence were the most powerful in medieval Europe, not just politically but commercially and financially too, developing an early form of capitalism which became a bastion against feudalism. Despite the threat that this represented to the established order, the young mercantile Republic was blessed by Pope Martin IV – not least because he was heavily in debt to the bankers of the Arte del Cambio.

The Signoria proudly made its decrees in the name of

the Commune and People, but in practice the Florentine Republic was a government of the people, by the guilds and for the guilds. Indeed, the guilds took on many of the responsibilities that today we would think of as being the functions of government. Their primary purpose was to advance and protect the interests of their members. Non-members were prohibited from practising a trade, but to belong to a guild you had not only to prove your competence and to pay an annual fee, but you also had to be the legitimate son of a member, thus ensuring class division and the continuity of family wealth, protected from competition. Each guild had its own laws, council, assemblies and judges to regulate the activities of its members, ensuring that quality standards were met, contracts were honoured and deliveries were punctual. They established markets to sell their members' goods, and feast days to enjoy the fruits of their efforts. The guilds also stipulated work hours: the wool merchants banned work at night, in an attempt to prevent the frequent fires started by night-workers' oil lamps and candles. As well as their regulatory functions, the Arte di Calimala supported their members both commercially, backing their credit, and charitably, providing pensions for members of long standing and looking after their widows and children.

The eight Priori elected from amongst the *arti maggiori* served for two months, during which time they were expected to live with their leader, who enjoyed the high-flown title of Gonfaloniere di Giustizia ('Standard-bearer of Justice'). A new palace was needed to house them in safety and suitable style, and naturally the Commune and People turned to Arnolfo di Cambio to build it. The site they chose faces Florence's most famous public square, the newly created Piazza della Signoria. While the word *signoria* has overtones of feudal lords, the nobles were in fact excluded from government. The male members of some 150 families, classified as noble, were permitted to join the guilds under an oath of loyalty, but were specifically forbidden from holding positions of authority. Unlike in Venice, where the names of the same aristocratic families recur time and again

Below
The Palazzo Vecchio

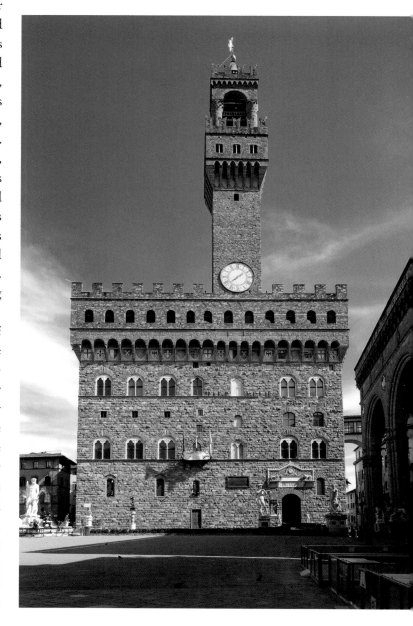

in the roll of doges over the centuries, the leading families in Florence were all merchants. The exclusion of the nobles could not have been made plainer by the choice of site: the Piazza della Signoria was created when the ruins of two palazzi owned by the aristocratic Uberti family, in exile since 1268 after the defeat of the Ghibellines, were cleared and paved over so they could never be rebuilt. Nor were the thousands of industrial workers and craftsmen allowed to participate in government. Out of pretended deference to them, the new Palazzo dei Priori, the 'Priors' Palace', was soon called the Palazzo del Popolo, the 'People's Palace'. (It was given its present name, the Palazzo Vecchio, or 'Old Palace', in 1565, when Duke Cosimo I of Florence, who had taken it over as his ducal palace in 1540, moved out to the Palazzo Pitti in the Oltrarno.)

At the Palazzo dei Priori, more a castle than a palace, Arnolfo incorporated the ancient tower of the Forabosci family into the façade to support his own 310-foot-tall tower, which explains why it is off-centre. Cavities under the arches of a first-century Roman theatre which had previously stood on the site were incorporated into the basement as prisons. As well as proclaiming Florence's wealth and status, the Palazzo is designed for defence, with projecting battlements on all sides of Arnolfo's original block, supported by arches built on projecting corbels, some of which are open to allow rocks or boiling oil to be dropped onto assailants. The tower is a confident piece of construction; its front face is supported not by the main façade of the Palazzo but by the wall of the projecting gallery below, and there's a second ring of double-height battlements around the top, projecting even further out over the square. Despite the demands of defence, Arnolfo brought a sense of proportion into the layout of the windows in the upper two storeys of a façade that is almost a perfect square.

The fortification of the Palazzo dei Priori reflects the turbulence of the age. The political battles between factions of the Guelph party involved much brawling in the streets, and the occasional pillaging of the houses of political enemies, or even their sudden demolition. However, the wars against the Ghibellines were away matches, fought nearer to Arezzo, Lucca or Pisa, so no permanent damage was done to the important business of making money. Florence's system of government by the guilds had the result that the prosperity they created was relatively widely spread, not concentrated in the hands of a duke or, yet, in those of a monopolist. Giotto's fame brought him work in many major cities, from Milan to Rome, Pisa to Padua, but while his commissions in Rome came only from the Pope, and in Naples only from King Charles of Anjou, in Florence, as we have seen, there were several families wealthy enough to commission him.

Another consequence of government by the merchant class was that the status of artists began to change. Along with two of his pupils, Giotto was admitted in 1327 to the Arte dei Medici e Speziali, the Guild of Doctors and Apothecaries, from whom the artists bought their pigments which were ground up in the same mortars as the medicines – the first time that the guild had admitted mere painters. Giotto was not regarded as just a craftsman, ineligible to join one of the major guilds, but ranked as a professional equal. When he died in 1337 he was given a state funeral by the city and buried with great honours in Santa Reparata. His earnings reflected his rising status: for his work as *Capomaestro* he was not only made a Florentine citizen but also paid one hundred gold florins a year, which Vasari says enviously was a great fortune in those days, while the Pope paid him six hundred golden ducats for his work in old St Peter's. His success overwhelmed his earlier Franciscan sympathies: he wrote verses expressing his aversion to poverty as 'a thing miscalled a virtue', and acquired property in Florence, including shops and looms which he rented out at exorbitant rates, and land in his home commune of Vespignano. A more enduring legacy was his influence on other artists: his workshop gave rise to a school of painters who continued to brighten the walls of Florence's churches. His style also had a profound effect on the next generation of sculptors.

Left and right
Taddeo Gaddi: scenes from the
life of the Virgin in the Baroncelli
Chapel, Santa Croce

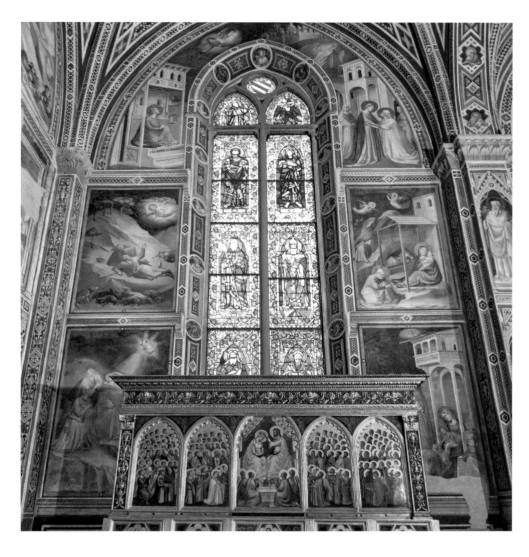

The High Priest was instructed by God to summon all the marriageable male descendents of King David, ordering them each to bring a branch. Although Joseph was older than the rest, the Holy Spirit descended in the form of the white dove which we see perched on the leafy branch that Joseph carries above his head. The dove had caused the branch to blossom, thus identifying Joseph as Mary's future husband, so the disappointed young man in the foreground is breaking his stick in frustration. However, in Gaddi's presentation, the religious symbolism takes second place to a portrait of Florentines simply having fun.

The story becomes more familiar as we continue on to the end wall of the chapel, above Giotto's altarpiece. A narrow lancet window rises through this wall, facing south. This gave Taddeo a problem: how to paint frescoes that could compete with the sunshine streaming through the window. His solution was to paint many of the scenes against a dark sky, or even set at night, using deep shadows and brilliant light effects. At the top the Angel Gabriel swoops down like a swallow to announce to Mary that she will have a child. On the right, Elizabeth kneels to embrace and congratulate her. In the middle level, in a dramatic,

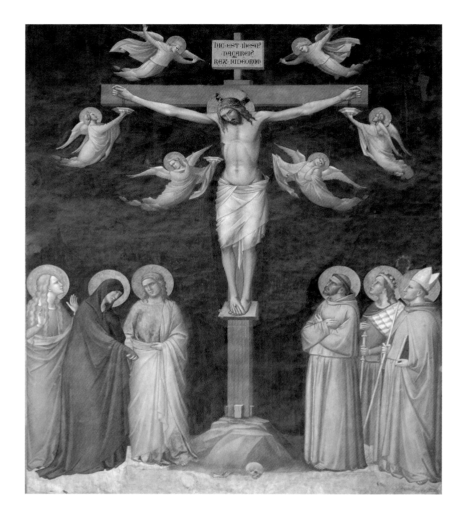

almost melodramatic, night scene, an angel appears in a cloud of light to rouse the shepherds along with their dogs and sheep, announcing the forthcoming birth of Jesus, which we see on the right, where angels frolic as Mary cuddles her baby and Joseph looks on adoringly as he sits at her feet. On the lowest level at the left, the angel star shines like a searchlight on the Magi as it leads them to worship the newborn Jesus, which they do on the right.

Taddeo tells the story in the traditional serial form, in a softened and more ornamental version of Giotto's style. But there's an interesting reversal of the moral position here. In the chapels around the corner, Giotto's St Francis renounces all his worldly goods, and Daddi's St Lawrence

is martyred for giving away the treasures of the Church. Yet Taddeo gives a very prominent position, in the largest panel at the start of the series, to Joachim, a rich man whose charity was rejected and who was unjustly kicked out of the Temple simply for being childless. Has Taddeo switched sides in his sympathies? This may be an early indication of the coming changes in ethical and social values.

Whatever the morality, the Franciscans must have liked Taddeo's work; his next big commission was for their sacristy (the spacious hall where the friars stored their vestments and other church furnishings), where he frescoed a classically harmonious *Crucifixion*, again importing flying angels circling like a flock of birds, and using a deep blue

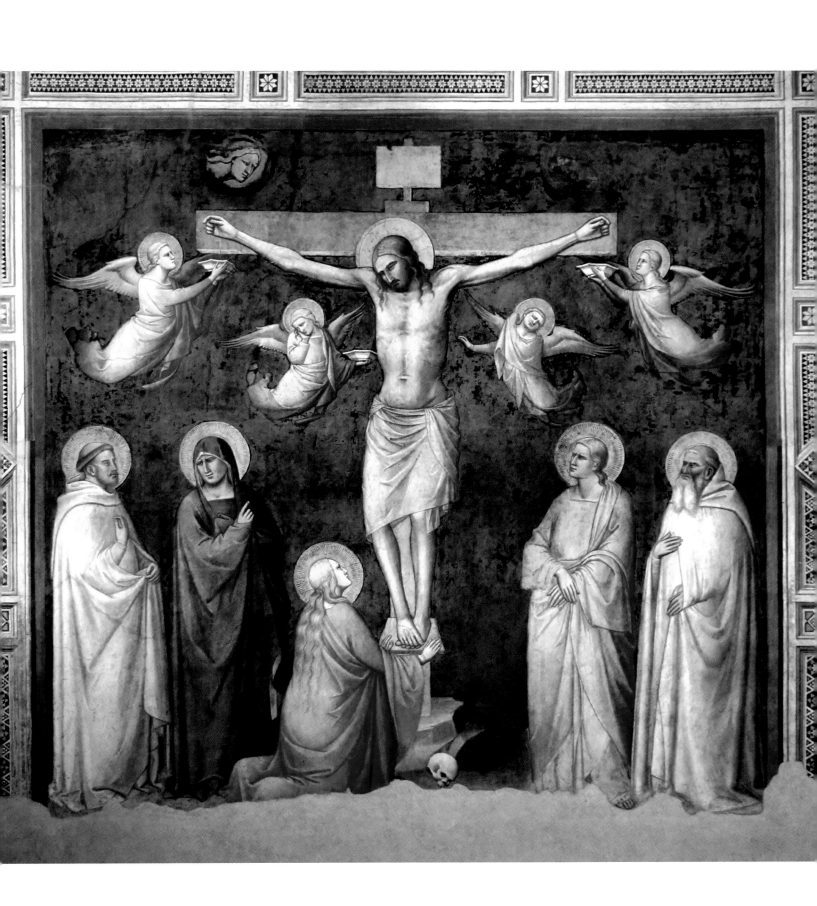

sky. Thirty years later in 1366, the year he died, Taddeo painted another *Crucifixion*, for the Ognissanti church of the Umiliati, in the former sacristy, now a bare room behind the left transept. While the composition has altered very little, the colour scheme has changed from gentle blues and oranges to the acid greens and purples that the fashionable Sienese painters by then had made popular.

In another commission for Santa Croce, Taddeo painted a series of panels showing scenes from the life of St Francis. Twenty-two of these lively and charming panels, probably originally incorporated with their quatrefoil frames into the sacristy chests which held the priests'

robes, are now in the picture gallery of the Accademia, the Academy of Fine Arts. One of the best of these, *The Dream of the Pope*, shows Pope Gregory IX dreaming of St Francis who holds up a collapsing church on his shoulder. The story harks back to a key incident in Francis's early life: he had a vision when he visited the crumbling chapel of San Damiano, outside Assisi, in which Christ in the Crucifix above the altar instructed him to repair his ruined church. Francis interpreted this literally, and sold some cloth from his father's warehouse to pay for the work. The resulting falling-out with his father set him on his life's course of spiritual repair to the Church.

THE HEART OF THE RENAISSANCE

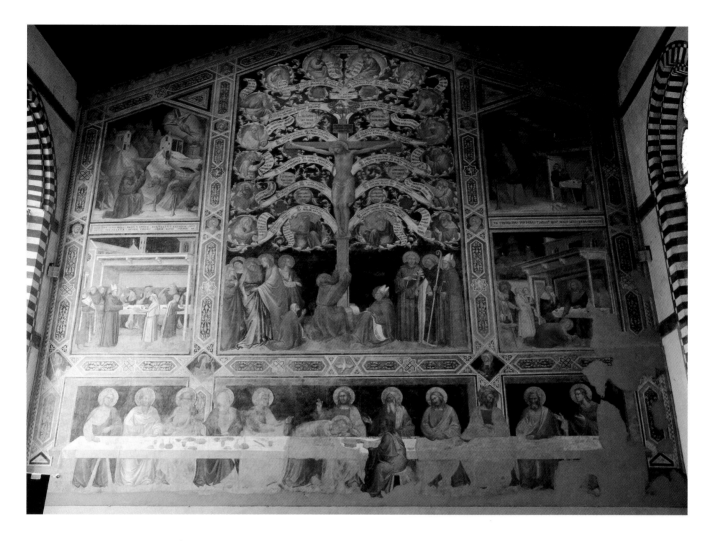

In the friars' refectory (perhaps the oldest part of the whole building complex, and now Santa Croce's Museum) Taddeo covered the entire end wall with frescoes. The refectory was where the friars took their meals, so the Last Supper was an appropriate subject, stretching right across at the lower level from wall to wall. Taddeo's fresco is the great prototype of the many representations of this theme which adorn the walls of refectories of convents and monasteries in Florence, and ultimately of Leonardo da Vinci's version in Milan. It shows the moment when Jesus announces to the Apostles that one of them will betray him. It's rather damaged by damp, but we can still admire

the tricks by which Taddeo creates the illusion that the figures of Jesus and the Apostles are sitting in front of the wall. The frames of the frescoes above continue downwards behind the backs of three of the Apostles, and the ends of the long trestle table cut across the frames at the sides, so that it seems to project forwards from the wall. Judas Iscariot, identified by his dark cloak and black beard, sits isolated on the near side of the table, and looks about to drop off the wall.

Above the *Last Supper*, there's an intriguing and very beautiful composition, called the *Tree of Life*, combining a Crucifixion scene, in which St Francis is transported back

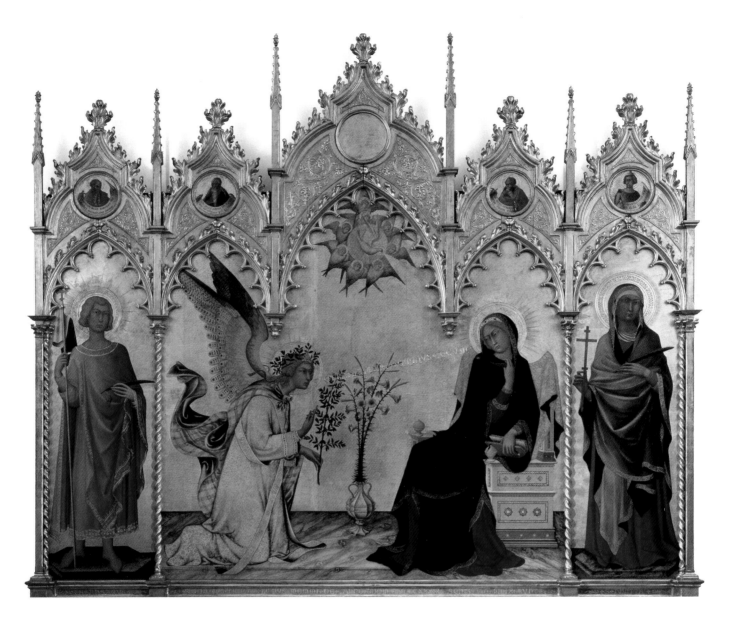

in time to clasp the base of the cross to which he was so devoted, with an attempt to trace the events of Jesus's life back to the prophets. This is really a theology lesson for the friars, with the words of the prophets written on scrolls that spread like branches from the cross to the portraits of the prophets, but it works remarkably well as a composition. Seated at the foot of the cross, a figure wearing both a bishop's mitre and a saint's halo stares intently at St Francis, while writing on a scroll on his lap. This is St Bonaventure, Cardinal Bishop of Albano, near Rome, who in 1260 wrote St Francis's official biography, as well as many works

of theology, philosophy, and spiritual exercises for the Franciscans, one of which was called *Lignum Vitae*, the Tree of Life. Behind St Francis kneels a small female figure dressed in the dark habit and white cap of a Franciscan Tertiary, that is a lay member of the Third Order of Brothers and Sisters of Penance, formed by St Francis for ordinary people who tried to follow his principles in their daily lives. She has been tentatively identified as the donor of the fresco, Mona ('My Lady') Vaggia Manfredi, whose family's coat of arms (a prancing lion with a long feathery tail) appears four times in the frame of the fresco and also in

Left
Simone Martini and Lippo
Memmi: *Annunciation with
Two Saints*, from the Chapel of
St Ansano in Siena Cathedral
(Uffizi)

Right
Taddeo Gaddi: *Madonna
enthroned with Angels and Saints*
(Uffizi)

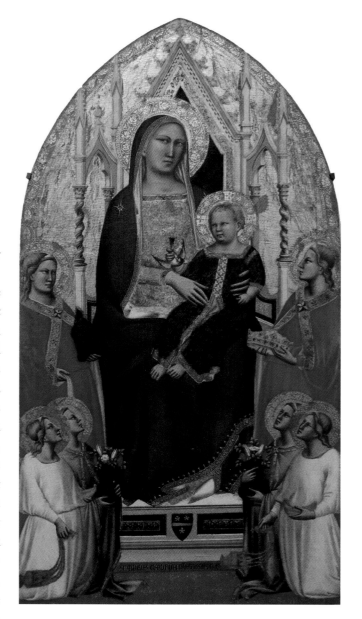

a tablet commemorating her husband Filippo above a door leading into the church on the north.

Giotto and his followers were by no means in the mainstream of the art of their day. The predominant style in Western Europe was Gothic. Originating in northern France, it reached Italy in the form of illuminated manuscripts and carved ivory figures carried by pilgrims and traders journeying to Rome on the Via Francigena (the 'Road from France'), an ancient route which passes through Siena but bypasses Florence. The Uffizi has a room dedicated to the works of Sienese Gothic artists, who absorbed the Northern style. The best known is the *Annunciation* painted for the altar of the chapel of St Ansano, a local martyr and one of Siena's patron saints, in that city's Cathedral. The gilded lettering on the narrow strip of frame below the picture declares it to be the work of Simone Martini, a pupil of Duccio, and of his brother-in-law, Lippo Memmi. The two angels in the side panels, St Ansano and St Juliet (or perhaps St Margaret), are attributed to Lippo, while Simone is given full credit for the beautiful central scene. One of the finest works of Italian Gothic art, it captures the moment when the Angel Gabriel greets Mary with the words inscribed across the golden background and emanating from his mouth, *Ave gratia plena dominus tecum* – 'Hail [Mary], full of grace, the Lord is with you'. The story is told by symbols: the olive branch in Gabriel's hand tells that he comes in peace; the central vase of Madonna lilies symbolises the Virgin's purity; and the dove surrounded by a ring of winged cherubim indicates the presence of the Holy Spirit. Every detail of the figure of Gabriel is sumptuous, from the swirling drapery of his

chequered cloak and the fine embroidery pattern on his robe to the delicate colouring of his wings, while Mary, sitting on an elaborate throne on a lavishly marbled pavement, shrinks back in timid modesty.

The frame dates the picture to 1333, coinciding with Taddeo Gaddi's work in Santa Croce. In his later works he, along with most of the Florentine painters of the later fourteenth century, was influenced by the elegance and beauty of Sienese Gothic art. As well as acres of fresco, Taddeo painted a number of altarpieces and panel paintings, of which a few remain in Florence. The Uffizi

has a *Madonna enthroned with Angels and Saints*, closely modelled on Giotto's version, combined with the sinuous lines of the Gothic style, and with the addition in Jesus's hand of a goldfinch, a bird that symbolised sacrifice, death and resurrection. (The natural diet of goldfinches includes thistle seeds; the legend is that goldfinches acquired the blood red feathers on their heads by plucking at Jesus's crown of thorns.) It was painted for Giovanni Segni, whose coat of arms appears on the shield at the base of the throne, and who intended it for his family's chapel in San Lucchese at Poggibonsi, some thirty miles away to the south. The church of Santa Felicita in the Oltrarno, just

beyond the Ponte Vecchio, has a beautiful and richly gilded polyptych version by Taddeo of the same subject in a more purely decorative Gothic style, which has remained in the sanctuary of the church despite its near total rebuilding in the eighteenth century.

Very little is known about another of Giotto's pupils, Maso di Banco, except that he died in 1348. A few years after Taddeo had finished his work at Santa Croce and had moved on to decorate the vaults of the crypt at San Miniato, Maso (short for Tommaso, i.e. Tom) was working for a branch of the Bardi family who had acquired a castle in Vernio, about twenty miles from Florence. (They

THE HEART OF THE RENAISSANCE

Right
Orcagna's tabernacle enshrining
Bernardo Daddi's *Madonna delle
Grazie* in Orsanmichele

sick and needy, and burying the dead. The Misericordia's orphanage looked after abandoned babies as well as those whose parents had died: the open loggia on the corner was designed to display such babies in the hope that they might be recognised before being given to foster parents. In the Loggia's small museum, a fresco of 1386 detached from the outside of the building shows infants being handed over by the Captains of the Misericordia to their adoptive parents. The orphanage later merged with another, run by the Compagnia del Bigallo (named after the village where it began), giving the Loggia its present name, while the Misericordia, whose headquarters are on the opposite corner, today operate the ambulances which are among

the very few motor vehicles allowed in the pedestrianised streets of the city centre.

A less acute necessity prompted the construction of another loggia, the Loggia della Signoria, on the Piazza della Signoria next to the Palazzo Vecchio. It was built in 1376–82 to shelter the investiture ceremonies of Priori and Gonfalonieri from the rain; also for issuing public decrees and receiving foreign ambassadors. It is often called the Loggia dei Lanzi, after Grand Duke Cosimo I's German mercenary pikemen, *Landsknechts*, who were stationed there in the sixteenth century. The architects were Benci di Cione (probably another of Orcagna's younger brothers) and Simone Talenti. The design is a classic of its type,

Right
Temperance, designed by Agnolo
Gaddi, on the Loggia della
Signoria or Loggia dei Lanzi

monumental – the arches are four storeys high – and well proportioned. The piers are so similar to those of the Duomo as to be almost exact copies.

The details are Gothic, especially the decorative battlements and the fine sculptures in high relief of Virtues set in the spandrels above the piers. Full of noble dignity, the Virtues were designed by Agnolo Gaddi, Taddeo's son, but executed by others. The three Theological Virtues on the side of the Loggia used to face a church, San Pier Scheraggio, down the Via del Ninna. Charity sits in a tabernacle above the centre of the arch, feeding her baby. In the spandrel to the left of the arch, Faith sits on a throne, holding a cross and a large chalice, and on the right Hope sits on a block like a tomb as she looks up to heaven. The four figures on the front of the Loggia, looking out over the Piazza, represent Plato's Cardinal Virtues of Prudence, Justice, Temperance and Fortitude, or Courage – just the qualities one would hope for in a republican government. Like Faith and Hope they have angel's wings and backgrounds of blue enamel and gold stars in frames of triangles with semicircles on each side. From the left, Prudence clasps a snake which she has spotted in her mirror, Justice has lost her sword and scales, Temperance pours some water into her wine flask, and, on the right Fortitude, enthroned above a whiskery lion, holds a shield and a stout shaft.

While the decorations have a Gothic flavour, the spirit of the Loggia is a sober anticipation of the Renaissance: the arches are round, the proportions are strong and broad – except for the lions. As at the Baptistery and at San Miniato, the architects just couldn't resist adding little lions. Four small lions stand guard on the rings around the bases of

each of the piers, while lots of little lions' faces emerge from the stone below, and two larger ones from the front and back of the central piers, expressing the determination of the small Republic to remain independent of its neighbours. Indeed, according to legend, the lion was chosen as a symbol for Florence because lions are capable of killing an eagle, for centuries the symbol of the Holy Roman Empire. This attitude was expressed most vividly by the live lions that had been kept at the expense of the Signoria in a cage near the Baptistery from around 1280. Around the time the Loggia della Signoria was built, their cage was moved to Via dei Leoni ('Lions' Street') behind the Palazzo Vecchio, where as many as twenty-four lions were housed until they were banished in 1771. The lions on the pillars were joined in 1789 by the famous Medici lions, which stand guard at the top of the short flight of stairs up to the Loggia, each with a heavy forepaw resting on a globe. One dates from the second century AD; its matching pair was made at the end of the sixteenth century for the Villa Medici in Rome, from where they were brought to the Loggia.

The Loggia del Bigallo has the same combination of Gothic decoration on a Classical frame. Indeed, take away the decoration, and the ground floor has the proportions of a Roman triumphal arch. The carving is lavish on the piers and arches of the open loggia, but it is just surface ornament. Underneath, there's a Classical structure waiting to get out, but we shall have to wait another fifty years, for the great architects of the fifteenth century, to see it emerge.

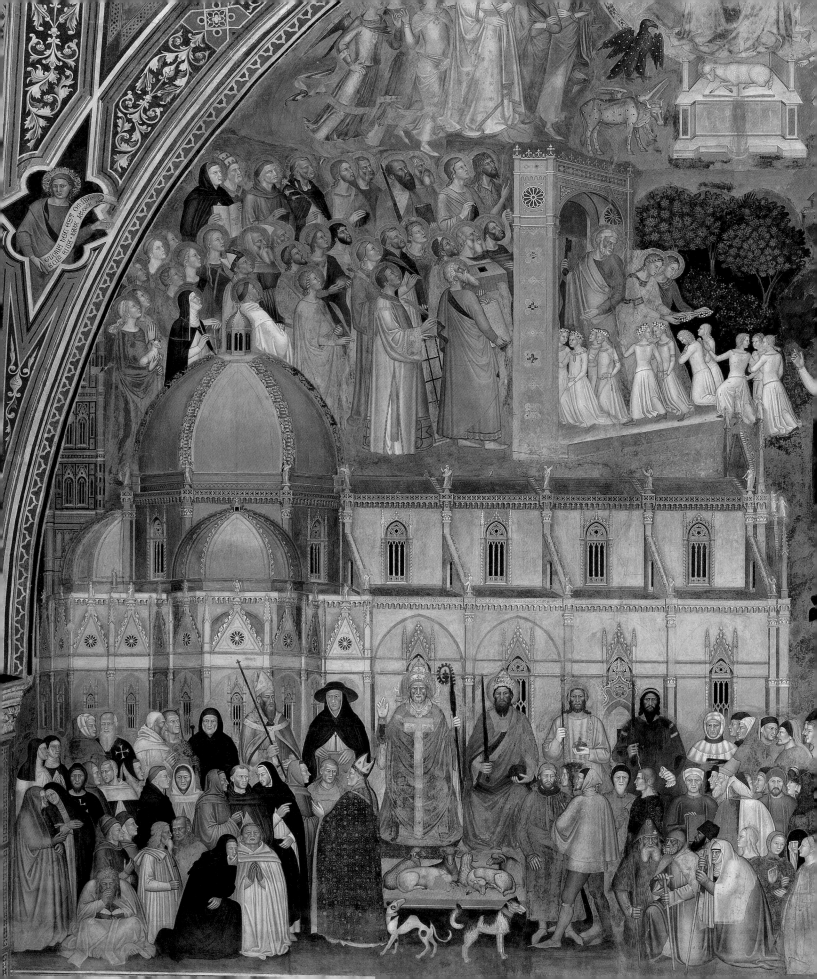

INTERNATIONAL GOTHIC

Whereas the Franciscans attracted radical idealists, the Dominicans appealed to those who feared for established order and religious orthodoxy. Their self-confident morality is clearly demonstrated in the frescoes of the Spanish Chapel, on the north side of the cloister beside Santa Maria Novella. Commissioned in 1343 by Buonamico di Lapo Guidalotti as his funerary chapel, its construction was interrupted by the Black Death and not finished until twelve years later. The soaring vault is the major achievement of its architect, the friar Fra Iacopo Talenti , who had completed Santa Maria Novella with a classic Romanesque *campanile*. Originally the chapel was used as a chapter house, where the friars would gather daily to read a chapter of their Rule, and as a court of inquisition, for examining suspected heretics. St Catherine of Siena was interviewed here by the Dominican authorities in 1374; found not guilty, she went on to become one of Italy's two patron saints, along with St Francis. In the sixteenth century it was used by Eleanor of Toledo, the much-loved wife of Cosimo, the first Grand Duke of Florence, and her Spanish retinue, to whom it was assigned after her death from malaria at the age of only forty – hence its present name.

The frescoes, dating from 1365–68, are the work of Andrea di Bonaiuto, also known as Andrea da Firenze. (By a happy coincidence, the patron's name Buonamico translates as 'good friend', and the painter's as 'good help'.) Not much is known about Andrea, who may have trained with Orcagna, but these frescoes in the Sienese Gothic style are his only surviving works. Their dire subjects – the *Allegory of the Church Militant and Triumphant* and *The Triumph of St Thomas Aquinas* – make no bones about what these frescoes are really all about: promoting orthodoxy and smiting heresy. But don't be put off: these are the most colourful and interesting paintings, and while they may not be a step forward in the development of artistic style, the chapel is a one of the major masterpieces of the later fourteenth century, presenting a comprehensive overview of the Dominicans' intellectual world.

We'll come to the philosophy later; when we walk in to the chapel, our eyes are immediately drawn to a vast pale-pink version of the Duomo painted on the right-hand wall. But hold on – it has Gothic windows on the upper storey, not the round ones we see today. Also, it has a dome – yet the dome wasn't completed for another seventy years. (In fact, at the time Andrea was painting, only the nave and façade of the Duomo had been completed.) And for good measure, the Campanile has been moved from one end of the Duomo to the other. There are explanations for some of these changes: in 1365, the same year as he started the frescoes, Andrea di Bonaiuto submitted a model for the completion of the Duomo to the authorities, and the fresco may well show his proposal. Despite Andrea's efforts at self-promotion, his plans were rejected. The Gothic windows were probably Andrea's design, but the unbuilt dome, based on Arnolfo di Cambio's original model, was an unchangeable requirement. The Campanile was no doubt moved to the east to suit the composition of the fresco, but the most likely explanation for the startling pink colour of the Duomo's walls is that their marble facing was still incomplete.

The Duomo features in the fresco that is variously called the *Allegory of the Church Militant and Triumphant* or the *Way of Salvation*; its theme is how the teaching of the Dominicans leads those who follow it to heaven. The Duomo symbolises the established Church. In front of it sits a pope, probably Benedict XI, who had been a Dominican friar and later Master General of the Dominican Order at the close of the previous century. To the left of the Pope sits a figure wearing the black cloak of the Dominicans and the red hat of a cardinal, identified as Niccolò Albertini, who succeeded Benedict XI as Master

On page 114
Andrea di Bonaiuto: the Duomo, in the *Allegory of the Church Militant and Triumphant* or *The Way of Salvation* in the Spanish Chapel, Santa Maria Novella

Below
Andrea di Bonaiuto: *Allegory of the Church Militant and Triumphant* or *The Way of Salvation*, in the Spanish Chapel, Santa Maria Novella

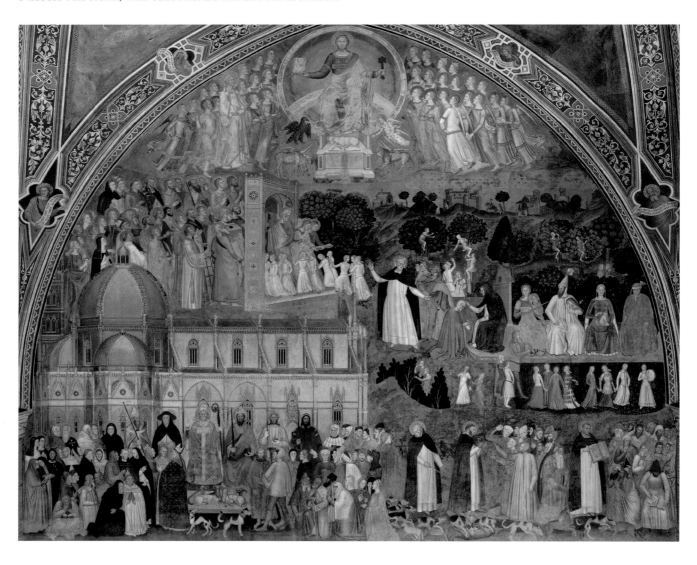

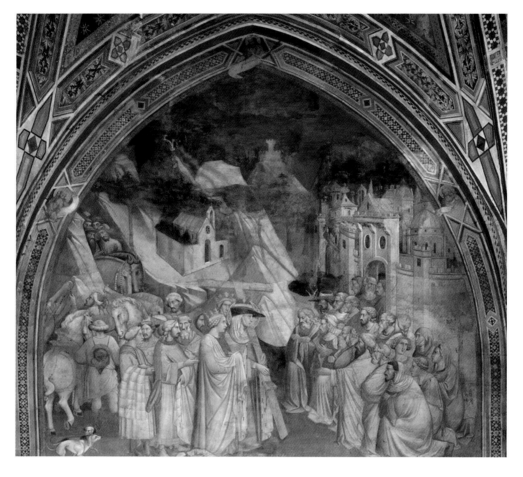

Agnolo Gaddi: frescoes in the chancel of Santa Croce

Left
St Helena carries the Cross to Jerusalem

Right, above
King Khosrow captures the Cross

Right, below
King Khosrow worshipped as a god; the Emperor Heraclius in his tent, and defeating Khosrow's son

of the scene. The True Cross is identified, on the left, by the stratagem of holding it over an ashen-faced woman on her sickbed. It heals her and she sits up in her bed, while St Helena, appearing a second time dressed in brilliant scarlet, kneels to acclaim this cross as the true one. In the background, Agnolo includes some charming details: a lion rests at the mouth of a cave; a Franciscan friar draws water from a well, while another fishes in the stream. Between them, a squirrel climbs a tree; ducks and a heron swim by; a dog crouches and geese peck for food thrown at them by a figure who might be St Francis himself.

The legend continues in the topmost panel on the left wall, where an elegant St Helena, wearing the most fashionable of hats, carries the cross to Jerusalem, whose citizens kneel in grateful rows outside their walls. Moving down and on another three centuries, the Persian King Khosrow II, the last great king of the Sasanid dynasty that ruled most of the Middle East before the rise of Islam and who captured Jerusalem from the Romans in AD 614, gallops off from Jerusalem with the cross, while his foot-soldiers stagger under the weight of their loot. The panel below is split into three scenes: starting on the left, Khosrow is enthroned in a fantasy temple of silver and gold, surrounded by courtiers who worship him as a god; in the middle, the Byzantine Emperor Heraclius lies in his tent, dreaming of recapturing the cross; and on the right, he charges on his horse to defeat Khosrow's son in single combat on a bridge over the river Danube. The final panel

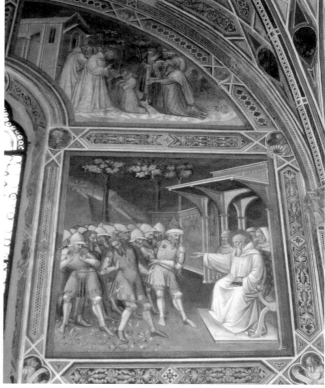

scene he accepts Maurus and Placidus as disciples.

The story continues on the lower right side of the west wall, where a hairy black ape-like devil is shown dragging a monk away from Mass, and at the other side of the scene Benedict is about to give a hearty thwack with a club to the demon prancing on the head of a monk who kneels before him. Continuing clockwise at the lower level, in a practical miracle, St Benedict reattaches the blade of a sickle to its handle for a Goth who is cutting the undergrowth from the side of the lake, in order to be admitted to a monastery. In the next scene he rescues Placidus from drowning, by sending his fellow disciple Maurus to walk on the water of the pond to pull him out. In another practical miracle, next to the window round the corner, St Benedict's prayer helps the monks to lift a stone slab on which another devil is squatting. St Benedict's enthusiasm for construction is reflected in the lower left scene on the west wall, where we

see him reviving a monk who was crushed by a collapsed wall of the church that he was building at Monte Cassino, while the devil who pushed it over beats a hasty retreat. Norcia, the city where St Benedict was born, is in the centre of Italy's earthquake zone, so perhaps this devil was a tremor in the rocks below.

On the other side of the window, St Benedict recognises the Ostrogoth King Totila's sword-bearer Riggio, who came to meet him at his monastery of Monte Cassino disguised as the King. So, round the corner of the south wall, Totila, who had led the Goths' invasion of Italy in AD 541, is reprimanded as he comes to pay homage himself to St Benedict. A few years later, in AD 547, St Benedict died, and his funeral is shown in the last scene, to the right. He lies on his bier surrounded by his monks and clergymen, some of whom see him climbing up a carpet path to heaven.

These stories come from Pope Gregory's contemporary

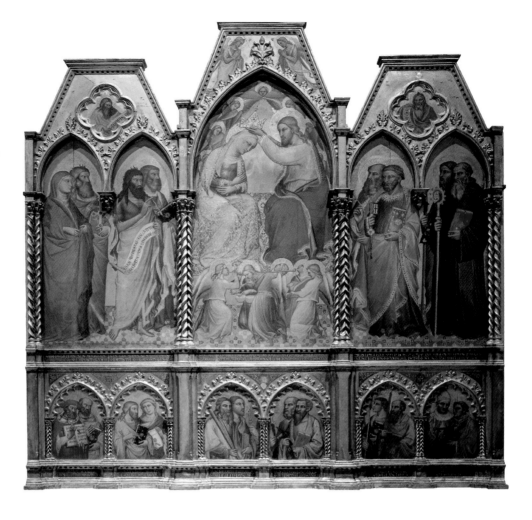

account of Benedict's life. It is striking how Spinello's scenes reflect a view of the world, and not just of hell, as being full of devils. No doubt the Dominicans would have had strong views on this! But they would have approved of Spinello's frescoes of the Evangelists holding their Gospels on the vaults of the sacristy, accompanied by their symbols which we saw in the mosaic in the apse of San Miniato.

Spinello's style at this time shows the last traces of Giotto's pioneering influence. His colours are chosen from a narrow range, but they are broadly natural. His drawing is strong and clear, even if not done from life, and his compositions focus squarely on the story, uncluttered by extraneous detail. His architecture is solid, stylised and simplified, very much in the tradition of Giotto and the Gaddis. At the end of his career, Spinello adopted a new style, known as International Gothic, from which all signs of Giotto's inspiration disappear. Originating in the elegant courts of France and Burgundy, the style emerged in Italy at the end of the fourteenth century, at a time when Florence had recovered from the Black Death and was rebuilding its prodigious riches, and patrons of art wanted works which reflected their power, piety or wealth. The interest in progress, learning and humanity reflected in the works of Giotto and Andrea Pisano, though never extinguished in intellectual circles in Florence, fell out of artistic fashion for fifty years.

Spinello's *Coronation of the Virgin* is a gorgeous example of the International Gothic style. Painted for Santa Felicita (where we saw Taddeo Gaddi's polyptych in the sanctuary) with the help of two other artists, it is now in the Accademia. It shows Jesus placing a crown on her head, as Queen of Heaven, after her death and Assumption. The subject, which we first saw in Gaddo Gaddi's mosaic in the Duomo, originates not from the Bible but from the popular devotion

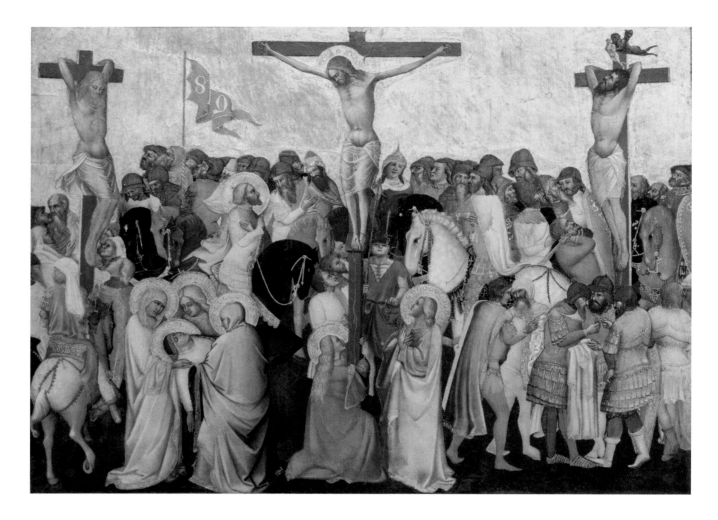

to Mary; it was frequently commissioned for nunneries, permitting the nuns to dream of becoming a bride of Christ after a life of prayer and penitence. Not only the subject, but also the spirit of this altarpiece take us back a hundred years or more to Byzantine art. Like Coppo di Marcovaldo's *Virgin in Majesty* in Santa Maria Maggiore, it is painted almost entirely in scarlet, blue and gold; the figures are symbols first and people secondly, and the composition is determined by the frame. Of course, the drawing is more delicate, the shading is subtler, and the carving of the frame infinitely more elaborate, but the spirit is similar.

Agnolo Gaddi also adopted the International Gothic style for his Crucifixion scene, intended for San Miniato

and now in the Uffizi. The harmonious pastel shades of his frescoes in Santa Croce are gone, again replaced almost entirely with intense shades of scarlet, blue and gold – gold everywhere, as a background, on the haloes, and on the armour of the soldiers who throw dice for Jesus's clothes. Gone too are the contemporary fashions of the Santa Croce cycle, replaced by floor-length robes. Contemporary visitors to San Miniato would not have been looking at people they might have recognised, but at an exotic scene in a far-off land.

The International Gothic style influenced the sculpture of the late fourteenth century as well as the painting. The major project of the time was of course the

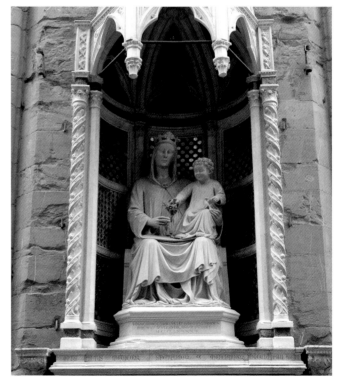

Duomo; the structure of the nave having been completed, its decoration could begin. A sculptor, Pietro di Giovanni Tedesco, of German origin as his name implies, created fifteen statuettes for the niches around the main doorway, now destroyed. He also sculpted the figures above the Porta dei Canonici, the Canons' Door, on the southern side of the nave, which has survived and is currently the door through which visitors leave after their visit to the dome. As at Orcagna's tabernacle in Orsanmichele, every scrap of surface is carved or decorated, overpowering Pietro's figures, but the central group of the Madonna and Child with two bronze-winged angels is softer, more rounded and better composed than many a Northern European version. The best-known work attributed to him is the *Madonna della Rosa* commissioned around 1399 by the Guild of Doctors and Apothecaries for their niche on the southern side of Orsanmichele. The Virgin and Child are enclosed in a wonderful little canopy, protruding from the wall with all the High Gothic trimmings, and the figures themselves are a step forward in sculptural style. The infant Jesus is remarkably human, with chubby cheeks and curly hair, stretching forward naturally to touch the roses which give the statue its name. With his other hand he moves to stroke the dove on his knee. The Madonna isn't idealised and ethereal in the Gothic way, but solid and real, an effect achieved in part through the deep folds in the drapery.

Two other statues had been made for the guilds' niches in Orsanmichele since its 1337 rebuilding (a *St Stephen* by Andrea Pisano and a *St John the Evangelist* by Simone Talenti, now in the Cathedral Museum and the Ospedale degli Innocenti respectively), but with fourteen niches in all

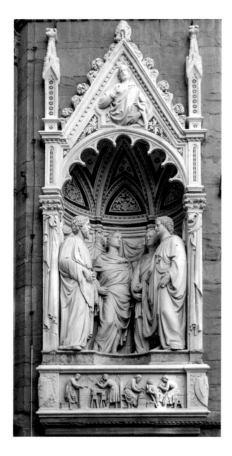

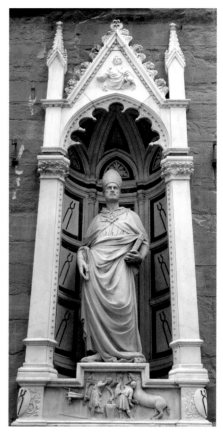

to fill, eleven were still empty even after Pietro's *Madonna della Rosa* had been installed. By 1408, with the plagues and disasters of the previous century receding into memory, the Signoria decided that it was time to move the project forward, and set a ten-year deadline for completion of the statues. The Guild of Stonemasons and Carpenters responded with a commission for an unusual group of *Four Crowned Saints*, which stands diagonally opposite the *Madonna della Rosa,* on the northern wall. These third-century martyrs were themselves stonemasons, who were put into barrels of lead and then thrown into the sea, according to the *Golden Legend*, for refusing to carve a pagan statue for the Emperor Diocletian. The commission went to Nanni di Banco. Nanni (short for Giovanni), like so many of the artists and sculptors of the day, was trained by his father, Antonio di Banco, who was *Capomaestro* of

the Duomo. Nanni's first commission was a life-size *Esaias* (Isaiah) intended for the main façade of the Duomo, and now in the Cathedral Museum. This work shows Nanni experimenting in two directions at once. On the one hand, Isaiah is not the stooping greybeard of convention, but a young athlete with the face of a Roman nobleman. On the other, his swaying pose shows him frozen in a stylish dance move. The result may not be entirely convincing, but after half a century of stultifying Gothic piety, it is a breath of fresh air. *Esaias* is not instantly recognisable as an Old Testament prophet, but he is a human being, not a stylised formula. Nanni's study of Roman sculpture is obvious in his *Four Crowned Saints*, who, although they do not have crowns, have dignity and gravitas aplenty. In the panel below them, showing stonemasons and sculptors at work, Nanni has a joke at our expense. The cherub on the

designs far and wide. Ghiberti himself prospered mightily as Bartoluccio had predicted, becoming the richest artist of his day, and his lasting fame was assured when, twenty years later, he was awarded a second contract, this time without a competition, to make a third set of doors for the Baptistery.

Amongst the painters, the greatest exponent of the International Gothic style in Florence (granted, he was Sienese by birth, so he had Gothic in his veins) was Lorenzo Monaco. As his name 'Laurence the Monk' suggests, at one stage he joined the monastery, now defunct, of Santa Maria degli Angeli ('St Mary of the Angels') in Florence run by the Camaldolese, another reformed branch of the Benedictines. By 1402 Lorenzo was enrolled in the Painters' Guild under his real name, Piero di Giovanni, and was living outside the monastery. The Accademia has two of his works from this period, a *Crucifixion* and an *Annunciation*. Both were subjects that he painted several times; in this version of the Crucifixion he has distilled his style down to a striking simplicity. Most of the surface is gold; the vestigial landscape is scooped into a symmetrical U shape, with no pretence of reality at all. The figure of Christ follows a formula, with elongated limbs and stylised body. Angels catch blood from his hands and his side. On either side of him, the lance that pierced his side, and a pole with the sponge soaked in vinegar, stand vertically, with no one to hold them up. On top of the cross, above the label INRI – for *Iesus Nazarenus Rex Iudaeorum*, Jesus of Nazareth, King of the Jews – a pelican, symbol of self-sacrifice, pecks its breast to shed blood to feed its young. The picture no longer tells the story; it is intended for contemplation and devotion by monks who already knew the story well.

The *Annunciation* also gleams with gold, but glows with the saturated colours, especially on the Virgin's rich blue mantle and the angel's pink, yellow and violet robes, contrasting with the precisely painted rows of blue and white feathers in the wings. Their poses are so familiar, we do not need the captions below – Gabriel's greeting, *Ave [Maria] gratia plena*, 'Hail Mary full of grace', and Mary's

Below
Lorenzo Monaco: *Crucifixion*
(Accademia)

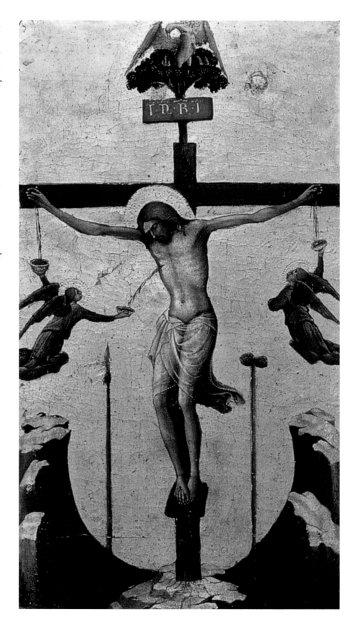

Left
Lorenzo Monaco: *Annunciation*
(Accademia)

Right
Lorenzo Monaco: *Altarpiece of
the Annunciation*, in the Bartolini
Salimbeni Chapel, Santa Trinita.

reply, *Ecce Ancilla Domini*, 'Behold the handmaiden of the Lord' – to tell us what is going on. The saints on either side are also labelled, here more necessarily, as it would be hard to identify St Proculus, a local martyr for whose thirteenth-century church in Via dei Giraldi Lorenzo made the painting, from his gorgeous tangerine cloak alone. Next to him on the right St Francis is identifiable by his stigmata. On the left, St Catherine has her wheel, and the elderly monk beside her, wearing a long grey gown, is signalled as being St Anthony by the tiny black piglet looking up at him. St Anthony, the early Christian monk who lived in Egypt, worked as a swineherd before becoming a hermit in the desert, so pigs became his symbols.

The popularity in Florence of the Annunciation as a subject for painting has been attributed to the importance of the Feast of the Annunciation, being the first day of the New Year in the Florentine calendar, used throughout medieval Italy. Falling on 25 March, exactly nine months before Christmas, it was a major holiday. But more than this,

the special significance of the Annunciation in Florence, which grew into something of a cult in the early fourteenth century, can be traced to a miraculous painting of the subject in the church of Santissima Annunziata. This church was founded as Santa Maria in Cafaggio (the name of the district north of the city then) in 1250 by the Servites. Two years later, a painter called Fra Bartolomeo was frescoing an Annunciation scene for the Servites, but despaired of creating as beautiful a face for the Virgin Mary as she deserved. In a miracle which brought great renown to the picture and the church, an angel completed the face for him while he slept. The painting was so venerated that the church became a place of pilgrimage, and in 1314 was rededicated to the 'Most Holy Annunciation'. The miraculous image itself is encased in a giant shrine, known as the Chapel of the Annunciation, immediately to the left of the main entrance to the church. The angel's brushwork has been repainted, and the work that can be seen today, when not concealed behind a protective wooden screen, dates from the middle

of the fourteenth century. The otherwise conventional scene includes an Oriental rug on the floor between the angel and Mary, the earliest known in a European picture, illustrating the taste and trade of the era.

Despite the challenge of the subject, artists were no doubt glad to have the opportunity to paint lovely young ladies and elegant angels. Another of Lorenzo Monaco's beautiful Annunciation scenes stands in Santa Trinita, still in its original three-arched frame and in its original location, on the altar in the fourth chapel on the right aisle. As well as creating this altarpiece, Lorenzo frescoed the entire chapel in his last few years until his death in 1424, for the merchant Bartolini Salimbeni family whose handsome Renaissance palazzo stands across the Piazza Santa Trinita

from the church. In this *Annunciation*, the Virgin and the angel who brings her a present of some Madonna lilies have traditional Gothic poses, but in a significant development the Virgin is not hovering somewhere in front of an architectural backdrop: she sits firmly on a wooden bench, itself resting squarely on a tiled floor, under a loggia that, if too thin to be called Classical, is no longer exactly Gothic. Lorenzo was clearly influenced here by some of the younger generation of fifteenth-century artists. The frescoes which cover not just the walls of the chapel but the vault and the arch as well, show scenes from the Life of the Virgin, most of which, although much damaged, are identifiable from Taddeo Gaddi's versions in Santa Croce. On the left, wall, the scenes at the top, of the Expulsion of Joachim from the Temple and the Annunciation to Joachim, have been badly damaged. Below, the Meeting of Joachim and Anne at the Golden Gate of a very jolly pink Jerusalem has survived rather better. The best preserved, on the right-hand wall, show her Death above and the most attractive scene of the series, her Marriage, below.

In the same room in the Uffizi as Agnolo's *Crucifixion* there are two of Lorenzo Monaco's spectacular later masterpieces, both created for local churches. The enormous *Coronation of the Virgin* (it is 14 feet wide and 11 feet high) was originally displayed in Lorenzo's old monastery of Santa Maria degli Angeli. This traditional composition, in an ornate triple-arched frame, shows in the centre a very human Christ carefully placing a crown on the head of Mary, a humble but heavenly princess. Their throne stands on a rainbow of starry blue spheres, symbolising

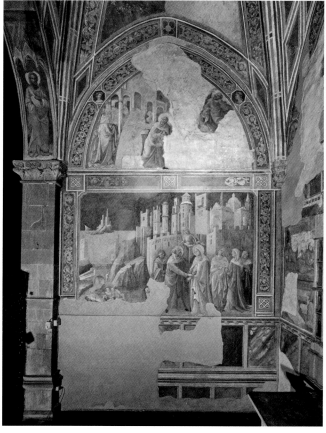

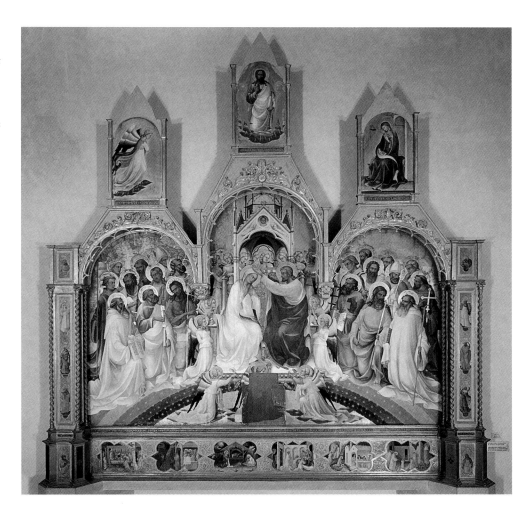

heaven, as in the mosaic of Christ in the Baptistery, while saints in glowing robes throng the side panels. Below them, there's a trio of angels with wings as bright as parakeets', repeated in the Annunciation scene in the flanking panels on top of the arches of the frame.

The colours are every bit as brilliant in Lorenzo's *Adoration of the Magi*, painted probably to mark the reconsecration by Pope Martin V of the church of Sant'Egidio ('St Giles'), now absorbed into the hospital of Santa Maria Nuova. If the reconsecration was an occasion for great celebration, to have a legitimate pope to perform the ceremony was even more so. Since 1309 the popes had resided in Avignon, until Gregory XI returned to Rome

in 1377. When he died the following year, the cardinals couldn't find a suitable Roman to elect, and settled on the Neapolitan Urban VI. Unfortunately they soon regretted their decision and elected another pope, Clement VII, thereby plunging the Church into chaos. Clement re-established the papal court in Avignon, with French and Spanish support, and for forty years there were two popes, a state of affairs known as the Western Schism. In an attempt to resolve the situation, seven cardinals met in Pisa in 1409, and made things worse by electing a third pope, Alexander V, who was succeeded the next year by their leader John XXIII. Matters were improved when the Holy Roman Emperor summoned the Council of Constance,

Above
Lorenzo Monaco: *The Adoration of the Magi* (Uffizi)

Right
Gentile da Fabriano: *The Adoration of the Magi* (Uffizi)

which resolved that all three popes should abdicate, and in 1417 elected Martin V, who left Constance when the Council ended, coming to Florence and staying until 1420 while he re-established his control over Rome.

It was during Martin's stay in Florence that the reconsecration of new church of Sant'Egidio took place. The event is depicted in a large fresco by Bicci di Lorenzo displayed in the entrance hall of the museum of the hospital of Santa Maria Nuova. Lorenzo Monaco's *Adoration of the Magi* for that church is almost a Gothic fantasy, in which

commission he kept it at home until the year before he died, when he gave it to the Dominican friars of Santa Maria Novella, where it now hangs in the Gondi family's chapel. It shows a very different concept of Christ from Donatello's. Brunelleschi's Christ is pale-skinned, tall and lean, almost emaciated; his body, not just the muscles but the ribs, the kneecaps, even the tendons of his wrists, is so carefully studied and clearly delineated that he might have been skinned. The tension in the arms and the awkwardness of his crossed feet capture the pain of crucifixion in a way that we have not seen before. It is a matter for debate whose concept of Christ has been the more influential on subsequent artistic portrayals, but it seems entirely appropriate that Donatello's down-to-earth vision of the son of a carpenter hangs in Santa Croce, the church of the Franciscans with their emphasis on simple humanity, while Brunelleschi's intellectualised notion of the perfect man is in Santa Maria Novella, the church of the theological Dominicans.

Despite the success of this Crucifix, Brunelleschi did not make much more sculpture. He may have carved the high-quality statue of St Peter for the Arte dei Beccai, the Guild of Butchers, for their niche at the north-east corner of Orsanmichele, across the street from the guild's Palazzo, which bears their emblem of a rampant goat on a shield high up on the façade. However, this *St Peter* is also attributed to Donatello, and indeed is very similar to his *St Mark*. Brunelleschi worked mainly as a goldsmith, for which he had trained before his time in Rome, when amongst other things he made clocks, including one of the first alarm clocks. In his early forties he also branched out as an

architect, designing a house for his cousin near the Mercato Vecchio. This was followed by two commissions for chapels, one for the Ridolfi family at San Jacopo sopr'Arno, which was demolished when the interior of the church was rebuilt in 1709, and the other for the Barbardori family, to the right of the entrance door in the church of Santa Felicita in the Oltrarno, just across the Ponte Vecchio, which survives, although its original dome has been altered.

Meanwhile, Donatello's career as a sculptor went from strength to strength. The Arte dei Corazzai e Spadai, the Guild of Armourers and Swordmakers, commissioned a statue of St George from him. A copy of this famous work stands in the Armourers' niche at Orsanmichele, and the original in the Bargello. While St Mark wears a cloak of linen out of deference to the Linaiuoli, St George is dressed

as the soldier in the Roman army that he was, sheathed in plated metal on his feet and forearms, and wearing an armoured kilt. He stands ready to seize his shield, the slight twist in his strong body expressing his controlled energy. Vasari saw *St George* as reflecting youthful beauty, courage and skill in arms, as well as a fierce vitality. His furrowed brow and anxious look tell a different story, of a young soldier in danger. Despite being a symbol of saintly heroism, an idealised type rather than an individual, the subtlety of his expression and the natural vigour of his stance show how far Donatello had progressed. The bronze *St John the Baptist* around the corner, completed only a year or two earlier by his former master Ghiberti, its deep curving folds in the heavy cloak concealing the body beneath, suddenly appears old-fashioned and contrived by comparison to the vigorous realism of *St George*.

The panel at the base of the niche, showing St George saving the princess of Cappadocia by slaying the dragon to which she was to be sacrificed, is almost as well known as the statue above. On either side of the panel, shields display a breastplate and a sword, emblems of the patrons. In the centre, St George charges on his rearing horse and plunges his lance into the noxious dragon guarding its lair. The trembling princess, who had been sent out dressed as a bride, clasps her hands as she recoils in fright in front of an arcaded building on the right. The technique of the panel marks two significant developments. The arcade and the landscape beyond it are cut in extremely shallow gradations, a technique called *rilievo schiacciato* – literally 'squashed relief' – first seen here and perfected by Donatello in his later work. Also, the arcade is drawn in correct perspective: if we imagine two lines linking the bases of the pillars and the tops of the arches, these converge on a vanishing point at the centre of the scene.

The theory of perspective, the method of representing three-dimensional objects on a flat surface, had been understood by the ancient Greeks, at least for use in theatrical scenery. Euclid developed the mathematical theory in his book *Optics*. The skill of perspective

Left and right
Brunelleschi: the Ospedale
degli Innocenti, and a capital of a
column of the loggia

which was declined in favour of Baccio's design. Work stopped in 1515, and after Michelangelo's devastating comment that it looks like 'a cage for crickets' it probably will always be unfinished.

The fruits of Brunelleschi's study of Roman ruins are visible in his first surviving building in his own original style, the Ospedale degli Innocenti, or Foundling Hospital, which was commissioned in 1419 by his guild, the Silk Merchants and Goldsmiths, the Arte della Seta. The loggia which forms the façade of the Ospedale facing on the Piazza Santissima Annunziata has been much altered, but nevertheless is one of the most significant buildings of the Renaissance. Brunelleschi planned a loggia of nine arches, set on slender columns with Composite capitals (combining the acanthus leaves of the Corinthian order with the volutes, or scrolls, of the Ionic). The arches carry a heavy horizontal cornice, dividing the height of the façade into two almost equal parts. The columns are as far apart as they are tall, so that the semicircular arches between them are exactly half as high again. The columns are the same distance forward of the rear wall of the loggia as they are apart, so they form the corners of a series of cubes, each of which is roofed with a Roman-style sail dome – a hemisphere with its sides squared off – rather than a Gothic rib vault. The central nine arches were originally flanked by two end bays with walls framed by pairs of fluted pilasters and central doors, at one end for men to enter the hospital and at the other for women. The intention was for the pairs of pilasters to be repeated on the upper floor of the end bays up to the eaves, serving as book-ends to frame the building as a whole. However, it seems that Brunelleschi was too busy with other

projects to supervise the construction of the Ospedale, and the upper pairs of pilasters were never installed.

In addition to his architectural projects, as *Capomaestro* Brunelleschi was called upon to design military fortifications for Pistoia and for other towns and strongholds at risk from attack by the Milanese. Then in 1430 he was distracted by a disastrous attempt to capture Lucca by diverting the river Serchio to surround the city, and force it to surrender. His dam was swept away when the Lucchese breached his canal and flooded the Florentine camp.

Within thirty years, two more bays were added to the façade of the Ospedale, one at each end, while the two original end bays were later opened out to create an additional pair of arches, the one on the left at a lower level to allow the traffic through, further weakening and unbalancing the original design. But not all the later alterations were for the worse. Brunelleschi left the stone roundels between the arches blank; his serene but rather plain design was enlivened by the addition at the end of the century of the much-loved terracotta babies wrapped in striped swaddling clothes on bright blue backgrounds,

Left
Andrea della Robbia: one of the
terracotta tondi on the façade of
the Ospedale degli Innocenti
Right
Brunelleschi: the Men's Cloister
of the Ospedale degli Innocenti

made by Andrea della Robbia. In the nineteenth century four more roundels, or *tondi* as they are technically known, were also squeezed in, two in each of the end bays.

While the Ospedale is not as impressive as the dome of the Duomo, or even finished according to Brunelleschi's plans, it was nevertheless enormously influential, and repeated all over the city. The most faithful copy is on the other side of the Piazza Santissima Annunziata, in the Loggia dei Serviti of 1525 by Antonio da Sangallo, now fronting a hotel. On the northern side of the Piazza, the portico in front of the church of Santissima Annunziata, built in 1601 by Giovanni Battista Caccini, alters the proportions with taller columns, but was still clearly intended to unify the design of the square. The loggia of the former hospital of San Paolo, which faces the church of Santa Maria Novella from the far end of the Piazza and dates from the 1490s, was clearly inspired by Brunelleschi's example. Other imitations can be found in the Piazza della Libertà in the north, and in the Loggia del Pesce (the Fish Market), originally in the Mercato Vecchio, the 'Old Market' in today's Piazza della Repubblica, but rebuilt in 1956 in the

Piazza dei Ciompi, at the eastern edge of the city centre.

Despite its influence, the façade of the Ospedale was neither totally new nor correctly Classical. While the inspiration was Roman architecture, we do not have to go that far to play the game of identifying where the parts come from. The windows of the upper storey with their temple-front frames follow the façade of San Miniato or the Baptistery, as do the arches and columns. Indeed, by Roman standards the columns are too far apart and too slender. Nor even is the idea of a loggia in front of a hospital an innovation: only a few hundred yards away on the corner of the Piazza San Marco, the former Ospedale di San Matteo, founded in 1385 and now containing the library of the Accademia, has a loggia with plain arches resting on columns in the Tuscan Gothic style. What makes all the difference is Brunelleschi's sense of proportion, and while the style is more a reinvention of local Romanesque than a thoroughgoing Classical revival, it is the attention to the details of the arches, the columns and their capitals that shows his search for perfection.

There was another reason for the great influence of the Ospedale degli Innocenti on building in Florence: the fashion had changed. It wasn't just Brunelleschi who was interested in Classical architecture. The leading intellectuals of the day were hungry to learn about all things Classical. A group of them met at the Camaldolese monastery of Santa Maria degli Angeli, at the invitation of the Prior, Ambrogio Traversari, who later became Prior General of the Camaldolese order, and then a saint. Traversari had studied Greek literature under the Byzantine scholar Manuel Chrysoloras, who in 1396 had

been invited to teach ancient Greek grammar and literature at the University of Florence. Chrysoloras stayed for only three years, but nevertheless this was a development of great significance: no one had studied Greek in Italy for seven hundred years. His circle of students, who have become known as the humanists, were interested in Greek thought and culture as much as literature. They included the scholar Leonardo Bruni, later to become Chancellor of Florence, and Poggio Bracciolini, an enthusiastic hunter of manuscripts. Bracciolini had been secretary to Pope John XXIII, accompanying him to Constance for the Council. After John had fled to Germany and been deposed, Bracciolini took the opportunity to travel along the shore of Lake Constance to the monastery at St Gallen, where, along with other treasures, he recovered a copy of the original treatise on Classical architecture, the ten-volume *De Architectura* by Vitruvius, written in the first century BC as a guide for building projects for his patron, the Emperor

Augustus. The bankers Cosimo de' Medici, who had been educated at the convent school at Santa Maria degli Angeli, and Palla Strozzi were also in this group. Strozzi, seventeen years older than Cosimo, remained faithful to the opulent International Gothic style, bestowing his patronage on Lorenzo Ghiberti, Gentile da Fabriano and Lorenzo Monaco. Cosimo's enthusiasm for the new style of architecture, backed by his prodigious wealth, was to change the face of the city.

Brunelleschi designed the rest of the Ospedale degli Innocenti, behind the loggia, but his design was not entirely followed by the builders. It was loosely based on the layout of a Roman villa, with a symmetrical plan around a central courtyard, the Chiostro degli Uomini or Men's Cloister. The design of the cloister follows that of the loggia outside, simply bending the arcades round the corners as if folding cardboard. The details are simplified, and the arcades are covered with Gothic style vaults rather than domes, yet the

Right
Brunelleschi: the Women's
Cloister of the Ospedale degli
Innocenti

effect is still graceful and elegant. Around 1493 another terracotta panel made by Andrea della Robbia was added in a lunette above a door in the north-west corner of the central cloister. The *Annunciation* shows a handsome young Angel Gabriel handing a bunch of lilies to an anxious Virgin Mary, while the dove of the Holy Spirit flies towards her from God the Father and a cluster of angels in the sky above. All the figures are glazed in white, including the arch of sweet-faced cherubs above the scene, and the leaves and stems of the flowers are green, against a dark blue background. The Chiostro delle Donne, the Women's Cloister, is plainer still, but has columns that are even more slender and topped with Ionic capitals, suggesting that Brunelleschi had studied Vitruvius, who wrote that the Ionic order imitated feminine slenderness.

While the Ospedale di San Matteo, funded by the Bankers' Guild, was founded to assist the sick poor, and the Compagnia della Misericordia opened the Loggia del Bigallo as an orphanage, the Ospedale degli Innocenti was specifically for foundlings – abandoned babies. In any

day and age there will always be some, but why was there a need for such a large hospital? Part of the answer is that in 1336 the import of foreign slaves was permitted, provided that they were not Christians, in response to a shortage of domestic servants caused by a plague. These slaves, usually girls, were bought in the markets of Venice and Genoa from traders who brought them from Greece, Turkey and the shores of the Black Sea. They lived in the houses of their masters, who legally had complete power over them. The inevitable result was a large number of babies, some of whom were accepted into their fathers' households, but many were bundled up and delivered to the Ospedale.

Around the time that Brunelleschi's career as an architect was taking off, Donatello continued to work for the Duomo. Assisted by Nanni di Bartolo, another local sculptor, Donatello created a version of the *Sacrifice of Isaac* for the niche above the entrance door of the Campanile (now in the Cathedral Museum, replaced by a copy). The subject was a challenge in two ways: it required two figures to be squeezed into the tall, narrow niche; and

elements. Considerably larger and more elaborate than any tomb in Florence before, and almost all since, it is squeezed in between two of the Roman columns on the wall to the right of the chancel, 24 feet tall up to the brass ring which appears to hold up the lavish stone canopy. This Gothic feature is combined with statues by Michelozzo of *Faith, Hope* and *Charity* at the lower level, standing in Classical shell niches separated by fluted pilasters with Corinthian capitals. The Theological Virtues would be appropriate for a clergyman's tomb, but are hardly so for a man who seems to have devoted his life to the pursuit of money, sex and power. On the left Faith holds her chalice, and on the right Hope holds her hands together in prayer, while Charity, in the centre, carries a flaming brazier in one hand and a cornucopia like the Roman goddess Ceres in the other. The Madonna and Child in the large shell niche at the top are surprisingly solemn. John's gilded bronze effigy, Donatello's contribution to the project, is a fine piece of work. It shows John dressed not as a pope but in a cardinal's costume, reflecting his position at the end of his days, when, following a reconciliation with Martin V, he was given as a consolation the title of Cardinal Bishop of Tusculum, a ruined Roman city. The design does not quite combine to make a unified whole, and the quality of the work is uneven, but the overall effect is a spectacular memorial to a man who had been both a pirate and a pope. The Medici family were doubtless pleased with the outcome: Donatello and Michelozzo were showered with commissions by Cosimo over the years.

The year 1419 saw spectacular success for Brunelleschi's new career as an architect. His second major commission of the year came from Giovanni di Bicci de' Medici, one of the committee of eight parishioners formed two years earlier to rebuild the church of San Lorenzo, which had been destroyed by fire. That Romanesque church, just outside the north-west corner of the city walls, itself had replaced one of the earliest churches in Florence, consecrated at Easter 393 by St Ambrose, Archbishop of Milan. Giovanni di Bicci commissioned Brunelleschi to build a family funerary chapel which would also serve as the church's

Below
Donatello and Michelozzo:
monument to Pope John XXIII,
in the Baptistery

sacristy, thus allowing a much more imposing edifice than would otherwise have been acceptable for a private chapel.

The Sagrestia Vecchia, or Old Sacristy, as it is known, speaks the quiet language of harmonious proportions. The concept is simple – a dome on top of a cube – but one which presents challenges of construction, requiring a new, or rather the revival of an old, solution. The dome is supported by means of curved triangular panels, known as pendentives, in the upper corners of the cube. Originally a Roman device, pendentives were used in Byzantine architecture, most notably at Hagia Sophia. Brunelleschi would not have known those, but may have seen other examples during his years in Rome. The umbrella dome is carried on twelve ribs which meet in a ring, supporting a small lantern, with small circular windows between them, filling the space below with cool light. The altar

wall is composed of Classical elements picked out in *pietra serena*, the fine-grained grey sandstone of Tuscany. The fluted pilasters at the corners of the square altar recess, with their Corinthian capitals of acanthus leaves, have strong Roman proportions. They carry the full Classical system of structure: the main beam, called the architrave; above it the frieze; and then the cornice, the projecting ledge at the top; these three elements together forming the entablature. Above the cornice, the pilasters are linked across the altar recess by a semicircular arch, adopting a Romanesque pattern which became characteristic of Renaissance architecture.

Brunelleschi's entablature is lighter than the Greek or Roman precedents, which are usually one quarter of the height of their supporting columns, because he has turned the Classical system inside out. In a Classical

temple the columns are on the outside, supporting the entablature, which in turn takes the weight of the roof. But Brunelleschi was constrained by the traditions of Italian church architecture, in which interiors were decorated and exteriors left bare and plain apart from their façades, so he had to reinvent the Classical system, putting the pilasters and the entablature on the inside. They look structural, but are not: it is the walls that carry the weight. This is clear in the corners of the chapel, where the pilasters appear to be buried in the walls. The entablature isn't there to carry the weight of a roof, but to decorate the walls and divide the space horizontally into two. This is most obvious in the side and entrance walls of the chapel, left blank for the sacristy cupboards that once stood against them, where Brunelleschi pretends to support the entablature by brackets at intervals where pilasters would have been. He may well have noticed this visual trick in the Baptistery, where a couple of Corinthian capitals above the arch over the altar chapel appear to support the beam above them, but can only have tiny pilasters beneath them because of the arch below.

Two years later Brunelleschi was appointed to build the whole church, starting with the transepts, where he re-used the pattern of the arch linking pairs of pilasters, on the end walls. Work progressed very slowly, due to lack of funds, a situation which was made worse in 1433, when Cosimo de' Medici, the driving force behind the project, fell into a trap set by his political enemy, Rinaldo degli Albizzi. Summoned to the Palazzo della Signoria on a pretext of an important meeting, he was imprisoned in a cell near the top of the bell tower, humorously known as the Alberghettino,

or 'Little Inn'. He had seen trouble coming, and taken the precaution of sending the capital of his bank, which in those days took the form of strongboxes full of gold coins, to the branches in Venice, Rome and Naples, and depositing bags of coins in the monasteries of San Miniato and San Marco for safekeeping hidden among their holy relics. Accused of trumped-up charges of treason, Cosimo escaped execution by bribing the Gonfaloniere della Giustizia not to support the sentence of death requested by Rinaldo degli Albizzi. Instead, he and his family were sent into exile for ten years. Cosimo was first ordered to Padua, then was allowed to move to Venice, where he stayed in the monastery of San Giorgio Maggiore, and busied himself with managing his bank. In Florence, the absence of their largest lender led to a squeeze on the city's finances, and Rinaldo's increasingly dictatorial behaviour soon provoked a public reaction. Cosimo's sentence was revoked and he returned to cheering crowds the following year, when the Albizzi, the Strozzi and their allies were themselves banished.

Amazingly, considering that he had just been through the worst crisis of his life, Cosimo carried on as before, commissioning works of art. Brunelleschi was reportedly not best pleased when Cosimo asked Donatello to decorate the sacristy at San Lorenzo, disrupting the cool simplicity of his spare architecture. Donatello added a row of smiling winged baby angels, alternately red and blue, to the frieze – a cheerful Renaissance interpretation of seraphim and cherubim. He also inserted four terracotta images of the Evangelists into the stone roundels above the centres of the walls; all sitting at stone desks as they write their Gospels, they can be identified by their symbols. St John and his eagle

are over the arch above the altar, and the larger circles on the pendentives display four scenes from his life. High up, these are not easy to see. On the pendentive to the left he lies on the ground on the island of Patmos. On the right he is being boiled in a cauldron of oil by the Romans in his martyrdom. The scenes of his ascension, and of the raising of Drusiana (on the left and right pendentives respectively on the back wall), show Donatello's skill in making complicated but convincing architectural perspectives from shallow relief.

One can imagine that Brunelleschi was especially distressed by the addition of the Medici's emblem, of red balls on a gold background, on shields on the pendentives in each corner, their bright colours clashing with his carefully considered harmony. Their family name, Medici, means 'doctors', probably indicating the profession of their ancestors, so the red balls may symbolise pills, or the coins of the current generations of bankers.

In another piece of Medici promotion, Donatello made a terracotta panel showing Cosmas and Damian, the patron saints of physicians and surgeons, in learned conversation, above the right hand one of the pair of doors on either side of the altar recess. These third-century twin brothers were doctors in what is now southern Turkey, who practised their profession for free. By coincidence, Cosimo was born on their saints' day, 27 September. He was christened after Cosmas, whose image, with his brother Damian, we shall

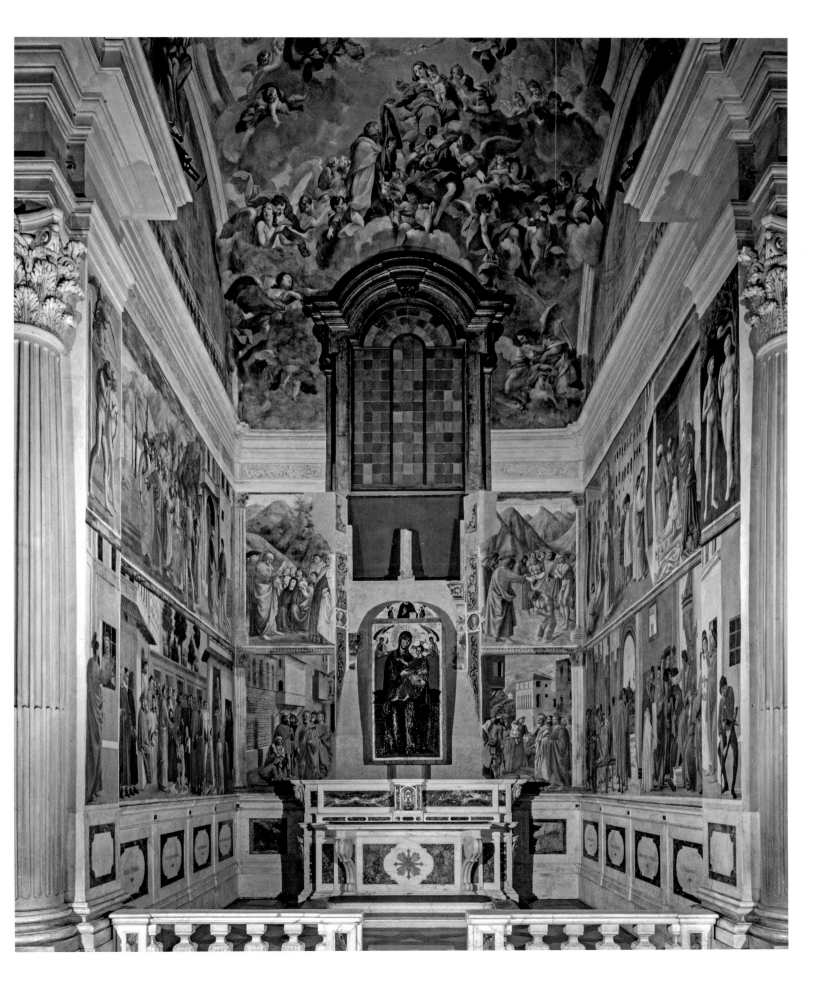

Frescoes in the Brancacci Chapel, Santa Maria del Carmine

Below
Masolino: *The Temptation*

Right
Masaccio: *The Expulsion from the Garden of Eden*

Far right
Masaccio: *The Tribute Money*

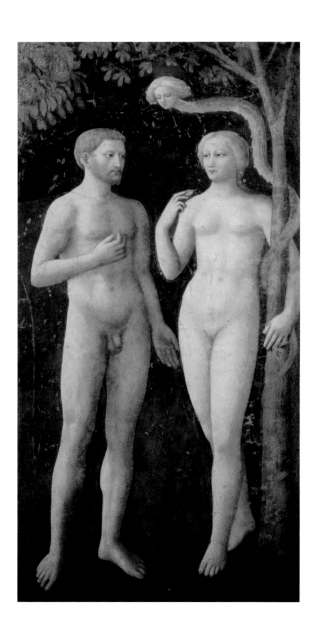

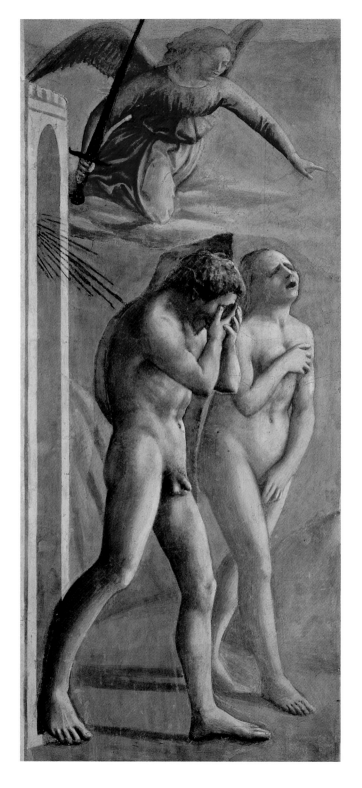

arm around the stem of the Tree of Knowledge, while the serpent, with a pretty female face, coils its tail around the tree, suggesting their similarity, and medieval misogyny.

In Masaccio's *Expulsion* Adam and Eve howl with anguish as they are driven by a sword-wielding angel from the gates of the garden. But while Masolino uses the graceful International Gothic style, to which he reverted as court painter in Hungary, Masaccio builds on Giotto's developments. Whereas Masolino's figures are drawn with strong outlines and light shading, so that Eve is almost flat, Masaccio's figures are fully rounded, and his colours natural. Masolino's figures are static, floating in front of a velvety background, while Masaccio's figures touch the barren landscape, of convincing depth, across which they move, and cast their shadows. Vasari wrote enthusiastically that 'Masaccio . . . realised that painting is nothing other than the art of imitating all the living things of Nature with their simple colours and design just as Nature produced them'.

The main sequence begins to the right of the *Expulsion*, with the *Tribute Money* by Masaccio. Whereas the subjects of *Temptation* and *Expulsion* hark back to the medieval obsession with original sin, this unusual subject reflects a contemporary concern – taxes. The story comes from St Matthew's Gospel: when Jesus and his disciples arrived at Capernaum, on the shore of the Sea of Galilee, the Temple tax-collector (seen with his back to us in the centre of the picture, wearing an orange tunic) came up and said to Peter (with the grey beard and brown cloak, on the left of the group), 'Your master doesn't pay Temple-tax, we presume?' After a discussion, Jesus, wearing a blue cloak over his bright pink robe in the centre of the fresco, concluded that they were exempt, but in order not to give offence told Peter to go down to the lake, throw in a hook, and open the mouth of the first fish that bit. Jesus looks at Peter and points to the lake. In the scene at the left, Peter crouches down to take a coin from the fish's mouth, and on the right he pays it to the tax collector with a contemptuous gesture, while fixing him with a meaningful stare.

In the *Expulsion* Masaccio appears to have learned from Donatello how to express emotion, and in the *Tribute Money* we can see how well he has mastered perspective. It is not just that lines of the building on Capernaum's seafront all converge, using Brunelleschi's technique, on a vanishing point near Jesus's head; in the background the

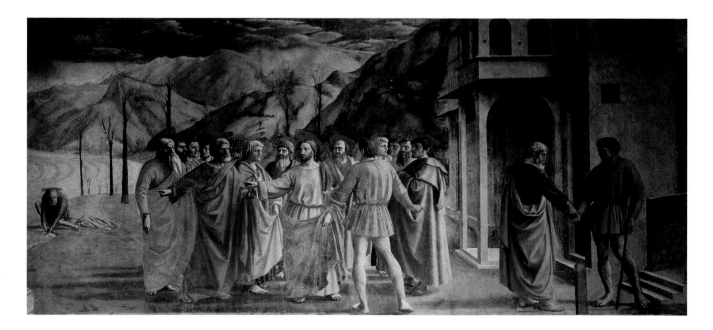

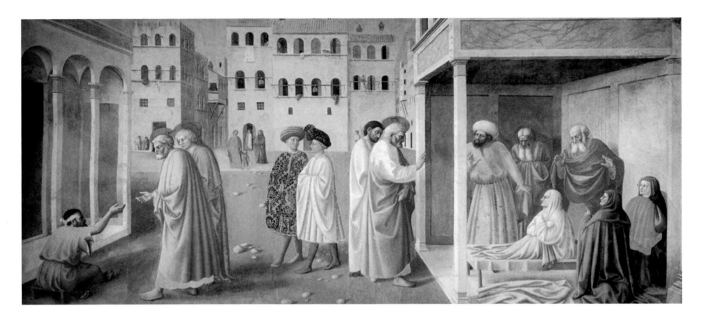

mountain ranges recede into the distance convincingly, and hardest of all to achieve, the group of disciples appear to stand, some in front and others behind, over a stretch of the shore on which they cast their shadows.

This newfound skill in using perspective is evident in the next painting of the series, which shows two scenes, the *Healing of the Cripple* and the *Raising of Tabitha*, in which the two painters collaborated. The source for both these stories is the Acts of the Apostles, which tells how Peter healed a man called Aeneas, who had been paralysed for eight years, by telling him to get up, and at Joppa (today, Jaffa) he brought a dead woman called Tabitha back to life, simply by using the same command.

The scenes are both set in the same city, whose architecture looks very Florentine. St Peter, wearing a golden coloured cloak, and St John, wearing a red cloak, meet the crippled beggar Aeneas as they are about to enter a temple through the loggia on the left. St Peter appears again and raises his hand to bless the charitable Tabitha who lies on a bed under another loggia on the right. The women kneeling behind her are two of the widows with whom Tabitha had worked.

It is not known for certain which artist painted which

figures; the two elegantly dressed gentlemen chatting as they stroll across the piazza in the centre of the picture, in their very decorative Gothic style coats, are certainly by Masolino, while the foreshortened figure of Aeneas in the lower left-hand corner, his right leg tapering sharply as it recedes away from us, may be by Masaccio.

One scholar's examination of the painting has detected a nail-hole in the plaster at the exact location of the vanishing point, behind the head of the right hand one of the two central figures, at eye height – as it should be, to create the illusion that we are standing in the same piazza as they are – suggesting that the lines of the loggias were drawn from a piece of string stretched taut and rotated around the nail, giving perfect perspective to the architecture in the picture. The grand palazzi in the background have some amusing domestic details. As well as a sheet and several pieces of washing hanging out of the windows, a pet monkey is walking along the ledge below the top floor windows.

Between these two large frescoes there are two smaller ones on the end wall of the chapel: in *St Peter Preaching*, by Masolino, on the left, we can see how much he appears to have learned from his younger colleague. He adopts the technique of using two different colours to

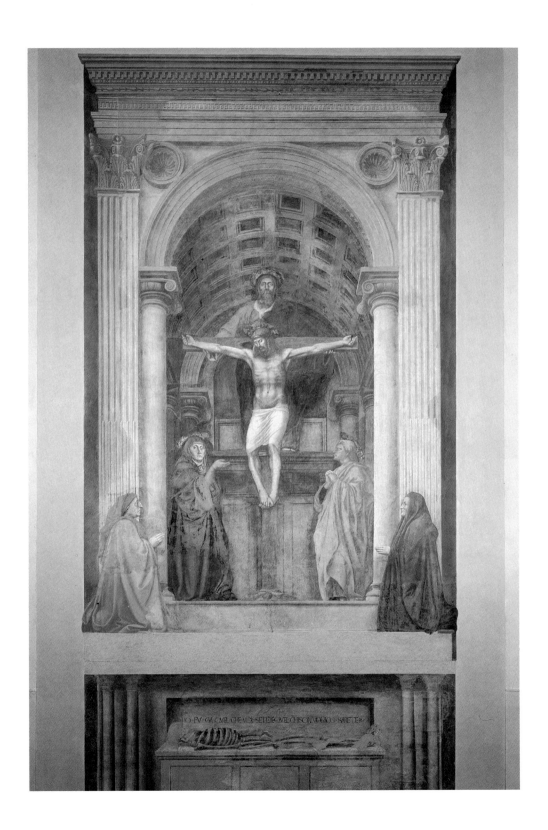

CHAPTER 6

SCULPTURE BRINGS HUMANITY INTO RENAISSANCE ART

Lorenzo Ghiberti's bronze doors for the Baptistery resulting from the 1401 competition were so much admired, and his workshop so well established, that in 1425 the Opera del Duomo dispensed with a competition and awarded the commission for another set of doors directly to him. This second set took even longer to make than the first. Although the scenes were cast by 1447, the doors were not finally hung in the eastern doorway until 1452. The long years of labour produced a work, in Vasari's opinion, 'perfect in every detail and the most beautiful the world had ever seen' – and indeed, no more elaborate or richly decorated pair of doors has ever been produced. Michelangelo famously judged them to be 'truly worthy to be the Gates of Paradise', the name by which they are usually known. His words of praise were also something of a pun: the patch of the piazza between the eastern doors of the Baptistery and the front of the Duomo, which the newly baptised would cross on the way to their first Communion, was known as 'Paradise'. Following recent work to preserve and restore them after the damage of the 1966 flood, the doors are now in the Cathedral Museum, and have been replaced by copies.

The framework on the backs of the doors shows that the original intention was to have twenty-eight panels following the pattern of Andrea Pisano's and Ghiberti's first sets of doors, but the quatrefoil frames of the earlier doors were beginning to look old-fashioned, and restricted the scope of the scenes within them. Ghiberti was by then working on larger-scale panels for other commissions, and at some point the format for the doors was changed to ten large gilt-bronze panels, big enough to allow him not just to illustrate incidents but to tell stories, and to make whole pictures rather than small scenes. Ghiberti may not have had to submit to a competition, but he was by no means given a free hand in the selection of subjects. Those for the twenty-eight-panel project were to have been chosen by no less a person than Leonardo Bruni, a humanist scholar and successor to Coluccio Salutati as Chancellor of the Republic. The choice of subjects for the ten panels has been traced to Ambrogio Traversari, Prior of Santa Maria degli Angeli.

Traversari chose subjects from the Old Testament. He had learned Greek from Manuel Chrysoloras, and was able to consult the texts which were the sources of the episodes illustrated in Ghiberti's panels. Traversari was also a protégé of Cosimo de' Medici, who was one of the circle who met at Santa Maria degli Angeli; though outwardly an ordinary citizen, he was, through the shrewd use of his growing wealth, becoming the most powerful person in Florence. Several of the episodes mirror events in Cosimo's life, and allude to his achievements. The choice of Old Testament subjects also reflects the more universal religious outlook that Traversari encouraged. A century and a quarter earlier, the sermons in Santa Maria Novella of the influential Dominican preacher Fra Giordano da Rivalto had incited the slaughter of the Jews of Florence. Residual anti-Semitic feeling might account for the absence in religious art until now of the stories of the Children of Israel in the Old Testament – apart from portrayals of prophets like Isaiah, who was interpreted as foretelling the coming of Christ, and of stories which were seen as echoing Christ's sacrifice and saving of mankind, such those of Abraham and Isaac and of Noah.

On page 194
Lorenzo Ghiberti: the eastern
doors of the Baptistery, the *Gates
of Paradise*

Left and right
Lorenzo Ghiberti: *The Creation of
Adam and Eve*, and *Cain and Abel*,
in the Baptistery eastern doors

The first three panels tell familiar stories from Genesis, with the old theme of the sinfulness of mankind. Starting from the top left, in *Adam and Eve*, God gives life to Adam as he helps him to stand up with one hand, and blesses him with the other. Then, in the centre of the panel, he creates Eve. A glance across to Andrea Pisano's carving of the same subject, just a few yards away at the base of the Campanile, illustrates the difference between the realistic sensibility of the early Renaissance style and Ghiberti's more glamorous late Gothic. In Andrea Pisano's hexagon God draws Eve like a heavy sack, only half alive, from Adam's side. In Ghiberti's gilded version, Eve is an elegant weightless figure, supported by cherubic angels as she soars gracefully above Adam – the first real celebration in Florentine sculpture of the beauty of the female nude. To the left, in the low relief technique Ghiberti learned from Donatello, the serpent tempts Eve with the apple, and on the right she and Adam are expelled from Eden.

The next panel, *Cain and Abel*, tells the story of their two sons. In the top left corner they are still a happy family, the parents sitting with their little boys outside the door of their hut. Below, the younger brother Abel, now a young man, watches his flock of sheep with his dog. Cain, who has become a farmer, guides a plough drawn by two oxen. The source of their strife is shown at the top, where Cain burns an offering of the grain he has grown on an altar, and Abel sacrifices a lamb. God is shown looking with favour upon Abel and his offering, and ignoring the downcast Cain, who, angry and jealous, clouts Abel with a stout club in the central scene. Cain is shown again below, turning away

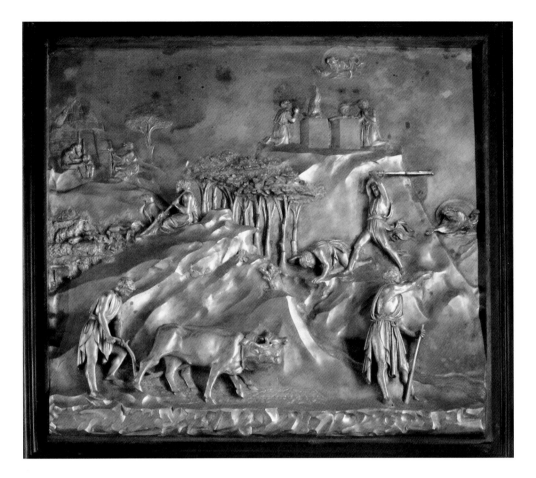

from us to face God, who reappears reproaching Cain, who answers him with the words 'Am I my brother's keeper?'

The third panel tells the story of *Noah*. The flood, sent by God to wipe his creation from the face of the earth because of man's wickedness, has subsided. Noah and his family, elegantly dressed as if arriving for a party, have emerged from the Ark in the strange shape of a pyramid, and stand above the drowned corpse of a man who did not find a place in it. The animals set off peacefully to reclaim the land: a lion pads after an ox, and a leopard stretches on the rocks. An elephant enters the scene on the left, and a flock of birds flutters around the apex of the Ark. In the bottom right corner, Noah sacrifices a burnt offering of thanks to God, who appears in the sky above, backed by a small rainbow, his sign of peace. The greatest prominence

is given to the scene of Noah's drunkenness, which artists evidently enjoyed most of all. In his old age (he was five hundred years old when his sons, Shem, Ham and Japheth, were born) Noah took up cultivating vines, but enjoyed to excess the wine stored in the substantial vats behind his sleeping figure. Ham, in the centre, is embarrassed by his naked and inebriated father, while his brothers spread their cloaks behind their backs to shield Noah from sight.

The next three panels, telling the stories of Abraham and Isaac, Jacob and Esau, and Joseph sold into slavery, show a number of developments. Ghiberti introduces for their own sake figures that do not occur in the biblical stories, and in the latter two uses imaginary idealised architecture to invest the scenes with dignity. In *Abraham and Isaac*, the most prominent figures are a trio of beautiful

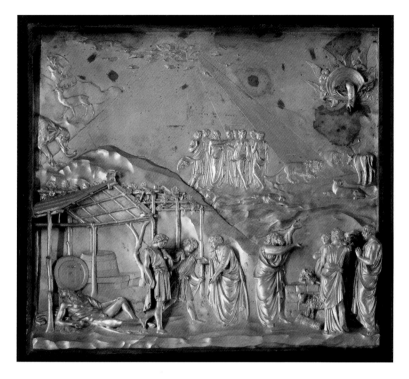

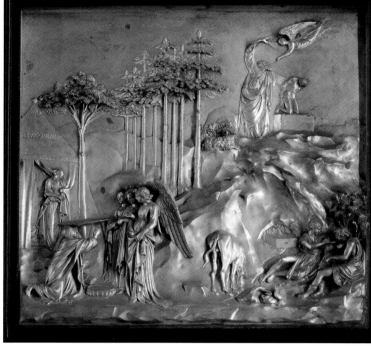

angels, invented as the carriers of God's instruction to the distraught Abraham to sacrifice his son. The lines of the rocky landscape draw our eyes up to the figures showing this critical event in the story, carved in shallow relief in the middle distance, but centre stage is given to the hindquarters of the donkey, drawn in impeccable perspective. Abraham's two servants are in the foreground, but they are not involved in the action: they just chat in the corner. The psychology of the sacrifice is very different from Ghiberti's trial panel for the 1401 competition; in this version, Isaac bends down flinching, while Abraham's attention is on the angel who grasps his arm. Perhaps Ghiberti thought that Brunelleschi's interpretation had been the more dramatic.

Isaac reappears in the next panel as an old man. The story of the hostility between his twin sons, Esau and Jacob, begins even before their birth, when they jostled within their mother Rebekah's womb. Sculpted in shallow relief at the top right-hand corner, the pregnant

Rebekah is informed by God that her sons are fighting inside her and will continue to do so all their lives. Esau was born first, red and hairy, and his brother Jacob grasped his heel – the implication being that Jacob was trying pull his brother back into the womb, so that he could be the first born. This early rivalry is alluded to by the figure of Rebekah on her maternity bed, in shallow relief in the distance on the left. She is upstaged by a group of four graceful young women, gratuitously inserted into

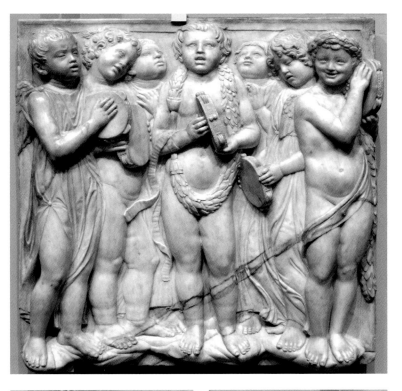

Left
Luca della Robbia: panels of lute
players, drummers, tambourine
players, dancers, musicians
and cymbalists on the *cantoria*
originally above the door of the
New Sacristy of the Duomo
(Cathedral Museum)

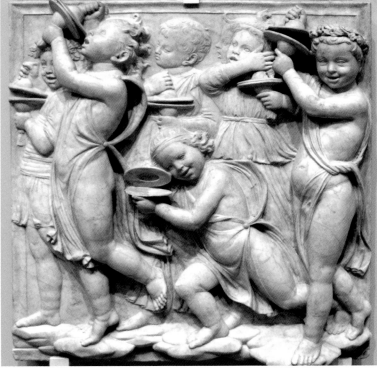

these boys. *Putti* became enormously popular in the art of
the Renaissance and for at least two centuries afterwards.
Descended artistically also from the six-winged seraphim
and cherubim, via Donatello's smiling faces, they bring
simple happiness to the scene. Behind the girls, the boys
squeeze into the picture. One stresses a girl by putting his
hand on her shoulder, another claps his hands as he looks
adoringly at his favourite's face, while two others don't seem
interested – just like teenagers. In the next panel, two young
women play six-stringed lutes. One looks soulful as she is
absorbed in her playing; the other throws her head back
as she sings, carried away with the music. Behind them,
the other women may be singing or chatting to each other,
while the babies playing at their feet point proudly up at
them, as if to say 'That's my Mum!' In the most joyful scene,
on the right, the festivities really get under way: a couple of
young men sway with the rhythm they are beating on hand
drums, and another plays a pipe. A pair of uninhibited
small boys dance naked to the beat, while two shyer ones,
longing to join in, peer out from behind the musicians.

The fun continues at the lower left, where seven
children sing as they dance in a ring, their faces conveying
all the excitement of a party. Next, a group of older children
give a concert, playing a lute, a harp and a portable organ,
so well carved that we can see both the bellows behind and
the keyboard resting on the child's knee. Then a group of
children, one of whom must be a cherub as he has the wings
of an angel, sing as they play the timbrels or tambourines, and
in the final scene on the front, children relish the opportunity
to make as much noise as they want on the cymbals. At either
end of the gallery, choirboys sing with gusto.

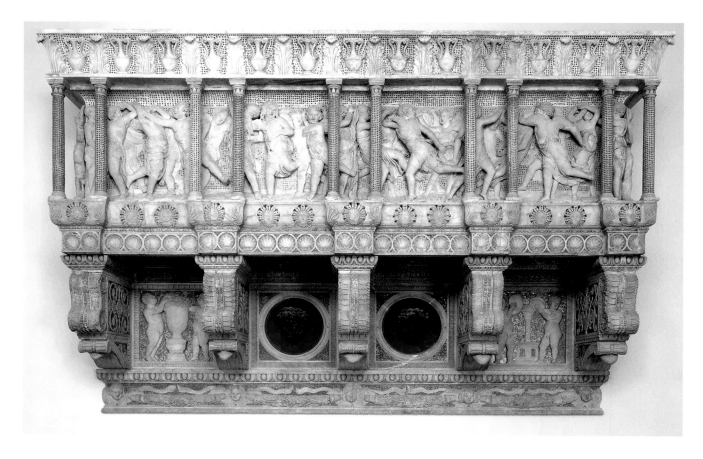

Luca's figures reflect a significant step forward, not just in the religious attitude they express praising the Lord through celebration, instead of the privation and abstinence of the previous century, but in their bodies and the contemporary clothes they wear. Their bodies have more or less normal proportions, (even if some of the cherubs are a bit on the chubby side), not the elongated and elegant limbs of International Gothic. The women wear dresses, the men and boys wear everyday tunics, caps and sandals. In showing people as they are, albeit at their best, but without distortion or refinement, Luca expresses a fresh attitude towards the human condition. Little by little, the more progressive artists were escaping from the burden of original sin, and revealing a welcome new view: it's okay to be human. Technically as well, the sculpture reaches a new level of sophistication; some of the figures almost stand free

of the marble, others are carved in deep relief, half in and half out of the block, and a third layer is carved in shallow relief. Highly polished and precisely carved, they are best seen from close up.

Donatello, a more experienced sculptor, understood the tricks our eyes play on us, and knew that figures to be seen even from a short distance away look much better left rough-hewn and unpolished. If Luca expresses a new freedom in his *cantoria*, Donatello seems completely unconstrained. Superficially, the structure of his *cantoria* is similar to Luca's, divided by five pairs of colonnettes, but behind these runs one continuous scene of vigorous, exuberant movement. Crowds of *putti* dance, run, and jig about in a big street party, their wild happiness surely a celebration of freedom and life. Donatello's approach to the frame of the *cantoria* is similarly uninhibited. Whereas

his friend Brunelleschi would not have countenanced
anything other than a correct Classical entablature,
Donatello's cornice is decorated with a frieze of acanthus
leaves alternating with urns, with bright mosaic tiles on
the marble background, as on the colonnettes and the
background to the dancing *putti*. The base of the gallery
and the five supporting consoles are even more exuberant,
abounding in lines of seashells and egg-and-dart ornament,
as well as scrolls, leaves, flowers, feathers and faces. Who
knows where the inspiration for this came from, whether it
was from remains he saw in Rome, but the Donatello who
created this appears a happier man, as two other celebrated
sculptures dating from around this time seem to show.

 A relatively small bronze statue in the grand first floor
Council Hall of the Bargello, *Atys* is a cheerful cherub
with a saucy smile, wearing only a belt and a pair of chaps.
He has a small pair of wings and little faun's tail, a snake
writhes around the winged sandals on his feet, and his
gesture suggests that once he held something in his hand
for us to admire. But these clues cannot explain why he
should be named after a shepherd with whom, according
to Ovid, the goddess Cybele fell in love, making him her
priest, and thereby requiring his chastity. The back of his
belt is embossed with poppy seed-heads, the emblem of
the Bartolini family, which suggests it was made for one
of them. Most families chose symbols of their military
prowess or commercial enterprise for their emblems, but
the Bartolini preferred to celebrate the skulduggery of one
of their forebears, who invited his fellow merchants to a
feast the night before the sale of a large shipment of silk and
spiked their wine with opium (produced by poppies), so he

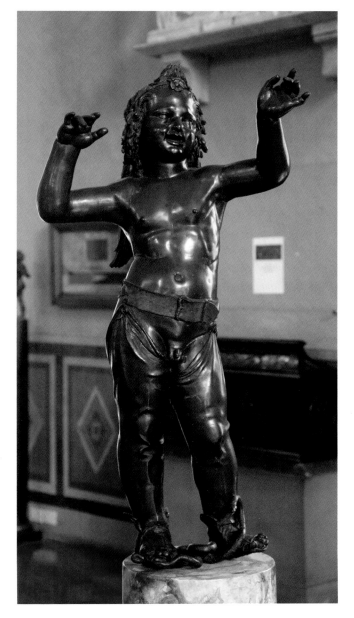

was the only one awake the next day and able to buy the lot. This playful pagan is an unlikely messenger to announce a revolution, but here we see for the first time a character chosen from Classical mythology, not from the pages of the Bible or the *Golden Legend*, and a piece of sculpture made just for fun.

In the same hall of the Bargello is Donatello's second statue of *David*, this time in bronze. It is probably his most famous work, and undoubtably the strangest. The first known free-standing nude figure since ancient times, designed to be seen in the round, David wears nothing but his elaborate boots and a Greek-style sunhat with a laurel crown around it. His nudity can be justified by the story in the book of Samuel, which tells how King Saul of the Israelites dressed David in his own tunic with a coat of armour and a bronze helmet before he went to fight Goliath, but David took them off because he was not used to them. David stands on the victor's laurel wreath, with one foot placed on Goliath's severed head. One wing of the giant's highly decorated helmet almost fuses to David's inside leg. In an affected pose, he holds the stone with which he slew Goliath in one hand resting on his hip, while with the other he idly dandles the sword. Some have seen his adolescent body as androgynous, its soft modelling leading them to suggest that Donatello was homosexual. Certainly David has long girlish locks tumbling under the pointed brim of his hat which draw attention to his effeminate face and gentle gaze. Commissioned by Cosimo de' Medici, this extraordinary statue used to stand in the courtyard of his palazzo, where it attracted mutterings from the devout. Like Donatello's first, marble, *David*, it was seen as an allegory of civic virtues defeating irrational brutality, which indeed it may be. It may also have been conceived as the continuation of a Classical tradition, but above all it is, like *Atys*, surely a very personal piece of self-expression.

'The thing that earned him a name and brought him recognition', says Vasari, was an *Annunciation* which Donatello made around 1435 for the altar of the Cavalcanti family's chapel in Santa Croce. Carved from *pietra serena*

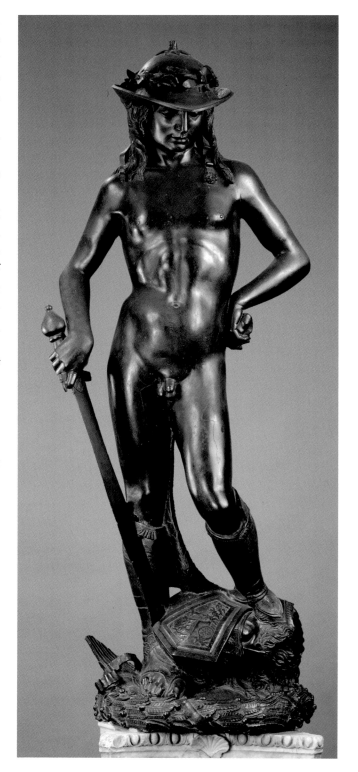

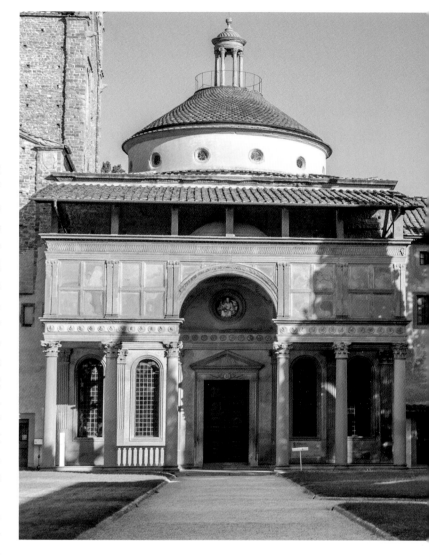

of the art-loving humanist circle, his choice of Brunelleschi as architect was driven by a desire to emulate Cosimo de' Medici. The Pazzi Chapel at Santa Croce was intended to serve as the monastery's chapter house, but also to double as a family funerary chapel, like the Medici's Old Sacristy at San Lorenzo. The two buildings are similar in size and concept. Brunelleschi's plans for the Pazzi Chapel were prepared while he was still working on the Old Sacristy, giving him the opportunity to revise and develop his new architectural style, but neither he nor his patron lived to see the completion of this most celebrated building of the early Renaissance. Andrea de' Pazzi died in 1445, leaving funds in his will to finish the chapel, and Brunelleschi died the following year. Work continued for a further thirty years, until their disastrous conspiracy against the Medici caused the downfall of the Pazzi family. The exterior porch was never finished at the top, accounting for the strange appearance of the façade.

In the completed part of the porch, a central arch is flanked by rows of three Corinthian columns that carry a straight entablature. Classical architecture has become so familiar to us that there seems nothing remarkable about this, but after centuries of Romanesque and Gothic architecture in which columns invariably carried arches, this was a novel reversion to an older style. However, the reversion was not complete: the porch is roofed with a barrel vault and a central cupola, rather than the straight beams of Roman temples, so the wall above the columns is a screen to hide the vault. This is obvious if we approach the porch from the side, coming from the church as most visitors do. The unsatisfactory effect is accentuated by the tiled canopy over the porch, which looks so out of place above the carefully arranged pattern of panels framed by paired pilasters on the upper wall. The canopy is provisional, required to cover the gap that remained when the porch was left unfinished; Brunelleschi may have intended to put a triangular pediment at the top of the façade, its peak concealing the central cupola.

Inside the porch, the six Corinthian columns are mirrored by pilasters on either side of the windows. These in turn are echoed inside the chapel by the pilasters on the

entrance and altar walls, which stand on the low stone benches for the friars to sit on during their assemblies. Like the Old Sacristy, the interior of the Pazzi Chapel is based on a circle within a square. A central dome sits above a cube, enlarged at each side by a short barrel-vaulted bay, to make a chapter house large enough to accommodate all the friars. It too has a small square altar recess, covered by a dome. The four tall windows are repeated by blank frames on the altar and side walls, and the dome above the altar recess repeats the cupola in the porch. Everything is arranged to create a clear geometric rhythm. All the architectural elements in grey *pietra serena* – the pilasters, entablature and arches, the mouldings on the barrel vaults and the framed rosettes within them, the frames of the windows and matching frames on the other walls, and of the tondi above them – are clearly presented in the light reflected off the whitewashed walls.

The chapel is so famous for its use of classic Roman elements that its compromises with medieval forms are often overlooked. The main dome, technically an umbrella dome, is essentially a Gothic structure (imagine the vaulting of the apse of Santa Croce, just around the corner, rotated and repeated four times), resting on pendentives, while the ground plan of the chapel is very similar to that of Florence's other major chapter house, the Spanish Chapel at Santa Maria Novella. And the use of Classical elements is still a decorative deception: the pilasters do not support the vaults, nor are the mouldings of the barrel vaults structural.

The decoration of the Pazzi Chapel is more in sympathy with the ordered calm of Brunelleschi's architecture than the passion of Donatello's doors at San Lorenzo. Luca della Robbia sculpted the twelve handsome terracotta medallions of the Apostles in the rings above the windows and panels on the other walls, their white glaze and deep blue backgrounds harmonizing with Brunelleschi's cool colour scheme. He also created the terracotta relief depicting the seated figure of St Andrew holding the cross on which he was crucified, over the doorway to the chapel, and the glazing of the cupola above it. (The chapel is dedicated to St Andrew, being the

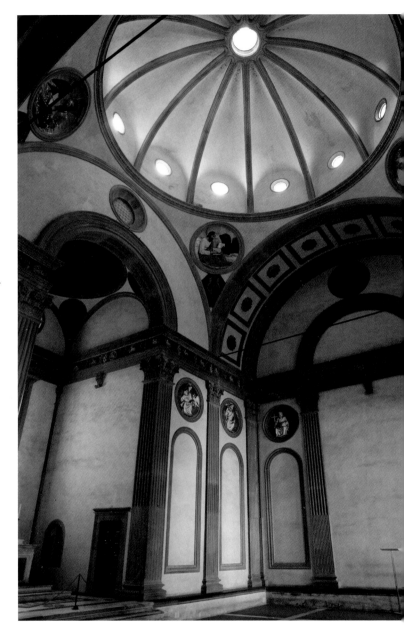

Above
Brunelleschi: interior of the Pazzi Chapel, Santa Croce. The altar recess is on the left.

Right
Façade of Santo Spirito.

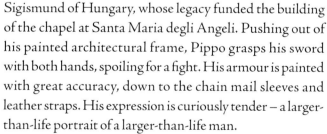

Sigismund of Hungary, whose legacy funded the building of the chapel at Santa Maria degli Angeli. Pushing out of his painted architectural frame, Pippo grasps his sword with both hands, spoiling for a fight. His armour is painted with great accuracy, down to the chain mail sleeves and leather straps. His expression is curiously tender – a larger-than-life portrait of a larger-than-life man.

Next in the series is Niccolò Acciaiuoli, also a soldier and a nobleman, who came from the wealthy banking family. As Grand Seneschal of the kingdom of Naples he had conquered most of Sicily for King Robert in 1356–57, and became Lord of Corinth. A lover of the arts and friend of Petrarch and Boccaccio, he is portrayed with a hooded gown over his armour and a thoughtful look on his face, delicately weighing his commander's baton in his hands.

The third of the aristocratic men of action is Farinata degli Uberti. His nickname, which means 'floury' or possibly 'porridge', apparently referred to his long blond hair, some of which we can see beneath his extravagant and fashionable hat. Although he is shown wearing a contemporary suit of armour similar to Pippo's, he was leader of the Ghibelline faction in Florence, allied to the Holy Roman Emperor, in the middle decades of the thirteenth century. The inscription below his left foot describes him as 'SUE PATRIE LIBERATOR', 'The liberator of his country'. This is something of an

THE MEDICI'S FAVOURITE ARTISTS

At the same time as running his bank and establishing himself as a statesman, Cosimo de' Medici embarked on a major building project. There had been a monastery at San Marco, in the streets north of the Duomo, since the twelfth century. Founded by the Vallombrosians, it had passed to the Silvestrines. Originally an austere order of hermits, their rule became so decadent that in 1418 they were ordered by Pope Eugenius to leave their crumbling monastery, to be replaced by the friars of the recently founded strict order of Observant Dominicans, who moved down the hill from their monastery of San Domenico on the road to Fiesole. This community had become part of the Dominican Congregation of Tuscany, whose Vicar-General, Antonino Pierozzi, born in 1389, was brought up in the Torre dei Pierozzi, just south of the Duomo on the corner of Via della Canonica and Via dello Studio. He became Prior of San Marco, where he campaigned for assistance to the poor and needy, and then Archbishop of Florence from 1446 to 1459, and was posthumously canonized as St Antoninus in 1523. Pierozzi suggested to Cosimo that he finance the rebuilding and enlargement of San Marco, a request that was pressed on him by Pope Eugenius during the Council of Florence.

Cosimo's motives for agreeing were various. He had reason to be grateful to the friars of San Marco: they had accepted the deposit of a substantial hoard of gold coins which Cosimo entrusted to them for safekeeping in 1433, in anticipation of the political move against himself. He was also obliged to Pope Eugenius, who had supported him against Rinaldo degli Albizzi, and who arranged for him, his friend and banker, to be accommodated at his former monastery of San Giorgio Maggiore in Venice, during Cosimo's year in exile there. And his conscience was troubled: usury, although no longer against the law, was still considered sinful by the Church, and Cosimo's careful success as a banker seems to have weighed on his mind. No doubt he remembered the fate awaiting moneylenders illustrated on the wall of Tommaso Strozzi's chapel at Santa Maria Novella. Cosimo also found life in a monastery congenial: he had his own cell constructed in the monastery of San Marco where he would go to retreat from the pressures of commercial and political life. He may also have been aware that, while it was likely that Florentine politics would wash his family and their wealth away in a few generations, buildings and works of art might leave a lasting memorial; and by beautifying the city, he would gain acceptance of and confer a kind of legitimacy on his *de facto* rule. Whatever his motivation, he commissioned Michelozzo to rebuild on such a scale that it began to embarrass the Dominicans. Cosimo glossed over their concerns, saying 'Never shall I be able to give God enough to set him down in my books as a debtor.'

Michelozzo, the son of a French nobleman who worked as a tailor after his arrival in Florence, was becoming Cosimo's favourite architect. He had followed his patron into exile in Venice in 1433. This was prudent: Brunelleschi, who remained in Florence to work on the Duomo and San Lorenzo, found himself arrested and imprisoned for a few days on the politically motivated charge that, while working as an architect, he had failed to join and pay his annual dues to the Guild of Stonemasons

and Carpenters. Michelozzo had designed a new library for San Giorgio Maggiore in Venice, which Cosimo gave to the monastery in gratitude for Pope Eugenius's protection and the monks' hospitality during his exile. More recently he had restored for Cosimo the Franciscans' church and monastery at Bosco ai Frati, near Cosimo's country estate at Cafaggiolo, in the hills north of Florence.

The rebuilding of San Marco from 1437 to 1452 was Michelozzo's largest project to date: as well as the church, the monastery includes two main cloisters, a chapter house, two refectories (the larger one for the friars and the smaller one for guests), a pilgrims' hospice, six guest rooms on the ground floor, forty-four cells for the friars, and a library on the first floor. The church was redesigned internally in the sixteenth and seventeenth centuries, and given a Neoclassical façade in the late eighteenth century, but the first cloister that we enter, dedicated to St Antoninus, gives a taste of Michelozzo's simple and elegant architecture, combining the austerity of the Dominicans with Classical proportions and structure. This is best seen in the spacious first floor library, where a double row of slender Ionic columns carries groin vaults and a central barrel vault the whole length of an airy hall, well lit from windows on both sides. If any place can be identified as the intellectual home of the Renaissance, this is it. Far larger than required for the needs of the friars, Cosimo had this library built to hold not only the rare Greek and Latin manuscripts and books collected for him by his agents, but also the private libraries of the Chancellor Coluccio Salutati and of the Classical scholar Niccolò Niccoli, whose eight hundred volumes Cosimo acquired after Niccoli's death through cancellation of the debt that Cosimo had generously allowed to build up to support his friend's enthusiasm for books. The poet Agnolo Poliziano and philosopher Giovanni Pico della Mirandola, both of whom are buried in San Marco, were among the many humanists who studied here, in the first public library in Europe. This would have pleased both Salutati, who had promoted the idea of a library

On page 244
Michelozzo: cloister of
St Antoninus in the monastery
of San Marco

Below
Michelozzo: library of the
monastery of San Marco

Right
Fra Angelico (attributed):
Thebaid (Uffizi)

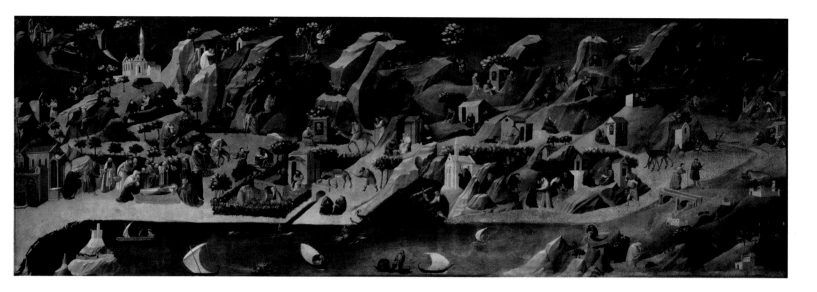

open to scholars, and Niccoli, who had intended that his collection of manuscripts be available to all.

The church of San Marco has been so much changed that we can have little idea of its original appearance, but the monastery buildings have been preserved largely unaltered, giving a rare glimpse of what the quiet monastic life was like. The chief glory of the monastery, the frescoes on the walls of the friars' cells and of the cloisters by Fra Angelico, have also survived. Fra Angelico was born Guido di Pietro around 1395. To Italians he is known as Il Beato Angelico, the Blessed Angelic One, and indeed he was beatified by Pope John Paul II in 1982. To the English-speaking world he has always been known as Fra Angelico. He was born at Rupecania, a village in the hills north-east of Florence. Nothing more is known of him until, already a painter, he entered the community of friars at the Carmine in 1417. Within a few years, he moved to join the Dominicans at Fiesole as Fra Giovanni – Brother John – and again with them to San Marco, where, commissioned by Cosimo de' Medici in 1438, he dedicated himself to embellishing the monastery walls with frescoes. He had left the Carmine around 1420, before Masaccio had started work in the Brancacci Chapel, but he was clearly aware of Masaccio's innovations, mastering his techniques while remaining true to the spirit of the older courtly style. His work at San Marco occupied Fra Angelico until 1445, when Pope Eugenius, who would have become aware of the friar's talent when he attended the Council of Florence, summoned him to work in the Vatican.

Fra Angelico's religious outlook was much influenced by the Blessed Giovanni Dominici, who had founded the order of Observant Dominicans in reaction to the corruption and venality of the Papacy and the Church during the years of the Western Schism. One of the earliest works attributed to him, the *Thebaid*, shows the influence of Dominici's thinking. It shows a vast fantasy landscape, supposedly of the banks of the Nile outside Thebes in Egypt. The wilderness is dotted with chapels and tiny dwellings, thronged with hermits engaged in their daily activities, while the river is busy with dhows. The plasticine mountains are reminiscent of Lorenzo Monaco, whose *Adoration of the Magi* is in the same room in the Uffizi, and with whom Fra Angelico may have trained. The name of the painting refers to Thebais, the Roman desert province of Upper Egypt, which in the third and fourth centuries AD was inhabited by numerous hermits living in communities of single cells, inspired by the example of St Anthony, an ascetic monk who lived for twenty years in the remains of a Roman fort in the Egyptian desert. St Anthony was the channel through which abstinence, self-denial and withdrawal from the world became grafted onto Christianity. The idea of monastic life does not appear in the Bible; it was perhaps through Syrian traders who came into contact with abstemious Buddhist monks and Hindu

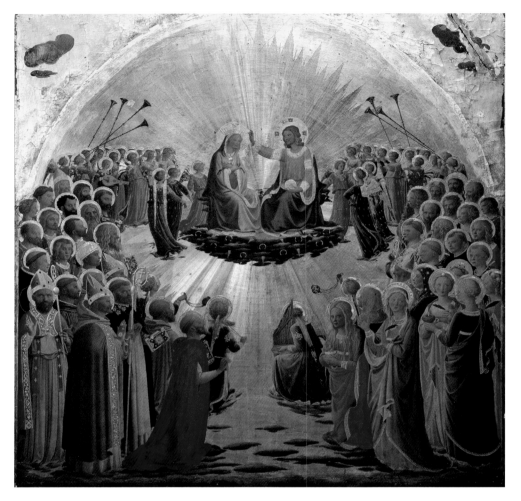

holy men that it became embedded in the mainstream of the Christian tradition.

Another of Fra Angelico's early paintings in the Uffizi is his *Coronation of the Virgin*, painted for the church of Sant'Egidio in the Hospital of Santa Maria Nuova, a charming example of his colourful style. Brightly lit apparently from inside the painting, it shows crowds of saintly clergymen, and angelic musicians and dancers circling around the heavenly ceremony, standing on clouds which cleverly create a sense of perspective.

Fra Angelico no doubt painted the *Thebaid* for a monastery, to transmit the inspiration of St Anthony to the monks of his day, but in the first frescoes by him that

we see at San Marco, he drew their attention to the rules. In the north-west corner of St Antoninus's cloister, above the door that leads into the sacristy and the church, we see the solemn figure of St Peter Martyr, staring intently at us from between a pair of later Baroque angels. Unconcerned by the blood oozing from the split in his skull, he puts his finger to his lips, reminding us of the Dominicans' rule of silence in their monasteries. Other lunette panels in the arches of the vaults showed St Dominic with his Rule (formerly between the door and window of the chapter house, now moved to the Sala del Lavabo), and St Thomas Aquinas with his *Summa Theologica*, above the exit door from the Pilgrims' Hospice. More welcoming is the panel above the

Left
Fra Angelico: *Crucifixion with St Dominic*, in the cloister of St Antoninus in the monastery of San Marco

Right
Fra Angelico: *Crucifixion with Saints*, in the chapter house of the monastery of San Marco

on him. Vasari writes that 'He never painted a Crucifix without tears streaming down his cheeks'. His work at San Marco must have cost Fra Angelico many tears: in addition to the dozen Crucifixions frescoed on the walls of the friars' cells on the upper floor, there is a very large *Crucifixion with Saints* on the wall of the chapter house. We can deduce that it was probably painted in 1441–42: the monastery's records show that the friars had to meet in the sacristy during this time as their new chapter house was not yet ready. Around seventy-five years after Andrea di Bonaiuto's work in the Spanish Chapel (at that time, the chapter house) at Santa Maria Novella, it gives us an update on the world view of the Dominicans of Florence.

Like all of Fra Angelico's frescoes at San Marco, this *Crucifixion* is intended as a subject for contemplation by the friars and an inspiration for their prayers. Beyond the central figure of Christ, the details of the narrative are reduced to the two thieves crucified on either side and the distraught figure of Mary at the foot of the cross, who falls in a faint and is supported by three women, traditionally called the three Marys. The one dressed in scarlet, with her back to us, is St Mary Magdalene. She was dear to the Dominicans. The *Golden Legend* popularised the stories that she was a repentant prostitute (hence her scarlet dress), for which there is no evidence in the Bible, and that after the Crucifixion she travelled to southern France and ended her days there, living in a cave. In December 1279, barely twenty years after the *Golden Legend* was written, her relics were found in the Dominicans' church at Saint-Maximin-la-Sainte-Baume near Aix-en-Provence, so she was adopted as patroness of their order. Consequently

entrance to the Hospice; it shows Christ as a pilgrim (the hat which identifies him as such hangs on his shoulders, so as not to conflict with his halo) being received by two Dominican friars.

Also in the north-west corner, diagonally opposite St Peter Martyr, is a *Crucifixion with St Dominic* by Fra Angelico. Here we see the intense spirituality and profound faith of his character. The figure kneeling at the base of the cross is nominally St Dominic, but tradition has it that it is a self portrait of Fra Angelico. Clasping the stem of the cross, he gazes reverently up at Christ, who looks kindly down

Right
Fra Angelico, frame by Ghiberti:
Linaioli Tabernacle (Museum of
San Marco)

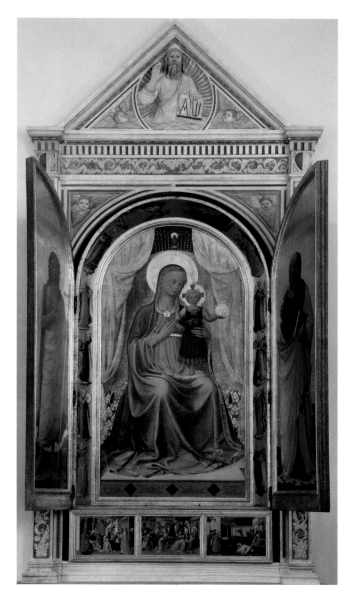

his statue of *St Louis of Toulouse* at Orsanmichele, installed some seven years earlier. The pediment shows Christ in a *mandorla*, giving his blessing and holding a golden panel with Latinised versions of the letters alpha and omega. The six wings of charming cherubs are carefully arranged to fit into the corners here and below, above the arch. When closed, the doors show Fra Angelico's statuesque figures of St Peter, holding his key to heaven, and St Mark, the patron of the Linaioli, with a lion crouching behind his heels. They open to reveal St John the Baptist and St John the Evangelist. In the centre are the Virgin and Child, comparable in concept and size to those in Cimabue's *Maestà* and, in the standing figure of the fully clothed Christ Child, in its Byzantine style as well. The faces of the Virgin and Child have a contemporary Renaissance sweetness, as do the twelve charming musician angels, who are banished to the frame and replaced by elaborate golden curtains, acknowledging the trade of the Linen Drapers. The three small painted panels of the predella, the base, show how Fra Angelico has mastered the representation of three-dimensional space. On the left, *St Peter Preaching* is set in a Florentine streetscape in which the towers resemble those of the Badia and the Palazzo Vecchio. In the central *Adoration of the Magi*, the figures are arranged in an unusual circular composition. On the right, the *Martyrdom of St Mark* shows the saint being dragged through the streets of Alexandria when his assailants are driven off by a heavy hailstorm. The contract specified the price of 190 gold florins for Fra Angelico's work – not bad for a friar who had vowed to live in poverty. He is recorded as being a modest and self-denying man, so one imagines that most

of the money went into the coffers of the monastery – but Ghiberti must have been jealous!

To celebrate the rededication of the high altar at San Marco in 1438 to his patron saints Cosmas and Damian, Cosimo de' Medici commissioned a new altarpiece from Fra Angelico. The main panel, a *Virgin and Child enthroned with Angels and Saints*, and two of the original nine predella panels telling the legendary story of Cosmas and Damian

are in the Pilgrims' Hospice at San Marco. The others of this wonderful series of paintings are still in existence but have been dispersed to museums around the world. The altarpiece was intended not only to remind the friars of San Marco of their benefactor, but to promote Cosimo's public image more broadly to the citizens of Florence. From the end of the fourteenth century the Confraternity of the Magi, whose members included most of the male members of the Medici family, had every third year on the feast of the Epiphany, 6 January, celebrated the journey of the Magi to Bethlehem. Led by three members of the Confraternity on horseback, dressed up as Oriental potentates and followed by large retinues, and a whole menagerie of wild animals, including apes, baboons, tigers and cheetahs, the pageant gathered in front of the Baptistery, representing the Temple at Jerusalem. The procession then set off along Via Larga ('Broad Street'), as Via Cavour was then known, passing several houses owned by the Medici, to San Marco, representing Bethlehem. Here the 'Three Kings' entered the choir of the church to offer their gifts to the Christ Child, and the general public were allowed to follow the procession in and admire the altarpiece. Until 1438, this was the spectacular High Gothic *Coronation of the Virgin* by Lorenzo di Niccolò, painted as recently as 1402. Cosimo had this transferred to the church of San Domenico in Cortona and replaced with something even larger – the main panel is over 7 feet square – and reflecting his taste.

Fra Angelico's altarpiece fuses the Dominican

tradition with contemporary style. As we have seen in his *Deposition*, he was quite prepared to please his patrons, even when painting the most sacred of subjects. Whereas Palla Strozzi preferred the opulence of the International Gothic style, Cosimo de' Medici favoured the more intellectual and restrained new style. The San Marco Altarpiece, although badly damaged and darkened by over-vigorous cleaning with caustic soda which has removed the glazes and some sharpness of detail, shows many hallmarks of what has become known as the Renaissance style. The central Virgin and Child sit on a throne the back of which is very like, but more correctly Classical than, the frame of the Linaioli Tabernacle across the room. The infant Jesus, blessing the world symbolised by the globe in his hand, is human – a naked baby, not a miniature adult. In front of the throne, the saints are assembled on a Turkish carpet, painted with signs of the zodiac in fantastic detail to create a totally convincing perspective, and with red balls, the *palle* of the Medici emblem, on its golden edge. The saints themselves stand in informal poses, talking to each other and gesturing naturally, a portrayal that became known as a *sacra conversazione*, or holy conversation. The remains of their names can be made out on some of their haloes; the prominent pair kneeling in front are St Damian, turned towards the throne, and St Cosmas, wearing the scarlet woollen hat of a Florentine merchant, and with the features of Cosimo de' Medici, looking directly at us – not just a passive participant in the scene like Palla Strozzi, but interceding on our behalf!

The other saints are chosen for their Medici family and local connections: on the left, St Lawrence does not hold his gridiron, but is named, as are all the saints, on his halo. His church nearby was currently benefiting from Cosimo's largesse. Next to him are St John the Evangelist; and St Mark, who holds his Gospel open above St Cosmas's head. The Gospel is open perhaps at a reference to the Apostles healing people with oil, thus linking Cosimo's patron saint to the Evangelists. On the right the saints are St Dominic, St Francis and the Dominicans' local hero, St Peter Martyr.

A small Crucifixion scene at the centre of the lower edge of the altarpiece, complete with a painted frame, gives the *trompe l'œil* illusion of a painting propped up in front of the carpet. It has been suggested that this curious insertion is included in deference to the Dominicans' custom that only Crucifixions, painted or sculpted, were displayed on their altars. Before the predella was dismantled, this scene would have been directly above a panel showing the Entombment, continuing Christ's story and providing a link to the story of Cosmas and Damian, who are shown, in one of the panels in the Pilgrims' Hospice, being laid in their graves – this after having been bound with chains and thrown into the sea but not drowned, then into a fire but not burned, then stoned and shot with arrows which turned back to hit their assailants, and finally being crucified and beheaded along with their three brothers. The charming *Sepulchring of SS. Cosmas and Damian* shows four of the brothers, each with a ring of blood round his neck to show where his head was cut off, laid out like sardines in a tin in the square of a Tuscan town, while the fifth dead brother is being dragged to join them and a swan-necked camel strolls into the scene

carrying a message on a scroll in its mouth, saying that they all deserve to be buried together.

The other panel from the predella in the Pilgrims' Hospice, the *Healing of Justinian by SS. Cosmas and Damian*, shows that Fra Angelico could paint an indoor scene every bit as well as an urban streetscape. It tells the unlikely story of a posthumous miracle by the two saints, the first successful leg transplant. A man who worked in the church dedicated to Cosmas and Damian in the Forum of Rome suffered from an ulcer which had eaten away his thigh. The saints appeared to him as he slept, examined him, and concluded that the best treatment would be to cut off his diseased leg and replace it with that of an Ethiopian who had been freshly buried in the nearby churchyard of San Pietro in Vincoli. He awoke delighted to find his pain gone and a healthy leg replacing his own, which was found in the Ethiopian's tomb. Fra Angelico's picture shows the moment when the saints, both wearing scarlet hats and floating on wispy clouds, are fitting the coal-black replacement leg on to the thigh of their patient, who sleeps serenely on what looks a very hard wooden bed.

The remains of another Medici commission are nearby: the *Armadio degli Argenti*, or Silver Chest, was constructed to hold the offerings of silver given to the Servites' church of Santissima Annunziata by devotees of the miraculous painting of the *Annunciation*, completed, as the legend goes, by an angel. The *Armadio* was commissioned by Piero de' Medici, Cosimo's elder son, also known as Piero the Gouty because of his medical condition which was so bad that he sometimes had to be carried in a litter, when he was able to rise from his bed. The *Armadio* originally stood in a Medici family oratory chapel between the tabernacle that surrounds the miraculous *Annunciation* and the monastery's library. The movable wooden shutters of the chest were Fra Angelico's last commission in Florence, dating from 1451–53, by which time he had been appointed Prior of the monastery of San Domenico in Fiesole. He had previously been considered for the position of Archbishop of Florence by Pope Eugenius IV, for whom he had been working in Rome, and who recognised the 'most holy life, quiet and modest' led by the friar. When Fra Angelico realised the Pope's intentions, he turned the offer down, saying he did not feel capable of governing other people, and diplomatically suggesting another, more suitable, candidate. Antonio Pierozzi, his superior as Prior at San Marco, got the job.

The shutters of the *Armadio* were divided into forty-one small panels, almost square, showing scenes from the Life of Christ. Six have been lost, leaving thirty-five on display in the Pilgrims' Hospice, including three by Angelico's workshop assistant, Alesso Baldovinetti. Fra Angelico's panels begin with one group of nine, formerly perhaps the side of the chest, followed by one of twelve and one of eleven (the *Last Judgement* scene is a double panel) that might have been its doors, opening wide to show the silver figurines inside, given by the faithful. Unusually among Fra Angelico's commissions, the *Armadio* was not intended for solitary contemplation by friars, or for the private enjoyment of popes, bankers or guildsmen in their chapels or offices, but was on display to the public, so he made the chest as appealing

Left, above
Fra Angelico: *Madonna of the Shadows*, in the monastery of San Marco

Left, below
Domenico Veneziano: *Madonna and Child with Saints* (Uffizi)

Right, above
Fra Angelico: *Noli me tangere*, in Cell 1 in the monastery of San Marco

Right, below
Fra Angelico: *The Mocking of Christ*, in Cell 7 in the monastery of San Marco

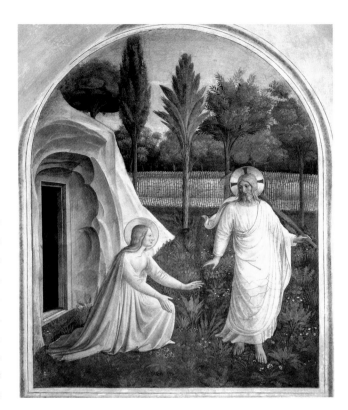

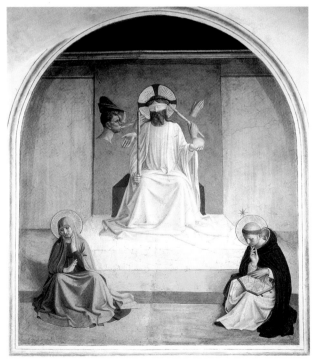

learned from Fra Angelico that led to him becoming one of the most widely respected artists of the Florentine Renaissance. Very few of his paintings survive, but the St Lucy Altarpiece shows a number of reasons for this respect – the monumental figures, the delicate colouring, the transformation of the traditional Gothic triple-arched setting of the scene into a loggia worthy of Michelozzo, with a clearly defined sense of space, and above all the sunlight, which streams through the right side of the open roof of the loggia, illuminating the figures and casting deep shadows on the architectural background.

Returning to San Marco, there are a number of beautiful and some innovative frescoes in the friars' cells. Cell 1 has a *Noli Me Tangere* scene, in which a resurrected Christ floats in the early morning light across the flowers in the grass outside the door of his tomb. He carries a hoe over his shoulder, and is first mistaken for a gardener by St Mary Magdalene, who then tries to reassure herself that he really is Christ by kneeling to touch his robe. Christ said to her that he had not yet ascended, so 'Do not touch me', *Noli me tangere*. Cell 7 has an almost surreal painting, called *The Mocking of Christ*, in which Christ is shown enthroned but blindfolded. Painted on a screen behind him the detached head of a soldier, his cap raised in mock salute by a detached hand, spits at him. Another hand wields a stick, forcing the crown of thorns down onto Christ's brow, while others make as if to slap him. Cell 35 shows the moment at the last supper when Jesus takes the bread and breaks it, saying 'This is my body which is given for you', hence the title of the scene – *The Institution of the*

Left
Fra Angelico: *Crucifixion with the Virgin, St Cosmas, St John the Evangelist and St Peter Martyr*, in Cell 38 of the monastery of San Marco; Cell 39 lies beyond

Right
Benozzo Gozzoli: *Adoration of the Magi*, in Cell 39 of the monastery of San Marco

Eucharist or *The Communion of the Apostles*. Unusually, the supper table is shown with a right-angled bend, and, more radically, Mary Magdalene is shown kneeling at the table's end. We should probably take her surprising presence in the scene in the same spirit as the Crucifixions showing St Dominic or St Peter Martyr at the foot of the cross.

At the end of the northern corridor are two cells, 38 and 39, which were reserved for Cosimo de' Medici. Above the door to Cell 38, a stone tablet dated 1442 records the promise of Eugenius IV PM (*Pontifex Maximus* – Bridge-Builder-in-Chief, i.e. Pope) that Cosimo would be absolved

of all his sins in recognition of having rebuilt the monastery. Inside the cell a *Crucifixion* by Fra Angelico, painted against a background of costly lapis lazuli rather than plain plaster as in the cells along the corridor, includes the patron saints of Cosimo's family – St Cosmas, St Peter Martyr, patron of his elder son Piero the Gouty, and St John the Evangelist, patron of his father Giovanni di Bicci – along with the Virgin Mary. While the friars had only one cell, Cell 38 functions as an anteroom to Cosimo's inner sanctum, Cell 39, up a short flight of steps. Here the fresco is by Fra Angelico's most gifted pupil and principal assistant, Benozzo Gozzoli. The main subject, no doubt chosen to flatter Cosimo's notion of himself as a sage or a generous ruler, is the Adoration of the Magi, above a small image of Christ as the Man of Sorrows. Coming from a family of wealthy farmers and landowners who moved to Florence from the nearby hamlet of Sant'Ilario a Columbano when he was small, Gozzoli had first joined Lorenzo Ghiberti's workshop, working on the Gates of Paradise. In 1445 he signed a formal contract to assist Ghiberti, from whom he learned the International Gothic style of this *Adoration of the Magi*, with its long line of figures. He may not have the same ability to show people standing in three-dimensional space as Fra Angelico, but his fresco is more colourful and cheerful than those in the other cells, and Cosimo was pleased.

The *Armadio degli Argenti* was built as part of a thoroughgoing reconstruction of the church of Santissima Annunziata, begun at the expense of the Medici in 1444 by Michelozzo, whose brother was by coincidence the Prior of the Servite order. Michelozzo's design was based on the influential idea of turning the aisles into a series of families'

Left
Michelozzo: central courtyard of
the Palazzo Medici

Right
Michelozzo, with frescoes by
Benozzo Gozzoli: Chapel of the
Magi in the Palazzo Medici

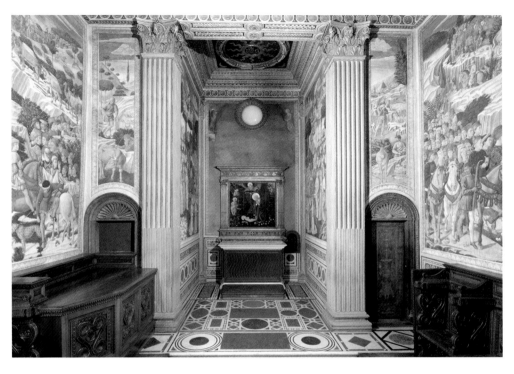

of the palazzo we are struck by how much more modern it is than the façade. Michelozzo's design derives from Brunelleschi's Men's Cloister at the Ospedale degli Innocenti, and makes no compromise with medieval traditions. The striking deep frieze above the colonnade was decorated by Maso di Bartolomeo with swags and ribbons scratched through layers of coloured plaster, a technique known as *sgraffito*. Between these, twelve large medallions were added a few years later. The central ones on each side hold shields with the Medici *palle*. One of the *palle* in some of the shields is combined with *fleurs-de-lys*, the arms of the French royal house of Valois. King Louis XI of France had been so taken with Piero the Gouty when he was Florentine ambassador in Paris that he granted Piero this honour when he became head of the family in 1465. On either side of these, the medallions show scenes from Classical mythology, inspired by the antique gems and cameos that Piero and his brother Giuliano liked to collect. From the outset, the courtyard was used to display Cosimo's growing collection of sculpture. When the fifteen-year-old

Galeazzo Maria Sforza came on a diplomatic visit in 1459, he reported that the palazzo was crammed with books, tapestries, pictures, chests, carvings and sculptures, gold and silver. Galeazzo Maria came as his father Francesco Sforza's ambassador; a decade earlier, Cosimo had ended the longstanding hostility between Florence and Milan through his support for Francesco in his battle to establish himself as Duke of Milan in succession to his father-in-law, Filippo Maria Visconti.

The private family chapel on the first floor is an internal room, and relatively small, yet it is one of the most magical places in Florence. Through a door inserted by the Riccardi we enter a rectangular space lined with heavily carved stalls of gleaming dark wood, facing inwards around a highly patterned floor paved with marble and purple porphyry. This floor and the sumptuous carving of the cornice and ceiling, encrusted with gold, were made to Michelozzo's designs by Pagno di Lapo Portigiani, the master craftsman who made the tabernacle in Santissima Annunziata for Piero the Gouty. By 1459 these works had

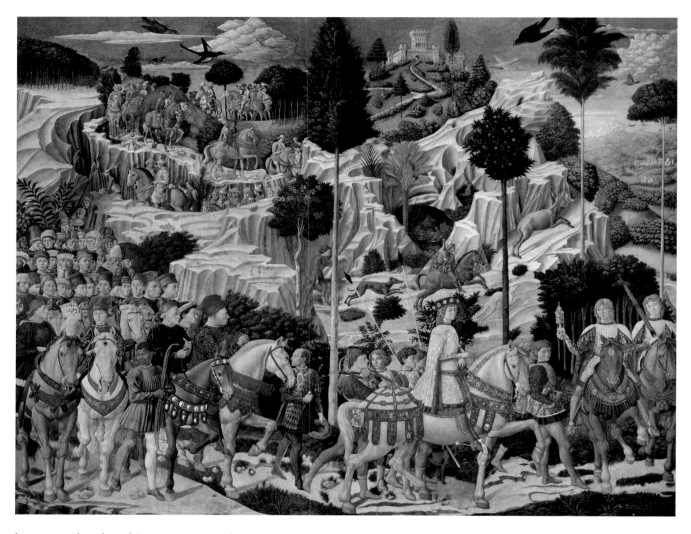

Above
Benozzo Gozzoli: *Procession of the
Youngest King*, in the Chapel of
the Magi in the Palazzo Medici

been completed, and Piero summoned Benozzo Gozzoli
from Rome to paint the walls. Cosimo had been pleased
by the painter's fresco of the Adoration of the Magi in
his cell at San Marco. He was comforted by the idea of
the Magi bringing their gifts to Christ, a rare story in
the Bible of rich men doing good, and his involvement
with the Confraternity of the Magi and their Epiphany
processions to San Marco suggests that he liked to think
that he was following their example. Piero commissioned
Gozzoli to decorate the whole chapel on the same theme.

Gozzoli's frescoes in the Chapel of the Magi can be seen
as a celebration of Cosimo's role as patron of the Council of

Florence, the prestigious high point in his involvement in international diplomacy. It will come as no surprise that they are also something of a family album. As we enter the chapel, the first fresco we see on the wall opposite, the *Procession of the Youngest King*, is full of portraits. The Youngest King, wearing gorgeously gilded silks as he leads the cavalcade on a lavishly caparisoned grey charger, has the idealised features of Cosimo's twelve-year-old grandson Lorenzo, later known as *Il Magnifico*, 'The Magnificent'. Lorenzo had in fact played the part of the youngest king, by tradition given the name of Caspar, in the procession to San Marco on the feast of the Epiphany in 1459, the year the frescoes were commissioned. The identification is reinforced by the laurel bush, symbolising fame and success, which forms a kind of halo behind Lorenzo's head. The next rider is Lorenzo's father Piero the Gouty. He also rides a handsome grey horse, whose harness is decorated with his motto *Semper* ('Always') and the family devices of gold coins, groups of feathers and diamond rings. Behind him comes Cosimo, looking careworn and playing distractedly with the reins in his hands. He wears a more sober black coat than his son's gold-embroidered green brocade, and rides a brown mule. This was not intended to convey some false humility; mules were the mount of great princes and prelates, and were correspondingly much more expensive than horses. Between them, the black-haired man with a white head-band tied around his bright blue hat has been identified as Cosimo's illegitimate son Carlo, born of his Circassian slave-girl Maddalena. Forced by his father into a life as a clergyman, he was appointed Bishop of Prato shortly after Gozzoli started work at the chapel. Leading the group, the page in smart livery who turns to look back at them might be Cosimo's younger son Giovanni.

Naturally, Gozzoli included his own self portrait, in the centre of the sea of faces following the family. He looks out at us from under his round scarlet cap, on which he has inscribed, lest there be any doubt, *Opus Benotii* – 'The work of Benozzo'. On either side of him are two of the bearded Greek scholars brought to Florence by Cosimo to educate his intellectual circle. To his left, wearing a black and gold cap, is George Plethon, who had accompanied the Byzantine delegation to the Council of Florence. Above them, wearing a *camauro*, a crimson papal cap with white ermine trim, is the crabby face of Pope Pius II, who had visited Florence in the spring of 1459. Beneath Benozzo's chin is a young boy in a red cap – Cosimo's grandson Lorenzo, who appears again with his prominent nose more honestly portrayed. Three heads to the right, also wearing a red cap, is the downcast face of his eight-year-old younger brother Giuliano. Below the brothers, the young man on a white horse, riding towards us, is the young Galeazzo Maria Sforza, who had visited the Medici Palace in the year Gozzoli started work. There is an African wearing red, white and green, the colours of the theological virtues, carrying a large bow as he walks in front of Galeazzo Maria's horse. It has been suggested that he is a servant or Galeazzo Maria's body guard. Another portrait celebrating Cosimo's powerful political allies is in the corner to the left: the man on a chestnut horse is Sigismondo Pandolfo Malatesta, a military leader and Lord of Rimini. The magnificent parade follows a rocky track winding down the flank of a mountain, crowned by a castle very like the Medici's fortified villa at Cafaggiolo which, following a reconstruction to Michelozzo's designs, at that time had a tall central tower in addition to its surviving gatehouse. On the craggy lower slopes a huntsman pursues a deer, followed by an enormous hound. With their family, friends, country estate and pursuits included, what more could the Medici hope for from Gozzoli?

The sequence continues on the back wall of the chapel. The fresco of the *Procession of the Middle King* suffered from the Riccardi's alterations to the layout of the palace, when they installed the grand staircase up to the first floor. To accommodate this, the south-western corner of the chapel had to be rebuilt inside. The end sections of the frescoes on the southern and western walls were transferred to the rebuilt walls, but with their order reversed, upsetting the balance of their compositions. In

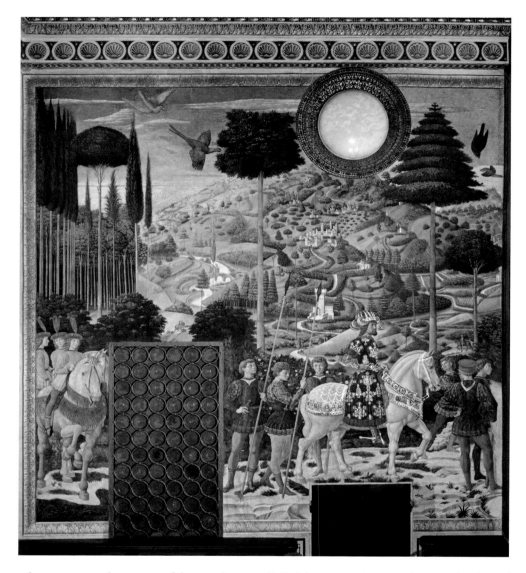

what was once the centre of the southern wall, Balthasar, the Middle King, sits bolt upright on his stallion, stiff as his long golden spurs. His high status is announced by his tall crown, studded with rubies, its spikes tipped with pearls, on a velvet cap trimmed with red, green and white feathers, and confirmed by the generous use of gold in the embroidery of his coat and his horse's trappings. He stares ahead a little anxiously. As well he might: his features are those of the Emperor John VIII Palaiologos, who had led the Byzantine delegation to the Council of Florence.

By 1448 he was dead, and the failure of the Council to achieve a lasting reconciliation between the Greek and Roman Churches contributed to the loss of his empire when Constantinople fell to the Ottoman Turks in 1453.

The Emperor is attended by half a dozen handsome young men in red and blue, and followed by three more pages on horseback, wearing the same silvery-white tunics as Lorenzo, who we saw as the Youngest King. They have curly hair and wear the Medici feathers in their hats, leading some to identify them as Piero's three daughters,

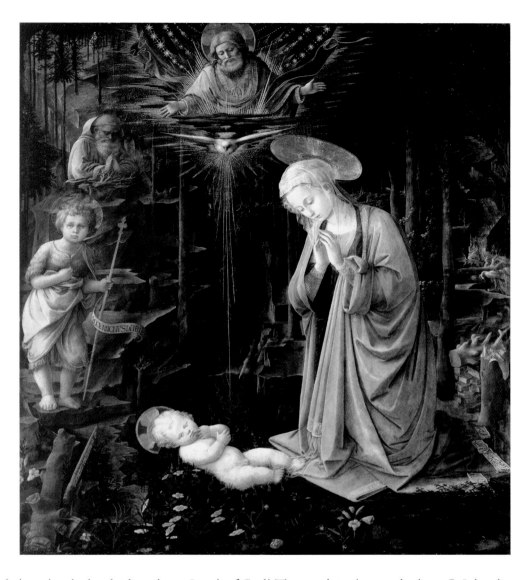

Madonna praying over her baby, who she has laid on the forest floor. But it is not devoid of theology: vertically above Jesus is God the Father, and between them, linked by rays of golden light, the dove of the Holy Spirit. Filippo is illustrating the Catholic doctrine of the Holy Trinity, to whom the chapel is dedicated, and which had proved so contentious at the Council of the Churches which Cosimo had brought to Florence some twenty years earlier. St John the Baptist is shown as young boy dressed as a shepherd, carrying a scroll reading 'ECCE AGNUS DEI', 'Behold the Lamb of God'. The monk in the woods above St John the Baptist's head has been identified as St Bernard, another of Florence's patron saints, pointing to the Medici's status in the city.

Another delightful *Madonna and Child* commissioned by Cosimo from Filippo is around the corner, displayed in the Sala Sonnino, which serves as an anteroom to the main gallery of the palazzo. In a most intimate portrayal of maternal affection, the half-length Madonna gently presses her son's head against her inclined cheek. She is as

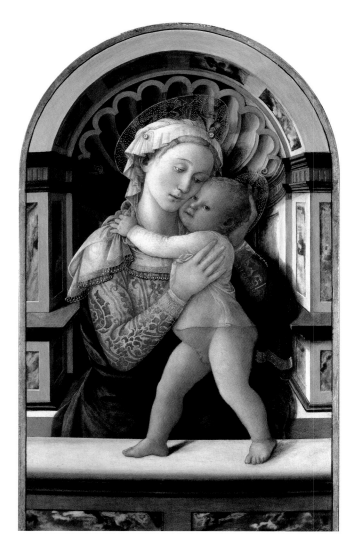

Left
Filippo Lippi: *Madonna and Child*, in the Palazzo Medici

Right
Filippo Lippi: *Coronation of the Virgin* (Uffizi)

he returned to Florence and set up his own studio. The earliest of these paintings, called the Barbadori Altarpiece after the family who commissioned it in 1437 for their chapel in Santo Spirito, is now in the Louvre. Another commission came from Francesco Maringhi, a lawyer and canon of San Lorenzo, who left money in his will for a new altarpiece for the high altar of the church of Sant'Ambrogio. This church, to the east of the city centre, was built on the site where St Ambrose, a Roman prefect chosen as Bishop of Milan by popular acclamation in AD 374, stayed when he visited Florence in AD 393. In recognition of his success in eliminating the Arian heresy espoused by the Visigothic invaders of Milan, Ambrose was awarded the title of one of the four Doctors of the Church (the others being SS. Augustine and Jerome, and Pope Gregory the Great) as well being chosen as the patron saint of Milan.

Despite having the help of three assistants, Filippo took eight years to complete this commission. The *Coronation of the Virgin* can be dated to 1439–47, from the receipts for Filippo's payments. It remained in Sant'Ambrogio until it was stolen in 1810, and is now in the Uffizi. Although the arches of the frame suggest a traditional triptych format, it is conceived as one unified scene. This is just the first of the many innovations in the picture. In the central arch, the Virgin Mary is crowned, not by Jesus, but by God the Father. She wears a short-sleeved dress of feminine rose pink and a chalky blue cloak, while God is clothed in darker shades of the red and ultramarine blue that were normally reserved for her. Unusually, she turns away from us, allowing Filippo to show her profile and his skill in painting the diaphanous veil over her hair, braided into a *mazzocchio*. Even more

lovely as any of Filippo's ladies, and beautifully dressed in contemporary fashions, wearing a damask gown and a veil fringed with pearls. She looks at her plump Child with an expression of wistful tenderness, as he clasps her around the neck to help himself stand on a marble parapet. A warm glow lights this domestic group, and falls across the shell-shaped niche behind them.

It was probably Filippo's altarpieces that brought him to Cosimo's attention. He had worked in Padua, where he came into contact with the strong lines and colour of Flemish and Venetian painting, for five years to 1437, when

276

technically accomplished is the long semi-transparent scroll of golden lettering that rests on God's shoulders, its trailing ends held by attendant pairs of angels. The scene is set in Paradise, but against a sky of dark blue beams, reminiscent of the spheres of the heavens, rather than the usual golden sky. God's throne is set in front of a shell niche taken from contemporary architecture. On either side, crowds of angels hold lots of lilies, symbols of the Virgin's purity, against the dark sky. With garlands of flowers around their curly golden hair, the angels have joyous youthful faces like those in Luca della Robbia's *cantoria* panels.

At the lower level, below God's throne, a group of unusually human saints kneel, identifiable mainly by the tiny lettering on their brightly coloured garments, although a teenage St Lawrence whose head is below the Virgin's knees has brought a pale gridiron with him. At the left of the group, St Martin of Tours, wearing a green cloak and his bishop's mitre, looks over his shoulder towards us, and behind him, in a spiky crown, is the prophet Job. The central saint, wearing a blue robe and orange cloak, is St Eustace. A Roman general, known as Placidus before his conversion to Christianity, he was married to St Theopista ('Believe in God'), who was kidnapped by a sea captain when they took a voyage. They had two sons, Agapius and Theopistus, who were carried off by a lion and a wolf as they and their father were crossing a river. Despite these trials, Eustace

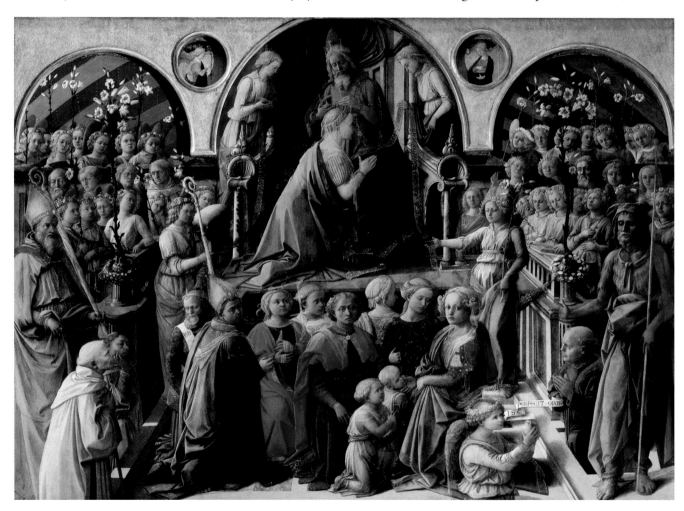

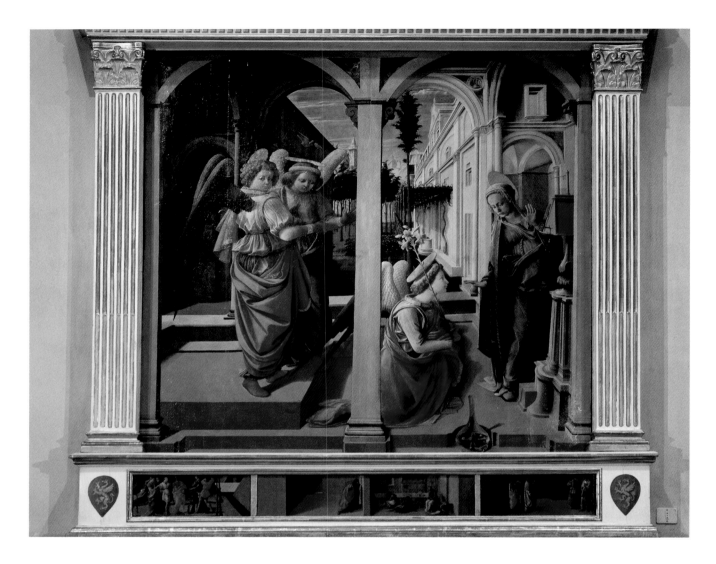

retained his faith. The two little boys kneel between their father and a particularly pretty St Theopista, who attracts our attention by looking straight out of the picture, aided by the spotlight that Filippo puts on her fashionable centre-parted hairstyle, high forehead and large wide eyes. It is not clear what these characters from the *Golden Legend* are doing in the picture. It is possible that they were intended as examples of faith to the Benedictine nuns of the convent of Sant'Ambrogio. The tradition that the faces of Eustace and Theopista are portraits of the banker who owned the altar to the right of the high altar,

and of his sweet young wife, seems more convincing.

Below Theopista, an angel rises into the picture holding a scroll that leads towards the greyish figure of the donor, Francesco Maringhi, who died in 1441 when Filippo had been working on the picture for only two years. It reads 'IS PERFECIT OPUS' – 'He has completed the work'. The angel is carrying Filippo's message to his patron up in heaven, telling him that the intention of his will has finally been fulfilled. Maringhi is praying at the feet of St John the Baptist, who, in a reversion to the Gothic tradition, is drawn on a larger scale to emphasise his importance. He

is matched on the left by St Ambrose. Heavily bearded, Ambrose holds his bishop's crozier, combined with a furled parasol. Below his hand, the tonsured friar who cups his chin in his hand and looks curiously at us is Filippo himself.

While he was working on the *Coronation of the Virgin*, Filippo painted an attractive *Annunciation* for the Martelli family's chapel in the left transept of San Lorenzo, where it has remained. This too breaks with tradition in a number of ways. While set within a nearly square frame, the picture is effectively split by the central pillar of the porch outside the Virgin's house, but is not divided into a diptych: the scene is visually united by Gabriel's scarlet cloak and wings, which appear on both sides of the pillar. Filippo follows the formula of Angel on the left, Virgin on the right, established by Lorenzo Monaco, Fra Angelico and almost every artist before them. Both figures are pushed into the right half of the picture, and balanced on the left by the introduction of two large angels, and a dove above their heads wearing a halo and emitting golden blobs of light from its beak, representing the Holy Spirit. The gap created between the figures allows Filippo to display his draughtsmanship in the steep perspective of the elegant contemporary buildings in the background. Nor are the poses of Gabriel and the Virgin traditional: Filippo adopts those of Donatello's Cavalcanti Altarpiece, but goes further. Gabriel kneels like a supplicant lover before the standing Virgin, who twists her body gracefully as she shies away in alarm. In a niche cut into the step between them, there is a glass flask filled with water. It is not clear what this is doing here. While it gives Filippo an opportunity to show off his technical skill, learnt from the Flemish masters, in the reflections,

shadows and highlights on the glass, the water has been seen as an allusion to the Holy Spirit, or, more prosaically, it could be a vase for the lily that Gabriel carries in his hand.

Filippo's complicated life brought him into contact with the law a number of times. In 1450 he was in court for having forged the signature of one of his apprentices on a receipt for 40 florins. He was released from prison after confessing under torture. The following year he was on trial again for having delivered a picture executed by his workshop that his customer had specified that he paint himself. As a result of these episodes, he lost his lucrative position as Rector and Commendatory Abbott (i.e. entitled to the income) of San Quirico in Legnaia, a little to the west of Florence. His career was salvaged in 1452 by his appointment to fresco the altar chapel of the Cathedral in Prato, with scenes from the lives of St Stephen and St John the Baptist. Filippo was the second choice; Fra Angelico had turned the job down as too big a task. The project kept him occupied, off and on, for thirteen years. In 1456, when he was fifty, Filippo was appointed Chaplain of the Convent of Santa Margherita in Prato, where the nuns asked him to paint a Madonna. He persuaded them to allow a twenty-three-year-old novice, Lucrezia Buti, who had caught his eye, to be his model. Amusingly, her surname was absolutely appropriate, as we will see in Filippo's paintings. The inevitable happened; he fell in love with Lucrezia, and abducted her in 1458 from the convent to live with him in his house in the Piazza del Duomo in Prato. Their son Filippino ('Little Philip'), who later became a great painter himself, was born the following year. There was, of course, a great scandal. Cosimo de' Medici interceded with Pope Pius II on their behalf, and obtained his consent that they should be released from their vows, but Filippo refused to marry. However, they stayed together, having a daughter, Alessandria, in 1465, and Lucrezia was the model for many of Filippo's paintings.

It may well be Lucrezia's face that appears as that of the Virgin in his *Madonna and Child with Scenes from the Life of St Anne*, in the Palatine Gallery at the Palazzo Pitti. The

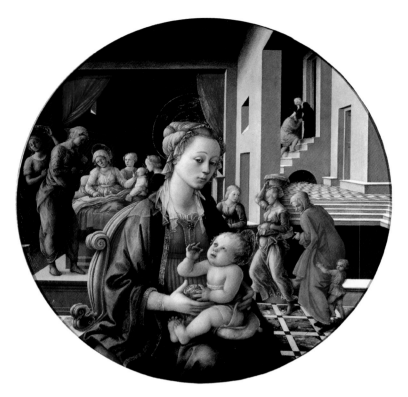

picture, painted on a novel circular panel, is also known as the *Bartolini Tondo*, as it was commissioned most probably by Leonardo Bartolini to celebrate the birth of a child. In the centre, the blonde Madonna, one of the sweetest and most beautiful of Filippo's Virgins, holds her baby on a cushion on her lap. The infant Jesus picks a seed from a pomegranate, a symbol of fertility from biblical times, also used, when broken or bursting open, as here, to recall Christ's Passion and resurrection. The small figure climbing the stairs at the back on the right is St Joachim, who meets St Anne at the Golden Gate of Jerusalem. He clasps her hands, thereby initiating the immaculate conception of Mary. Below them, two women and a child bring presents for Anne who sits up in bed on the left, having given birth to Mary. The scenes are cleverly separated by the strong perspective of Filippo's imaginary architecture, but unified by his colour harmony, repeating the tones of orange-red, olive green and ivory white.

Lucrezia certainly appears in the best-loved of Filippo's paintings, also a celebration of motherhood and children,

the *Madonna and Child with two Angels*, in the Uffizi. The smooth curves of her profile, her high forehead, arched pencil eyebrows and luminous skin are very similar to those of the Madonna of the *Bartolini Tondo*, as is her blonde hair, wrapped in a cloth with a transparent veil hanging behind her long neck. This time, instead of cuddling her baby, her hands are pressed together in prayer in a gesture which, together with the melancholy look on her face, suggests that she knows his destiny. The baby's round features and curly golden hair are also very similar to those of the *Bartolini Tondo*: both are possibly those of little Filippino. Or perhaps Filippino was the model for the young angel who turns to look over his shoulder at us with a gleeful expression as he lifts the infant Jesus to his mother.

The Madonna sits on a well upholstered chair in front of the frame of a painting, or of an open window, through which we see an extraordinary imaginary landscape of distant mountains, seas and cities. This idea, derived from Flemish art, of combining sacred subjects with landscapes, was adopted by many of Filippo's followers, not least his own son.

Filippo's *Adoration of the Child with Saints* was commissioned by Lucrezia Tornabuoni, the devout poetess wife of Piero the Gouty. It was painted for a cell in the monastery founded in 1046 by St Romuald at Camaldoli, in the Apennine mountains east of Florence and north of Arezzo, which her husband rebuilt in 1463. Their connection with the monastery stems from Cosimo's friendship with Ambrogio Traversari, Prior of the Camaldolese Order, who was buried there after his death in 1439. This *Adoration*, in the same room in the

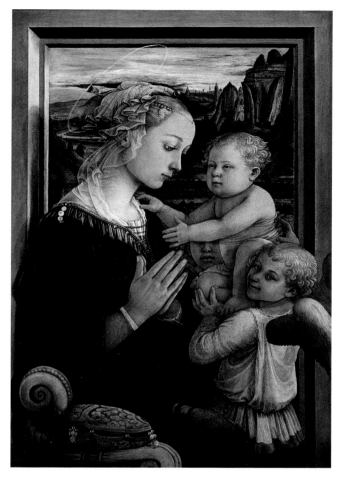

Uffizi as Filippo's *Coronation of the Virgin* and *Madonna and Child with two Angels*, is almost a mirror image of his *Madonna in the Forest* in the chapel of the Medici Palace. In both pictures, the Madonna who kneels to pray over her Child has a sweet face like Lucrezia Buti's, and St John the Baptist carries a scroll reading 'ECCE AGNUS DEI' – 'Behold the Lamb of God'. They share the symbolism of the Holy Trinity, although in the Uffizi *Adoration* God the Father is reduced to a pair of hands appearing out of the dark sky above the dove of the Holy Spirit. The elderly monk in the bottom right corner is St Romuald. The rocky mountain background landscape of the *Adoration* is even more fantastical, with the greenish colours and deliberate lack of perspective of a tapestry, but both include a large number of cut-down trees and stumps, a reminder of Jesus's warning in his Sermon on the Mount of the fate of trees that do not bear good fruit, and also serving as a hint to the Medici's political enemies.

Cosimo de' Medici's favourite artists painted in a wide variety of styles. Fra Angelico combined the clarity of the Florentine tradition with the colours and crowds learned from Lorenzo Monaco, while Benozzo Gozzoli reverted to the luxury and pageantry of International Gothic. Fra Filippo Lippi fused the realism learned from Masaccio with the elegant style of the courts of France and Burgundy. Of the three, he had the greatest influence on the next generation of painters, as their principal patrons, the leading citizens of their day, aspired to the status of the Northern kings and dukes. By contrast, their sculptor contemporaries, led by the aging Donatello, mainly looked south to ancient Rome as they developed their own artistic language.

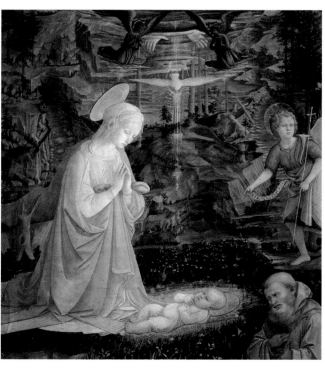

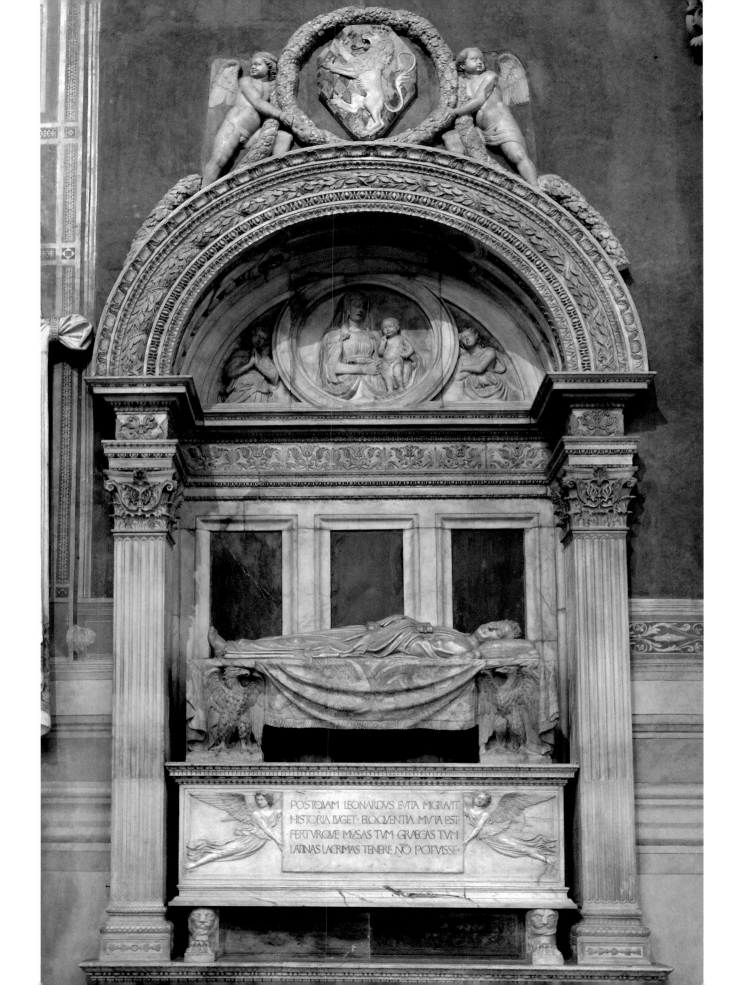

POSTQVAM LEONARDVS E VITA MIGRAVIT
HISTORIA LVGET ELOQVENTIA MVTA EST
FERTVRQVE MVSAS TVM GRAECAS TVM
LATINAS LACRIMAS TENERE NŌ POTVISSE

CHAPTER 9

THE HIGH POINT
OF HUMANISM

Donatello inspired a whole generation of sculptors in Florence. One of the leading lights among them was Bernardo Rossellino, a sculptor and architect born in 1409 into a family of farmers and quarry-owners from Settignano, a few miles to the east of the city. His family name was Gamberelli, but he's always known as Rossellino, a nickname meaning 'the little redhead', which he acquired not because he was red-headed himself, but because he was apprenticed at the age of eleven to a sculptor known as 'Il Rosso', 'the redhead' – perhaps Nanni di Bartolo, who had worked with Donatello on *Abraham and Isaac*. His three younger brothers were known by the same nickname, including Antonio, who joined Bernardo in his workshop.

The first major job that Rossellino worked on was to finish the façade of the palazzo of the Misericordia in Arezzo. When he returned to Florence in 1436 he established his own workshop and joined a band of stonemasons working on the Chiostro degli Aranci (the 'Cloister of the Orange Trees') at the Badia. The delicate pilasters above the Ionic columns on each of the two storeys may be his design. Soon after, he bought a house in the Santa Croce district, and worked in subordinate roles at the Duomo and the Ospedale degli Innocenti. In the early 1450s he worked on the Inner, or Second, Cloister at Santa Croce, whose design is often attributed to Brunelleschi. This most elegant of the Renaissance cloisters in Florence is also called the Spinelli Cloister, after the family whose crest, carved by Rossellino, of a rampant lion and rows of helmets, appears surrounded by garlands above the corner doorways, surmounted by semi-circular pediments terminating in scrolls, the first of many variations on a theme inspired by Donatello's Cavalcanti Altarpiece.

Later in his career, Rossellino progressed from working as a mason or foreman on projects designed by others to become an architect in his own right. He worked for Pope Nicholas V on projects in Rome, both as a draughtsman and as a mason, but his big break came when Pope Pius II chose him as the architect of the most extravagant architectural vanity project of the Renaissance. Between 1459 and 1464, he rebuilt the remote hilltop village of Corsignano, Pius's birthplace, as an ideal town, creating the city of Pienza, complete with a cathedral, two palaces – a massive one for Pius and a slightly more modest one for the Bishop – and a city hall.

Rossellino was also an accomplished sculptor. His first major work in Florence is the tomb of Leonardo Bruni in Santa Croce, to the left of the door to the cloister in the right-hand aisle. Bruni, who died in 1444, was Chancellor of Florence, one of the highest offices in the government of the Republic. He was also a humanist scholar who translated Plato, Aristotle and other Greek authors into Latin, and a historian, who wrote a *History of the Florentine People* in twelve books , as well as biographies of Cicero, Dante and Petrarch. He was a strong supporter both of the rule of law and of republican government, arguing that, in contrast to dukedoms such as that of Milan, they gave equal liberty to all citizens. Bruni embodied the Greek notion of 'civic virtue', which he revived, together with his teacher and predecessor as Chancellor, Coluccio Salutati. Instead of cajoling sinners towards their salvation by threatening them with eternal damnation, as the moral teaching and

On page 282
Bernardo Rossellino: tomb of
Leonardo Bruni, in Santa Croce

Left
Tomb of Giuliano Davanzati:
third-century AD sarcophagus
with cover attributed to Bernardo
Rossellino, in Santa Trinita

Right
Bernardo Rossellino and
Desiderio da Settignano: tomb of
the Blessed Villana de' Botti, in
Santa Maria Novella

Last Judgements of the previous centuries had done, they stressed the importance of education and the dedication of leading citizens to the common welfare, in order to improve the moral condition of all. His epitaph, composed in Latin by Carlo Marsuppini, his successor as Chancellor, is inscribed on a plaque on the face of his sarcophagus. It speaks of the high regard in which he was held: 'Since Leonardo departed his life, History mourns, Eloquence is mute, and it is said that both the Greek and Latin Muses cannot hold back their tears'.

In his will, Bruni asked for a humble burial, beneath a marble slab simply bearing his name. Nevertheless somebody, probably the Signoria of Florence, or perhaps of his hometown of Arezzo, decided that something much grander was appropriate. Rossellino was commissioned to create a monument almost on the scale of Antipope John XXIII's in the Baptistery. In sympathy with Bruni's Classical scholarship, Rossellino revived an ancient form of tomb design, found in the catacombs of Rome, in which

the sarcophagus is set into a niche in a wall, beneath a round arch. Bruni is shown lying on a catafalque draped with a cloth with a beautiful incised pattern. His face, turned towards us, is a remarkably natural portrait. He wears a laurel crown, and his folded arms hold a copy of his *History* to his heart. Behind him, the back wall of the niche is made of polished red marble panels set in frames almost like pilasters, as if he is lying in a luxurious Roman house. Heroic symbols of glory, deriving from the styles of the Roman Empire and Republic, abound: the base is decorated with dancing cherubs, garlands and a lion's head in the centre. The plaque inscribed with Bruni's epitaph is borne by two figures which were surely inspired by Classical winged Victories, such as those on the triumphal arches in the Roman Forum. The sarcophagus is supported on legs combining lions' claws and heads, and the catafalque is carried by two imperial eagles with spread wings. At the apex of the arch, a sturdy pair of winged *putti* hold up a wreath encircling Bruni's coat of arms – a rampant lion,

Left
Alberti: Rucellai Sepulchre,
in San Pancrazio

Right
Alberti: façade of Santa
Maria Novella

large capitals. The words said by an angel to the women who came to Jesus's tomb, according to the Gospel of St Matthew, translate as 'You seek Jesus of Nazareth who was crucified; he is risen, he is not here; this is the place where they put him'. Above the sepulchre there is a lantern with a spiral-fluted canopy carried on a tall circular colonnade, very like the one that Brunelleschi built for the Old Sacristy of San Lorenzo. Serving no purpose indoors, it looks strange, but follows the model of the original in Jerusalem. Inside are the tombs of Giovanni Rucellai and his family, and, just visible through a low wooden grille, a fresco of Christ attended by two angels, blessing Giovanni Rucellai.

Between the pilasters of honey-coloured marble on the walls of the tomb there are thirty inlaid circular motifs set in frames of dark green marble. Most of these have heraldic, geometric or floral subjects; however, beside the entrance door we see a diamond ring with two feathers – Piero de' Medici the Gouty's personal device. At the other end, in the centre of the apse, are Lorenzo de' Medici's three diamond rings, and in the middle of the left side, Cosimo de' Medici's three ostrich plumes in a *mazzocchio* hat. Only in the middle of the right-hand wall do we see the Rucellai family's own emblem of the billowing sail of fortune. It would seem that Giovanni Rucellai was as much concerned for his salvation on earth as in heaven.

In 1456 Giovanni Rucellai gave Alberti yet another commission, to finish the façade of Santa Maria Novella. The piazza in front of the church was used for chariot races each year from 1563 until the late nineteenth century, and if we stand by one of the obelisks, each resting on four bronze tortoises, which marked the bends in the race track, we can see that, like San Miniato, the façade is in two parts.

Again, there is a fairly clear line between the Tuscan Gothic lower level, begun in 1310, and the upper parts, which are Alberti's work. His other church façades, in Rimini and Mantua, had been based on Roman triumphal arches, and he might have been expected to come up with something severe and completely Classical. But Alberti also valued what he called *concinnitas*, or 'consonance' in a building, so he devised a solution that fits very well with the earlier parts. These consist of the row of arched niches at ground level, which continues to the left of the church beside the piazza and around the churchyard to the right, and above this, another row of blank arches and window frames picked out in green marble. Alberti replaced the Gothic central doorway with a highly Classical one inspired by the Pantheon in Rome, decorating its frieze with Medici rings and feathers. He added four very tall columns of green serpentine marble, as at San Miniato, and stripy corner pillars, as at the Baptistery. Then he put an entablature across the top, decorating the frieze with a row of billowing Rucellai sails. Next he put a tall horizontal band all the way across, and lo and behold, he has created the outline of a wide triumphal arch, but disguised it with a row of Romanesque-style boxes with decorative roundels inside. Then he put another Classical temple front on top, again disguised with Romanesque-style decorations, and in the pediment a huge flaming sun, a symbol of St Thomas Aquinas and more generally of the Dominicans, with the face of the Child Jesus at its centre. The magnificent marble work was created by Giovanni di Bertino, who had also worked for Alberti on the inlays of the Rucellai Sepulchre.

Alberti was not able to make the pillars of the upper storey line up with those below, as no doubt he would have wanted to, because the doors into the aisles were already in place, off-centre. But he did achieve a trick that gives the whole composition its harmony: the upper temple front is nearly the same size as each of the squares on the lower floor on either side of the main door. Another stroke of genius was to put the highly decorated scrolls on either side of the upper storey to hide the end walls of the aisles. These

have wheels of decoration repeating the round sun emblem in the gable and the existing rose window, which Alberti squeezed between the temple pillars – more *concinnitas*! This charming and original solution was adopted by Giacomo della Porta in his influential design for the façade of the Gesù, the church of the Jesuits in Rome, a century later. The first truly Baroque church façade, the Gesù has been the model for hundreds of variations on the theme throughout the Catholic world.

At the top, just under the pediment, the inscription in letters a yard high reads 'JOHAN[N]ES ORICELLARIUS PAU[LI] F[ILIUS] AN[NO] SAL[UTIS] MCCCCLXX', 'Giovanni Rucellai, son of Paolo, in the year of salvation 1470'. It would be unthinkable today for a donor's name to be splashed across the front of a church. The Dominicans were evidently more able to accommodate the demands of wealth and commerce than were the Franciscans at Santa Croce. Perhaps this ostentatious commemoration is not so different from the modern practice of naming art galleries or university buildings after their benefactors. Rucellai wrote, of the works that he had commissioned for Florence: 'All these things have given me, and are giving me, the greatest satisfaction and the sweetest feelings. For they . . . do honour to the Lord, to Florence, and to my own memory.' One has to assume that the people of the day saw the honour as being in that order too.

Alberti's last piece of work in Florence was at Santissima Annunziata, where in 1470–77 he completed the tribune, transforming Michelozzo's unfinished polygonal choir into a rotunda surrounded by chapels. The basic proportions of Alberti's design remain, but the interior of the tribune, as in the rest of the church, was overlaid with rich Baroque marbles and overdecorated with gaudy gilt swags in the seventeenth century. Were it not for these later additions, this highly unusual tribune might be more celebrated for its novel incorporation of an ancient Roman circular temple shape into church architecture. Having succeeded in completing a centrally-planned church building,

Luca was involved in the creation of one of the most remarkable funeral monuments of the Renaissance, the Chapel of the Cardinal of Portugal in San Miniato. This chapel is the result of a collaboration, not just between an artist and his workshop, but between an architect, Antonio Manetti, Brunelleschi's pupil and biographer; the sculptors Luca della Robbia, Bernardo Rossellino and his brothers Antonio and Giovanni; the painters Alesso Baldovinetti and the Pollaiuolo brothers, Antonio and Piero; and the craftsman Stefano di Bartolomeo. Despite the number of artists involved, the chapel is completely united in style. The Cardinal whom it commemorates was James of Coimbra, or of Lusitania, nephew of King Edward of Portugal, and cousin and brother-in-law of Edward's successor, Afonso V. He had Spanish royal blood in him too: his mother, Isabella of Urgell, came from the house of Aragon. From the age of seventeen, due to political troubles at home in Portugal, he had lived in Flanders with his aunt Isabella, wife of Duke Philip the Good of Burgundy, who advised him to travel to Rome, where the Popes showered him with positions in the Church. On the way from Rome to a Council at Mantua, called by Pope Pius II to consider how to deal with the Ottoman Turks after their capture of Constantinople, he fell ill with tuberculosis. Accompanied by his Ethiopian slave Bastiano, he stopped his journey in Florence. One of his doctors apparently recommended him to lie with a woman to cure his illness, but he refused. The story, supposed to show James's holiness, surely tells us more about the madness of medieval medicine! He died in 1459, at the age of only twenty-five. His dying wish was to be buried in San Miniato, and his aunt Isabella added to his legacy to pay for his magnificent memorial.

Rather than build a chapel inside the basilica, Manetti knocked a large arch through the wall of the left aisle, and added a square chapel outside. The chapel is roofed with a sail dome, a device that Brunelleschi had first used at the Ospedale degli Innocenti. The coffered arch from the aisle is repeated on all four sides of the chapel, creating the shallow arms of a Greek cross. The sculptural work

on these arches, and the other architectural details, such as the pilasters embedded in the corners of the chapel, was the work of Giovanni Rossellino, the third of the five Rossellino brothers. Luca della Robbia decorated the vault in painted and glazed terracotta: five large medallions, each one surrounded by rings of fish-scales in darkening shades of blue, set against a background of small brightly coloured yellow, green and purple tiles, which give the illusion of a grid of cubes. The relief in the central medallion shows the dove of the Holy Spirit. In the other four medallions are fine versions of the Cardinal Virtues that we saw on the façade of the Loggia della Signoria. On the far side, *Prudence* holds a black snake as she gazes in her mirror, and *Justice* holds a sword and an orb. On the near side, the grille across the entrance arch to the chapel holds us back, so it is hard to see *Temperance* pouring water into her wine and *Fortitude* holding a club and a shield carrying Cardinal James's coat of arms.

The roundels of the vault are mirrored in the swirling pattern of the inlaid floor, the work of Stefano di Bartolomeo. The beautiful coloured stones include semi-precious green serpentine and red porphyry. Very hard and difficult to work, porphyry was used by Egyptian kings and Roman emperors, and famously for the decoration of the room where Byzantine empresses gave birth; here it was used to imply Cardinal James's royal lineage.

The altarpiece opposite the entrance arch, and the frescoes above it, were painted by the Pollaiuolo brothers. Antonio was the older, born in Florence around 1431, some ten years or so before Piero, with whom he shared a highly productive workshop. Both were painters, and Antonio a goldsmith and sculptor as well, but their nickname, meaning 'poultry-keeper', came from their father's occupation. The altarpiece in the chapel is a copy; the original was transferred to the Uffizi in 1880. It shows three saints associated with the young Cardinal. In the middle his name-saint, James, looks to the right, directing our attention towards the Cardinal's tomb. Buried in Compostela, St James is also the patron saint

of Spain. He wears a beautifully painted velvet cloak over his damask robe, holds a pilgrim's staff in his hand, and in the band of the hat at his feet is the scallop shell worn by pilgrims to his tomb. On his left St Vincent, the patron saint of Lisbon and of the royal house of Portugal, wears the gorgeous robes of a deacon. On the right, a youthful St Eustace is included as James was Cardinal Deacon of his church in Rome, Sant'Eustachio. All three have faint haloes, but the painters seem to have paid more attention to their sumptuous clothing, studded with jewels, than to their sainthood. They stand on paving inlaid with circles of coloured marble, continuing the floor of the chapel, in front

of a balcony with a bronze lattice, through which we catch glimpses of a distant landscape. The influence of Duchess Isabella of Burgundy's patronage is evident in both the materials and the style of the work; the rich colours and sharp detail of the clothes were achieved by the Flemish technique of painting in oils, and the bird's-eye view of the landscape recalls contemporary Flemish painting.

The magnificent gilded frame, by Giuliano da Maiano, is worth a look for its own sake. The inscription on the upper frieze is addressed to the saints, and by extension to Cardinal James; it reads 'VOBIS DATUM EST NOS[S] E MISTERIUM REGNI DEI', 'To you it is given to know

Right
Alesso Baldovinetti:
Annunciation (Uffizi)

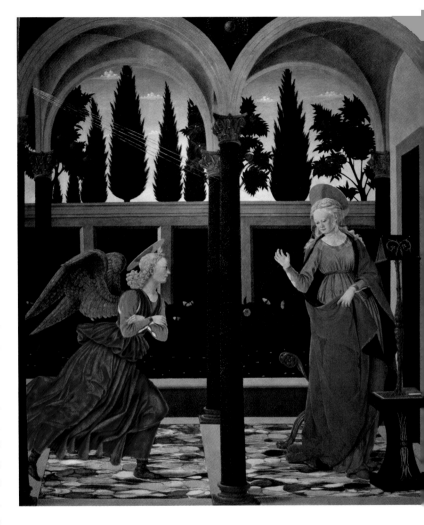

the mystery of the kingdom of God' (Mark 4:11). The Latin names of the unfamiliar saints, Vincentius and Eustacius, are given below. In the centre of the upper frieze a small enamelled brass shield bears the Cardinal's coat of arms. As on the shields carried by *Fortitude*, and above the arch outside the chapel, they are the blue and white shields, arranged in a cross, of the Portuguese royal House of Aviz, quartered with the red and yellow stripes of Catalonia. Looking up, we see these arms, in all their different variations celebrating the Cardinal's royal ancestry, on the thirty shields painted on the frieze of the chapel itself.

The Pollaiuolo brothers also painted the angels who hold back the curtains above the altarpiece, to reveal a cloudscape that continues the sky in the altarpiece itself. The rest of the frescoes in the chapel, including the heraldic shields, are by Alesso Baldovinetti, who painted the *Annunciation* panel above the bishop's throne on the left wall of the chapel. Dating from 1466–67, it is a variation on the lovely *Annunciation* he painted some ten years earlier for the Silvestrine monks of San Giorgio alla Costa nearby in the Oltrarno (now in the Uffizi). Instead of the painted columns of a portico, in this version he uses an elaborately carved and gilded lily to separate Gabriel and the Virgin. On the wall above the panel, he frescoed cypress and cedar trees against a dark sky, and rays of golden light, symbolising the Holy Spirit, shining on the Virgin. He also frescoed eight prophets in pairs of two in the lunettes below the vault, and the four Evangelists and Fathers of the Church in the spandrels above the arches.

The handsome bishop's throne commemorates James's appointment at the age of only nineteen as Bishop

of Arras and Archbishop of Lisbon, although he never actually visited Lisbon as Archbishop, because of his political difficulties. Made by Antonio Rossellino of white marble and purple porphyry, with elegant curving steps, it faces Rossellino's masterpiece and the high point of the chapel – the Cardinal's tomb. Antonio was assisted in the execution of the tomb, his first recorded commission, by his older brother Bernardo, but the inspiration seems to have come more from Desiderio da Settignano's tomb of Carlo Marsuppini than from Bernardo's tomb of Leonardo Bruni. Desiderio's example can be seen not just in the elements of the design, which includes a curtain, not merely frescoed

Left
Antonio Rossellino: tomb of
the Cardinal of Portugal, in his
chapel in San Miniato

been a model of ascetic self-restraint. Two angels kneel on the cornice behind his sarcophagus. One holds a crown, reserved for martyrs and those who endure temptation; the other formerly held a bronze palm leaf, a symbol of victory. In the centre of the finely carved relief on the pedestal on which the sarcophagus stands there's a skull between a lily and a palm, telling us that James went to his death pure and having defeated temptation. The swag below this is held by two seated unicorns, each resting a fore-hoof on an urn. Yes, unicorns! Through an obscure medieval fable that a unicorn had been trapped and tamed by a beautiful maiden, representing the Virgin Mary, the unicorn had become a symbol of the virginity of a virile man. At the ends of the pediment two winged young men, holding large bunches of flowers and sitting on lions' heads, symbolise the Cardinal's moral strength. On the short side of the pediment, visible through the entrance arch of the chapel, is a man driving his chariot – a Neoplatonic symbol of the mind that guides the soul and rules the passions. If this assessment of Cardinal James's character is untainted by eulogy, then he deserves to be remembered in such a magnificent chapel.

Cosimo de' Medici died at the age of seventy-five in 1464, in his country villa at Careggi. In contrast to the Cardinal's elaborate chapel, he was buried in the crypt at San Lorenzo, beneath a discreet and relatively simple pavement of red porphyry and flecked green serpentine, designed by Andrea del Verrocchio. Appropriately, the slab is placed centrally in front of the altar, and inscribed with the words *Pater Patriae*, 'The Father of his Country', a title awarded to Cosimo by the Signoria. His tomb may be modest for a man who was held in such respect, but the

but carved in stone, but also in the delicacy of the carving and the lightness of spirit of the figures, the vitality of the cheerful angels, the smiling *putti* and the serene Madonna in the wreath above the Cardinal's reclining effigy. How much happier an outlook than that of Spinello Aretino's frescoes in the sacristy across the nave, whose world, only eighty years earlier, was full of demons and disasters.

It would be presumptuous to try to assess the moral character of someone we can know of only from history books, but if we allow our judgement to be guided by the intriguing mixture of Christian and Classical symbols on his tomb, the young Cardinal James would appear to have

Right
Andrea del Verrocchio: memorial
to Cosimo de' Medici, in San
Lorenzo

Right, below
Mino da Fiesole: *Piero de' Medici*
(Bargello)

whole of San Lorenzo could be seen as his memorial.

Cosimo was succeeded as head of the family for only
for a few years by his son Piero, who commissioned marble
portrait busts of himself and his younger brother Giovanni.
They were carved by Mino da Fiesole, a talented sculptor
who was born in the beautiful hill town of Poppi in the
mountains east of Florence, but his name suggests that he
moved to Fiesole when still young. He was a friend of his
contemporary Desiderio da Settignano and worked with
him, developing his own speciality of portrait busts.

Dating from around 1453–55, when the brothers
were in their mid-thirties, the busts commissioned by
Piero the Gouty were originally displayed above doorways
in the Medici Palace; they are now in the Bargello. Piero's
bust gives him a determined look, with a firmly set thin
mouth and a hint of his poor health in the swollen glands
of his neck. He wears contemporary finery with lots of his
diamond ring crests on the borders of his tunic. Despite
being well received as an ambassador to Milan and Venice
as well as to Paris, Piero was not an astute politician. When
Cosimo died, he made the mistake of calling in some long-
outstanding loans, thereby bankrupting a substantial
number of merchants, and losing their political support.
The next year, he was fortunate to get wind of an attempt
to ambush him on the road from Careggi and oust him
politically, orchestrated by Luca Pitti, whom Piero had
further offended by refusing to agree a marriage between
his son Lorenzo and Luca's daughter. Pitti grovelled in
apology and Piero was confirmed in power until his death.
He died of gout and lung disease in 1469, and was buried
in San Lorenzo next to his brother Giovanni, who had

Left
Andrea del Verrocchio: tomb of
Piero and Giovanni de' Medici, in
the Old Sacristy of San Lorenzo

Below
Mino da Fiesole: *Giovanni de'*
Medici (Bargello)

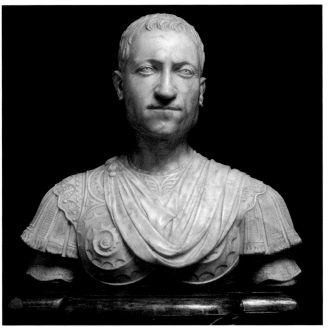

died in 1463. Their lavish and substantial sarcophagus, commissioned from Verrocchio by Piero's sons Lorenzo and Giuliano, is made from porphyry and serpentine, richly ornamented with bronze, but is squeezed into an arch in the wall of the Old Sacristy.

In view of Piero's poor health, Cosimo had looked on his younger son Giovanni as more likely to be his successor in commerce and public life, enrolling him in the Arte del Cambio at the age of five and in the Arte della Lana at fourteen. Giovanni began work in the family bank at seventeen, in the Ferrara branch, and became general manager at twenty-four, but wasn't a success, so his father appointed Francesco Sassetti, who had managed the branches in Geneva and Lyons, whom we saw in the Chapel

of the Magi in the Medici Palace, to share the role with him. Giovanni was able to devote his time, and his fortune, to his enthusiasm for art and antiques. He advised others on commissioning works of art, and commissioned them for himself. He collected sculptures, coins, manuscripts, jewels, and Flemish tapestries and paintings bought for him by the bank's agents in Bruges. Mino portrayed Giovanni as one of the Roman emperors on the coins that he and Piero collected, wearing armour over a soldier's tunic, with a square jaw and the same prominent nose as his brother.

The idea of a portrait bust of an ordinary living person, not of a dead saint or ruler, enjoyed a brief popularity. Antonio Rossellino made one of Donatello's doctor, a wise old owl called Giovanni Chellini, in 1456

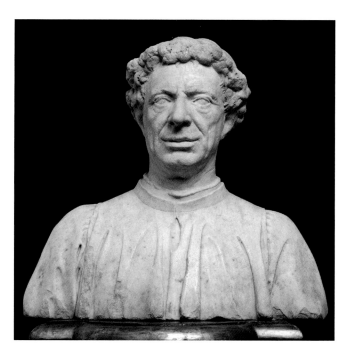

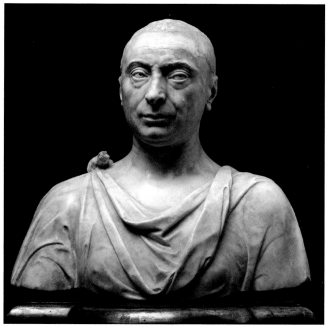

(now in the Victoria and Albert Museum in London), and another of Matteo Palmieri in 1468. Palmieri was a humanist and historian who found time to run a profitable apothecaries' shop as well as serving as Florence's ambassador to the court of Naples. His bust in the Bargello was displayed outside his house until the nineteenth century, so it is badly weathered, but still gives a lively psychological insight into the spirit of an independent-minded and highly intelligent man. Also in the Bargello is Antonio Rossellino's portrait bust of Francesco Sassetti, looking even more anxious than in Gozzoli's fresco portrait of him in the chapel of the Palazzo Medici – as well he might, given the troubles of the Medici bank during his years of stewardship. The della Robbia family workshop also cashed in on this trend. The Bargello has a *Portrait of a Lady*, usually attributed to Andrea but perhaps by Luca, showing the ideal of female beauty and high fashion of the age. The unknown young lady glances down modestly, the better to display her shaven forehead, high plucked eyebrows and the pearls of her headdress, of a kind that provoked bitter criticism from St Bernardino of Siena, a popular preacher of the day. Mino da Fiesole's finest bust, of Bishop Leonardo

Left
Mino da Fiesole: bust of Bishop
Leonardo Salutati, in Fiesole
Cathedral

Right
Mino da Fiesole: *Madonna with
Saints*, in the Salutati Chapel,
Fiesole Cathedral

Far right
Mino da Fiesole: tomb of
Bernardo Giugni, in the Badia

Perkins, a nineteenth-century commentator on Tuscan sculptors, that his prose turned purple: 'The bust of Bishop Salutati is certainly one of the most living and strongly characterised "counterfeit presentments" of nature ever produced in marble. Any one who has looked at those piercing eyes, strongly marked features, and that mouth, with its combined bitterness and sweetness of expression, knows that the bishop was a man of nervous temperament, a dry logical reasoner, who, though sometimes sharp in his words, was always kindly in his deed.' The grandson of the scholarly Chancellor Coluccio Salutati, Bishop Leonardo was indeed an expert in both civil and ecclesiastical law, as confirmed by the inscription on the panel on the underside of his hefty sarcophagus carried on elaborate brackets above his head.

This commemoration of Bishop Leonardo's enthusiasm for law is repeated in the inscription across the bottom of the steps at the base of the lovely sculpture of the *Madonna with Saints* opposite his tomb. The Madonna looks down with a gentle smile on the charming figure of the infant Jesus sitting on the steps below her, who stretches an arm out to the young St John the Baptist. She stands between St Leonard on her left and St Remigio (St Rémy) on her right in the niches of a temple. St Leonard, Bishop Salviati's patron saint, is also the patron saint of prisoners, as he was granted the right by the Frankish King Clovis to release prisoners who were worthy of liberation. He and Clovis were baptised on Christmas day in AD 496 by St Rémy, the Bishop of Rheims, leading to the conversion of all the Frankish people. St Leonard founded an abbey at Noblac in France, and is shown dressed as an abbot, reading

Salutati, was made between 1462 and 1466, when he was working on the Bishop's chapel in his Cathedral at Fiesole, to the right of the raised choir. This startlingly realistic portrait is the centrepiece of the bishop's tomb. Instead of lying flat on his back, the Bishop looks out from under his sarcophagus across the chapel towards the delicately carved marble altarpiece of the *Madonna with Saints* that he commissioned from Mino. His head is angled outwards, catching our attention as we pass his chapel with his kindly smile and anxious frown. The carving of the lines and wrinkles on his wise face is perfect, as are his jewelled mitre and the heavy collar of his cape. His mitre is repeated below his bust above a shield displaying his coat of arms, the claws of a lion's paw holding a lily of Florence, a combination of power and purity.

This marvellous piece of work so inspired Charles C.

his Bible and holding the fetters of prisoners he released. St Rémy points to the baby Jesus as he looks down at the man sitting on the steps below him, who looks up admiringly at him, It is not known who this man is, but he may be the dying pagan who asked St Rémy to baptise him. On the centre of the entablature above the panel, the handsome head of Christ looks down at Salviati across the chapel with a warm expression of blessing.

During the 1460s, tombs and funerary monuments began to be placed in the Badia. Bernardo Rossellino's workshop executed the first of these, the substantial but relatively plain monument to Giannozzo Pandolfini, set in a deep niche beneath an arch in the wall just to the right of the entrance door inside the church. According to the plaque held by two prancing cherubs on the front of his tomb, he was a knight, worthy of the highest praise,

'SUMMA CUM LAUDE', who died in 1456. His sarcophagus is carried on the crests of a pair of sharp-toothed dolphins, his family emblem. We shall meet several of Giannozzo's descendants and their dolphins later in the century, including his son Niccolò, who according to the inscription commissioned the monument, and later became Bishop of Pistoia, and then a Cardinal. Bernardo Giugni, a knight who was also a prominent lawyer and diplomat, died the same year. In his handsome tomb in the right transept, finished ten years later, Mino transformed the conventions of funerary sculpture into a new, secular and humanist language. In place of the usual Madonna and Child, he put a portrait head of Giugni's hook-nosed profile in the circular frame above the architrave, and above the arch a female figure representing Faith. Another figure, holding a sword and scales to represent Justice in

Left
Mino da Fiesole: monument
to Ugo, Margrave of Tuscany,
in the Badia

Below
Mino da Fiesole: *Neroni Dossal*,
in the Badia

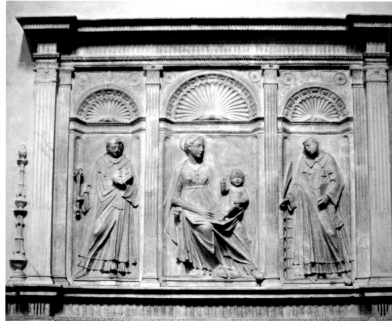

reference to Giugni's profession, stands above his effigy.

Mino put a figure of Charity cuddling one of her babies in a similar position above the effigy of Ugo, Margrave of Tuscany, in his handsome monument, in the left transept of the Badia. Ugo had moved his residence from Lucca to Florence, and bestowed great wealth on the Abbey that his mother, Willa, had founded. His coat of arms, simple red and white vertical stripes, hangs above the chancel arch, and also high above the main entrance to the Badia on the Via del Proconsolo. He was buried in the Badia when he died in 1001, but it was not until 1481 that his memorial, commissioned by the Abbot of the Badia, was completed. Mino includes two young *putti*, standing guard

at the corners of the sarcophagus, following the examples of Desiderio da Settignano and Antonio Rossellino, but in contrast to their exuberant humanity, Mino's work is marked by its Roman dignity and the perfect proportions of its strong architectural framework.

On the right wall of the Badia's short nave there is a sculpted alabaster relief panel, the so-called *Neroni Dossal*, another fine piece of work by Mino da Fiesole. Commissioned by Diotisalvi ('God Save You') Neroni, a politician and advisor to Cosimo de' Medici, it was intended for the church of San Lorenzo, where his family had a chapel. Cosimo had recommended that Neroni should govern Florence after his death, but Neroni joined

attributed to a workshop assistant, while the gentle angel on the left who turns his back to us, the waters of the river Jordan in which Christ and the Baptist stand, and the hazy landscape in the distance are attributed to Leonardo da Vinci. Vasari says that Verrocchio thought Leonardo's angel was so much better than his own figures that he resolved never to touch a paintbrush again. Certainly, if we compare the subtlety of light and shadow on the face, hair and clothes of Leonardo's angel with the rather bony bodies and cruder lighting of Verrocchio's figures, which almost seem to stand forward on a different plane from the rest of the picture, we can see that he had reason to respect his talented young pupil.

One of Leonardo's earliest solo works, a contemporary *Annunciation*, is nearby in the same room in the Uffizi. It was painted for the monastery of San Bartolomeo a Monte Oliveto, just outside the city to the south-west, where the church had recently been rebuilt. The faces and

draperies of the Angel Gabriel and the Virgin are painted with Leonardo's usual delicacy, and we see more of his inventiveness in the extraordinary marble table in front of the Virgin, whose serpentine curves and ornamentation were perhaps inspired by Verrocchio's tomb for Piero and Giuliano de' Medici. While the carpet of flowers in the lawn recalls Fra Angelico's San Marco fresco of the same subject, the distant landscape in the centre, showing ships at anchor off a busy port whose towers are packed in beneath gigantic misty mountains, must come from Leonardo's imagination.

Some time between 1475 and 1478 Verrocchio made a terracotta bust of Lorenzo's younger brother, Giuliano, which has found its way to the National Gallery of Art in Washington. It shows Giuliano wearing the breastplate of a Roman emperor and smiling complacently, so it must have been made before 26 April 1478. For on that day, a month after his twenty-fifth birthday, Giuliano was murdered in broad daylight, in the Duomo of all places, in front of thousands of people at High Mass. In a conspiracy orchestrated by the Pazzi family, he was killed by a blow to the head from Bernardo Baroncelli, a business associate of the Pazzi who was deeply in debt to them, and his corpse

was stabbed a further nineteen times by Francesco de' Pazzi and his accomplice.

Lorenzo was of course the main target of the plot, but two priests turned would-be assassins who were to kill him bungled their job. He was cut in the neck, but leaped over the altar rail aiming to escape into the New Sacristy. He was shielded from further attack by a senior manager of the Medici bank called Francesco Nori, who was stabbed in the stomach by Baroncelli. Lorenzo's secretary Angelo Poliziano locked him in safely in the New Sacristy behind Luca della Robbia's splendid bronze doors. Nori's bleeding body was dragged in too, but he soon died of his wounds.

In recognition of his loyalty and bravery, Francesco Nori was given the honour of being buried in Santa Croce, at the foot of the first pier of the right aisle, below his memorial sculpted by Antonio Rossellino. A lovely Madonna and Child, surrounded by a *mandorla* of cherubs' faces and wings, and backed by a stone curtain draped around the pier with patterns delicately carved in relief, above a marble holy water stoop, Nori's memorial is one of the most charming and hopeful. Strangely, it is known as the *Madonna del Latte*, a name usually given to images of the Madonna feeding her baby.

Right and below right
The Sala dei Gigli in the Palazzo
Vecchio (with later frescoes), and
the doorway leading from it to the
Sala dell'Udienza

The doorway between the two rooms is as
fine an example as any of the craftsmanship of the
period. The frame facing the Sala dell'Udienza is the
plainer, ornamented mainly with geometric patterns,
supplemented by acanthus leaf and egg-and-dart
mouldings. A marble figure representing Justice, who
sadly has lost her hands, sits on the cornice above the
doorway. The decoration of the other side, facing the Sala
dei Gigli, shows just how free the language of architecture
had become, in comparison with the rules of the Classical
precedents. The capitals of the fluted pilasters display
scallop shells, in which a nude reclining female pours the
last drops from a flask into a bowl held by a winged cherub,
all surrounded by acanthus leaves and flowers. The frieze
above has lavish swags of flowers between shields bearing
the cross and the lily of Florence. At the ends of the cornice
above, pairs of playful *putti* wrap themselves with more

Below
Benedetto da Maiano:
Pietro Mellini (Bargello)

Right
Benedetto da Maiano:
pulpit in Santa Croce

swags hanging down from huge candlesticks. Between them stands the life-size figure of a lean and youthful St John the Baptist. He wears his camel-skin tunic underneath his cloak, and with the slight serpentine bend in his body of a classic *contrapposto* pose, leans back and a little to his left, casting his eyes modestly downwards.

The brothers enlisted the help of Francione, Giuliano's former master, to make the doors themselves. These rare examples show the amazing quality of the marquetry work of the times. The sides of the doors facing the Sala dell'Udienza have inlaid urns of flowers on their lower halves, and above, gratings drawn in such clever perspective that they appear to be opening inwards. The sides facing the Sala dei Gigli have inlaid full-length portraits of Dante and Petrarch standing in *trompe l'oeil* niches, above panels

showing stacks of books. The work is so skilful, even the light and shadow on the poets' cloaks is clear.

The brothers' work in the Palazzo Vecchio would have been noticed by Pietro Mellini, a wealthy merchant and friend of the Medici, who served several times as a Priore. Mellini commissioned Benedetto, who had trained as a sculptor with Antonio Rossellino, to make a number of works, among them a marble portrait bust of himself, dated 1474, now in the Bargello. Benedetto captured every wrinkle and wart on the old man's face and the deep creases of his brow. His pursed lips and lowered gaze give him a watchful, slightly sceptical look. As well as the wonderful realism of the portrait, the virtuoso carving of the embroidered arabesque patterns on Mellini's cloak show Benedetto's skill as a sculptor.

Left
Andrea del Verrocchio:
Lady with a Nosegay (Bargello)

façade was rebuilt in the nineteenth century, and is now in the church's museum. Three years later, the Guelph party were pressed to sell their niche to the Mercatanzia, the merchants' tribunal which adjudicated commercial disputes, and whose building committee included Piero the Gouty and then Lorenzo the Magnificent. In 1466, the Mercatanzia commissioned a new statue from Verrocchio. It took ten more years for the project to be developed, and it was finally finished in 1483.

The subject they chose was the Incredulity of St Thomas. One of the twelve Apostles, Thomas refused to believe that the others had seen Jesus alive again after his resurrection, until Jesus invited him to touch his wounds. At first sight, we might expect the choice of this subject to have had a religious motivation. However, being in such a prominent public position, it may well have been chosen for philosophical and political reasons. It expresses the judicial role of the Mercatanzia, to probe and assess the evidence, and a spirit of enquiry in tune with the times. The Medici family also had an association with St Thomas: when they first arrived in Florence in the twelfth century they had lived for generations in houses by the Mercato Vecchio near the church of San Tommaso, which was destroyed when the area was redeveloped to create the Piazza della Repubblica.

The bronze *Incredulity of St Thomas* is Verrocchio's masterpiece. Instead of looking outwards from his niche like the other Orsanmichele statues, St Thomas has one foot on the edge of the base of the tabernacle as he turns towards Christ, drawing our eyes into the niche. Christ lifts one hand in blessing above St Thomas, and pulls the rent in his tunic aside with the other, allowing his doubting

fingers, and of the pleats and folds of her dress.

Verrocchio did not work exclusively for Lorenzo the Magnificent, although Lorenzo's influence was never very far away. Since 1425 the central niche in the main eastern side of Orsanmichele had housed Donatello's gilded bronze statue of *St Louis of Toulouse*. The niche was owned by the Guelph party, with which many of the families who had resisted the rise of the Medici were associated, but whose power was now fading. The statue was therefore too closely associated with the Guelphs for the liking of the Medici. St Louis had joined the Franciscans, who adopted him as one of their saints, so, to dilute its Guelph connotations, his statue was moved in 1460 to an alcove in the centre of the façade of Santa Croce. It remained there until the

disciple to touch the wound in his side. Both have flowing curls and are clothed in expressive swags of drapery, which conveys the emotion of the moment and yet reveals the tensions in their bodies, in particular of St Thomas beneath the lighter folds of his thinner cloak.

The Mercatanzia made another commission, of a set of painted backs for the chairs in their meeting hall, showing the Virtues. Six of these, showing figures representing *Charity*, *Faith*, *Temperance*, *Prudence*, *Justice* and *Hope*, were painted in 1470 by Piero del Pollaiuolo, Antonio's younger brother. The set, now in the Uffizi, was completed by *Fortitude* by Sandro Botticelli, one of his earliest works. The poses and symbols of these Virtues clearly inspired Benedetto da Maiano, who adopted them on a much smaller scale for his pulpit at Santa Croce.

Botticelli was born in 1445 in Via Nuova ('New Street'), which has since been renamed Via del Porcellana ('China Street'), close to the Ognissanti monastery. His father, Mariano di Vanni Filipepi, like many who lived in the area was a tanner, and had a shop in the Santo Spirito district across the river. Sandro, short for Alessandro, was the youngest of four brothers. Botticelli, which means 'Little Barrel', was in fact the nickname of his rotund oldest brother, Giovanni, which, as seems often to have happened, spread to all the family. After an initial training as a goldsmith in the workshop of his second brother, Antonio, at the age of seventeen Sandro was apprenticed to Filippo Lippi. After five years with Filippo he worked for Verrocchio for three years, before setting up his own workshop. During his apprenticeships he painted at least ten variants on the Madonna and Child theme, and around 1470 he painted an altarpiece for the church of Sant'Ambrogio. This early masterpiece is now in the Uffizi, along with all the others of his paintings that we shall look at.

A classic *sacra conversazione* composition, the *Madonna and Child with Six Saints* shows the Virgin with her Child on her knee, sitting on a white marble throne, raised on a small dais and backed by red marble panels, like the one in the Cardinal of Portugal's chapel, completed four

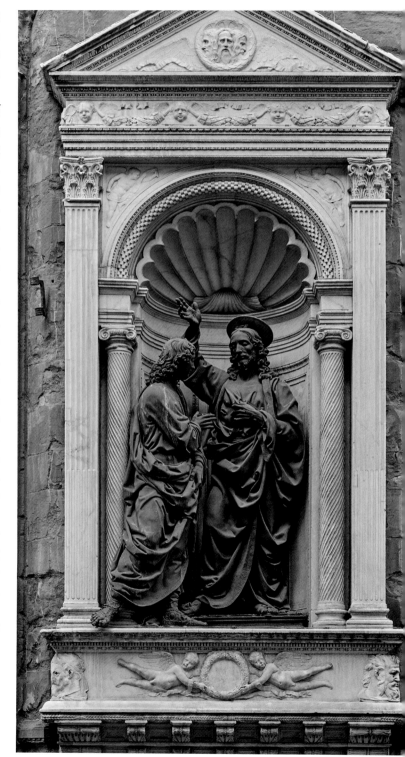

Left
Andrea del Verrocchio: *Christ with Doubting Thomas*, at Orsanmichele

Right
Botticelli: *Madonna and Child with Six Saints* (Uffizi)

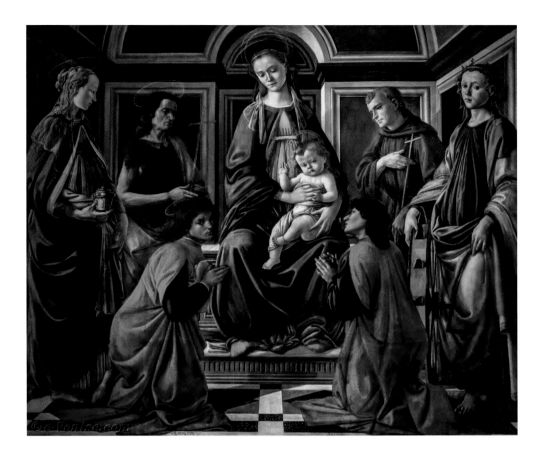

years earlier. The saints in conversation with her are St Mary Magdalene, holding her jar of ointment, St John the Baptist wearing his camel skin, St Francis of Assisi and St Catherine of Alexandria, with her wheel drawn in very steep perspective. SS. Cosmas and Damian kneel in the foreground, suggesting that the picture was commissioned by the Medici, or perhaps by the Doctors and Apothecaries' Guild. Following the precedent set by Fra Angelico in his San Marco Altarpiece, one of the medical saints looks out from the picture to catch our attention, while the other turns to adore the Virgin and to draw us into the scene. Filippo Lippi's influence is also evident not just in the composition and setting of the picture, but in the loveliness of the ladies: St Mary Magdalene is young and beautiful, not gaunt and haggard in old age, as Desiderio saw her, and St Catherine is sweet and shy, as befits a girl who rejected a forced marriage. St Catherine appears again in several altarpieces of this era, not just for her beauty, but probably because, having been a studious youth before she was martyred, she is the patron saint of scholars and philosophers, symbolising the combining of Christianity with the rationality of the Renaissance.

Botticelli was also influenced by Antonio del Pollaiuolo, as we see from the detailed landscape backgrounds in a pair of his early pictures. *The Discovery of the Body of Holofernes* and *The Return of Judith to Bethulia* were painted around 1470–72. In the *Discovery* the brightly dressed Assyrian soldiers and noblemen who discover Holofernes look very distressed. Holofernes's headless youthful corpse lies on the sheets of his bed in front of the huge blue canopy of a

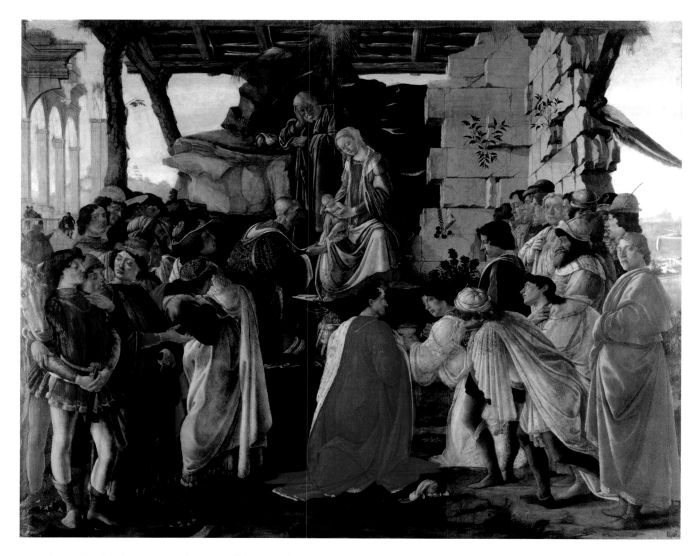

tent through which we get a glimpse of the streaky clouds in the sky above the feathery plants on a rocky bank. In the *Return of Judith*, Judith carries the sword that she used to behead the drunken Holofernes and a branch of an olive tree, symbolising the peace she achieved. Her maid, skipping behind her, carries Holofernes's head, the hairy head of an older man, wrapped in a sheet in a basket on her own head, and two flasks in straw baskets that may have held the wine that inebriated him. They are hurrying along a path in front of a landscape of hedges and fields, where cavalry are galloping over a bridge.

Around 1475, a broker and moneychanger called Gaspare del Lama commissioned Botticelli to paint an *Adoration of the Magi* for the altar of his chapel in Santa Maria Novella. Gaspare had risen from humble origins to become a wealthy member of the Arte del Cambio, the Bankers' Guild, but had a chequered career. He had been convicted of embezzlement of public funds in 1447, and was again convicted of illicit dealings by the consuls of his guild in 1476. Gaspare dedicated his chapel to the Epiphany, the manifestation of Jesus to the wider world, as represented by arrival of the Magi. He was named after Caspar, the

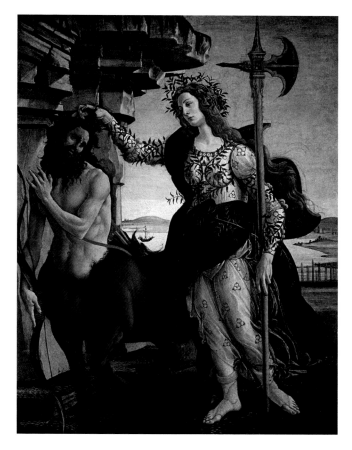

Flying above a glassy sea patterned with rippling waves, Zephyr puffs strongly at Venus's shoulders while embracing Aura, goddess of the breeze, who blows gently as she hugs the wind-god tight. On the grassy shore, a young girl stretches forward in front of a grove of orange trees to offer Venus a swirling rose-pink mantle embroidered with daisies. The girl, one of the Horae, the Greek mythological goddesses of the seasons, personifying spring, wears a white dress adorned with cornflowers, with garlands of roses round her waist and myrtle around her neck. She stands on tiptoes in a meadow sprinkled with violets, symbolising modesty. The whole picture is suffused by light, which Botticelli achieved by painting in tempera over a ground of finely powdered alabaster and highlighting the hair, the wings of the winds, and the leaves and trunks of the trees with delicate streaks of gilding.

Such is the fascination of the painting that, while many have tried to understand its meaning, others have analysed it technically. It has been observed that the proportions of the canvas (and it is the first known large-scale painting on canvas) closely follow the golden ratio. This ratio, which artists and architects were beginning to discover, is expressed mathematically as 1:1.618. It is such that the proportion of the long side of a rectangle to its short side is the same as the proportion of the short side to the difference in length between the two sides. The horizon of the sea in the *Birth of Venus* is also placed to divide the height of the painting in this ratio. This repeated proportion gives a sense of perfection to the composition. Others have complained that Venus's pose, though derived from Classical precedent, is impossible: her weight is too

far to one side. Also that she stands right at the front of the sea shell, which would make it flip over – but surely she is just about to step ashore. Be that as it may, the *Birth of Venus*, with its harmonious composition, graceful figures and sinuous lines, must be one of the most beautiful of all paintings. While commemorating the unforgettable loveliness of Simonetta Vespucci, her perfect form also expresses the Neoplatonic idea that the love of beauty leads to the search for the ideal, the quest for understanding.

Another of Botticelli's allegorical paintings, once on the walls of Lorenzo di Pierfrancesco's house in Via Larga, has puzzled many people as to its meaning. *Pallas and the Centaur* may have been commissioned by Lorenzo the Magnificent as a present for his nineteen-year-old cousin on the occasion of his marriage to Semiramide Appiani, arranged by Lorenzo to cement a political alliance with

her father, the Lord of Piombino. It shows Pallas Athene, the Greek goddess of wisdom, holding a heavy halberd with one hand, and a contrite centaur by his curly locks of hair with the other. Pallas wears a dress patterned with the Medici symbol of three entwined diamond rings and is crowned with a wreath of laurel branches. Centaurs, since the frieze of the Parthenon in Athens, have symbolized unbridled passion and lust. So the interpretation seems plausible that the painting is a hint from Lorenzo to his young cousin that, now that he is married, it is time for the rational side of his character to restrain his wild behaviour.

In the same years as he produced these works of pagan mythology, Botticelli also painted two of his most beautiful Madonnas. Both are tondos, a format which Botticelli frequently used, and have retained their original wonderfully carved round frames. There is no record of who commissioned either painting, but it is probable that the *Madonna of the Pomegranate* was painted for the city's tax officials, for their audience hall in the Palazzo Vecchio, as, like the hall, its frame features golden *fleurs-de-lys* against a blue background. Simonetta Vespucci had died, but

Botticelli had not forgotten her face, which he gave to the Madonna in both paintings. The *Madonna of the Magnificat* shows Mary with a pen in her hand, writing the words of praise to God that she spoke when, newly pregnant, she visited her cousin Elizabeth. She looks lovingly down at her baby on her lap, who returns her gaze. The figures are painted as if they are reflections in a convex mirror, thereby enlarging and focusing attention on Jesus's and Mary's faces. As in the *Madonna of the Pomegranate*, Jesus holds a bursting pomegranate, symbol of his Passion and resurrection. In both pictures, mother and child are surrounded by angels, only some of whom have wings, but all have sweet teenage faces, mops of curly hair and brilliantly coloured clothes painted with refined clarity. In the *Madonna of the Magnificat* one angel helpfully holds an inkwell for Mary, and two others hold a filigree crown of gold above her head, from which translucent ribbons of veil descend. In the *Madonna of the Pomegranate*, two angels hold lilies and roses, while two others turn the pages of their hymn-books.

Simonetta's family were silk merchants, who lived at this time in Via Nuova, down the road from where Botticelli

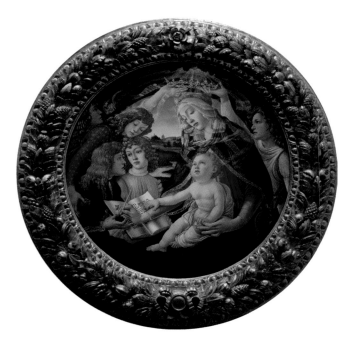

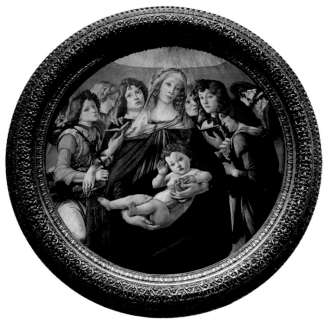

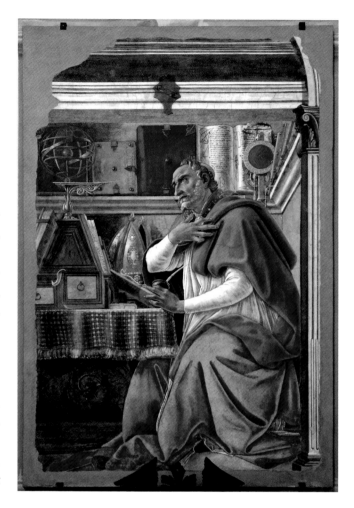

was born. They commissioned a fresco of *St Augustine in his Study* from Botticelli for their local church, the Ognissanti. The Vespucci also commissioned a matching fresco of *St Jerome in his Study* from Domenico Ghirlandaio, a talented painter some four years younger than Botticelli. The two frescoes were originally on the rood screen, on either side of a door that opened into the chancel, so the saints looked towards each other. But when the church was remodelled internally the frescoes were moved, St Augustine to the wall between the third and fourth altars on the right, and St Jerome to face him, opposite on the left. The two Doctors of the Church are shown at work in their studies, suggesting that they were selected, unlike almost all of the saints we have seen before, not for their good deeds or any assaults they might have suffered but for their intellectual contributions to Christianity. They reflect a broader change in the religious role of saints, evolving from protectors of individuals or communities, and intercessors on their behalf, to exemplars of qualities they would aspire to emulate.

Botticelli's St Augustine sits squeezed behind his writing-desk, surrounded by symbols of his scholarship. He holds an inkwell and a quill pen in his left hand, but interrupts his writing, raising his bony right hand to his chest, and gazing upwards, as if seeing a vision. There is a story that the vision he saw was of St Jerome, who announced his imminent death and departure to heaven. An oversized bejewelled mitre on his desk indicates Augustine's position as Bishop of Hippo, in modern-day Algeria, from AD 395 to 430. His books, bound between heavy wooden covers closed with metal clasps, are stored on the shelf behind his head. The patronage of the Vespucci

family is acknowledged by the shield bearing their coat of arms, three golden wasps (inspired by their name, as *vespa* is a wasp), attached to the beam above the books. Botticelli appears to credit the theologian with an interest in astronomy and mathematics: an armillary sphere, showing the positions of the planets on its spiral bands, stands on the lectern on front of him, and a clock on the cornice above his shoulders. Behind the clock, Augustine has doodled geometrical drawings in the margins of an open book. But we should not take this too seriously; the writing in the book is just a scribble, except for a couple of lines, marked by a cross in the margin, where a scholar has detected the words 'Dov'è Frate Martino? È scappato. E dov'è andato?

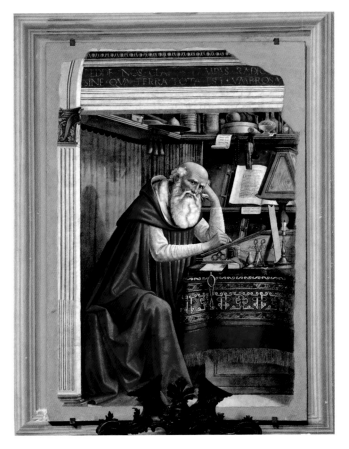

È fuor dalla Porta al Prato' ('Where's Brother Martin? He's run away. And where's he gone to? He's outside the Prato Gate'). We may guess that Botticelli was having a joke at the expense of an errant friar whose escapades he had witnessed while working in the church. His works may give us the impression that Botticelli was very serious-minded, but evidently he was not entirely devoid of a sense of humour, or at least of mischief.

Ghirlandaio's St Jerome works in an equally cramped but slightly more comfortable study, crammed like a student's with academic clutter. He looks up friendly from his writing, as if posing for a photograph. His desk is covered with a rich Oriental carpet, more luxurious than St Augustine's plain grey chequered cloth, and his bookshelves are concealed behind a curtain. Jerome was only ordained as a priest, but the tassels of the cardinal's

hat that was used as his emblem hang down from the shelf behind his head. Next to the hat are his ceramic jars, one glazed with the letters of Christ's monogram, IHS. A scroll with Hebrew writing hangs down beside some rosary beads and a purse, below a box of oranges next to a glass flask half full of water. Another scrap of paper, with a note written in Greek, is pinned to the shelf behind his lectern, to remind us of St Jerome's translation of the Bible into Latin, completed around AD 405. His writing desk, bearing the date of the painting, 1480, in roman numerals, is splattered with spots from the red and black inkwells attached to its side, between his glasses and some scissors, a ruler and a candlestick.

Ghirlandaio's talent for painting portraits, which enliven many of his frescoes, emerged at an early age. He was the eldest son of Tommaso Bigordi, a goldsmith who specialised in making the headdresses worn by fashionable Florentine women, called *ghirlande*, which so outraged St Bernardino of Siena, but gave Tommaso his adopted name, inherited by his children, which means 'garland-maker'. Ghirlandaio's first apprenticeship was in his father's workshop, but he did not enjoy working as a goldsmith, and 'did nothing but draw continuously'. Vasari records that 'he would sketch everyone who passed by the shop, and in his drawing he immediately produced their likeness'. So he moved on to train as an apprentice painter with Alesso Baldovinetti, and in Verrocchio's workshop.

Among his earliest surviving works are some frescoes painted around 1472, when he was twenty-three, for the Vespucci family's newly constructed chapel, the second on the right in the Ognissanti. The shallow chapel is barely

Left
Domenico Ghirlandaio: *Last Supper*, in the refectory of the monastery of the Ognissanti

Right
Domenico Ghirlandaio: *Last Supper*, in the guests' refectory of the monastery of San Marco

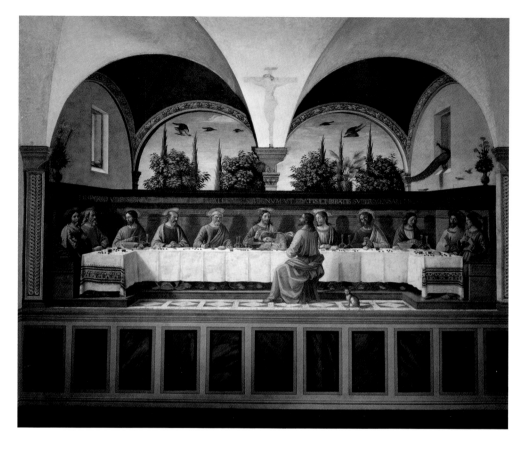

would indicate that they are wondering if they will be the ones to betray their lord. The face of Jesus himself, in the centre, has suffered from poor restoration.

The perspective of the painting is carefully designed so that, although the scene is set halfway up the end wall of the refectory, we appear to be looking down not only on the marble patterns of the floor, thus pushing the table away into the distance, but on the top of the table itself. Whereas Botticelli focused on symbolic meanings in his paintings, Ghirlandaio filled his with realistic and homely details. The tablecloth is covered with all the clutter of a good dinner – boards with bread and cheese, cutlery, fruit, and skilfully painted transparent glasses and decanters. The cloth itself, at the two ends of the table, is woven with a pattern of winged dragons. Ghirlandaio also showed off his technical expertise in the reflections on the polished

surfaces of two large metal jugs at the left of the scene, and of a round brass dish on the right. He includes some symbols too: the cherries on the table are seen as reminders of drops of Christ's blood. A peacock perches on the ledge of the window on the right, matched by a dove of peace on the left, while the palm tree visible through the right arch of the loggia is the emblem of martyrdom. Above the trees, two goldfinches swoop down, while ducks, symbols of heavenly joy, are attacked by wicked sparrowhawks.

In 1486, Ghirlandaio was asked by the Dominican friars at San Marco to paint another *Last Supper* in their smaller refectory, used by guests staying in the monastery. It is almost an exact copy of the Ognissanti version, and the theory is that while Ghirlandaio was responsible for the design, by this time he was too busy to complete the work himself and left much of the execution to his brother

Davide and another assistant from his workshop. Overall, it presents an equally calm scene of low-key drama. The most striking difference is that the strong green and orange colours of the eleven panels at the base of the picture are replaced, rather more subtly, with painted marbling. A strip is inserted above the bench behind the heads of Jesus and the Apostles bearing a Latin inscription of Jesus's words to his disciples, entirely appropriate to a guests' dining room, which translate as 'As surely as my Father has given me my kingdom, so I give you the right to eat and drink at my table in that kingdom'. This time, the tablecloth is embroidered with a design of swans perching besides the towers of castles. Another, more down-to-earth, addition is the cat which sits on the floor behind Judas's stool, waiting hopefully for a scrap to fall. Cat-lovers will be disappointed to learn that cats were associated with darkness and black magic, because of their nocturnal habits.

Ghirlandaio was among the group of Florentine painters whom Sixtus IV summoned to Rome, at the suggestion of Lorenzo the Magnificent, to fresco the walls of the Sistine Chapel. When he returned to Florence in 1482, the Signoria commissioned him to decorate the eastern wall of the Sala dei Gigli in the Palazzo Vecchio, where Giuliano and Benedetto da Maiano had recently finished the magnificent coffered ceiling and sculpted portal. At the time, the Palazzo Vecchio had not yet been extended at the back, and there were two large windows in the wall. Their tracery survives, but one has been filled in and is now blank, while the base of the other has been cut down to allow access through to the next room. Ghirlandaio framed the windows with painted pilasters splendidly decorated with spirals supporting three highly ornamented arches between taller pilasters, thus creating a magnificent triumphal arch. The symmetry of his design was upset when a door was knocked

through to the Stanza della Guardaroba (where the doors of the cupboards are painted with fascinating maps of the world) as part of Vasari's renovations in the later sixteenth century. The dark marble columns that flank the door came originally from a Roman temple.

The theme of the fresco, not surprisingly, is a celebration of all things Florentine. Two heraldic Marzocco lions guard the central arch, the one on the right obscured behind the pediment of Vasari's doorframe, holding banners bearing the red cross of the people, and the red lily of Florence. This arch frames a scene known as the *Apotheosis of St Zenobius*, although the first Bishop of Florence is not shown ascending into heaven but seated on his throne, his hand raised in blessing, beneath a della Robbia-style lunette of the Madonna and Child and two angels. The figures on either side are his deacons, SS. Eugenius and Crescentius. Ghirlandaio was already beginning work on another major project, and these figures are believed to have been painted by his assistants, which accounts for their static poses and simpering expressions. Squeezed in beside the deacon on the left is a distant aerial view of the Duomo, showing Arnolfo di Cambio's façade.

The arches on either side of the central group are drawn in perspective, which, if we stand in the centre of the room, gives the illusion that we are looking through them to cloudy skies beyond. The animated and brightly coloured figures that stand on the door frames in these arches are attributed to Ghirlandaio himself. They represent heroes of ancient Rome, illustrating the Signoria's ambition to emulate its strength and civic virtues. Curiously, the first figure on the left is Brutus, a leading member of the group

who assassinated Julius Caesar in 44 BC because of his increasingly autocratic behaviour. The dagger in Brutus's hand is still smeared with Caesar's blood. Painted only four years after the Pazzi's attempt to murder Lorenzo the Magnificent, was this intended as a warning to him by the Signoria? Surely not – Lorenzo controlled almost everything in the political life of Florence, including the membership of the Signoria. Perhaps it should be taken as Lorenzo's reassurance that he did not intend to overthrow the Republic and become king. The next figure, in a sky-blue breastplate, is Gaius Mucius Scaevola, shown putting his right hand in a bowl of fire to demonstrate his willingness to die for Rome, after having been captured sneaking into the camp of the Etruscans who were besieging Rome in 508 BC, with the intention of killing their king, Lars Porsena. The stalwart soldier on the right of the group is Marcus Furius Camillus, 'the second founder of Rome', who significantly enlarged the Roman territories and expelled the Gauls who had invaded in 390 BC. He is holding one of the pikes with which he equipped his soldiers to keep the Gauls and their swords at a distance. The three figures' tight-fitting armour is closely moulded to the contours of their chests, making them look like musclebound athletes.

The first figure in the right-hand group is the Emperor Decius. He points upwards, as if to heaven – a strange gesture for someone who persecuted Christians (St Minias included!) who refused to obey his edict of AD 250 that all Roman citizens should sacrifice to their ancestral gods, issued as part of his attempts to strengthen the authority of the empire. Next is Scipio, the general who defeated Hannibal and the Carthaginians at the battle of Zama in 202 BC, his cloak fluttering in an unseen breeze, and a bronze dragon on his helmet. Finally, holding the fasces, the bundle of rods around an axe carried by the lictors, the bodyguards of Roman magistrates, is Cicero. During his year as consul, in 63 BC, he thwarted a conspiracy to assassinate him and overthrow the republic, led by Lucius Catilina. His presence here balances Brutus's, and must have reassured Lorenzo the Magnificent.

The project that distracted Ghirlandaio from his work in the Sala dei Gigli was a commission, on Lorenzo the Magnificent's recommendation, to fresco a funerary chapel for Francesco Sassetti. Sassetti's career had been spent working for the Medici bank, becoming a junior partner in the branch in Avignon, then in Geneva, where he was also general manager, and in Lyons. Later Cosimo de' Medici appointed him to the position of general manager of the bank as a whole, at first jointly with Cosimo's son Giovanni. Sassetti continued in this role after the deaths of both Giovanni and Piero the Gouty. His family had long held the right to decorate the main altar in the chancel at Santa Maria Novella, and they had acquired the rights over the walls of the chancel as well, from the Ricci family who had struggled financially since going bankrupt in 1348. However, the Dominican friars of Santa Maria Novella refused Sassetti's request to decorate their chancel with stories of his name-saint, St Francis of Assisi, so around 1478 he acquired a smaller chapel in Santa Trinita instead. The Vallombrosians of Santa Trinita were not so suspicious of the otherworldly spirituality of St Francis as were the dogmatic Dominicans. But the stories of St Francis were not the only theme of Ghirlandaio's frescoes here; just as he had extended Florence's glory back to the days of Rome in the Sala dei Gigli, here he linked the Christian story to the Classical era.

The entrance to Sassetti's chapel, the second to the right of the chancel, is marked by his coat of arms in glazed terracotta, above the arch. The white shield, crossed by a diagonal blue and yellow stripe, is flanked by two slings for throwing rocks, *sassate* – punning on his name – and ringed with one of the della Robbia workshop's customary wreaths of fruit and leaves. Above this, Ghirlandaio frescoed the myth of the Tiburtine Sibyl (perhaps a portrait of Sassetti's daughter Sibilla) pointing to the sun. She is drawing the Emperor Augustus's attention to the golden sign in the sky, which bears Jesus's name abbreviated to IHS, and announces his coming. In the vault of the chapel, between ribs decorated with garlands of fruit and flowers, instead

of the usual Evangelists there are four more sibyls who foretold the coming of an age of gold, or of Christ. Seated on thrones of clouds, and warmed by golden haloes, three of them carry scrolls inscribed in Latin with references to their prophesies described by 'Virgil Magnus' – the great Virgil. The Cumaean Sibyl, who we saw before in Andrea del Castagno's fresco in the series of *Illustrious Men and Women*, is above the entrance to the chapel. The others are the Agrippine and Erythraean Sibyls, while the fourth, on the left, who has not finished writing on her scroll, may be the Cimmerian Sibyl. The inclusion of these prophetesses illustrates the Renaissance's integration of elements of Classical culture into Christian traditions.

Sassetti and his wife, Nera Corsi Sassetti, are shown kneeling in prayer on either side of the altarpiece on the back wall. On the right, Sassetti's sombre figure is clothed in a merchant's red cloak, while Nera, who unusually occupies pole position on the left, wears a nun's sober

Left
Domenico Ghirlandaio: *The Meeting of Augustus and the Sybil*, above the arch of the Sassetti Chapel, Santa Trinita

Below
Giuliano da Sangallo: tomb of Nera Corsi, in the Sassetti Chapel, Santa Trinita

black habit and a white wimple. Below them, in Roman numerals, is the date, 25 December 1485, probably when the frescoes were finished. (Some of the numerals are lost, but were previously reported to be there.) Their simple black marble sarcophagi, decorated only with ox's skulls and thin ribbons, are housed in niches in the side walls of the chapel, whose arched frames, once gilded, are richly carved with Classical images which make erudite allusions to themes of death and resurrection. Their design is attributed to Giuliano da Sangallo, executed in the last few years before Sassetti died of a stroke in 1490. This is a novelty – not just in the entirely Classical imagery of the funeral memorials, but in its timing. Every other tomb we have seen was made after the death of its occupant. But then, Sassetti was just the Medici's bank manager, not one of their family. As his simple coat of arms confesses, he was not a nobleman or a knight, or a chancellor or a cardinal,

so he could not expect to be honoured by others after his death. Perhaps the political troubles of the times made him lack confidence that his wishes would be fulfilled if he merely spelled them out in his will.

The imagery of the funeral memorials, including cherubs and centaurs, emperors and eagles, reflects Sassetti's love of Classical literature, which he enjoyed so much that contemporaries suggested that it distracted him from his stewardship of the Medici bank. In retribution for the execution of Archbishop Salviati and other priests involved in the Pazzi conspiracy, Pope Sixtus, aided by his ally, King Ferrante of Naples, had seized or frozen the assets of the Medici bank's branches in Rome and Naples. While this cannot be laid at Sassetti's door, the near collapse of the Lyons branch occurred on his watch. More disastrously for Lorenzo's financial position, the branch in London failed under the weight of loans to Edward IV of England and to his Lancastrian opponents, which they were unable to repay due to the Wars of the Roses. The bad debts were transferred to the branch in Bruges, which had also lent excessively to Charles the Bold of Burgundy, and was liquidated with heavy losses.

Ghirlandaio makes some, mainly stylistic, Classical references in the series of stories of St Francis. Instead, his main concern seems to be to link the scenes more closely to Sassetti's life. Following Giotto's precedent in the Bardi Chapel at Santa Croce, the series starts in the lunette at the top of the left wall of the chapel, and shows the *Renunciation of Worldly Goods*. In the centre, Francis, stripped to his underpants, kneels before Bishop Guido of Perugia who wraps his cloak protectively around the young saint's

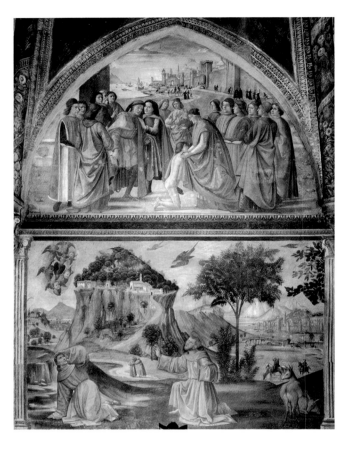

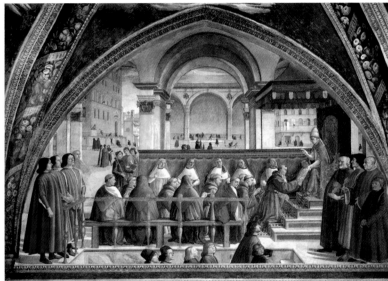

shoulders. His distressed father, Pietro Bernardone, carries Francis's clothes in one hand and a rope in the other. Is this Francis's belt, or is his father about to give him a thrashing? Pietro is restrained and comforted by an anxious woman, no doubt his wife. Above the heads of the onlookers, the receding towers and walls of a city draw the eye to a busy distant harbour. This has been identified as one of the cities where Sassetti lived while working for the Medici bank, Geneva or perhaps Genoa.

The next scene, at the upper level on the back wall of the chapel, is clearly set in Florence. The *Confirmation of the Rule* shows Francis and his followers kneeling before Pope Innocent III, an event which happened in Rome, but looking through the arches above the friars' shaven heads, we see the Loggia dei Lanzi, and on the left, the Palazzo Vecchio. The protagonists of the story are upstaged by

the people in the foreground, whose portraits combine Sassetti's family album with a clear statement of his allegiance to the Medici. The dark-haired man in the group on the right is Lorenzo the Magnificent, identifiable by his long flattened nose. Sassetti stands beside his boss, wearing his red gown. On the other side of Lorenzo, in blue, is the elderly silk merchant and politician Antonio Pucci, a loyal supporter of the Medici, whose son Alessandro married Sassetti's daughter Sibilla. The boy at the front of the group is Sassetti's youngest son, Federico.

Oblivious to the Pope and the saint behind them, the attention of this group is focused on the figures who climb up the stairs towards them. Lorenzo gestures to welcome his sons: Piero 'the Unfortunate', the eldest, whose bust by Verrocchio we saw in the Bargello, is the tallest of the three boys and in the middle of the group; nearly at the top of the

OTHER FAMILIES IN FLORENCE AND THE IMPACT OF SAVONAROLA

The longstanding rivalry between the Dominicans and the Franciscans of Florence became even more intense in the last decades of the fifteenth century, so it is hardly surprising that the Dominicans refused Francesco Sassetti's request to fresco their main chapel at Santa Maria Novella with scenes celebrating the life of St Francis. The right to decorate the chancel walls reverted to the Ricci family, who re-sold it, this time to Giovanni Tornabuoni. The brother of Piero the Gouty's wife Lucrezia, Tornabuoni was the manager of the Rome branch of the Medici bank, which brought him the lucrative position of treasurer to Pope Sixtus IV. He was descended from a branch of the Tornaquinci family which had renounced their noble status in order to be eligible to participate in the government of Florence, altered their coat of arms and changed their name to Tornabuoni. The chapel, dedicated to the Assumption of the Virgin, had been decorated by Orcagna in 1348, but his frescoes were damaged after the roof of the chapel was struck by lightning ten years later, and the impoverished Ricci family had been unable to have them restored. Orcagna's original frescoes were of the lives of the Virgin and of St John the Baptist, the patron saints of the chapel and of the city, and Tornabuoni agreed to retain these themes. It was fortunate that his forename was the same as the Baptist's. On the recommendation of his nephew Lorenzo the Magnificent, Tornabuoni chose Domenico Ghirlandaio to renew the decoration, a task that occupied Ghirlandaio and his workshop from 1485 to 1490. Tornabuoni also commissioned the magnificent wooden choir stalls with their inlaid backs that run round the chapel walls below the frescoes, made by Baccio d'Agnolo a few years later.

Even more than at Sassetti's chapel at Santa Trinita, the ostensible subjects of Ghirlandaio's frescoes in the Tornabuoni Chapel at Santa Maria Novella seem to be used as excuses for painting portraits of his patron's fashionably dressed family and friends, set in magnificent contemporary architecture or dramatic landscapes. Naturally, the portraits of Giovanni Tornabuoni and his wife, Francesca, daughter of the wealthy Luca Pitti, the builder of the Palazzo Pitti, were placed prominently at the base of the end wall of the chapel, facing each other as they pray on either side of the gloriously colourful stained glass windows, also designed by Ghirlandaio. These days they are rather hidden behind the massive nineteenth-century Neo-Gothic high altar. While Tornabuoni wears a lavish pink silk gown with enormous drooping sleeves, his wife is primly dressed in a nun's black habit and white wimple. The two portraits are set in the gilded loggia of a villa, while colonnades in the distance behind them lead our eyes to detailed imaginary landscapes.

The loggia reappears as almost the main protagonist, dominating the scene in the first of the scenes from the life of the Virgin on the left wall of the chapel. The series starts in the left-hand panel at the bottom of the wall, with the *Expulsion of Joachim from the Temple*. As in Taddeo Gaddi's version at Santa Croce, we see Joachim, Mary's aged father, recoiling from the steps of the Temple, carrying away his offering of a lamb, rejected because of his childlessness. The other characters from the apocryphal story, the priest receiving sacrifices at the

On page 354
Domenico Ghirlandaio: frescoes in the Tornabuoni Chapel, Santa Maria Novella

Left and left, below
Domenico Ghirlandaio: *The Expulsion of Joachim from the Temple* and *The Nativity of Mary*, in the Tornabuoni Chapel, Santa Maria Novella

central altar and the young men and women bringing their lambs, are pushed to the back of the scene underneath the complicated cross-shaped loggia. Behind them we can see the arches of another loggia, which copies Brunelleschi's Ospedale degli Innocenti. Coincidentally, the loggia of the Hospital of San Paolo, across the piazza from the church, also closely modelled on Brunelleschi's original,

was built from 1489 to 1496 to a design by Michelozzo, just as Ghirlandaio was finishing his frescoes.

The two groups of four men in the foreground show Ghirlandaio's delight in portraiture. Naturally he includes his self portrait, in the group on the right, holding the folds of his red cloak to his hip, and looking out towards us. Vasari identifies the young man with long black hair behind

Domenico Ghirlandaio: *The Presentation of Mary at the Temple*, in the Tornabuoni Chapel, Santa Maria Novella

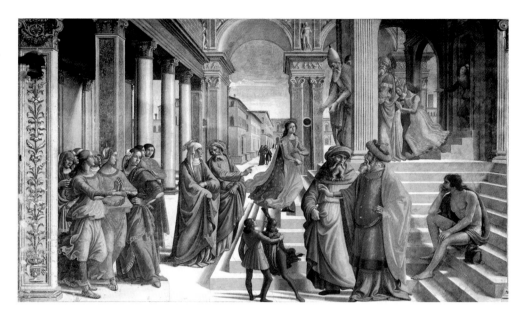

him as his pupil and brother-in-law, Sebastiano Mainardi. The old man with a red headdress is Alesso Baldovinetti, his first master, and at the left of the group the man with his back to us, wearing a red cap, is his brother Davide, who worked with Ghirlandaio on the frescoes. The long-haired young men fashionably dressed in colourful clothes on the left are thought to include Giovanni Tornabuoni's son Lorenzo, turning towards us at the front of the group. The man standing behind him, wearing an identical outfit, might be Alessandro Nasi, who in 1491 married Lorenzo's fifteen-year-old sister Ludovica.

Ludovica and the ladies get their look-in in the next scene, to the right, of the *Nativity of Mary*. The setting is indoors; Mary's mother Anne sits up in bed, raised on a dais in a room whose walls are topped by a frieze of *putti* dancing and playing musical instruments, like those in Donatello and Luca della Robbia's *cantorie* for the Duomo. The *putti* are celebrating the occasion: the gilded inscription at the top of the panelled wardrobe beneath their feet translates as 'Your birth, O Virgin Mother of God, brought joy to all the world'. It is baby's bath-time; a maid sitting on the dais holds the newborn Mary, while another, whose dress flutters as if caught in a gust of wind, pours water into a

bowl. A third maid turns to look at the group of elegant ladies who have come to congratulate Anne. They are led by Ludovica Tornabuoni, wearing a magnificent dress of gold brocade embroidered with the Medici's diamonds and falcons – perhaps her wedding dress. The two young women behind her have not been identified, but the two older ladies at the back of the group could be Giovanni's sisters, Dianora and Lucrezia, Piero the Gouty's widow, who had died in 1482. A couple embrace on the landing at the top of the stairs leading out of the room. These are Anne and Joachim, echoing their meeting outside the Golden Gate of Jerusalem, where Joachim's kiss led to Mary's immaculate conception. A self portrait would not be appropriate in this scene; Ghirlandaio merely inscribed his real surname, 'BIGHORDI', and a version of his nickname, 'GRILLANDAI', in the gilded decorations on the wardrobe doors.

The story continues with the *Presentation of Mary at the Temple*, one row up on the left. The girlish figure of Mary, carrying a book as she hurries up the steps to the welcoming priest, is almost overwhelmed by the elaborate architecture of the Temple. In a homely touch, a group of girls run in to the Temple behind the priest to greet their

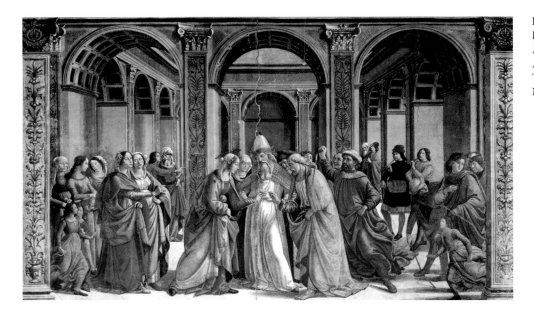

friend. Mary's elderly parents stand behind her at the foot of the steps, but are upstaged by two bearded gentlemen in the foreground, and a group of ladies on the left, probably all portraits of people from local noble families. Between them are two strangely half-sized youths, and on the far right an even more puzzling figure – a nearly naked young man who gazes intently at Mary, sitting on the stone steps of the Temple. Beside him is an oval wooden flask, exactly like the one that Ghirlandaio put beside Joseph's saddle in his *Adoration of the Shepherds*. Could he be the young Joseph, catching his first glimpse of the girl he was later to marry? As he does in the next scene, to the right.

In the *Marriage of the Virgin* Joseph has aged considerably and is now grey-haired and bald on top. He wears a striking golden cloak with a green lining, while Mary wears her traditional blue cloak over a red dress. Ghirlandaio could not resist including a group of elegant ladies on the left, and some half-sized figures rushing in at the corners of the scene. On the right, recalling the apocryphal story, two of the disappointed descendants of David break their sticks, while another raises his fist in frustration behind Joseph's head. Despite this undignified interruption, the wedding is given an appropriate solemnity

by its setting in the Temple with its noble coffered arches.

The sequence continues on the same level in a narrow panel on the back wall of the chancel. The *Annunciation* scene is set indoors, inside a contemporary palazzo, with a glimpse of a mountain landscape through the paired windows. The scenes above on the left wall have been badly damaged by damp, and were probably painted by Ghirlandaio's assistants, as they are hard to see so far above ground. The central figures of the *Adoration of the Magi*, on the left, have been obliterated, but in the distant landscape in the upper right-hand corner we can still see a giraffe ambling down the mountain track. Lions were kept in a cage the Via dei Leoni behind the Palazzo Vecchio, but there was no giraffe in Italy until 1487, when the Sultan of Egypt had sent an ambassador to Florence with a giraffe as a gift to Lorenzo the Magnificent, who kept it in his menagerie of exotic animals at his country villa at Poggio a Caiano. The giraffe caused a sensation when it arrived in Florence. Ghirlandaio no doubt included it as a nod to his patron's nephew and employer.

On the right, the *Massacre of the Innocents* is one of Ghirlandaio's most original and vigorous compositions. Although the theme of the series is stories of the Virgin,

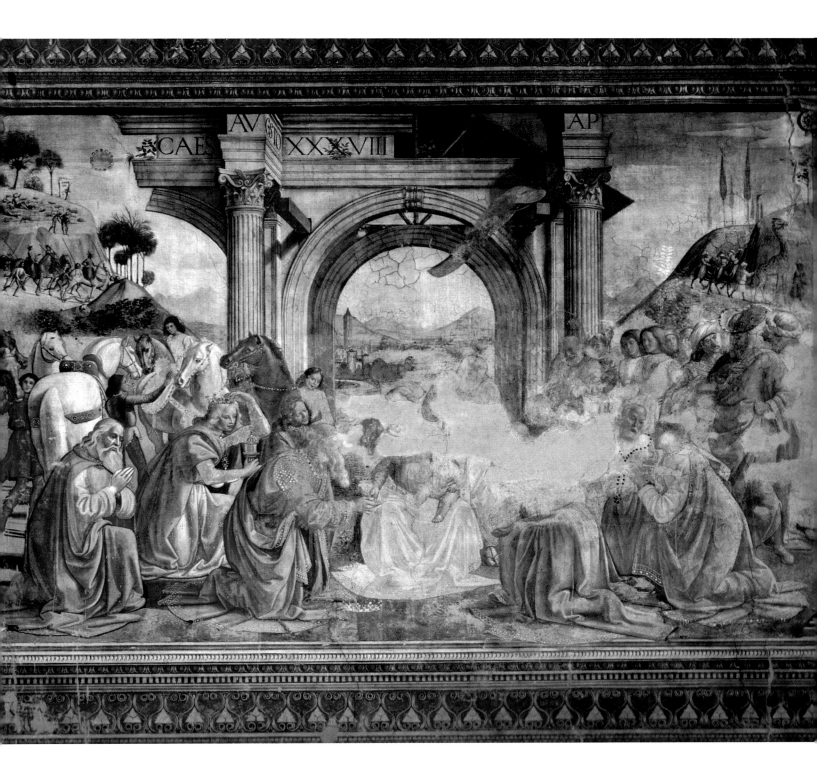

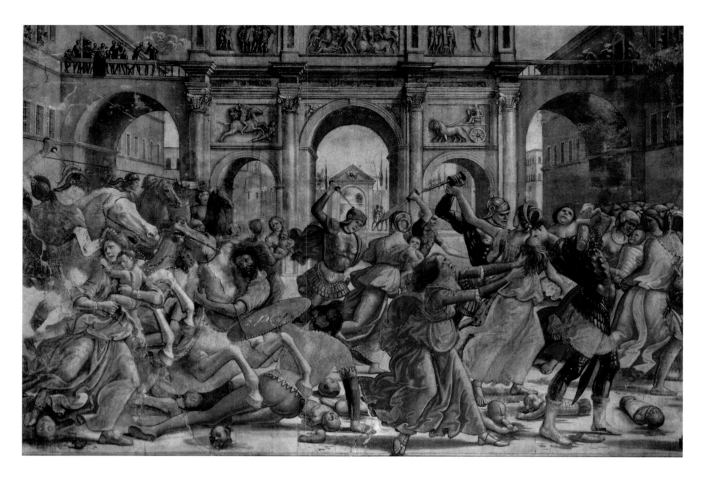

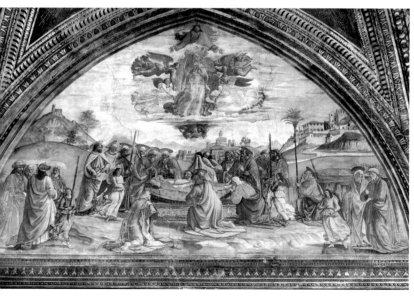

Mary does not feature in this dramatic scene. The foreground is filled with lively figures; Roman soldiers, some on foot and some on prancing horses, slash with their swords and the terrified mothers of Jerusalem try to resist them or to escape clasping their babies. The massacre takes place against the backdrop of a Roman triumphal arch, decorated with reliefs repeating the scenes of slaughter. The next scene in the series, the *Death and Assumption of the Virgin*, is hard to see in the lunette above these scenes, but we can step back to see the final scene, the *Coronation of the Virgin*, at the top of the end wall. It has been badly damaged by cracks in the wall, but three rows of brightly coloured saints and angels remain.

The upper walls on either side of the windows provide the opportunity to include the Dominicans' two favourite

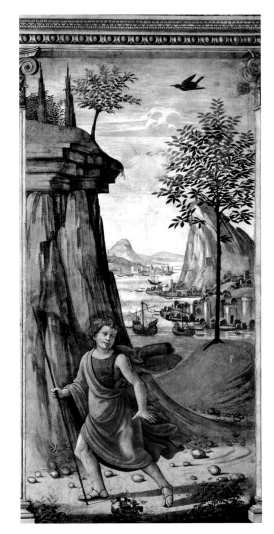

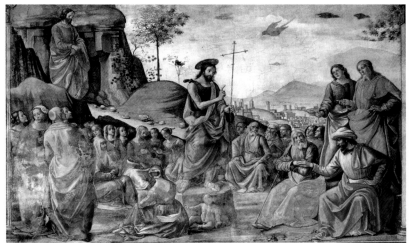

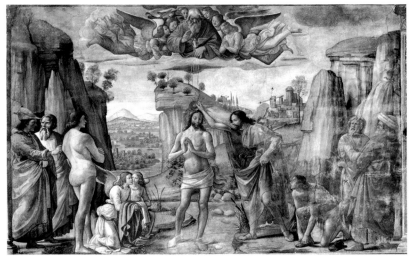

Left
Domenico Ghirlandaio:
Zacharias writes the Name of his Son, in the Tornabuoni Chapel, Santa Maria Novella

Above, left
Domenico Ghirlandaio and attributed to Michelangelo:
St John the Baptist in the Desert, in the Tornabuoni Chapel, Santa Maria Novella

Above, right
Domenico Ghirlandaio: *St John the Baptist Preaching* and *The Baptism of Christ*, in the Tornabuoni Chapel, Santa Maria Novella

to be a self portrait. If it is by Michelangelo, it must be one of his earliest works, as he was then only thirteen. John is a grown man in the next scene, one level up, *St John the Baptist Preaching*. He stands on a rock, wearing his camel-skin and preaching to the crowds gathered around him of the coming of Christ, who approaches down the path from the crag behind him. The landscape continues into the next scene on the left, the *Baptism of Christ*. The central group of Christ, the Baptist and two kneeling angels very closely follows the version that we saw in the Uffizi by Verrocchio and Leonardo da Vinci. However, the figure

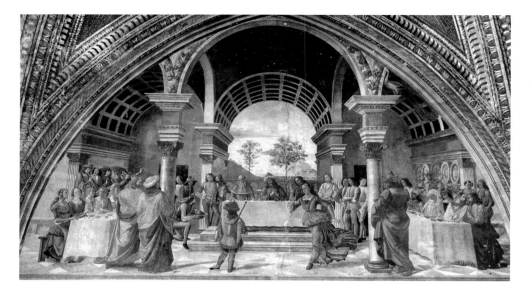

Left
Domenico Ghirlandaio: *Herod's Banquet*, in the Tornabuoni Chapel, Santa Maria Novella

Below
Domenico Ghirlandaio: *Adoration of the Magi* (Uffizi)

of God the Father, floating on a cloud above Christ's head and surrounded by angels as he blesses the Baptism, is an unusual reversion to the conventions of late Gothic art. The two nude figures of young men waiting their turn to be baptised, one standing on the left with his legs crossed, and one on the right kneeling to remove his shoes, are also attributed to Michelangelo.

John's story ends above, where a servant brings his head in a basin into *Herod's Banquet*. Herod is seated at the centre of the table in his huge barrel-vaulted hall, while Salome dances and a dwarf performs for him in the foreground. The magnificent architecture and the bright colours of the courtiers' clothes gives the fresco an inappropriately stately and celebratory air – but then, the significance of the religious story has taken second place to Ghirlandaio's gifts as an illustrator and portraitist in almost every scene on the walls of the chapel. He follows the rules of tradition more closely in the four portraits of the Evangelists in the vaults above.

Even while working on such a massive project, Ghirlandaio found time to make panel paintings for his clients. He painted a large brightly coloured tondo of the *Adoration of the Magi*, crammed with horses and soldiers as well as the kings' retinues, for the Tornabuoni

family in 1487, now in the Uffizi. The following year, he made another version of the same subject, even more crammed with colourful characters and intriguing detail, commissioned by Francesco Tesori, the Prior of the Ospedale degli Innocenti, for the hospital's main altar (now in the Hospital's Museum). In view of its intended location, this version includes the Massacre of the Innocents in the

Right
Domenico Ghirlandaio:
Adoration of the Magi (Museum
of the Ospedale degli Innocenti)

background, on the shores of a distant port city. As usual, Ghirlandaio put a portrait of his patron in the painting, dressed in black behind St John the Baptist's cross, and his own self portrait, gazing at us behind Tesori's shoulder.

Despite being able to make these two beautiful paintings, he could not fresco another church at the same time. In 1442, the Dominican friar Antonino Pierozzi, who became St Antoninus, had founded the Buonomini di San Martino, a group of twelve 'good men' who supported him in helping families who had been reduced to poverty by their political opposition to Cosimo de' Medici or by economic turbulence. Their charitable Compagnia was based in the small church on the Piazza San Martino beside the Via Dante Alighieri, now known as the Oratory of the Buonomini di San Martino, which was rebuilt from 1479. Above the altar in the Oratory is a portrait bust of a thoughtful-looking St Antoninus, attributed to Verrocchio. The lunettes on the walls under the arches of

the ceiling were decorated by Ghirlandaio's workshop with frescoes of stories of St Martin. His workshop followed his style with frescoes full of colourful characters and background landscapes, but without portraits of patrons and their families and friends.

St Martin, to whom the church is dedicated, became the Bishop of Tours in France in the fourth century. His father was a senior officer in the Roman army, so he had to serve in the Roman cavalry for a few years before becoming a monk and then a hermit living on the small island of Albenga, off the coast of Italy near the border with France. The first two frescoes are above the altar. On the left, St Martin, a young soldier wearing armour and riding a horse, cuts his scarlet cloak in half with his cavalry sword to give half of it to a bare beggar, while another young soldier holds his horse's bridle

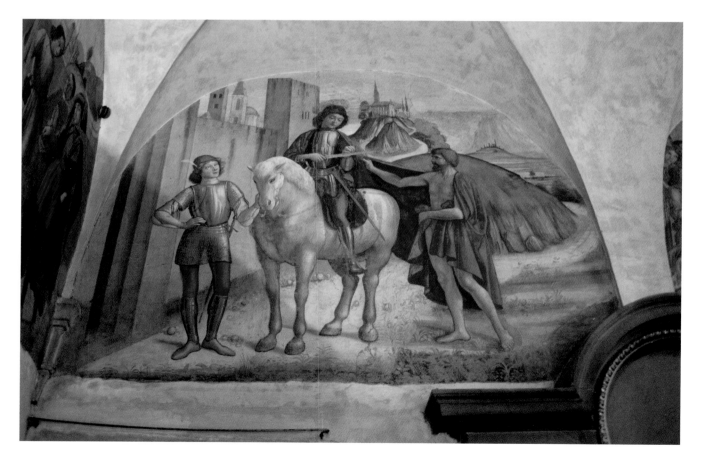

Left, above
Ghirlandaio's workshop: frescoes
in the Oratory of the Buonomini
di San Martino

Left, below
Ghirlandaio's workshop:
St Martin gives his Cloak, in
the Oratory of the Buonomini
di San Martino

Right
Ghirlandaio's workshop:
St Martin's Vision of Christ, in
the Oratory of the Buonomini
di San Martino

Right, below
Ghirlandaio's workshop: *Visiting
the Prisoners*, in the Oratory of the
Buonomini di San Martino

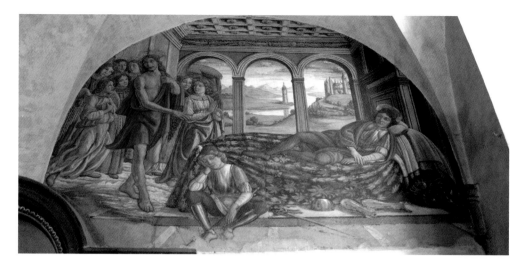

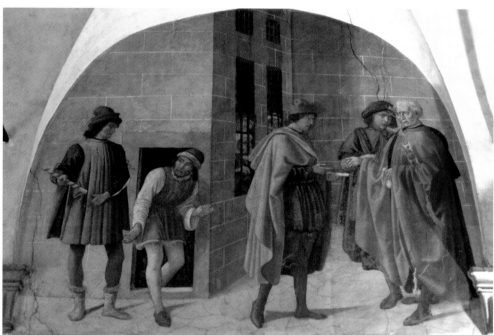

to keep it still. On the right, St Martin is sleeping on his large luxurious bed, still wearing his armour under half of his cloak, except for his legplates lying on the floor beside his young colleague. He dreams and sees Christ coming into his balcony bedroom wearing the other half of his cloak and followed by a group of lovely young female angels.

The frescoes on the left wall of the Oratory illustrate Works of Mercy, encouraging the Buonomini to be inspired by St Martin's charitable activities. The first one at the far end of the wall shows three Buonomini *Burying the Dead* with a group of clergymen, and the next one on the left shows them *Welcoming the Pilgrims*. Then they are *Visiting Prisoners* peering out from behind the grilles over the windows of their cells, and releasing one of them, a debtor,

by handing a bag of cash to his warden. At the front end of the left wall they are *Visiting the Sick*, giving a chicken and a flask of wine to the maidservant of a woman lying in bed with her newborn baby. Round the corner, on the inside of the front wall, they are *Dressing the Naked*, giving sheets of cloth to the family of a child. In the last of the series, on the left, they are *Giving the Thirsty to Drink*, pouring jugs of scarlet wine into their flasks and giving fruit to their children. The two frescoes beside the windows on the right wall of the Oratory promote the Arte dei Giudici e Notari, the Guild of Judges and Lawyers, whose headquarters were nearby in the Via del Proconsolo, which is named after their head. In *Inventory*, on the left, notaries are making a list of a family's possessions in a chest in their living room, and in *Marriage*, on the right, they are recording a civil wedding in a country arcade, as they used to do before the Church encouraged marriage ceremonies. These frescoes

Above and right
Ghirlandaio's workshop: *Visiting the Sick* and *Dressing the Naked*, in the Oratory of the Buonomini di San Martino

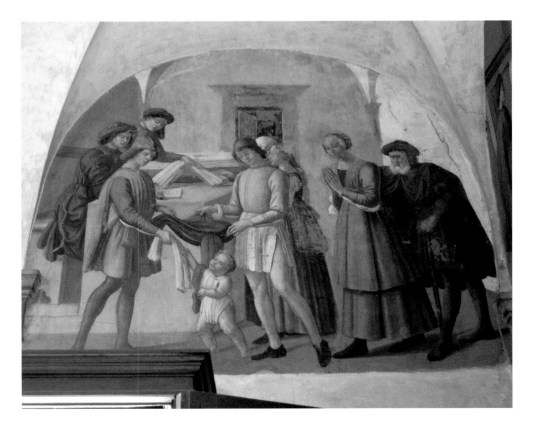

Right
Filippino Lippi:
*The Apparition of the Virgin
to St Bernard*, in the Badia

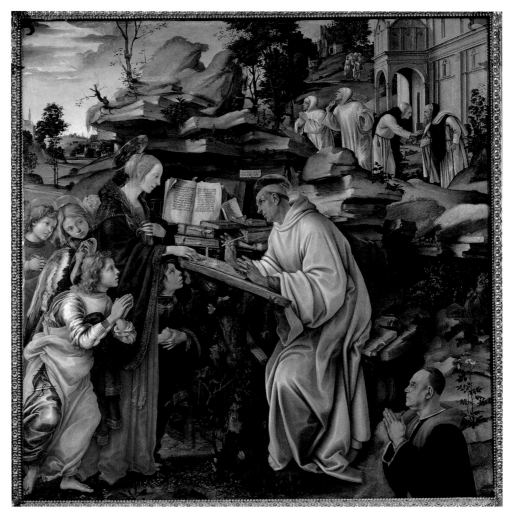

appears in the lower right corner, looking up at St Bernard of Clairvaux, the abbot who reinvigorated the Cistercian order, a fundamentalist branch of the Benedictines. The saint looks up from his writing on a makeshift lectern to gaze at the Virgin Mary, who is no vision floating on the sky, but a modest-looking natural woman surrounded by four shy and curious young angels. Some have speculated that they are portraits of Piero's wife and children. Above Piero's head, almost hidden in a cave, a sinister-looking owl stands beside a demon biting his chains, a reference to a medieval hymn celebrating the Virgin as liberating humanity from the chains of sin. The craggy rocks rise in

a pyramid behind the scholarly saint, forming a natural bookshelf. On a piece of paper pinned to the rock above the saint's head we read Poliziano's translation into Latin of the first-century Greek Stoic philosopher Epictetus's motto, *Substine et Abstine*. Literally meaning 'Sustain and abstain', the words, in tune with St Bernard's teaching, might today best be translated as 'Keep calm and carry on', as do the Cistercian monks, dressed in their white habits, going about their daily business in the background.

St Bernard, who was adopted by the Florentines as another of their patron saints, appears again in a large *sacra conversazione* by Filippino Lippi, the *Madonna*

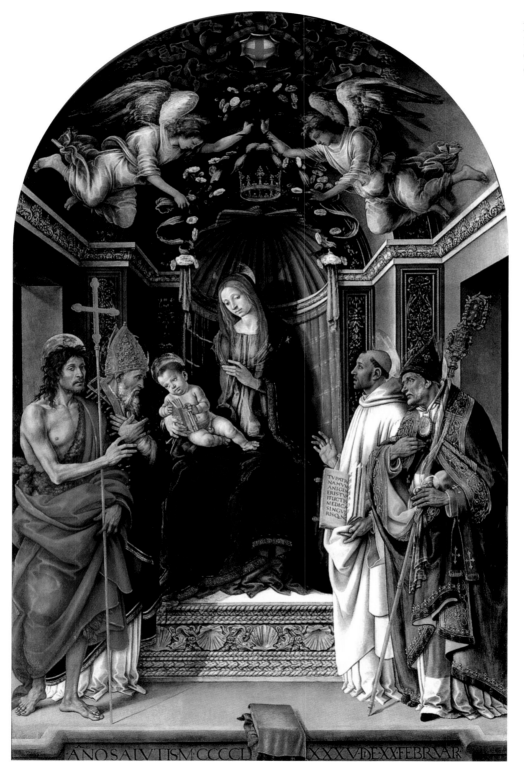

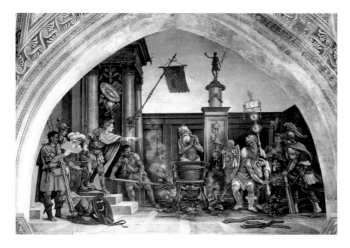

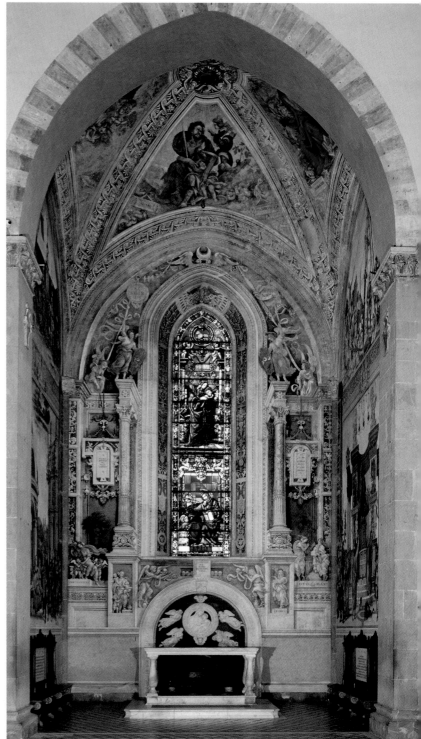

to stoke the fire under the tub. God helped John to escape, so Domitian sent him into exile on the island of Patmos, where he wrote the Book of Revelation.

In the vault of the chapel, Filippino's frescoes show four patriarchs of the Old Testament. Adam, not usually considered a patriarch, but clearly labelled as one, occupies the most prominent position at the back, above the altar. He has been expelled from the Garden of Eden, and is living a life of toil, as he wears a cow-hide cloak and holds a mattock. One of his feet rests on the tail of a serpent with a red-haired female face, wound around the Tree of Knowledge, which offers him another apple. His arms protect one of his sons, who shies away from the serpent in terror. The other cells of the vault show three more familiar figures: Abraham on the right, clasping his sacrificial knife, Noah on the left, and Jacob at the front. These figures were no doubt chosen as their stories foretell Christ's sacrifice and the salvation of mankind, a

theme which is expanded on the rear wall of the chapel.

The frescoes there contain several hints at the Neoplatonic idea that Christianity developed naturally out of pagan antiquity, so in Classical times, despite their pagan origins, the arts were in fact directed at worshipping the same God as in Christian times. Two highly ornamented painted columns appear to stand forward from the wall, their style contrasting with the Gothic lancet window between them. (Its stained glass was designed by Filippino; the Virgin and Child appear in the upper panel, and St John the Evangelist and St Philip in the lower.) The columns carry entablatures projecting forward. Two angels perch on the cornices, their brightly coloured clothing strengthening the illusion that they are standing in front of the wall. The tall pedestals beneath the columns are painted in *grisaille* – shades of grey – so they appear to continue Benedetto da Maiano's sculpted altarpiece below, with relief carvings of the Virtues of Charity and Faith. Between them, in the spandrels above the arch over Filippo Strozzi's tomb, two macabre winged young men step on skulls as they reach forward to add more skulls and bones to those on the central shelf. The inscription 'NI HANC DESPEXERIS VIVES' explains: 'If you do not despise these [the skulls, i.e. death], you will live'. The moral is broadly in line with that of the Last Judgement frescoes in Tommaso Strozzi's chapel round the corner, but expressed much less directly. In the arch above Strozzi's tomb, his symbol of a lamb lying down, signifying humility, indicates that he passed the test.

The figures outside the pedestals are even more novel. On the left, two *putti* play the pan pipes and a curious double flute to a female figure holding a lyre who sits under a palm tree, identified below as Parthenice, a pagan muse who, in Greek myth, lived on a mountain in Arcadia. The inscription on the painted panel above explains that 'The initiates sing to the heavenly gods'. On the right there are two more muses, one holding a mask of Tragedy, the other resting her foot on the mask of Comedy as she plays her lyre. They lean on an altar whose pedestal is inscribed 'DEO MAX[IMO]', 'To the Supreme God'. Again, the inscription in the panel above

explains that 'Hereafter, now we sing to the Supreme God'.

Although the theme of the triumph of Christianity over paganism on the side walls of the chapel appears to be in sympathy with Savonarola's preaching, it may be that it reflects the view that since Christianity had conquered paganism there was nothing to fear from studying Italy's glorious antiquity – an argument first promoted by Boccaccio. Indeed, the theme of the back wall is almost a manifesto of defiance to Savonarola's attacks on what he saw as the infection of the arts with paganism inspired by humanist ideas. Savonarola was adamant that scripture was the sole source of truth, whereas the humanists thought that human reason, as expounded by the Greek philosophers, could also contribute to our understanding of the truth. The choice of subjects and themes in the chapel was probably determined by Filippo Strozzi and specified in his contract before he died, rather than by Filippino. As well as a successful banker, Strozzi was also a humanist, who wrote a critical treatise on Pliny the Elder's *Natural History*, an encyclopaedic summary of first-century knowledge, and underwrote the printing in Venice of a translation of Pliny's book into Italian. Filippo's choice would have been endorsed by his son Alfonso, who paid Filippino for most of his work, and who was one of the Arrabbiati, the 'Enraged', Savonarola's political opponents. The Dominicans of Santa Maria Novella remained loyal to Pope Alexander VI, despite his unashamed venality, when he excommunicated Savonarola, so it would also have been acceptable to them.

Filippino could adapt his style to suit the sympathies of his patrons. Around 1500 he painted a triptych for the now demolished church of San Rufillo on the Piazza dell'Olio of which two pictures, of *St John the Baptist* and *St Mary Magdalene*, are in the Accademia. Their gaunt figures, bleak style and austere colouring suggest that they were commissioned by one of Savonarola's followers, known as the Piagnoni, the 'Weepers' or 'Snivellers'. His earlier *St Jerome*, for the Ferrantini family's chapel in the Badia, and now in the Uffizi, shows how well Filippino could create a

sense of drama and emotion from a painful figure of the penitent saint kneeling before a Crucifix in the wilderness, almost entirely in shades of brown and green.

Of all Filippino's wide range of styles, it is his bright and colourful paintings that are best known. His *Adoration of the Magi* was commissioned by the Augustinian monks of San Donato a Scopeto, a monastery just outside Florence to the south-west, to replace the one they had commissioned from Leonardo da Vinci in 1481, which Leonardo had left unfinished when he went to Milan the next year. Like the Augustinians' other monastery of San Gallo, San Donato a Scopeto was demolished in the siege of 1529, and Filippino's

altarpiece passed through the Medici's collection to the Uffizi, along with Leonardo and Botticelli's versions.

Filippino's *Adoration* is crowded with lively and colourful figures. Once again, the scene is set under the rickety wooden roof of a stable, and the Magi are portraits of members of the Medici family, but of a different branch than in Botticelli's picture. The oldest of the Magi, robed in black and kneeling before the lovely Virgin and her Child, is a portrait of Lorenzo, Cosimo de' Medici's younger brother, who had died as long ago as 1440. Behind him in a golden cloak with ermine sleeves is another posthumous portrait, of Lorenzo's bald-pated son Pierfrancesco who

died in 1476. He clutches an astrolabe, a symbol of the humanists' enthusiasm for scientific enquiry, which would have helped the Magi follow the star to Bethlehem. The young king, in a scarlet robe with a leopard-skin collar, is Pierfrancesco's older son Lorenzo, for whom Botticelli painted his *Primavera* and *Birth of Venus*. The young man in darker red, gazing adoringly as he kneels before the Christ Child, is Pierfrancesco's younger son, Giovanni.

The painting is dated 1496, two years after Piero the Unfortunate and his family had fled from Florence, and halfway through the four years of Savonarola's effective rule. In order to dissociate themselves politically from their cousins, Pierfrancesco's sons Lorenzo and Giovanni had changed their surname to Popolani, 'Popular', which might explain why Lorenzo is allowing his crown to be removed. Behind his brother Giovanni, the character on the right whose gesture seems to introduce us to the Holy Family is Piero del Pugliese, who commissioned Filippino's *Apparition of the Virgin to St Bernard* and may have been involved in brokering Filippino's commission for the *Adoration* from the Augustinian monks and the Popolani brothers. But, given Savonarola's domination of the city, why were the Popolani and their Medici ancestors celebrated in this painting, especially wearing the kind of finery that so outraged Savonarola? The answer is Church politics; Fra Mariano da Genazzano, who Savonarola had replaced as Florence's favourite preacher, was now head of the Augustinian Order in Rome, where he remained opposed to Savonarola's puritanical fundamentalist teaching, and loyal to the Medici family.

Part of the reason it took Filippino so long to complete Filippo Strozzi's chapel in Santa Maria Novella was that he was also painting an altarpiece for the Nerli family's chapel in Santo Spirito, the second chapel in the right transept. The Nerli were a long-established noble Florentine family, originally lords of the hilly area south-west of Florence, who settled in the parish of San Frediano in the Oltrarno, near the present Piazza dei Nerli. The majority of the family were Guelphs; the Ghibelline branch had been exiled after

1266, some moving to France. Those who returned had to change their name to della Piazza, taking it from the Borgo di Piazza, the former name of Via Guicciardini, which runs from the Ponte Vecchio to the Palazzo Pitti, where they lived and where the remains of their home, the Torre dei Nerli, reconstructed after being blown up by the retreating Germans in 1944, can be seen. Tanai de' Nerli, the donor of the painting, had been born in Avignon and when he came to live in Florence he continued to trade with France, as well as serving as Gonfaloniere di Giustizia. He was a bitter enemy of Savonarola, so much so that he punished the bell of the monastery of San Marco for warning Savonarola's followers of his arrest, by having it whipped in procession through the streets and taken up to the church of San Salvatore al Monte, where it was never rung again, and where Tanai de' Nerli himself is buried in another of his family's chapels.

In the centre of the altarpiece, the Madonna sits holding on her lap the infant Jesus, who reaches to touch a cross held by his young cousin, St John the Baptist. She is flanked by St Martin of Tours, identifiable by his bishop's mitre and by his name painted on his shoulder strap, who was chosen for his French connection, and by St Catherine of Alexandria, who stands by a broken section of a particularly vicious-looking wheel, and had long been a patron saint of the Nerli family. In front of them are Tanai de' Nerli and his wife Giovanna, or Nanna, Capponi, who holds a rosary as she prays. They also appear in the background: a small figure wearing a scarlet woollen cloak, Tanai is leaving on a trip to France. Outside his grand palazzo near one of the city's gates, he bends to hug his daughter, who stands in front of his wife, while a groom holds his horse for him.

The Roman-style decorative details of the scene include an incongruous goat's head on the leg of the Madonna's throne. The cherub above her head holds a dove, symbol of the Holy Spirit, while those on either side hold small shields emblazoned with the Nerli's red-and-white-striped coat of arms. Remarkably, the altarpiece is still in the place for which it was made. Both the painting and its original magnificently carved and gilded frame are masterpieces of their kind.

Above
Filippino Lippi: the Nerli
Altarpiece, in Santo Spirito

While Filippino Lippi adapted his style to suit the
attitudes of his patrons, Botticelli became increasingly
religious towards the end of his life, and a committed
member of the Piagnoni. According to Vasari, Botticelli's
support for Savonarola's ideas led him to abandon
painting, and he fell into poverty, and if it hadn't been
for the support of Lorenzo the Magnificent and his other

cherubim and seraphim above and by a troupe of youthful angels who hold hands as they scatter flowers and dance in a circle around them. Down on earth below, four saints stand in front of a watery landscape. On the left St John the Evangelist, sporting a long grey beard, holds his Gospel in one hand and gestures to the scene above with the other. Next to him, St Augustine makes a note in his book, and St Jerome looks anxiously up to heaven. At the right, St Eligius, carrying his crozier and wearing his bishop's mitre, blesses us with his gesture.

The saints reappear again in the small predella panels beneath the main picture, on either side of a cramped Annunciation scene. St John sits on the island of Patmos, St Augustine in his cell, and St Jerome kneels in penance on a rock. The Goldsmiths' patron, St Eligius, is treated to a more elaborate scene. He is shown nailing a shoe onto the hoof of a horse's leg which he has cut off from a horse possessed by devils, which a groom is struggling to control. The story is that Eligius later reattached the horse's leg while making the sign of the cross. A young woman with horns watches him as he works. She represents the Devil: Botticelli's attitude to women, as well to painting, may have been influenced by Savonarola.

He did paint again after Lorenzo the Magnificent and Savonarola had both died, but gloom replaced the joy of his earlier works. The strong contrasts and dramatic tension of his *Calumny of Apelles*, in the Uffizi, painted around 1495, reflect this change. An allegory, the composition is based on the description by the Greek writer Lucian of a work by a fourth-century BC Greek painter called Apelles, who painted the lost original as a response to a rival artist

patrons, he would have starved to death.

One of Botticelli's finest works from this period is his *Coronation of the Virgin* in the Uffizi, also known as the San Marco Altarpiece, as it was commissioned in 1488 by the Goldsmiths' Guild for their chapel in San Marco. The chapel was dedicated to St Eligius, the Frankish blacksmith turned bishop whose statue by Nanni di Banco we saw at Orsanmichele. The composition of Botticelli's *Coronation of the Virgin* revives several ideas from a hundred years before, showing both heaven and earth in one picture. In the upper half, God the Father sits on a carpet of clouds as he leans forward to place the crown on the head of a very humble-looking Virgin. They are framed by an arch of

who had falsely accused him of conspiring against Ptolemy IV of Egypt. It shows the near-naked innocent victim praying for justice as he is dragged by his hair by a beautiful young woman in blue and white, who represents Calumny, or Slander. She holds a flaming torch, a symbol of her lies. Perfidy, a young woman in red and yellow, encourages Calumny with flowers, while another, Fraud, arranges her hair, and a grim bearded figure in black representing Rancour helps her forward. Calumny drags the victim towards the legendary Phrygian King Midas, dressed as a judge, who stretches forward to her as he sits on his throne. Midas is flanked by figures representing Ignorance and Suspicion; they whisper into his donkey's ears, inflicted by Apollo as a punishment for Midas's decision to favour the satyr Marsyas in preference to Apollo in a musical competition.

There is no chance of justice for Calumny's victim.

At the other side of the painting, the nude figure of Truth, who reminds us of Botticelli's Venus, points to heaven, where justice should be found. Naked, like the victim, she has nothing to hide. An anguished old woman representing Repentance turns to look at her, dressed in a tattered black robe of the Dominican order. The violent movements of the figures, except the beautiful Truth, reflect the bitter politics of the time and, in the figure of Repentance, Botticelli's sympathy with Savonarola. All this takes place in an elaborate throne room, every surface filled with statues or reliefs of biblical or Classical subjects, suggesting that, despite his continuing interest in ancient Greek art, Botticelli thought that the humanists' fusion of Christian and Classical ideas created a setting in which calumny could succeed.

When Vasari saw the picture, it was owned by Fabio Segni, who had inherited it from his father Antonio, a very close friend of Botticelli's, who had given him the painting. Fabio had put a Latin inscription under the painting, which Vasari translated as:

> This little picture warns rulers of the earth
> To avoid the tyranny of false judgement.
> Apelles gave a similar one to the King of Egypt;
> That ruler was worthy of the gift, and it of him.

Politics had invaded art. Vasari's verdict on the picture was that it 'is as beautiful as anything possibly can be'. It is beautiful, but had he forgotten the *Birth of Venus*?

Botticelli produced many paintings in the last years of the fifteenth century, almost all on religious subjects, which have been dispersed around the world. Of the few that remain in Florence, the *Madonna and Child and the young St John the Baptist*, in the Palatine Gallery at the Pitti Palace, is surprisingly sentimental. It shows the Madonna with a very solemn look on her face bending down to hand her child into the embrace of the very young Baptist, who wears his camel-skin coat despite being only a boy. Their faces are even more solemn and much sadder than those in Botticelli's earlier Madonnas.

Another example of how Savonarola's influence affected Botticelli's style is his second version of *St Augustine in his Study*, painted sometime in the 1490s, perhaps for the Augustinians of Santo Spirito, and now in the Uffizi. Much darker and more austere than his earlier version in the Ognissanti, it shows St Augustine writing behind a curtain drawn back across the front of a small barrel-vaulted chapel, reminiscent of Masaccio's *Holy Trinity* in design, but in gloomy shades of grey. There are

Left
Botticelli: *Adoration of the Magi*
(Uffizi)

Right, below
Perugino: *Pietà* (Uffizi)

no ornaments or mischievous messages around the study, just scraps of paper on the floor below his desk.

Botticelli's final version of the *Adoration of the Magi*, painted around 1500, is in the Uffizi. The differences from his earlier version are striking: there are no identifiable portraits among the many faces of the Magi and their entourage. Their clothes are much plainer, and the crowds coming to hail the newborn Jesus are vast. But as before, the Holy Family are sheltering in the ruins of a collapsed temple: the old order has gone.

One artist whose clear and simple style, uncluttered with Classical or other decorations but full of sentimental piety, enabled him to flourish in Florence in the years when Savonarola's edicts on art determined the content of religious paintings, was Pietro Perugino. He was not a Florentine, being born in Citta del Pieve, near Perugia, hence his name, the 'Perugian', but he came to Florence to learn to paint. Vasari says he was born into a poor family, and his first job was as an errand-boy for a local painter, who inspired him to study painting by telling him how much money a good painter could make, and encouraged him to move to Florence because it produced the best artists. He started as an apprentice in Verrochio's workshop in the 1470s, and became a hard-working and prolific painter. Almost all his paintings are on religious subjects, although he wasn't particularly devout himself. Vasari says he was motivated by fear of poverty; indeed, he would do anything for money. His fame and his works spread throughout Italy; he returned to work in Perugia, and then was called by Pope Sixtus IV to work in the Sistine Chapel in Rome, where he made 'an enormous amount of money'. He came back

to Florence in 1489 and in 1493 married Chiara Fancelli, daughter of Luca Fancelli, the architect who designed the core of the Pitti Palace. She became his model for the Madonna; he painted her many times, always wearing the same red dress, often with a black band across its square neckline, under her dark blue cloak.

Perugino worked mainly in Florence until 1499, where some of his best works remain. He was commissioned by the Gesuati friars of San Giusto alle Mura, just outside the northern walls of the city, to paint a *Pietà* for their church, as well as a *Crucifixion* and *Agony in the Garden*. The monastery and its church were destroyed in the siege of 1529, along with Perugino's frescoes on its walls, but all three panels survived and are today in the Uffizi. In the *Pietà*, Christ's pale body, stiffened by death, lies across Mary's knees. His grieving mother has a bleak look on her face, which is not Chiara Fancelli's, nor are her clothes. Perhaps Perugino did the painting before he married her. A red-eyed St John the Evangelist supports Christ's head, and a weeping St Mary Magdalene his feet. Behind them stand the sad-faced figures of Nicodemus and Joseph of Arimathea, the two men who buried Jesus. Nicodemus, the young man on the

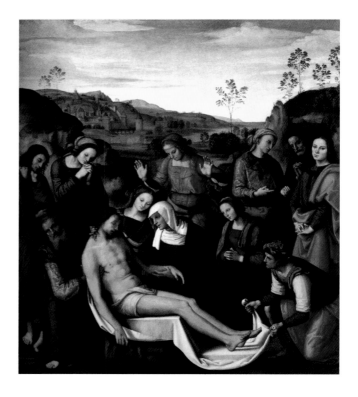

left, clasps his hands as he gazes upwards, in a pose that was to be frequently repeated in pictures of saints in the next century. As in many of Perugino's pictures, the composition is strongly symmetrical, set beneath a stately row of grand but plain arches that open to a simple landscape and pale sky, providing a serene atmosphere and strong contrast to Mary's dark outline. This is the kind of painting Savonarola approved of, barely decorated, sober, and deeply spiritual.

Also in the Uffizi is Perugino's portrait of Francesco delle Opere, a wealthy Florentine gem cutter who was the brother of one is his friends. He was a Piagnone, and has a very stern expression on his face, reinforced by his severe black beret. He holds a roll of paper with the words 'TIMETE DEUM', 'Fear God', taken from one of Savonarola's sermons. Despite Francesco's religious views, Perugino put a detailed Flemish-style landscape in the background, with a pale blue sky to provide a contrast to Francesco's frizzy brown hair. The Flemish style is perhaps no surprise, as the idea of painting panel portraits

of ordinary people, rather than introducing them into principally religious works, seems to have been imported to Italy from Flemish art.

A beautiful and even more detailed landscape, of a fortified city beside a lake, appears behind the carefully organised group of figures in Perugino's *Mourning of the Dead Christ*. It was painted in 1495 for the nuns of the convent of Santa Chiara, then on the southern edge of the city on Via dei Serragli, for the high altar of their church, and is today in the Palatine Gallery. Joseph of Arimathea and Nicodemus appear again too, at Christ's head and feet, holding the white shroud on which his dead body lies, and St Mary Magdalene, identifiable by her scarlet dress. The rich colours, careful details, and expressive characters of the painting have led it to be considered Perugino's masterpiece: indeed, Vasari tells how Francesco del Pugliese offered to buy the picture from the nuns for three times what they had paid for it, and to have Perugino paint them another, but they refused, as Perugino said he didn't

believe he could do another equal to it.

Another candidate for the accolade of Perugino's best painting in Florence is the *Crucifixion* that he frescoed on the wall of the chapter house of the Cistercian convent of Santa Maria Maddalena dei Pazzi. The recent reconstruction of the chapter house to Giuliano da Sangallo's designs had been paid for by Bartolommeo Scala, but Perugino's fresco was commissioned by Dionigi and Giovanna Pucci, from a wealthy merchant family. The three arched sections of the fresco are unified by the continuous landscape of a stream flowing through gentle hills and leafy trees. The crucified Christ dominates the composition from the top of the central arch, outlined against a pale dawn sky; at the foot of the cross kneels St Mary Magdalene, the patron of the convent which was founded for penitent former prostitutes, in a scarlet cloak. In the left arch are the Virgin, in an unusual purple cloak, and St Bernard, the founder of the Cistercians, while on the right are St John the Baptist, gazing heavenward in Perugino's favourite pose, and St

Benedict, from whose Order the Cistercians originated.

Perugino may not have been one of Florence's greatest painters – indeed Vasari was very critical of him for repeating figures and details and giving many of his faces the same expression – but his acceptance of Savonarola's views on art, suppressing the attitudes and insights of the humanists, was a key part of his influential artistic legacy. He trained many artists in his workshops in Florence and Perugia, including the young Raphael, who became one of the most important artists of the next century. Raffaello Sanzio, to give him his full name, was born in 1483 in Urbino, where his father was court painter to Duke Federico da Montefeltro, whose portrait by Piero della Francesca we saw in the Uffizi. He was only eleven when his father died, but he learned to paint, and by 1500 he was fully trained and working as an assistant to Perugino. By the time Raphael came to Florence in 1504, Savonarola's influence had waned, and art was enjoying a period of reinvigoration known as the High Renaissance.

At the same time as Michelangelo was completing his *David*, Andrea Sansovino, who had returned to Florence from Portugal in 1500, was working on his masterpiece, the sculpture of the Baptism of Christ, commissioned to stand over the eastern entrance to the Baptistery. Sansovino's two marble statues of St John the Baptist calmly pouring a scoop of water from the river Jordan over the dignified figure of Christ, wearing only a loincloth, are now in the Cathedral Museum. Sansovino was not able to finish them, as Pope Julius II invited him to Rome, where he created some magnificent tombs; they were completed much later by Vincenzo Danti, a sculptor from Perugia. Danti also created a group of three bronze statues representing the Beheading of St John the Baptist, installed above the southern entrance to the Baptistery in 1571, and also now in the Cathedral Museum. An angel was added to Sansovino's figures by Innocenzo Spinazzi in 1792, and copies of the trio stand on a ledge above the Gates of Paradise.

interpreted *David* politically, illustrating the Florentine Republic's readiness to defend its liberty, as expressed by his furrowed brow, the taut tendons of his neck, and the tension that the *contrapposto* pose gives to his body. It may just be coincidence that David's anxious gaze over his left shoulder looks down the length of the courtyard of the Uffizi towards Rome, where the leading members of the Medici family, seen as enemies of the Republic, were then living. The original was removed to the Accademia in 1873 to protect it from damage, and replaced by a replica.

The Arte della Lana were impressed by Michelangelo's *David*; even before it was finished, they had given him a contract to carve sculptures of the twelve Apostles for the Duomo. However, Michelangelo only produced the unfinished *St Matthew*, whose twisting figure emerges from a block of marble in the Accademia, before he was invited back to Rome in 1505 by Pope Julius II, who commissioned him to create his enormous tomb.

Savonarola may have wished the walls of the Hall of the Five Hundred in the Palazzo Vecchio to be blank, but Soderini, as Gonfaloniere, was keen to restore Florence's reputation for artistic leadership. He commissioned Leonardo da Vinci, who had returned from Milan in 1499, and Michelangelo to decorate the Hall with scenes celebrating its military victories. Leonardo worked on a fresco of a furious clash between warhorses in the Battle of Anghiari, at which the forces of the Italian League, led by Florence, had defeated Milan in 1440. When painting his *Last Supper* in Milan, Leonardo had problems with painting in fresco, so here he experimented with mixing wax in his paints, but the paint on the upper parts of the walls took too long to dry. Leonardo had wood-burning braziers set up to dry the paint, but the heat melted the wax and the paints faded and mingled together, so he abandoned his *Battle of Anghiari*. The unfinished painting was lost in the course of Vasari's extension of the Hall in 1555–72, and is known to us now from Leonardo's preparatory sketches, known as 'cartoons' – from *cartone*, the thick paper they were drawn on – and a drawing by Peter Paul Rubens, copied from an engraving.

Michelangelo's commission was to paint the opposite wall of the Hall with a huge fresco of the Battle of Cascina, another victory for Florence on a hot summer's day in July 1363 over the forces of Pisa, led at that time by Sir John Hawkwood, whose memorial by Paolo Uccello we saw in the Duomo. Cascina was a fortified stronghold on the banks of the Arno, a few miles upriver from Pisa. Hawkwood hoped to ambush the Florentine forces who had stopped to bathe in the river because of the heat, but was defeated

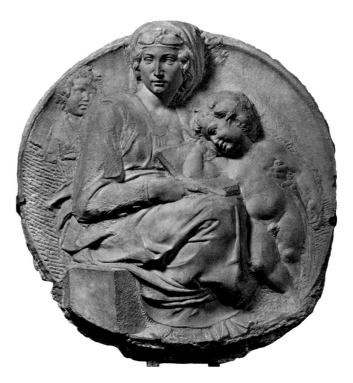

when he lost the advantage of surprise and his troops grew too hot in their armour. Michelangelo never painted his *Battle of Cascina*, because of Pope Julius's invitation to Rome, but surviving copies of his preparatory cartoons show that he planned a scene where, in response to an alarm call, the naked Florentine troops scramble out of the river and anxiously race to pull on their clothes, providing him with an opportunity to paint his favourite subject, male nudes in a variety of animated poses. His cartoons for the *Battle of Cascina* and Leonardo's for the *Battle of Anghiari* were much admired and studied by future generations of artists.

Before he went back to Rome in 1505, Michelangelo completed some smaller commissions for Florentine patrons. He carved a round marble tondo known as the *Pitti Tondo* for Bartolomeo Pitti (now in the Bargello). It shows the Madonna and Child, with St John the Baptist in low relief behind her shoulder. In this unusual composition, Mary sits on a square block, as she does in the *Madonna of the Stairs*, and holds an open book on her lap, on which her smiling baby rests his arm as he reads. Her head is

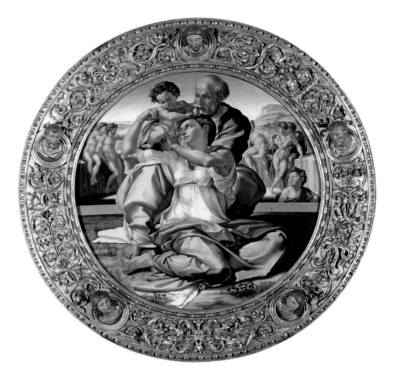

carved in high relief so it stands forward of the frame of the tondo, and is turned away from her son. She has a sad gaze, and the young Baptist a grimace; perhaps they know what the prophecies that Jesus is reading foretell. Parts of the background, and to a lesser extent the dress on Mary's right arm and shoulder, appear unfinished; the rough chisel marks have not been polished over and create a pattern of light and shade. This effect appears in many of Michelangelo's sculptures, so it was probably done deliberately, to create visual interest. He used the same technique in another beautiful tondo, featuring the same biblical trio, for the wool merchant Taddeo Taddei, now in the Royal Academy in London.

Michelangelo also painted a tondo of the Holy Family probably in 1507 for Agnolo Doni, a wealthy self-made banker, perhaps to celebrate Agnolo's marriage to Maddalena Strozzi in 1504, or the baptism of their first child, Maria, three years later. Agnolo and Maddalena lived in the huge Palazzo Doni, which they built on the corner of Corso dei Tintori ('Dyers Street') and Via Antonio Magliabechi that runs south from Santa Croce, where Michelangelo's tondo hung in their bedchamber.

The extraordinary *Doni Tondo*, which now hangs in the Uffizi, is Michelangelo's only surviving finished panel painting. It still has its amazing original frame, perhaps carved to Michelangelo's design, with five protruding heads like the ones on Ghiberti's Gates of Paradise which he so admired. The central head at the top of the frame is Christ; below him are a pair of prophets and two sibyls. Between them, the lions' heads of the Doni family's arms and the crescent moons of the Strozzi are entwined with a mass of exotic plants. In the picture, the brightly coloured and strongly lit central group of the holy family looks like a painted sculpture, their pronounced muscles and smooth skin glowing like polished marble. The composition is unusual: Joseph crouches behind Mary, instead of kneeling at her feet, and helps her balance Jesus on her shoulder, rather than on her knee. Mary, who has a book on her lap, twists backwards to look up at her son. She reaches for him with rather masculine muscular arms, which suggest that Michelangelo drew her from a male model.

The background is even more unusual: the smiling face of the infant St John the Baptist appears over a parapet on the right, and behind him a couple of nearly naked youths sit on a low wall tugging at each other's robes, behind another young man standing in front of the wall with no clothes on. Two more youths have undressed on the other side. What are these characters doing here? They may symbolise the pagan past, when love was physical, being displaced by the spiritual love introduced by the holy family. Or they may refer to Michelangelo's repressed love

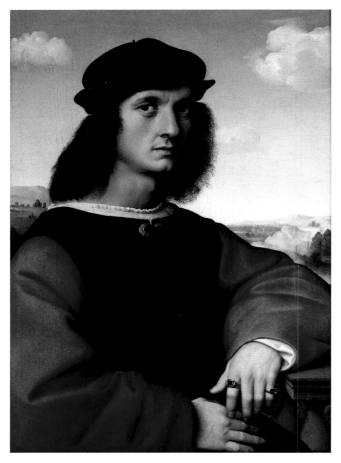

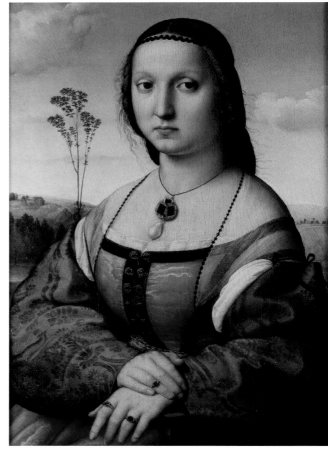

of men, or to his love of Classical Roman art. The man who sits just behind Joseph, pulling his mate's cloak, has a pose very similar to the main figure in the first-century marble sculpture of *Laocoön* that was unearthed in a vineyard near the Domus Aurea in Rome in 1506. When Pope Julius II, who acquired the sculpture, heard of the discovery, he sent Michelangelo to inspect it for him. The life-size original, which may itself be a copy of an even earlier bronze sculpture, is now in the Vatican Museum. It shows the Trojan priest Laocoön and his two sons wrestling with sea serpents, sent as a punishment by the goddess Athena for having attacked the Trojan Horse. The tension and energy in the muscular figures had a big influence on Italian art, in particular on Michelangelo's sculpture.

Agnolo Doni also commissioned two beautiful portraits of himself and his wife to celebrate their marriage, from Raphael, who had moved to Florence in 1504. Both the portraits painted around 1506, in the Palatine Gallery, use his teacher Perugino's ploy of setting the sitters against a pale sky, to provide a sharp outline and a steady light on their faces. We have to hope that the marriage was a success; Agnolo Doni looks worried about his next business deal, and Maddalena Doni rather sad, despite her silks and jewels. Her hands are placed one on top of the other, to show off her rings, in a gesture very similar to that of the *Mona Lisa* by Leonardo da Vinci, whose work Raphael admired and studied. However, Raphael in both portraits still followed the traditional Florentine style of

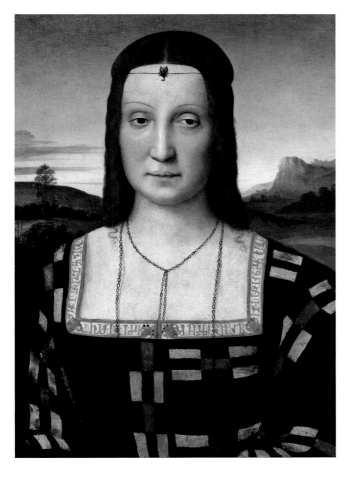

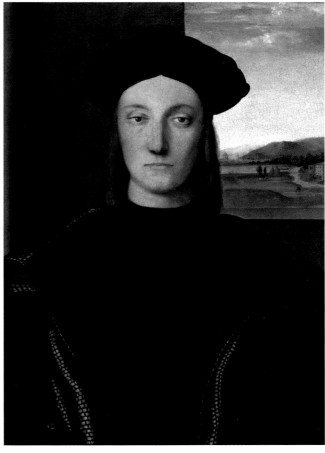

Left
Raphael: *Agnolo Doni* and
Maddalena Doni (Palatine
Gallery)

Above
Raphael: *Elisabetta Gonzaga*
and *Guidobaldo da Montrefeltro*
(Uffizi)

sharp outlines and clear forms, rather than the softened smoky shapes of Leonardo's *sfumato*, 'shady' technique.

Raphael's earliest works in Urbino, where he was born and learned to paint, were almost all of religious subjects, but he was also in demand as a painter of portraits. Two of the earliest portraits attributed to him are in the Uffizi, of *Elisabetta Gonzaga* and of her husband, *Guidobaldo da Montefeltro*, who succeeded his father Federico as Duke of Urbino. Elisabetta was the well educated daughter of Federico I, Marquis of Mantua, and she and Guidobaldo ran a very cultured court in Urbino, attracting artists, writers and scholars. They had been married for fifteen years or more by the time Raphael painted their portraits, but judging by the expressions on their long pale faces, it

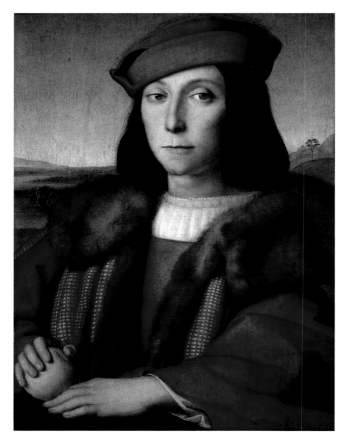 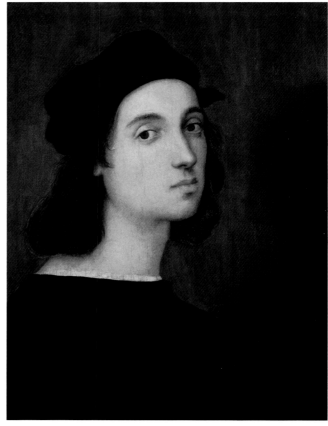

may not have been a happy marriage. While Guidobaldo looks glum, perhaps because he was sterile and they had no children, Elisabetta looks positively mournful. Both are dressed in luxurious fabrics in the Montefeltro family's colours of black and gold. Elisabetta has a fashionable hairstyle, with a centre parting and long straight braids, and a square neckline on her dress, but also has a small ornamental scorpion tied on her tall forehead, perhaps to ward off evil spirits.

As he had no heir, Guidobaldo adopted his nephew, Francesco Maria della Rovere – whose father Giovanni, nephew of Pope Sixtus IV and brother of Pope Julius II, had died when Francesco was only eleven – and appointed him as successor to his dukedom. Francesco Maria appears in another painting attributed to Raphael in the Uffizi, known as the *Portrait of a Young Man with an Apple*, painted

when Francesco Maria was about fifteen. He is dressed like a prince in a crimson cap and cloak, with a collar and lining of sable fur, and holds a golden apple on the balustrade at the base of the painting, hinting at his having been chosen for a golden future. Despite his good fortune, his thin-lipped expression is solemn, and he gazes slightly to the right, shyly looking past us.

The luxury of Francesco Maria's outfit contrasts with the plain black cap and clothing that Raphael wears in the contemporary *Self-portrait* attributed to him, in the same room in the Uffizi. The talented painter in his early twenties turns his soulful face to look directly at us. There is no landscape in the background, just a brown wash with a soft shadow. Raphael took this innovation a step further in his portrait of a woman known as *La Donna Gravida*, 'The Pregnant Woman', in the Palatine Gallery. Here, the

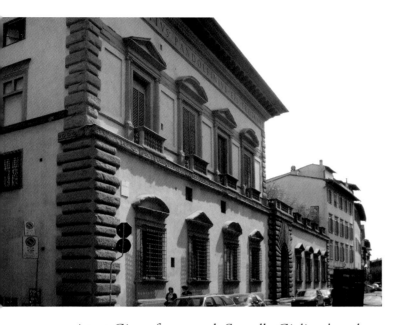

with the words 'IANNOCTIUS PANDOLFINIUS EPS TROIANUS', 'Giannozzo Pandolfini, Bishop of Troia', in such large letters that they stretch the whole width of the house. The inscription continues on the side wall, thanking Leo X and Clement VII, the two Medici Popes, for their gifts to himself and his uncle. This extraordinary advertisement points to how senior members of clergy were increasingly using patronage of the arts for dangerous self-aggrandisement.

Raphael was both a painter and an architect, but Michelangelo is the classic example of a Renaissance universal artist. He thought of himself primarily as a sculptor, but as well as a painter he was also a poet and an architect. His first architectural project came in 1507, when he was invited by the Works Committee of the Cathedral to submit a model for the completion of the external faces of the drum of the dome. His proposal, of a series of rectangles of green Prato marble, topped by a massive cornice, was designed to harmonise with the existing decorative patterns on the lower parts of the walls. However, the project was awarded to Baccio d'Agnolo, who designed a white marble arcade topped by a balcony, above a frieze of huge swags. At first sight it is surprising that only one section, on the south-eastern face of the drum, was completed, considering the resources that have been devoted to the beautification of the Duomo over the centuries. However, it was left unfinished in 1515 because of public disapproval following Michelangelo's scathing criticism of it as 'cages for crickets', leaving the other faces bare to this day.

Baccio had started his career as a woodcarver in his father's workshop in Florence, and he was an excellent craftsman, as his choir stalls in the Tornabuoni Chapel at Santa Maria Novella demonstrate, and he had also gone to Rome to study architecture. After work stopped on the drum of the Duomo he had other projects to work on, including the intricate designs for the multicoloured inlaid marble floor of the Duomo and the construction of the Chapel of the Priors in the Palazzo Vecchio. Piero Soderini appointed Baccio in 1511 to build this

assistant, Giovanfrancesco da Sangallo, Giuliano's nephew, who worked on the project until he was killed in 1530 in the siege of Florence, when his brother Bastiano took over. Raphael brought something of the grace and balance of his paintings into his architecture. The design of the façade was radically new and Roman; only two storeys high and four window bays wide, it is relatively small by comparison with many of the other palazzi we have seen, but dignified and symmetrical with harmonious proportions. It doesn't pretend to be a fortress like the palazzi of the previous century: the rustication is confined to the corners and around the massive doorway to the garden. The windows are rectangular rather than arched, and are framed by aedicules, 'little buildings', with Doric pilasters on the ground floor and Ionic half-columns on the first, topped by alternating triangular and segmental pediments. In a pleasant domestic touch, the first floor windows have little balconies with balustrades. Giannozzo Pandolfini died in 1525, before the building was finished, and was buried in his family's chapel in the Badia, as later was his nephew Ferdinando, who had taken over as Bishop of Troia in 1522, and who inherited the palazzo. It was probably Ferdinando's idea to inscribe the frieze below the cornice

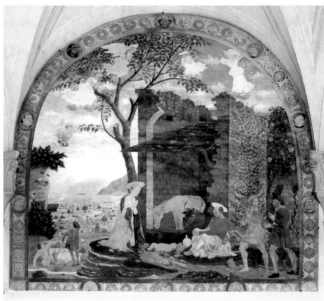

small chapel, dedicated to St Bernard, next to the Sala dell'Udienza on the second floor of the Palazzo. The location makes the chapel rather dark, as it is lit only by two small windows in the end wall of the cramped chancel around the altar. The chancel and the main part of the chapel both have simple low barrel vaults, lavishly decorated soon after they were built, by Ridolfo del Ghirlandaio, Domenico Ghirlandaio's son.

In 1509 the Servite friars of Santissima Annunziata initiated one of the few large artistic projects in the years of the Republic. They employed several painters, under the leadership of Andrea del Sarto, to finish the frescoes on the walls of Michelozzo's atrium in front of their church. The first fresco in the Chiostrino dei Voti, the *Adoration of*

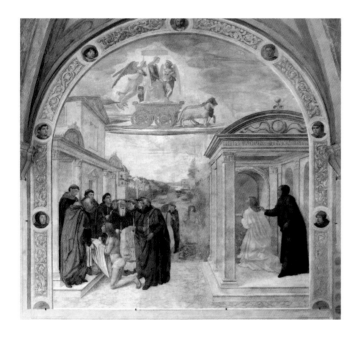

the *Shepherds*, to the left of the entrance to the church, had
been painted by Alesso Baldovinetti in 1460. Baldovinetti
filled the fresco with fresh colours and bright winter light,
paying as much attention to the details of the beautiful
background landscape of the Arno valley as to the figures,
some of which unfortunately he painted *a secco*, on dry
plaster. Like all the frescoes in the atrium it has suffered
from damp, so the colours of the Madonna and her Child,
the donkey in the stall behind and four angels in the sky
above have fallen off.

The next fresco in the atrium, of the *Vocation of St
Filippo Benizzi*, round the corner from the window to
the left of the *Adoration of the Shepherds*, was painted by
Cosimo Rosselli in 1476. Filippo Benizzi was born in the

Oltrarno in 1233, the year that the Servites were founded.
He became Superior General of the Order in 1267, and
successfully defended it against Pope Innocent V's attempt
to suppress it. Rosselli's painting shows Filippo as a young
man kneeling on the right in a small chapel reminiscent
of Michelozzo's Chapel of the Crucifix at San Miniato al
Monte. He looks up to heaven, where he sees a vision of
the Virgin Mary being drawn on a heavy four-wheeled
cart in the sky, pulled by a sheep and a pony. He appears
again kneeling on the left where he is given his robes by
the Servite monks. His vision of the Virgin in the sky has
been interpreted as the triumph of Chastity. It may have
been Savonarola's inspiration for the description in his
Triumphus Crucis, 'The Triumph of the Cross', written the
year before his execution, of his vision of Christ standing
triumphally, crowned with thorns and with many wounds,
in a four-wheeled cart.

Andrea del Sarto was, as his name says, the son of a
tailor. His first apprenticeship, when he was only seven
years old, was to a goldsmith, but his talent for drawing
was soon recognised and he was apprenticed to Piero di
Cosimo, from whom he learnt to paint. He soon established
a reputation for himself, and he and his friend, another
painter known by his nickname as Franciabigio, left their
masters and set up a workshop together on the Piazza
del Grano behind the Palazzo Vecchio. Fra Mariano dal
Canto, the Sacristan in charge of the decoration of the
atrium at Santissima Annunziata, heard people praising
Andrea del Sarto's proficiency as a painter, and persuaded
him to work for free, saying that as the church was visited
by foreign pilgrims as well as by Florentines, he should
pray to be given this opportunity to spread his reputation
abroad, and that if he wouldn't agree to this, Franciabigio
was willing to do so.

Andrea's commission was to add five more scenes of
miracles performed by St Filippo Benizzi, continuing round
the left wall of the atrium. The first scene shows *St Philip
healing a Leper*, by handing him an undergarment, on a rocky
hillside. Then, in the wall, there is a monument to Andrea

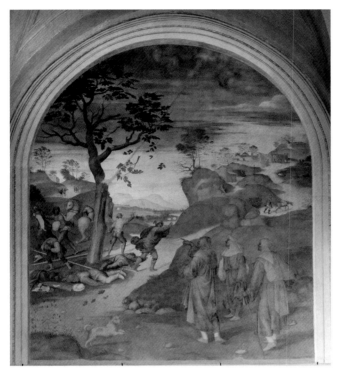
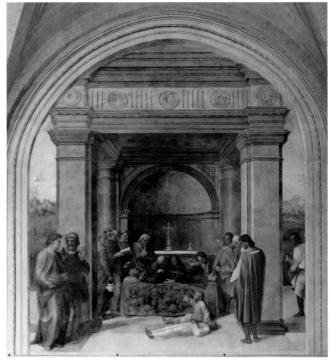

del Sarto with a marble bust by Giovanni Battista Caccini. The next scene to the left of the monument, the *Punishment of Blasphemers*, is also set in a fantastic mountain landscape: St Philip summons a bolt of lightning from a dark stormy sky to strike a tree under which the blaspheming gamblers were sheltering. The *Liberation of the Possessed Woman* also takes place in a dark setting, in front of a triumphal arch. St Philip blesses the woman to free her of the demon which escapes through the arch behind her collapsing body. In the next scene round the corner, the *Death of St Philip Benizzi and Resurrection of a Child*, even though the saint is dead and lying on a bier in a niche under a grand arch he revives a child, who appears twice, lying down dead and restored to life sitting up to wave his hand thankfully to St Philip. In the final scene, the *Devotion of the Florentines to the Relics of St Philip*, also set in front of an imposing arched chapel, a priest stands before the altar presenting a casket containing St Philip's relics to the families gathering on the steps below in hope of a miraculous cure.

Above
Andrea del Sarto: *Punishment of Blasphemers*, and *Death of St Philip*, in the atrium of Santissima Annunziata

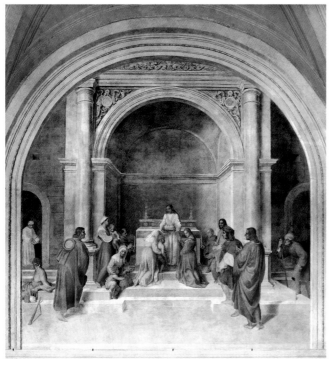

Left

Andrea del Sarto: *Devotion of the Florentines to the relics of St Philip*, and *Journey of the Magi*, in the atrium of Santissima Annunziata

Andrea del Sarto completed these five frescoes by 1510. By then he'd had enough of working for free at Santissima Annunziata, but Fra Mariano insisted that he continue and agreed to increase his pay. The next year he painted another fresco, the *Journey of the Magi*, to the right of the entrance to the church. It is unusual in several ways: the Magi are dressed in pale gold and salmon pink; they are visiting Herod's palace on their way to Bethlehem, rather than arriving at the stable; and the composition is dominated as much by the windswept trees and cloudy sky as by the figures in the foreground.

In 1513, Pope Leo X indicated that he would visit Santissima Annunziata and grant the church the status of a perpetual Jubilee, granting pilgrims remission of their sins, so the Servite friars wanted the decoration of the atrium to be completed rapidly. Andrea was then commissioned to start a series of scenes from the life of the Virgin. The first of these, round the corner to the right of the *Journey of the Magi*, is the *Birth of the Virgin*. It appears to be closely modelled on Ghirlandaio's version in the Tornabuoni Chapel, but with a huge canopy over the bed, on which cherubs are frolicking, and more natural and less formal characters. As in Ghirlandaio's version, the baby Mary is about to be given a bath in a bowl in front of the fireplace, which is signed with the inscription 'ANDREAS FACIEBAT', 'Andrew made this', 1514.

Despite the increase in his pay that he had negotiated, Andrea was still not satisfied and wanted to renounce his contract, so Fra Mariano allowed him to recruit assistants to finish the work. The next scene to the right, the *Marriage of the Virgin*, was painted by Franciabigio. He

Left
Pontormo: *Visitation*, in the
atrium of Santissima Annunziata

near Empoli where he was born. He was brought up there by his grandmother, as his father, Bartolomeo Carucci, a painter who had worked in Ghirlandaio's workshop, died when he was only five years old, and his mother when he was ten. After apprenticeships with Leonardo da Vinci and Piero di Cosimo, he had joined Andrea del Sarto's workshop in 1512, but the inspiration for Pontormo's composition seems to have come from Fra Bartolomeo's *Mystic Marriage of St Catherine of Siena*. Elizabeth kneels to greet Mary on the steps in front of a large curved portico. A *putto* sits on the steps below them, and two more pose on the cornice above the portico. Between them a bearded old man holds a knife above the neck of a young man kneeling before him. Abraham's sacrifice of Isaac is a reminder of the fate awaiting Mary's child, a disconcerting contrast to the cheerful greetings of the cousins below. The character of the people forming a circle around the saints may have been more inspired by Andrea: as in the *Devotion of the Florentines to the relics of St Philip*, they are ordinary Florentine folk.

The last fresco in the series, the *Assumption of the Virgin*, by another of Andrea del Sarto's pupils, known as Rosso Fiorentino, the 'Red Florentine', after his hair, is to the right, by the entrance to the atrium. It was painted in a hurry, to be finished in time for Pope Leo's visit, but the Servite friars were not satisfied with the result, so Rosso had to repaint it in 1517. Although he was only eighteen when he started the painting, the innovation of his style is already emerging: in the lower half, a jostling crowd of the Apostles gapes at the Virgin as she is carried up to heaven in the upper half by a swirling circle of baby angels.

too based his composition on Ghirlandaio's precedent, setting the figures in front of the loggia of a grand temple decorated with carved reliefs of Old Testament scenes. At the top Adam and Eve are being tempted by the serpent and expelled from the Garden of Eden, to remind us of the need for Mary's child. In the foreground a disappointed suitor sits as he breaks his stick which failed to flower, and another raises his fist behind Joseph's head. Despite a recent restoration, the paintwork of the disappointed suitor and the Virgin's head is badly damaged. Vasari tells how Franciabigio was so annoyed that the friars had uncovered his painting before it was finished that he took a hammer to it and smashed away the suitor and the heads of some of the women and the Virgin.

The friars offered to double Franciabigio's fee if he would restore his fresco, but he refused, so the next scene, the *Visitation*, round the corner of the cloister, was painted by Jacopo Carucci, known as Pontormo after the village

Also painted in *grisaille*, they show two events leading up to the Baptism of Christ. In the one on the right, the *Blessing of Young St John the Baptist*, his mother Elizabeth looks on as the young saint kneels before his father Zacharias, who raises his hand to bless him before he sets off for the desert. In the next scene, *St John the Baptist meets Jesus in the Wilderness*, Christ leans forward to embrace the Baptist while Mary and Joseph look on anxiously.

Andrea del Sarto's favourite model was Lucrezia del Fede. Her thoughtful face appears as the Madonna's in his best-known painting, the *Madonna of the Harpies*. It was painted for the church of the convent of San Francisco dei Macci, where the Poor Clares ran a hospital as a refuge for battered wives. The hospital and convent have closed, although the church remains in the Via de' Macci, to the east of the city centre, and Andrea's radically original picture is now in the Uffizi. It has a conventional pyramidal composition, but instead of sitting on her throne, the Madonna stands on a pedestal, her legs held onto it by a pair of mischievous *putti* with angels' wings. The colours of her clothing are memorably intense: she wears a shiny blue cloak over her pink dress through which a gold sleeve extends, and a bright yellow shawl over her shoulders. She looks at the book she holds in one hand, and with the other she holds the Christ Child who prances in an athletic pose and hides his smile behind his shoulder. This central group is flanked by St Francis, wearing a pale grey habit, and St John the Evangelist, dressed in a startling tangerine red cloak over his lilac robe. St Francis holds a cross and St John his Gospel, as usual, to confirm their identities. Their poses are not conventionally static but twisting with energy. The

figures are set against a simple backdrop of pilasters, but the creatures carved on the corners of the hexagonal pedestal on which the Madonna stands are even more unusual. These, the harpies that give the picture its name, look like a cross between ladies and locusts. They have anguished female faces and the bodies of skinny women sitting with their legs splayed apart, but wings instead of arms, and cloven feet. They symbolise temptation and sin, which the Madonna is suppressing beneath her feet – hardly an appropriate image for a hostel for battered wives. The inscription between them includes Andrea's signature and the date of the picture, 1517, as well as the first few words of a Latin hymn to Our Lady of the Assumption.

A few months before he left for France in 1518, Andrea del Sarto had married Lucrezia, soon after her wealthy hat-maker husband had died. He took his assistant with him to France but left his new wife behind, and although he enjoyed the boost to his career and prosperity of being a court painter, after a couple of years he began to miss Lucrezia so much that he returned to Florence. In 1520 he resumed his work at the Chiostro dello Scalzo, which took him a further six years to finish. First he completed the story of the Baptist's life, adding the *Dance of Salome* on the wall to the left of the *Capture of St John the Baptist*. Salome appears to enjoy her dance, swinging her hips for King Herod, who is engaged in serious conversation while dining with her mother, Herodias. Perhaps they are discussing what to do with the Baptist, who meets his fate in the next fresco to the left, the *Beheading of St John the Baptist*. Herod and Herodias are still eating their dinner in the last fresco in the series, round the corner, *Herod's*

Above and left
Andrea del Sarto: *The Capture of St John the Baptist* and *The Beheading of St John the Baptist*, in the Chiostro dello Scalzo

Right
Andrea del Sarto: *Herod's Feast*, in the Chiostro dello Scalzo

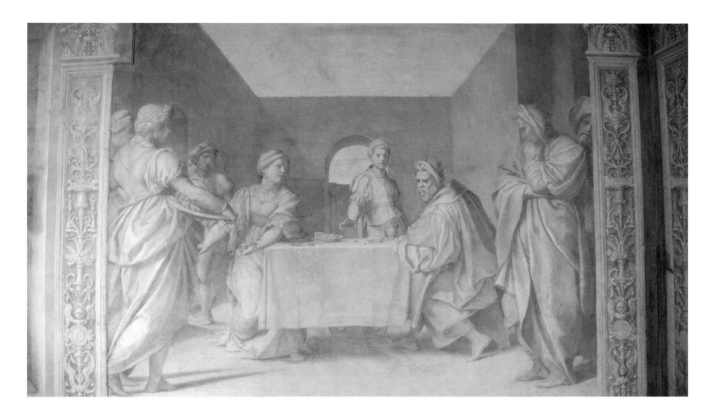

Feast, where Salome presents to her mother the Baptist's head hidden behind her arm on a platter.

Andrea del Sarto had reached the end of the Baptist's story, but there were still some gaps at the beginning. The next two frescoes that he painted are two more Virtues: *Faith*, with her cross and chalice, and *Hope*, with her hands pressed together in prayer, in *trompe l'oeil* recesses on either side of the entrance to the cloister. In the pediment above the doorway there's a bust of Andrea, very like the one by Giovanni Battista Caccini at Santissima Annunziata. Then he painted the first fresco in the series, the *Annunciation to Zacharias*, in the corner to the left. Zacharias looks apprehensive as he stands with one foot on the step of the altar where he is burning incense as the Angel Gabriel approaches him to tell him the good news that he and Elizabeth will have a son. The round altar is reminiscent of the pedestal in the *Madonna of the Harpies*, with female figures carved on its sides, but here

they appear to represent pregnancy rather than sin.

Continuing round the corner to the left, the last two scenes are the *Visitation*, in which Mary greets Elizabeth in front of a small chapel a little like the entrance to the Chiostro dello Scalzo, and the *Birth of St John the Baptist*, in which Zacharias sits on a box writing the name of his newborn son beside the pillows and drapery of Elizabeth's comfortably upholstered bed.

Andrea del Sarto's frescoes at the Chiostro dello Scalzo and at Santissima Annunziata were much admired, earning him the accolade of *Pittore senza errori* – the 'Faultless painter' – recorded in a plaque on the façade of the house he built after he returned from France, just behind Santissima Annunziata on the corner of Via Gino Capponi and Via Giuseppe Giusti. Being in public places, the balanced compositions and well drawn figures of his frescoes had a strong influence on the next generation of artists in Florence.

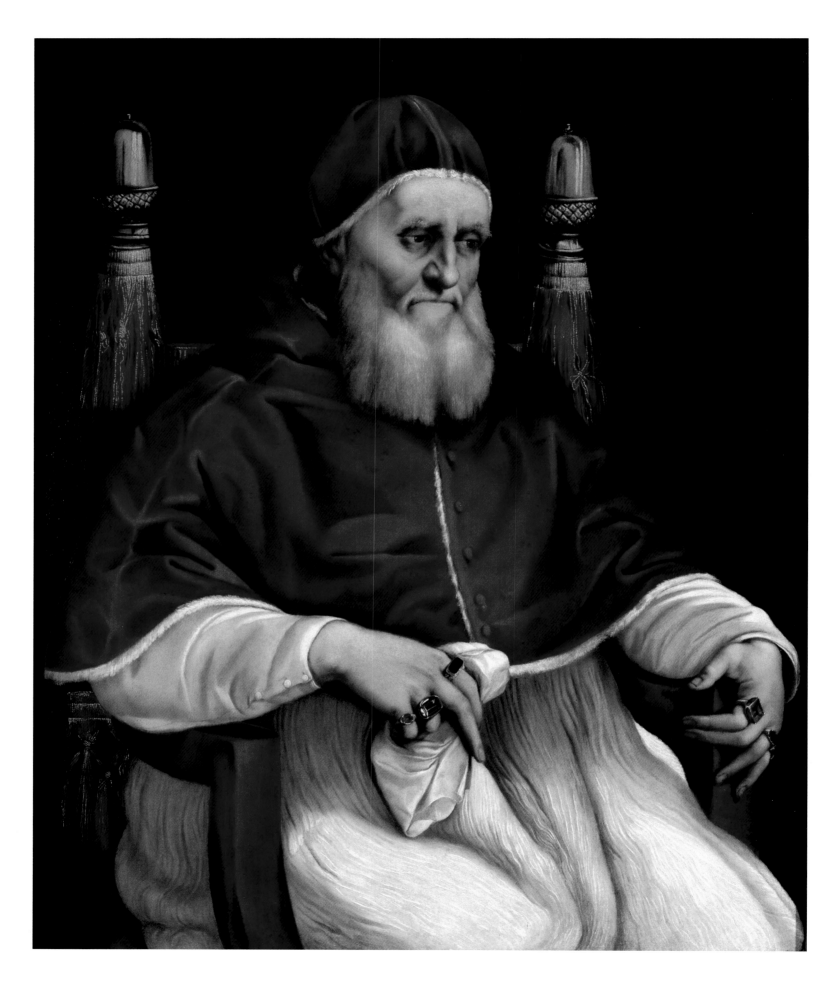

CHAPTER 13

THE RETURN OF THE MEDICI AND THE ARRIVAL OF MANNERISM

In 1513 Pope Julius II died, and Cardinal Giovanni de' Medici was elected Pope, taking the name of Leo X and returning to Rome. There are portraits of both popes in the Uffizi. The *Portrait of Julius II* is by Raphael and his workshop, perhaps a copy of the original in the National Gallery in London. Julius II was sixty-eight years old, with a long white beard and a worried look on his furrowed brow, when Raphael painted him a couple of years before his death. We would not guess from his portrait that, as well as a patron of the arts, Julius was a warrior who modelled himself on Julius Caesar, and personally led his army into battle to re-establish control over the papal dominions. He famously said to Michelangelo, who had suggested putting a book in Julius's hand in a statue that the Pope had commissioned from him, 'Put a sword there, I know nothing about literature!'

Raphael's portrait of *Pope Leo X with Cardinals Giulio de' Medici and Luigi de' Rossi*, painted around 1518 when Julius's successor was in his early forties, captures Leo's fondness for feasts and festivities in his plump features, and his love of luxury in his crimson velvet throne and the warm red tones of the painting. Leo's enthusiasm for literature and the arts is indicated by the beautifully illustrated manuscript on the table in front of him, which he holds a magnifying glass to read – he had poor eyesight – and by a highly ornate gold and silver bell beside the book. He was an even more lavish patron of the arts than his predecessor, and encouraged the Church to sell indulgences to finance the reconstruction of St Peter's in Rome. This had provoked Martin Luther to nail his Ninety-Five Theses to the door of the church in Wittenberg the year before the painting, thereby launching the Protestant Reformation. Despite this challenge to his authority, Leo looks confident and secure in his position, accompanied by two cardinals, both cousins of his. On the left is Giulio de' Medici, the son of Leo's murdered uncle Giuliano, who later became Pope Clement VII, and on the right Luigi de' Rossi, whose mother Maria was a Medici. Raphael's picture clearly illustrates the Medici family's ambition to dominate the Church, as well as Florence.

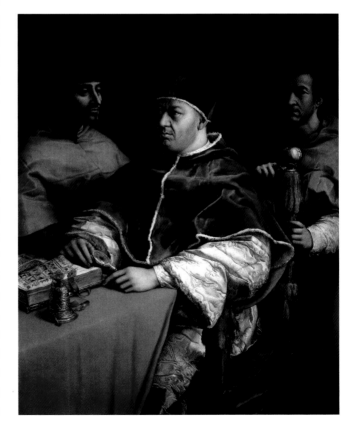

On page 430
Raphael and his workshop:
Pope Julius II (Uffizi)

On page 431
Raphael: *Pope Leo X with
Cardinals Giulio de' Medici and
Luigi de' Rossi* (Uffizi)

Below
Piero di Cosimo: *The Liberation of
Andromeda* (Uffizi)

After his election to the papal throne, Leo left Florence under the control of his younger brother Giuliano, who died in 1516, and then of his nephew Lorenzo, Piero the Unfortunate's son, who took the title of Captain General of the Florentine Republic. The Medici's return to Florence was celebrated in one of the most extraordinary paintings of the time, the *Liberation of Andromeda*, the best-known work of Piero di Cosimo, a former apprentice of Cosimo Rosselli, from whom he acquired his name and whose daughter he married. He had specialised in painting mythological and allegorical subjects, until the years of Savonarola's dominance. The painting, in the Uffizi, was commissioned around 1510 by Filippo Strozzi the younger, the son of Filippo the Elder who built the Palazzo Strozzi, reviving his father's taste for Classical mythology, and celebrating their reconciliation to the Medici. The Greek hero Perseus, probably representing Lorenzo de' Medici, appears twice, flying across the sky and prancing on the back of a sea monster, slashing its neck with a sword, preventing it from attacking Andromeda. The sea monster, with a face like a dog's and a twisty corkscrew dragon's tail, was sent to punish Andromeda by Poseidon, the Greek

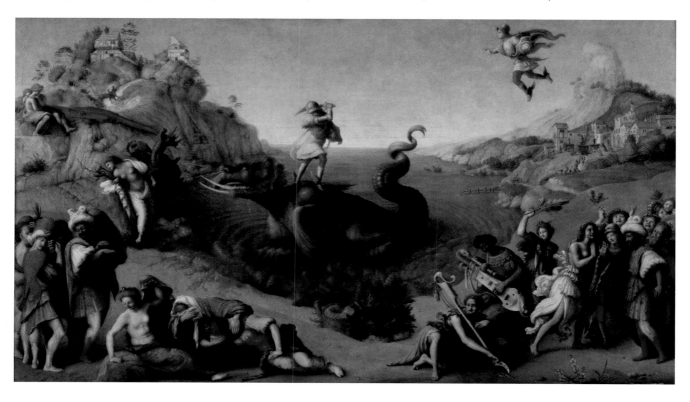

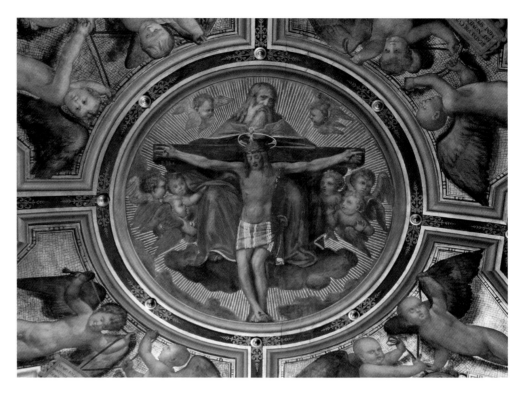

god of the sea, because her mother, Queen Cassiopeia of Ethiopia, had boasted that she was more beautiful than his sea nymphs. Andromeda is tied to the stump of a tree, chopped down but growing new shoots, which has been interpreted as symbolising the rule of the Medici family. The man in the red cape and hat with a large plume in the left-hand corner of the painting has been identified as Giuliano de' Medici. On the shore in the foreground, the onlookers wave laurel leaves, celebrating victory and Lorenzo, while two musicians, one of whom looks African, pluck highly unusual instruments. The figures and the landscape behind are all painted with the precise realism of the previous century. As well as celebrating the end of the Republic, the theme of the picture suggests that Savonarola's influence over the arts had waned, and beauty had been liberated.

Mostly concerned with politics and re-establishing the Medici family's power, Lorenzo was not as keen as his namesake grandfather to encourage the arts, but he did give Ridolfo del Ghirlandaio his first public commission, to decorate Baccio d'Agnolo's Chapel of the Priors in the Palazzo Vecchio when it was finished in 1514. Ridolfo, Domenico Ghirlandaio's son, had trained in Fra Bartolomeo's workshop. Like his friend Raphael, he painted a number of portraits on panels, not contrived into larger frescoes of religious subjects, as his father so often had done. In the Chapel of the Priors he painted the walls and the vaults with gilded frescoes and elaborate grotesque decorations, imitating mosaics. In the lunette on the wall above the altar Ridolfo's fresco, divided into two by the circular window, is of the *Vision of St Bernard*, and at the other end of the chapel, his *Annunciation* scene includes a view of the church of Santissima Annunziata, as it was before Giovanni Caccini's grand loggia was added to its façade in 1601. The chancel vault has the dove of the Holy Spirit surrounded by the twelve Apostles, and the main vault has a circular Holy Trinity in the centre, with the four Evangelists in cross-shaped panels in the corners.

Left
Ridolfo del Ghirlandaio:
Coronation of the Virgin and
Holy Trinity in the Chapel of the
Trinity, Ognissanti

Right
Baccio d'Agnolo: Palazzo
Bartolini Salimbeni

Far right
Interior of San Giuseppe, looking
towards the altar and organ case

Ridolfo's vision of the *Holy Trinity* on the vault largely follows the convention exemplified by Masaccio's fresco in the nave of Santa Maria Novella: God the Father, a sad-eyed old man with long grey hair and beard, sits on a cloud holding the arms of the cross on which Jesus hangs, while the dove of the Holy Spirit hovers between their heads, carrying Jesus's halo in its beak. In the 1520s Ridolfo created a new image of the Holy Trinity in a fresco in the church of the Ognissanti, behind the font in the second chapel on the left of the nave. Here, God the Father and Jesus sit on clouds facing each other, as if in conversation. God holds an orb in one hand, and raises the other to bless his son and point at the dove of the Holy Spirit. The colours of the image break with tradition too: instead of dark blue and crimson, God wears robes of pale violet and

scarlet. Jesus wears a cloak of violet knotted around his neck. In the fresco above, God is shown wearing robes of the same colours as he places a crown on Mary's head in the *Coronation of the Virgin*. The effect is very different from Ridolfo's frescoes in the Chapel of the Priors, much more intimate and less formal, showing how rapidly the style of painting moved on from High Renaissance to the 'Modern Manner', the style that is known as Mannerism.

The styles of architecture and sculpture were changing too. Baccio d'Agnolo was a very successful and busy architect in the first decades of the sixteenth century, designing several palazzi. One is the Palazzo Taddei, at 15 Via dei Ginori north of San Lorenzo, where Taddeo Taddei displayed the tondo that Michelangelo had carved for him. Baccio also designed the Palazzo Borgherini at 17 Borgo Santi Apostoli, just beside the church on Piazza del Limbo, and the Palazzo Stiozzi Ridolfi, at 99 Via San Niccolò in the Oltrarno. All have a broadly similar straightforward style, which by now had become traditional, reflecting the sober restraint of the years of Soderini's republican government. Their stuccoed walls are decorated only by heavily rusticated stone blocks on the corners and in the arches around their doors and windows, which on the upper floors stand on small 'stringcourse' cornices.

Baccio d'Agnolo must have been influenced by Raphael's Palazzo Pandolfini when he designed the Palazzo Bartolini Salimbeni, which confirmed the introduction of the Roman High Renaissance style of architecture to Florence. Built between 1520 and 1523, it stands in the Piazza Santa Trinita, facing the church. Among the novel features of its façade are the rectangular

windows, framed by pilasters carrying full entablatures of architrave, frieze and cornice under alternating triangular and segmental pediments, no doubt copied from the Palazzo Pandolfini, and separated on the first floor by deep niches that once held statues. The strong cornice under the roof and the columns on either side of the main doorway add to the three-dimensional liveliness of the façade. Giovanni Bartolini Salimbeni had asked for 'the most beautiful palace ever built in Florence', and he surely would not have been disappointed. He celebrated the story of how his family first made their fortune in the silk trade by doping their competitors with opium, by having poppy seed heads carved on the first floor frieze, and their motto, 'PER NON DORMIRE', 'For Not Sleeping' (referring to their reward for keeping awake), on the cross-bars of the upper

windows. Baccio added his own riposte to those who said that the building's style was more suited to a church than to a palazzo on the lintel above the front door: 'CARPERE PROMPTIUS QUAM IMITARE', 'It is easier to criticise than to imitate'.

Baccio did also design a church in his new Roman style. He began work in 1519 on the church of San Giuseppe, in Via San Giuseppe which runs along the northern side of Santa Croce, for the Confraternity of St Joseph, who had previously met in a small oratory on the site. The imposing façade of the church was rebuilt in a bland Neoclassical style in 1759, so it is easy to pass by, but Baccio's interior is worth a look. Following Il Cronaca's example at San Salvatore al Monte, Baccio uses the theatre motif of arches separated by tall pilasters, all made of *pietra serena*, creating a sense

of strength and dignity. The visual atmosphere inside the church, however, is dominated by the gilded organ case and balcony and the colourful eighteenth-century frescoes above the main altar.

Baccio d'Agnolo was also in demand as a designer of bell towers for churches. The most distinctive of these is at Santo Spirito, which combines a steep pyramid roof with buttresses composed of scrolls above rectangular frames at the corners of the upper storey, no doubt inspired by Brunelleschi's lantern on the dome of the Duomo. Building began on the 230-foot-tall tower around 1503, but it was not completed until 1570. In the early years of the century, Baccio also designed the small bell tower at the back of Santi Apostoli, in a simple Romanesque style to match the exterior of the church, in contrast to Benedetto da Rovezzano's elegant marble portal added to the façade at about the same time. The bell tower of San Marco was

rebuilt in 1512 to Baccio's design, with an extremely steep pointed roof above the arches around the bells. The bell tower at San Miniato al Monte had collapsed in 1499, and in 1523 Baccio started work on a new tower, in a compromise between Romanesque and Renaissance styles, but construction was interrupted by the siege of 1529, and was not finished until 1535.

Bartolomeo was a popular name in these years. Bartolomeo dei Sinibaldi, a sculptor known as Baccio (the short version of Bartolomeo) da Montelupo after the village near Empoli, west of Florence, where he was born, had worked with Michelangelo in Lorenzo de' Medici's sculpture garden at San Marco. He completed a statue of St John the Evangelist for Orsanmichele in 1515. A copy of his bronze statue stands in its tabernacle at the south-east corner of the church. The original, upstairs in Orsanmichele's museum, was commissioned by the Silk Guild, to replace a late fourteenth-century marble statue attributed to Simone di Francesco Talenti; they moved that, the first of all the Orsanmichele saints, to their Ospedale degli Innocenti, where it now stands at the foot of the stairs leading up to the museum. Baccio da Montelupo's bearded and balding *St John the Evangelist*, who looks down with a very serious expression at the open book he holds above his comically exaggerated pot belly, may well have been inspired by the curly hair and flowing beard of Talenti's earlier version, but has the much more detailed realism of his age.

Another Florentine sculptor with the name was Bartolommeo Brandini, now always known by his pseudonym of Baccio Bandinelli. Nineteen years or so younger than Michelangelo, he was heavily influenced by the master he saw as his rival. He caught the attention of the Medici family; one of his first surviving works is his statue of *Orpheus* in the courtyard of the Palazzo Medici, commissioned by Cardinal Giulio de' Medici. Orpheus's body and pose, apart from his arms, are closely modelled on the second-century statue of Apollo unearthed in 1489 and taken by Pope Julius II to the courtyard of the Belvedere Palace of the Vatican, from which it gets its name of the

Left, above and below
Benedetto da Rovezzano: *Assault on the Monks of San Salvi* and *St Giovanni Gualberto frees a Monk from a Demon* (Museum of San Salvi)

Above
Benedetto da Rovezzano:
The Trial by Fire of Pietro Igneo (Museum of San Salvi)

Below
Benedetto da Rovezzano:
The Translation of the Body of St Giovanni Gualberto and *The Obsequies of St Giovanni Gualberto* (Museum of San Salvi)

observing the event have lost their heads. Even more smashed up is a tondo showing Vallombrosian monks holding a bowl containing a miraculous catch of fish up to the remains of Pope Leo X. Two long panels on the opposite wall show Giovanni Gualberto's body being carried after his death through crowds of his distressed followers, and laid on a bier as the monks gather to say his

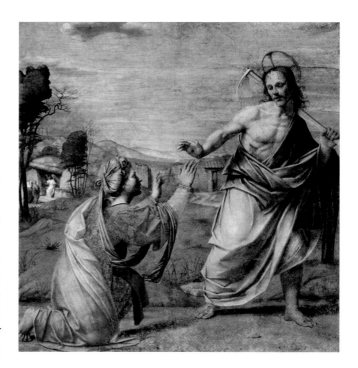

funeral rites. Both show Benedetto da Rovezzano's skill at carving animated and expressive figures.

St Giovanni Gualberto appears again, carrying a Crucifix and being worshipped by two of his Vallombrosian monks, in a low relief panel carved by Benedetto in dark stone in the lunette above the doorway in the cloister that leads to the chapter house at San Salvi. There are two more relief panels by Benedetto in the cloister: one is of St Salvi dressed as a bishop attended by two angels; the other is of St Michael the Archangel, to whom the church of San Salvi is dedicated, who holds a sword to slay the dragon between his feet in one hand, and a pair of scales to weigh souls on the day of judgement in the other. Unlike Michelangelo's and Baccio Bandinelli's allegorical and mythological statues, Benedetto's relief figures are all clothed: St Giovanni Gualberto and the two Vallombrosians are dressed in monks' habits and hoods of cloth with heavy folds; St Bernardo degli Uberti wears his bishop's mitre and a long mantle with an embroidered collar band over his pleated robe; St Michael wears the breastplate and armoured skirt of a Roman soldier with a cape billowing in the wind. All show the lively vigour of Benedetto's style. It is not known when he carved these works at San Salvi, but it must have been before 1524 when he went to work in Rome. He then went on to England, where he worked for Cardinal Wolsey, among other things making him a tomb; that was not used for the Cardinal, who had fallen from royal favour by the time of his death, but for Admiral Lord Nelson, and is in the crypt of St Paul's Cathedral.

The gallery of the Museum of San Salvi has some fine works by Andrea del Sarto's colleague Franciabigio.

His *Virgin and Child with SS. John the Baptist and Job* was commissioned by the Confraternity of St Job for the high altar of their chapel, which used to stand behind Santissima Annunziata. Franciabigio belonged to their confraternity and owes his nickname, which translates as 'Grey Frank', to them, derived from the grey habits they wore. The painting has darkened with age but the saints still retain their vigorous gestures and devotional poses. St Job is portrayed as a poverty-stricken beggar, while St John the Baptist, according to Vasari, is Franciabigio's self portrait. His *Noli Me Tangere* is displayed underneath the enormous canopy over the fireplace of the monastery's former kitchen. Franciabigio painted it for a cloth weaver called Arcangelo, on the wall of a terrace at the top of the tower of a house in Porta Rossa, from where it was salvaged when the Mercato Vecchio area was redeveloped. The fresco has lively figures of Christ and Mary Magdalene, a simple and powerful composition modelled on Andrea del Sarto's earlier version painted for the church of San Gallo now in the Uffizi, and striking fresh and bright colours.

Franciabigio may have been content to adopt his rival's clear and balanced compositions, but Andrea's pupils developed their own Mannerist style, with crowded, complex and sometimes chaotic compositions, focusing closely on the figures and their emotions, leaving little room for the landscapes or architectural backgrounds so favoured by Ghirlandaio's generation of painters. A fine example is Rosso Fiorentino's *Marriage of the Virgin*. Signed and dated 1523, it still remains in the chapel in San Lorenzo for which it was painted, the second chapel on the right of the nave, dedicated to Mary and Joseph, that had been bought by Rosso's patron Carlo Ginori three years earlier.

The priest conducting the ceremony stands at the top of the steps in the centre of the painting, looking at Joseph, who carries his blossoming branch as he places a wedding ring on Mary's finger. Disregarding convention, Rosso's Joseph is a handsome young man with curly hair. This has been interpreted theologically as symbolising the Medici popes' attempts to rejuvenate the Church, but that explanation seems a bit contrived. More likely, Joseph's youthfulness is just another aspect of Rosso's break with tradition. The saints on the steps in the foreground are equally intriguing. The friar who points to Mary and Joseph's hands, drawing our attention to the gift of the ring, is St Vincent Ferrer (perhaps with the features of Carlo Ginori). This is the first time we have encountered this Dominican friar from Valencia in Spain. He lived during the era of the Western Schism, and campaigned for the reunification of the Church, another issue made topical by Martin Luther's attacks on the Papacy, which may explain his appearance here. The young saint sitting below St Vincent is St Apollonia, also appearing for the first time. She lived in Alexandria in the third century, and was martyred for her Christian beliefs by having her teeth torn out with the tongs she carries in her left hand. The book she holds in her right hand has Rosso's Latinised name, 'Rubeus Florentino', in the text, but her presence here is otherwise unexplained. The older lady sitting facing her is more expected: she is St Anne, Mary's apocryphal mother. Behind these main figures, the picture is crowded with sweet-faced children, elegant ladies and disappointed men breaking their sticks.

Even more radical, both in subject matter and in style, is Rosso's *Moses defending the Daughters of Jethro* in the Uffizi. Vasari says that Rosso painted this picture for Giovanni Bandini, a companion of Alessandro, the illegitimate son probably of Lorenzo de' Medici, Duke of Urbino, who later became the ruler of Florence. The story in the book of Exodus is that when Moses was a young man he killed an Egyptian who was beating a Jew, and had to flee from the Pharaoh to the land of Midian, south of Israel. He sat down to rest by a well, where the seven daughters of a local priest were drawing water for their father's flock, when some shepherds came and drove the sheep away. Moses helped the girls to rescue their sheep and to water them. Their grateful father Jethro invited him to dinner and gave him his daughter Zipporah as his wife. Moses

appears twice in Rosso's picture, dominating the centre as he bends to beat up the shepherds, and rushing towards the alarmed Zipporah and her sisters at the back. Zipporah has a fancy hairstyle and wears a silvery-blue dress over one shoulder, but except for Moses' vestigial blue and rose-pink cloaks, all the men in the picture are nude. Their contorted muscular bodies were probably inspired by the soldiers in Michelangelo's cartoons for the *Battle of Cascina*. The most extraordinary feature of the composition is the way it focuses so closely on the bodies of these men that some of their limbs are cut off by the frame.

Rosso's *Madonna with Child and Saints*, in the same room in the Uffizi, follows the conventional *sacra conversazione* structure, but also zooms in so closely on the figures that there is no room for any background to

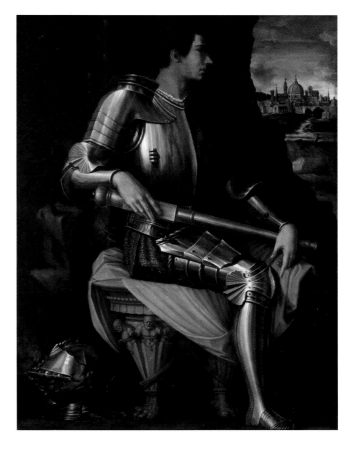

above the altarpiece to the left, has no eagle and is old and bald but is identified by his long white beard. He appears to be protruding forward through the picture frame, as does St Matthew, attributed to Bronzino, on the other side of the altar. A bare-shouldered young man, whose elbow half covers the face of his symbolic angel, Matthew is painted with sharp outlines and strong contrasts between light and dark. The gates of the chapel are usually closed, so the faces on the near side of the dome are not easy to see. If we go round to look through the arch opposite the *Annunciation*, St Luke can be identified by the dark head of his ox behind his shoulder, in the roundel above the far column on the right, so the young man above the near column must be St Mark, although he has no lion.

When Clement VII regained control of Florence in 1530, he abolished the republican government again and appointed the nineteen-year-old Alessandro de' Medici, who was generally thought to be the illegitimate son of Lorenzo de' Medici, Duke of Urbino, or perhaps of Clement himself before he became pope, to rule the city on his behalf, proclaiming him Duke of Florence. Giorgio Vasari painted a portrait of Alessandro in 1534, now in the Palatine Gallery. The famous author of the *Lives of the Most Excellent Painters, Sculptors and Architects* – these days, *Lives of the Artists* – started his career as a painter. He was born in Arezzo, but had the good fortune to impress his father's cousin Cardinal Silvio Passerini, to whom Giulio de' Medici had entrusted the government of Florence when he was elected Pope Clement VII. Passerini went through Arezzo on his way to Florence in 1523 when Vasari was about ten years old; he was appointed guardian to Alessandro de'

Medici and his cousin Ippolito, who were about the same age as Vasari, and he advised Vasari's father to send his son to Florence to complete his education. He arranged for Vasari to live in a house belonging to Niccolò Vespucci in Borgo San Jacopo and to come to the Palazzo Medici for his lessons with Alessandro and Ippolito. Vasari was also apprenticed to Michelangelo, but only worked for him for a few months before Michelangelo had to go to Rome again, so he was then apprenticed to Andrea del Sarto and later to Baccio Bandinelli. His close connection to Alessandro and Ippolito and his excellent apprenticeships gave Vasari the benefit of commissions from the Medici for most of his life. Alessandro's swarthy complexion in Vasari's portrait suggests that his mother, Simonetta da Collevecchio, was Moorish, probably a servant or a slave in his father's household. He is shown wearing shining armour from his

Left
Michelangelo: Tribune of the Relics, in San Lorenzo

Right
Michelangelo: *Victory*, in the Palazzo Vecchio

Far right
Baccio Bandinelli: *Hercules and Cacus*, in the Piazza della Signoria

had recovered and display them in their family church of San Lorenzo. Michelangelo designed the Tribune of the Relics, a balcony built in 1531–32 on the inside of the façade, carried on two large Corinthian columns, carefully matching Brunelleschi's in the main body of the church. Below the balcony a large shield displays the Medici's coat of arms. Behind its marble balustrade there are three blank windows, where the relics were exhibited on shelves, between two pilasters that Michelangelo designed, decorated with the Medici's diamond rings above heavy festoons of oak and laurel leaves.

One of Michelangelo's many projects in the next couple of years was his statue of *Victory*, on display in the Hall of the Five Hundred in the Palazzo Vecchio. It may have been intended as part of Pope Julius II's tomb, celebrating his reconquest of some of the papal territories, and was probably started as early as 1519, when Michelangelo was working on the *Slaves* for Julius's tomb. Victory is portrayed as an athletic young man, crushing the old man he has conquered, by kneeling on his back. His tall and twisted naked body is highly polished, while the bearded old man, bent double and chained, is rough and unfinished. Victory holds a sling over his shoulder, like David, and wears a crown of oak leaves, the emblem of Pope Julius's family, whose surname, della Rovere, means 'of the oak tree'. The story of the sculpture is given an interesting twist by the suggestion that the model for the young man was a young Roman nobleman, Michelangelo's lover Tommaso dei Cavalieri, to whom he dedicated hundreds of love sonnets, while the old man has Michelangelo's own face.

Back in 1505, the year after Michelangelo finished

feet up to his neck, holding a rather suggestive long brass hand cannon across his lap. He sits on a stool supported by figures with no arms or legs, implying his domination of the citizens of Florence, of which we get a glimpse behind a wall ruined in the siege. Alessandro's helmet, placed on the ground behind the stool, encloses flames flickering through its visor. Vasari explained to Alessandro's cousin Ottaviano de' Medici, who commissioned the painting, that this was meant to represent peace.

Despite his republican political sympathies, Michelangelo accepted another commission from Clement VII. Some of the relics of the Medici family had been stolen from their palazzo after they had fled in 1494. Clement wanted to preserve the ones that Leo X

Left
Michelangelo: vestibule of the
Laurentian Library, San Lorenzo

Right
Michelangelo: *Bandini Pietà*
(Cathedral Museum)

abstract sculpture. It has three flights of stairs. The main flight in the centre has unconventional curved steps ending in circular curls, except for the bottom three steps which have wider oval slabs, while the narrower steps at the sides are straight, but at different levels, and join the central flight under another pair of scrolls.

There's a sculpture among Michelangelo's works in the Accademia which used to be attributed to him. It is known as the *Pietà di Palestrina*, as for many years it was in a chapel in the Barberini Palace in the ancient city of Palestrina, near Rome. However, the attribution is uncertain as there is no historical documentation relating to it, and the figures of the dead Christ, Mary and Mary Magdalene are rather heavy and not perfectly proportioned. It might have been made by a pupil or an admiring imitator of Michelangelo's, or imperfectly executed to his design, which has a number of similarities to one of his last known works, the *Bandini Pietà* in the Cathedral Museum.

Michelangelo was over seventy years old when he began this sculpture, around 1547. Vittoria Colonna, a widowed poet from a noble Roman family, of whom he was very fond, died that year and he became increasingly conscious of his own mortality. He planned a *Pietà* to be placed above his own tomb, and put his self portrait inside the hood of the figure of Nicodemus who he included in the group, standing behind Christ and Mary. He also included the small figure of St Mary Magdalene, kneeling beside Christ and supporting his body. Despite his intention to be buried below this *Pietà*, he did not finish it, like so many others of his sculptures. When a defect in the marble caused Christ's left leg to break, Michelangelo was so frustrated

that he not only stopped working on it but smashed it in several places. His own face and Mary Magdalene's were finished, but Christ's is still rough and Mary's just blocked out. The unfinished sculpture passed into the ownership of his friend Francesco Bandini (hence its name), who asked Michelangelo's assistant Tiberio Calcagni to repair it.

Of all Michelangelo's late works, the *Bandini Pietà* most strongly reveals his piety and reflects his anguish and despair at the prospect of death, but it was still uncommon for an artist to produce a work expressing their personal feelings. Most of the next generation of sculptors in Florence were commissioned to produce works glorifying the ruling Medici family.

CHAPTER 14

THE GLORIFICATION OF DUKE COSIMO

When Cosimo de' Medici was selected as ruler of Florence after the assassination of his distant cousin Duke Alessandro in 1537, he was determined to establish his authority, and soon used his patronage of the arts to promote his power and glorify his family. One of his first commissions was a memorial to his father, the *condottiero* Giovanni de' Medici, who had commanded the papal forces in Leo X's war against Francesco Maria della Rovere, Duke of Urbino. When Pope Leo died, to manifest his mourning Giovanni had the purple and white stripes on his insignia painted black, giving rise to the name by which he has since been known, Giovanni delle Bande Nere, 'of the black stripes'.

Duke Cosimo intended the monument that he commissioned from Baccio Bandinelli to be displayed in the Neroni family's chapel in the church of San Lorenzo. That chapel, opposite the Medici family's chapel in the left transept of the church, had been confiscated by Piero the Gouty along with all the Neroni family's other assets in 1466, after Diotisalvi Neroni had joined Luca Pitti's attempt to overthrow Piero. The location would have served to remind Duke Cosimo's political opponents of the consequences of any attempt to overthrow him. Indeed, he had rapidly dismissed the members of the council that had selected him, prompting the exiled republicans, led by Bernardo Salviati and Piero Strozzi, grandson of Filippo Strozzi whose chapel we saw in Santa Maria Novella, to organise an army to overthrow him, within months of his accession to power. Their army, which was supported by France, was defeated by Cosimo's forces at the battle of

Montemurlo, leading the Emperor Charles V to recognise Cosimo as Duke of Florence. However, it would not have been acceptable to put a statue of a contemporary warrior in a church, so Bandinelli's monument shows Giovanni delle Bande Nere sitting down, and wearing Roman armour but no helmet or boots. Instead of a sword, he has a thick wooden stick in his hand, which might be a commander's baton, or the stump of a broken spear, symbolising his death in battle at the age of twenty-eight.

In fact, the statue was never displayed in the Neroni Chapel, as Bandinelli had not finished it when he died in 1560. After it was completed in 1592, it was taken to the Hall of the Five Hundred in the Palazzo Vecchio, and in 1620 it was united with its magnificent pedestal, which was moved from the Neroni Chapel to the north-east corner of the Piazza San Lorenzo, so Giovanni delle Bande Nere now sits facing his family's church. The short sides of the pedestal are decorated with the Medici's *palle* on panels with two unusually human lions' faces at their top corners, below the Medici's enormous diamond ring wrapped in feathers and scrolls. Lions had been symbols of Florence since the days of Donatello's Marzocco, so placing their faces close to the Medici's coat of arms signified the reunification of the city with its ruling family. The main panel at the front of the pedestal would also hardly have been suitable for a church; the bas-relief shows soldiers, one of whom is naked, presenting their commander with the distressed men and women whom they have captured. The pedestal is framed by four fluted Doric columns at the corners, which carry a Doric entablature that we have not seen so far. The frieze, like that of a Greek temple, consists of triglyphs, tablets

On page 464
Baccio Bandinelli: monument to
Giovanni delle Bande Nere, in
Piazza San Lorenzo

Left
Pontormo: *Maria Salviati* (Uffizi)

Right
Baccio Bandinelli: statues of
Pope Leo X (centre), Giovanni
delle Bande Nere (left) and Duke
Alessandro de' Medici (right), in
the Hall of the Five Hundred in
the Palazzo Vecchio

were married in 1539, when Cosimo was only nineteen, and
Eleonora just seventeen. The next year Cosimo moved his
home from the Palazzo Medici to the Palazzo Vecchio in
order to reinforce his role as ruler of Florence. The former
home of the government was large enough to allow Cosimo
to remodel the interior into separate apartments for himself
and his wife. His widowed mother Maria Salviati also had
an apartment in the palazzo. After her husband Giovanni
delle Bande Nere died of a wound suffered while in the
service of Pope Clement VII, she wore the black and white
clothes of a novice nun, as she does in Pontormo's grieving
portrait of her in the Uffizi.

Duke Cosimo transformed the Hall of the Five
Hundred in the Palazzo Vecchio from a council chamber
into the audience hall of his new ducal palace, replacing
any traces of its republican origins with celebrations of his
family. He commissioned Baccio Bandinelli and Giuliano,
the son of Baccio d'Agnolo who like his father was an
architect, to refurbish the northern end of the hall, creating
an impressive gallery between the two rows of enormous
windows, from which Cosimo could address his audience.
The central section of the wall below the gallery is modelled
on a triumphal arch, in front of which there is a platform for
his ducal throne. Cosimo also commissioned Bandinelli to
make a series of statues for the hall, commemorating the
most distinguished recent members of the Medici family.
The most imposing of these is the larger-than-life statue of
the portly and rather sour-faced Pope Leo X, raising his
hand in blessing as he sits on a tall pedestal in the apse in the
central archway of the triumphal arch. The vault of the apse
above him is lavishly decorated with gilded ornamentation;

of three vertical panels separated by notches, simulating
the ends of wooden roof beams, alternating with metopes,
panels carved with the Medici's emblems and military
symbols. Below each of the triglyphs are six *guttae*, stone
raindrops – an academically accurate detail. The slab that
supports Giovanni delle Bande Nere's seat rests on an even
more surprising Classical reference – a dozen ox's skulls,
which originally referred to pagan ceremonies of sacrifice.

Initially, perhaps for political reasons, Duke Cosimo
wanted to marry Duke Alessandro's fifteen-year-old
widow, Margaret of Austria, an illegitimate daughter of
the Emperor Charles V, but she was not keen on marrying
another young Medici, perhaps because Alessandro had
remained devoted to his favourite mistress throughout his
brief marriage to Margaret. Her father had other plans for
her, so he supported Cosimo's request to marry instead
Eleonora di Toledo, the beautiful daughter of the Marquis
of Villafranca, the rich Spanish Viceroy of Naples. They

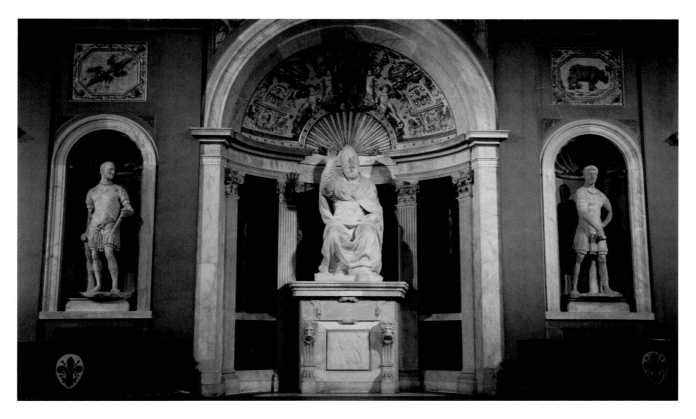

four chubby *putti* play with golden balls while supporting a shield with the Medici's coat of arms. Two more *putti* sit on the crossed keys of the Papacy above the shield, holding a papal tiara. As well as winged sphinxes and swags of fruit, there are two curious panels on the sides of the vault. Each is flanked by a pair of winged satyrs with goat's feet playing their trumpets, and has a banner bearing the words 'ENIM SUAVE' above a lion's face and an elaborate contraption which looks like a yoke. The words are an abbreviated Latin version of Jesus's saying in St Matthew's Gospel, 'For my yoke is easy and my burden is light'. Duke Cosimo was associating Pope Leo X, his godfather and great-uncle, with Christ, to promote his family's political status.

In the alcove to the left of the apse there is another statue of Giovanni delle Bande Nere by Baccio Bandinelli. This one has him standing instead of seated, smiling instead of staring ahead, and carrying a commander's baton, but he is still dressed as a Roman soldier. The rectangular panel above

the alcove has a gilded relief of a massive winged thunderbolt with streaks of lightning. This symbol of Jupiter, the king of the gods in Roman times, was modestly adopted by Giovanni delle Bande Nere as his own. Bandinelli's statue of Duke Alessandro de' Medici stands in the alcove to the right of the apse. He too is dressed as a Roman soldier, and looks even younger than Giovanni delle Bande Nere, as he was only twenty-six when he was assassinated. His strange symbol, the rhinoceros in the panel above his head, was supposed to suggest his strength, but seems to hint at the blundering brutality of his brief rule.

The Medici's coat of arms is displayed again, on a panel above the doorway round the corner to the left as we face the three statues. The *palle* are painted red, on a shield surrounded by a heavy chain collar holding a floppy ram tied around its waist. These are the emblems of the highly prestigious Order of the Golden Fleece which the Emperor Charles V awarded to Cosimo in 1545. The panel is

ornamented with heavy festoons of fruit and surmounted by a crown – wealth and power! To the left of the doorway is Bandinelli's tall statue of Duke Cosimo, dressed as a Roman emperor with a metal breastplate and a cloak hanging down his back. Vincenzo de' Rossi, Bandinelli's apprentice from Fiesole, completed this statue, and the one of Leo X, after Bandinelli's death in 1560. Cosimo was forty years old then, and had grown a thick beard and moustache, whereas in Bandinelli's marble bust of him in the Bargello, made when Cosimo was twenty-four, he only has four corkscrew curls under his chin. In the marble bas-relief portrait of him also in the Bargello that

Bandinelli made a few years earlier, when Cosimo was around twenty years old, he just has some whiskers on his chin. In the bust he wears Roman armour, with two heads of Medusa on the breastplate, confirming his perception of himself as an heir to the Roman emperors. Between them is the head of a goat. Cosimo was keen to publicise that he was born under the zodiac sign of Capricorn, and had all the ambition and determination associated with his star-sign, so we shall see many more goat's heads in the next decades. He had another curious symbol, displayed in the panel above his statue in the Hall of the Five Hundred. A turtle with a sail attached to its back illustrates Cosimo's

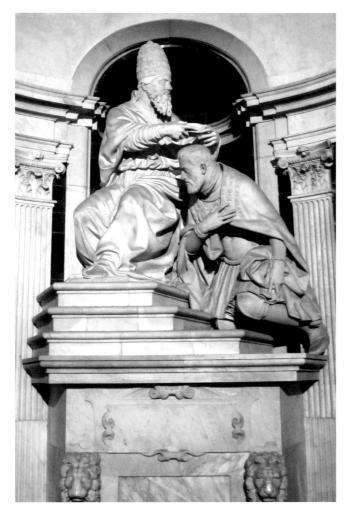

motto *Festina Lente*, 'Make haste slowly', which he adopted from Augustus, the first Roman emperor, revealing the scale of his ambition.

In another magnificent chapel-like apse, in the corner of the Hall opposite Cosimo's statue, Bandinelli's statue of Pope Clement VII wears a tall tiara as he puts a simple crown on the bare head of the Emperor Charles V, who kneels humbly on the steps below the Pope's throne. It was Pope Clement's agreement to recognise Charles as emperor that enabled him to use the imperial troops to besiege and recapture Florence, so the statue not only asserts the authority of a Medici pope over an emperor, but

also celebrates their alliance against the republicans. The statue of Pope Clement is by Bandinelli, but the Emperor was later added by Giovanni Battista Caccini, who also made the statue of Duke Cosimo's son, Francesco, in the alcove to the right. Francesco, who succeeded his father as ruler of Florence, is shown, like Cosimo opposite, as a Roman emperor wearing a cloak, but in a rather arrogant pose, with his foot on a skull and a threatening pole in his hand. His emblem, in the panel above the alcove, is a weasel holding a branch in its mouth, beneath a ribbon bearing the words 'VICTORIA AMAT CURAM', 'Victory loves carefulness', completing the family's propaganda.

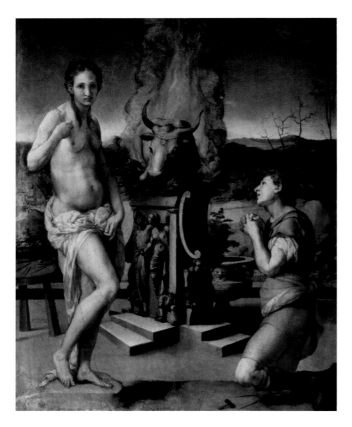

Bandinelli and Vincenzo de' Rossi made the two unusual marble guards outside the main doorway of the Palazzo Vecchio in 1542. Bandinelli's female nymph and de' Rossi's young man, both naked and standing in shrubs, used to carry a chain across the entrance but have lost their arms.

Eleonora di Toledo had a small private chapel created for her in the corner of one of the large rooms in her apartment on the second floor of the Palazzo Vecchio. The architect was Giovanni Battista del Tasso, the craftsman who had carved the ceiling of the Laurentian Library, who was later put in charge of the renovation and expansion of the Palazzo Vecchio, and whose best known creation is the handsome Loggia of the Mercato Nuovo, the 'New Market' at the crossroads of Via Calimala and Via Porta Rossa. Bronzino was chosen to paint the walls and ceiling of Eleonora's peaceful retreat. Since working in Pontormo's workshop he had developed his own distinctive style, often

characterised by brilliantly lit figures with crisp outlines and frozen poses. Two of Bronzino's early works are in the Uffizi – an angular and sculptural *Pietà*, and the mythical Greek story of *Pygmalion and Galatea*. Pygmalion was a Cypriot sculptor who fell in love with an ivory statue he had made of the maiden Galatea; the goddess Aphrodite brought it to life after he sacrificed an ox to her, and he married his former statue.

Bronzino frescoed the pictures in Eleonora's chapel with an undercoat and then overpainted them with tempera, creating an amazingly bright and colourful, but extraordinarily political, chapel. He painted the vault first, with four saints sitting on clouds against a background of a bright sky. Above the altar the Archangel Michael is about to slaughter Satan, depicted as a scraggy dragon, with the sword he wields above his head. The other saints in the ceiling are more peaceful, searching for God. On the right,

Far left
Bronzino: *Pygmalion and Galatea*
(Uffizi)

Left
Bronzino: ceiling of the Chapel of
Eleonora di Toledo in the Palazzo
Vecchio

Right
Bronzino: *The Crossing of the Red
Sea*, in the Chapel of Eleonora di
Toledo in the Palazzo Vecchio

St Francis is about to receive the stigmata, and on the left St John the Evangelist stares at his eagle as he has his vision of the Apocalypse on the island of Patmos. Above the entrance door, a penitent St Jerome sits beside his friendly lion as he clutches the rock with which he has beaten his chest.

The saints are separated by brown bands decorated with painted versions of the della Robbia workshop's brightly colourful fruit festoons, and cheerful winged *putti*, both by then conventional ornamentation. Originally Bronzino painted a combination of the Medici and Toledo coats of arms in the centre of the vault, but after Eleonora died aged only forty in 1562 it was replaced with a *Trifrons* on a golden background, a surprising revival of Savonarola's vision of the Holy Trinity. The pendentives in the corners of the chapel below the vault are painted with medallions holding small *trompe l'œil* statues of the Cardinal Virtues. Fortitude, in tune with the spirit of the times, is now portrayed as a man,

breaking a column with his arms, and Justice as a naked lady; but Prudence and Temperance have faded.

The Virtues of a good government give a hint as to the theme of the paintings on the walls of the chapel, which illustrate stories from the life of Moses, showing him, in a compliment to Duke Cosimo, as a successful and caring leader of his people. The largest picture, on the right-hand wall, shows the *Crossing of the Red Sea*. After their successful crossing of the sea, Moses – identifiable by the rays of light bursting like horns from his head and wearing trendy bright blue boots – is seated in the foreground on the right instructing Joshua, kneeling in front of him and wearing a golden hat, to lead the Israelites. In the background the defeated Egyptian horsemen are floundering in the sea as they return home. Over on the far left we can just see the crescent moon of the Strozzi family on a red banner carried by drowning Egyptians.

The role of a ruler to ensure essential supplies for his people is illustrated on the opposite wall. To the left of the window, in the *Miracle of the Spring*, Moses strikes a rock with a rod, causing water to pour forth, into the mouths of the parched Israelite men and the bowls of the women who give it to their children. Women looking after their families are illustrated again in the *Gathering of Manna*, on the right of the window, which shows them collecting the drops of manna falling like frost from the sky, while men, one of whom on the left has an amazing glamorous pose, help them to store it in jars to feed their starving families.

The painting on the wall around the entrance door to the chapel tells an even stranger story, of the *Brazen Serpent*.

When the Israelites grumbled that they were starving and thirsty in the desert, and would have been better off staying in Egypt, God sent poisonous snakes to bite them. Moses made a bronze snake and put it up on a pole, and those who looked at it lived. The foreground is full of the bodies of Israelites wrestling with snakes or dying from their bites, while those in the background gaze with relief at the brazen serpent on its T-shaped pole, resembling a cross. The moral, aimed no doubt at visitors to the chapel, seems to be the importance of remaining loyal to your leader.

The altarpiece of the *Deposition of Christ* is a copy made in 1553 by Bronzino of his original painting which had been sent, soon after it was finished in 1545, as a diplomatic gift

are the Rooms of Ceres, Opis, Jupiter, and Hercules. The decoration of the whole apartment was completed in three years, thanks to Cristofano Gherardi's help with the frescoes and Marco Marchetti's with the numerous grotesque ornamentations on the vaults.

Vasari's next major project was in the Hall of the Five Hundred on the floor below, where he raised the roof by over 20 feet and with the help of his assistants decorated the thirty-nine panels between the massive trusses of the ceiling with paintings of important episodes from the life of Cosimo I. The circular central panel shows the apotheosis of Cosimo, in which angels exchange his earthly crown for a halo as he ascends into heaven. Vasari also frescoed the walls with six huge illustrations of Florence's military victories. On the left wall as we look towards the statue of Pope Pius X, there are battles against Pisa that resulted from the French invasion in 1494, and on the right wall episodes from the war against Siena that ended in 1555 with Cosimo de' Medici being declared Duke of Siena as well as of Florence.

Far left
Vasari: *Allegory of the Immaculate Conception*, in the Altoviti Chapel in Santi Apostoli

Above
Vasari: Vulcan's forge and the Birth of Venus, in the Room of the Elements in the Palazzo Vecchio

Left
Vasari's paintings on the walls and ceiling of the Hall of the Five Hundred in the Palazzo Vecchio

Duke Cosimo must have been pleased with Vasari's work in the Hall; after he had been working there for a year, he started to decorate three rooms round the corner, known as the Apartments of Leo X. In the Room of Leo X, a fresco on the wall shows Leo entering the Piazza della Signoria when he visited Florence in 1515 for the first time after becoming Pope. The painting on the ceiling shows the troops of his ally, the Emperor Charles V, retaking Milan from the French in 1521. Next door, the walls of the Room of Lorenzo the Magnificent are frescoed with *grotteschi*, and the central panel of the ceiling shows foreign ambassadors presenting Lorenzo with animals including a giraffe, two camels, a leopard and a lion, and four horses. As well as the gifts laid in front of his throne,

his son Giovanni, who later became Pope Leo X, presents him with the cardinal's hat that Lorenzo obtained for him. The semicircular panel at its foot commemorates Lorenzo's humanism; he sits holding a red book on his lap, surrounded by philosophers and scholars. The last room in the apartment is the Room of Cosimo il Vecchio. The painting in the central panel of the vaulted ceiling shows Cosimo the Elder being welcomed by the city fathers outside the walls of Florence as he returned from his year in exile in 1434. While Bronzino was commissioned mainly to paint the current generation of the Medici family, Vasari's mandate was to glorify their ancestors.

While he was working at the Palazzo Vecchio, Vasari was also decorating the house at 8 Borgo Santa Croce that Duke Cosimo granted to him in 1557, as a supplement to his salary as court artist. The frescoes in the large hall reflect Vasari's enthusiasm for his profession, celebrating the arts, showing stories of Classical painters, and also portraits of his favourite painters recounted in his *Lives of the Artists*.

As well as renovating the inside of the Palazzo Vecchio, Duke Cosimo wanted to smarten up the buildings around the Piazza della Signoria. He encouraged Giovanni Uguccioni, one of his courtiers, to build the Palazzo Uguccioni which faces the Palazzo Vecchio from the north side of the square. It has one of the most handsome Roman-style façades in the centre of the city, built between 1550 and 1559 by a Roman architect, Mariotto di Zanobi Folfi, to a design influenced by Raphael or Michelangelo. The ground floor is heavily rusticated, and the smooth upper storeys are decorated with pairs of columns, Ionic on the *piano nobile* and Corinthian on the upper floor. Giovanni Uguccioni's brother Benedetto, who inherited the palazzo when Giovanni died in 1559, later added the handsome portrait bust of Cosimo's son, Duke Francesco de' Medici, standing above the front door on a ram's head decorated with golden stars, probably made by Giovanni Bandini.

Duke Cosimo hired another artist to work on the Palazzo Vecchio. Bartolomeo Ammannati, like many sculptors and architects who worked in Florence, was born

into a family of stonemasons in Settignano. He trained as an apprentice sculptor in Baccio Bandinelli's studio, and learned architecture when he worked in Venice with Jacopo Sansovino (Andrea's pupil, but no relation) on the famous library of St Mark's. One of his early works, in the Bargello, is an erotic *Leda and the Swan*, which he sent to Francesco Maria della Rovere, Duke of Urbino, perhaps for his son Guidobaldo. The composition of the sculpture, based on a lost painting by Michelangelo, shows the naked Greek princess lying down as she is seduced by Zeus, disguised as a swan, squeezing between her legs to peck her lips, with the result that she gave birth to Helen of Troy, the most beautiful woman in the world. Another of Ammannati's early works in the Bargello is *Victory*, a statue, originally part of a funeral monument, of a woman standing with one foot on the leg of a man crouching beneath her, and kneeling on his shoulder with her other leg. The composition of Ammannati's *Victory* is

Left
Vasari: *Lorenzo de' Medici receives Gifts from the Ambassadors of Various Nations*, on the ceiling of the Room of Lorenzo the Magnificent in the Palazzo Vecchio

Above
Mariotto di Zanobi Folfi: Palazzo Uguccioni

Right
Bartolomeo Ammannati: *Leda and the Swan* (Bargello)

Left
Bartolomeo Ammannati: *Victory*
(Bargello)

five years, where he worked with Vasari on the handsome Villa Giulia for Pope Julius III. When he returned to Florence he worked alongside Vasari in the Palazzo Vecchio, designing the marble fireplace under Vasari's fresco of Vulcan's Forge in the Room of the Elements, and the gilded stucco work of dancing cherubs on the ceiling of the Room of Lorenzo the Magnificent.

Ammannati was commissioned to make a magnificent fountain for the Hall of the Five Hundred, to celebrate the fresh water supplied to the Palazzo Vecchio by a new aqueduct built on Cosimo's instruction. The aqueduct, begun in 1551, brought water from a spring near the Porta San Giorgio, Orcagna's gate in the city walls at the top of Costa San Giorgio in the Oltrarno, across the Arno above the Ponte alle Grazie, and into the city centre. After the abolition of the Republic, the Hall of the Five Hundred was called the Sala Grande, the Great Hall, so the Fountain of Juno that Ammannati made between 1556 and 1561 is also known as the Fountain of the Sala Grande. It was intended to be installed in the centre of the end of the Hall opposite Bandinelli's sculptures. When they were finished, its components were at first put into the Loggia dei Lanzi, then moved to several different locations, and are now reassembled in the courtyard of the Bargello. The complex symbolism of the statues combines the supply of water and the city. The goddess seated on the centre of the rainbow arc is Juno, protectress of the Roman state. She holds a tambourine, suggesting that she could make thunder, as her husband Jupiter made lightning, creating rainfall. A pair of peacocks, sacred symbols of her proud beauty, perch on the arc on either side of her.

similar to Michelangelo's, but Victory is personified not as a naked man but as a graceful woman wearing clinging clothes, following the ancient Greek tradition, perhaps inspired by the second-century BC Cretan statue of Nike (Victory) in Cardinal Domenico Grimani's collection that Ammannati might have seen in Venice.

In 1550 Ammannati married a poet called Laura Battiferi, whose slightly haughty profile portrait by Bronzino is in the Dining Room on the mezzanine floor of the Palazzo Vecchio. That same year he went to Rome for

part of Elba over to Cosimo in 1546 after Barbary pirates had devastated the island, and Cosimo founded the town, originally called Cosmopoli (Cosimo's town), as a naval base for the Florentine galleys which successfully protected the shores of Tuscany from Barbary pirates and Turkish marauders. Cellini's bust portrays the duke as defender of the people of Tuscany, staring determinedly and wearing elaborate Roman armour, decorated with the head of a lion and a curious horned beast on his shoulder, and a winged head of a Gorgon on his chest.

Another project that Cellini offered to do for Duke Cosimo was to restore an antique Greek marble statue of a naked boy that had been sent to the Duke as a present. As well as restoring the head, arms and feet, Cellini added an eagle standing beside the boy, looking up at him, so 'we can christen it *Ganymede*'. In another of the Greek myths about Zeus's passions, Ganymede was the outstandingly beautiful son of Tros, the King of Troy. Zeus fell in love with Ganymede, and transformed himself into an eagle to carry him off to Mount Olympus, the home of the Greek gods, to serve them as their cup-bearer. The statue was seen as endorsing homosexuality. Although he denied it, Cellini was bisexual. He described sodomy to Duke Cosimo as 'the practice of the greatest emperors and greatest kings of the world', but the Duke did not join that group. There is another sculpture of *Ganymede* in the Bargello, made of bronze, which shows a naked young man sitting astride the shoulders of a large eagle, spreading its

wings to take flight. This used to be thought to be also by Cellini, although it is not mentioned in his autobiography, and is now attributed to Ammannati.

Two more marble statues by Cellini in the Bargello illustrate homosexual love stories of Greek mythology. *Apollo and Hyacinthus* shows the god Apollo, son of Zeus, standing beside his mortal lover Hyacinthus, a teenage boy sitting on the ground behind him. The statue was kept in Cellini's workshop until he died, probably because it demonstrates his enthusiasm for homosexual love affairs so blatantly. *Narcissus* is a beautiful young man gazing down at the pool we have to imagine at his feet, falling in love with his own reflection. Cellini may also have made this statue for himself, as it was in his shop in August 1557 when the rising waters of the Arno flooded Florence, toppled it off the wooden block it was standing on, and broke it across the chest. Cellini managed to put it back together, and disguised the crack with a garland of flowers, which has since gone, perhaps eroded away during the years when the statue was kept in the Boboli Gardens, behind the Palazzo Pitti.

While Cellini was celebrating pagan mythology, his bitter enemy Baccio Bandinelli, having finished working on projects glorifying the Medici, persuaded Duke Cosimo to instruct the Works Department of the Cathedral to commission him in 1547 to build a new choir under the centre of the dome of the Duomo. Bandinelli was assisted by the architect Giuliano di Baccio d'Agnolo in its design, replacing a wooden enclosure originally designed by Brunelleschi after his dome had been built, which had been renewed with another wooden structure in 1520. The low octagonal wall of their new grand design followed the pattern of Brunelleschi's choir enclosure. To this were added pilasters and columns carrying an architrave supporting balustrades between four arches facing the nave and each of the three tribunes. All this grand superstructure was removed in the nineteenth century, leaving only the marble wall, decorated with shallow relief sculptures of prophets, apostles and saints. Many of these sixty-four sculptures may be hard to see, as the choir is usually fenced

the fountain, and assisted by the Flemish sculptor Jean de Boulogne, known by the Italians then and everyone since as Giambologna, he added the bronze statues of sea gods and nymphs reclining on pedestals framed by fauns on the rim of the octagonal basin around the fountain, and the laughing satyrs on the corners.

As well as employing Ammannati and Giambologna to associate himself with Classical gods in the minds of the citizens of Florence, Duke Cosimo commissioned them to make several bronze birds to ornament the grotto in the garden of his restored villa at Castello. Together they made a falcon and a couple of owls, now displayed on the first floor balcony around the courtyard of the Bargello, along with a remarkably realistic eagle, turkey and peacock made by Giambologna.

Ammannati had another major project during these years. The flood of 1557 that toppled Cellini's *Narcissus* also washed away Taddeo Gaddi's Ponte Santa Trinita. Duke Cosimo commissioned Ammannati to design a replacement. Michelangelo was consulted by Ammannati to review his design, and he may be responsible for the

protruding points of the piers, which deflect the waters of a flood, and for the three elegant elliptical arches, which have the same curves as the tops of Michelangelo's tombs in the New Sacristy of San Lorenzo. Ammannati's bridge, built between 1567 and 1571, was blown up by the retreating Germans in August 1944, and was reconstructed *Come era e dove era* (As it was and where it was) in the 1950s. Duke Cosimo's emblems of goat's heads beneath relief sculptures of prancing capricorns were reinstated at the centres of the arches on the sides of the bridge, preserving another record of how art was almost entirely devoted to the Medici during the years of his dukedom.

After conquering Siena and acquiring its territories in 1559, Duke Cosimo wanted to tighten his control over the government of Florence by bringing its administrative and judicial offices spread around the city into one convenient location. In 1560 he commissioned Vasari to design the Uffizi – 'Offices' – consisting of two long wings joined by a loggia overlooking the Arno, around a narrow courtyard that is almost a street leading from behind the Loggia dei Lanzi down to the river. The façades are prime examples

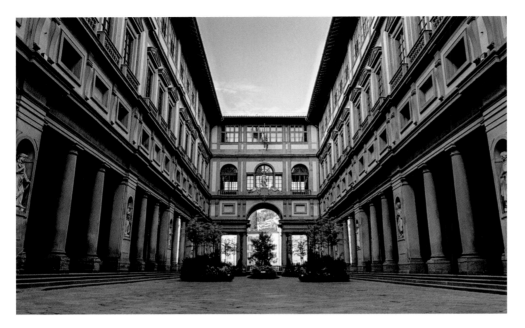

of Mannerist architecture, using Classical elements for decorative as much as functional purposes. The tall vaulted arcades on the ground floor are carried on Doric columns and broad piers. The twenty-eight statues of illustrious Tuscan soldiers, statesmen, scientists, artists and writers were inserted into the niches in the piers in the mid-nineteenth century. Above the entablature there is a row of rectangular frames separated by console brackets, some around blank windows, most of them around light shafts illuminating the complex strapwork decoration on the barrel vaults of the arcade, revealing that this is not the mezzanine floor that it appears to be when seen from the courtyard. The *piano nobile* has the most elaborate decoration: each of the windows in groups of three has a balcony and an aedicule frame, with triangular pediments on the outer pair and a segmental pediment in the centre. The windows on the top floor are later additions; originally it was unglazed.

The most spectacular part of the palazzo is the loggia by the Arno. The Serlian arch on the ground floor, with pairs of columns carrying a heavy entablature, is repeated in the Venetian window on the first floor overlooking the long courtyard. In front of the window is a group of statues, of Duke Cosimo standing between a male and a female reclining nude, modelled on the figures on Michelangelo's tombs in the New Sacristy of San Lorenzo. The statue of the Duke dressed as a soldier wearing contemporary armour under his cloak was made by Giambologna in 1585, eleven years after Duke Cosimo died, so he could not have felt insulted by the cheeky codpiece peeking through the split in his armour, but he would have been proud if had been able to see the large letters engraved on the plinth below the statue, 'CMMDE', standing for *Cosmus Medices Magnus Dux Etruriae*, 'Cosimo de' Medici, Grand Duke of Tuscany'. Cosimo's status is repeated by a stone copy of the grand-ducal crown of Tuscany, above a large scrolly shield bearing the Medici *palle*, in front of the cornice below the plinth.

Giambologna's statue replaces one made by Vincenzo Danti twenty years or so earlier. Danti was a Perugian sculptor who Cosimo summoned to his court in 1557. His slightly absurd statue of the podgy *Cosimo as Augustus*, dressed as a Roman emperor, is now in the Bargello, along with his *Honour Triumphant over Falsehood*, one of the first sculptures that Danti made in Florence. Its composition

Left
Giorgio Vasari's corridor across
the Ponte Vecchio

Right
Giorgio Vasari: *Assumption of the
Virgin*, in the Badia

Right, below
Bronzino: *Martyrdom of St
Lawrence*, in San Lorenzo

by goldsmiths' shops; even today there are still several
jewellery shops. The fish market on the riverbank by the
Uffizi was moved to the Mercato Vecchio, where the Loggia
del Pesce, a grand gallery with two rows of nine arches
designed by Vasari, was built in 1568; demolished in the
nineteenth century, it was recreated in the Piazza dei Ciompi.

Vasari found some time to paint during the years he
worked as Duke Cosimo's architect. His religious paintings
have crowded and complex compositions, often with rather
murky colours against dark backgrounds. However, the
robes of the figures in his *Assumption of the Virgin* in the
Badia have brighter colours. The huge painting has a
magnificent frame behind an intricately carved *cantoria*
balcony above Mino da Fiesole's monument to Ugo, the
Margrave of Tuscany, in the left transept. The elaborate
gilded frame also houses two colourful panels of monks
talking to bishops, and two round portraits of female saints,
supported by the leafy legs of pairs of cherubs.

Bronzino's style deteriorated in a similar way, but
in 1565 Duke Cosimo commissioned him to paint the
Martyrdom of St Lawrence on the wall of the left aisle in
the church of San Lorenzo. This huge and very memorable
fresco, full of light and colour, was unveiled on the saint's
feast day in 1569. One of the most bizarre purportedly
religious paintings, it shows St Lawrence looking so
relaxed as he lies on a gridiron above burning coals: perhaps
he is asking the man who is stoking the fire behind him
to turn him over. St Lawrence waves his hand towards
the Emperor Valerian, who ordered the persecution of
Christians, and who sits at the top of some stone steps
pointing at the martyr. The poses and gestures of the saint

and the emperor echo Michelangelo's famous fresco of God reaching to touch Adam's hand on the ceiling of the Sistine Chapel. These main characters in the painting are surrounded by a crowd of energetic figures in contorted poses – soldiers, executioners, and some grieving men. A colourful group of surprisingly unconcerned women sit in the foreground holding their babies. Two cherubs fly down bringing Lawrence his martyr's crown, a palm leaf and a chalice. These last two are naked, but most of the other males have cloths draped around their loins, in acceptance of the judgement of the Council of Trent, which ordered that the nude figures in Michelangelo's *Last Judgement* in the Sistine Chapel should have loincloths and fig leaves painted over their private parts.

The orderly architecture of the upper part of the fresco, contrasting with the jostling crowd below, shows that it is a homage to Michelangelo as much as to its subject saint. In the centre of the background is the dome of a church, a simplified version of Michelangelo's dome of St Peter's in Rome, between two Corinthian arcades painted with detailed precision, displaying statues of nude men, in Michelangelo's style. The statues, standing with their weight on one leg, like Michelangelo's *David*, wear metal garlands of fig leaves around their loins, like the one that had been put around *David* by the Cathedral authorities earlier in the century. Standing in front of the pedestal of the statue that looks like Mercury on the left are three fully clothed small figures. In the middle of these three is a self portrait by Bronzino, between a man with a long grey beard on his left, his first employer Jacopo Pontormo, and Alessandro Allori, his pupil and adopted son.

Michelangelo died in Rome in 1564. His body was brought back to Florence by his nephew Lionardo, and after a grand funeral in San Lorenzo sponsored by the Medici was buried in Santa Croce. His tomb, designed in 1570 by Vasari and incorporating allegorical decorations specified by Vincenzo Borghini, is behind the first column in the right aisle. His portrait bust stands on a sarcophagus shaped like the ones he designed for the Medici dukes in

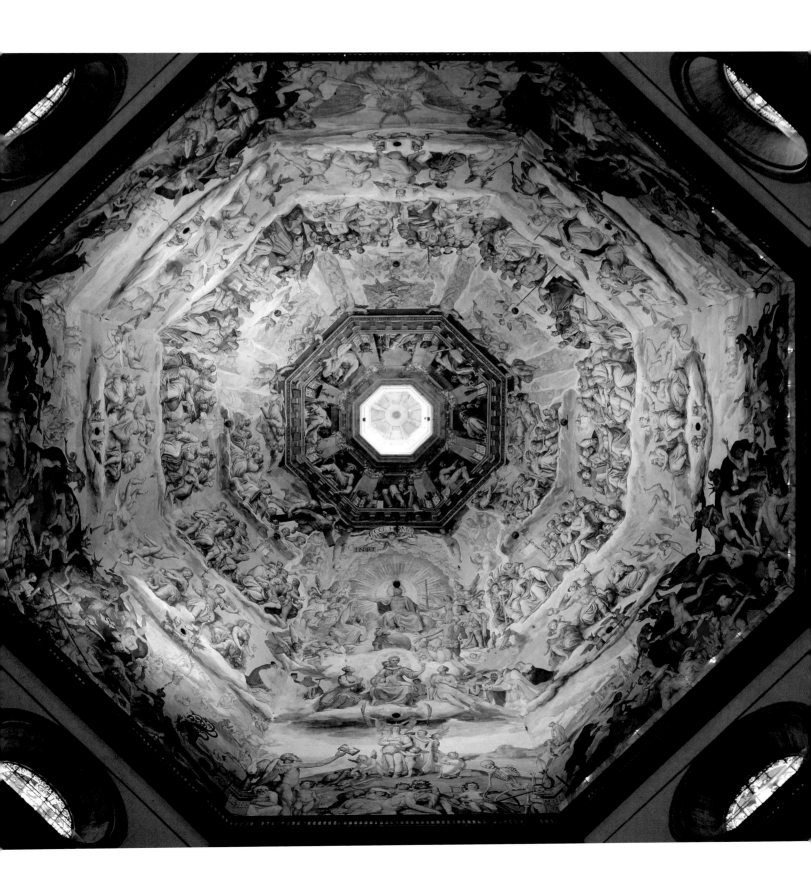

GIAMBOLOGNA, AND THE LAST OF MANNERISM

I f we walk through Ammannati's grand courtyard at the back of the Pitti Palace into the Boboli Gardens, and turn left, we pass a copy of Valerio Cioli's comical Fontana del Bacchino, the Fountain of Little Bacchus. It portrays Duke Cosimo's popular court dwarf, Nano Morgante, as a plump drunkard sitting undressed astride a turtle, reflecting how the spirit of the age had been influenced by the transformation of Florence from a religious republic to an indulgent dukedom. Morgante lived in the Palazzo Pitti, where there is a double portrait of him by Bronzino in the Palatine Gallery, seen from the front and back, again with no clothes on but holding an owl to hunt for small birds.

After the fountain we continue into a garden court with Vasari's corridor above the wall on the left, and the most amazing grotto at the far end. It was originally built as a reservoir, linked to the aqueduct that supplied fresh water to the Palazzo Vecchio to ensure a continuous supply of water to the gardens. The lower part of the façade was built by Vasari from 1557. The niches, on either side of the Tuscan columns supporting a heavy architrave over the entrance, display handsome statues of Apollo and Ceres by Baccio Bandinelli. The panels above are decorated with Duke Cosimo's capricorns and *Festina Lente* turtles with sails, framed by mosaics. Above the centre of the arch inevitably there is the Medici coat of arms beneath a grand-ducal crown. The two reclining ladies on either side represent Justice, holding a bundle of *fasces*, and Peace, holding a dove. Like the crown and the coat of arms, they are covered with coloured mosaic.

In 1583 Cosimo's son and successor as Grand Duke,

Francesco, decided to transform the reservoir into an ornamental grotto, and appointed Bernardo Buontalenti to direct the project. Buontalenti, whose flattering nickname means 'good talents', was a local architect who had survived the landslide that demolished his family's house in Costa San Giorgio when he was a lad, and had became a pupil of Vasari, adding the top floor gallery to the Uffizi. One of his earliest works is the amazing flight of altar stairs that he created for the church of Santa Trinita, which look as if they were made from folds of cloth curved like waves. They were moved in the course of a restoration in the 1890s to Santo Stefano al Ponte, and are much more at home in the exuberant seventeenth-century interior of that church than they would have been in the severity of Santa Trinita's mid-fourteenth-century gloom. Buontalenti's design for the Grotto is even more original and inventive – no wonder it is named after him. The arch and the pediment of the façade are encrusted with stonework carved to look like stalactites, sponges and seashells, as if we were entering a cave on the seashore. The walls of the first chamber inside are decorated with sheep, goats and shepherds, one of whom plays his pipes, among trees, rocks and stalactites that all look as if they are natural stone but were made of stucco by Pietro Mati. Concrete copies of Michelangelo's *Slaves* are crouching in the corners, as the originals in the Accademia were kept here until 1924. The domed ceiling is frescoed with the sky, as if we were in a pit with all sorts of birds and animals, including goats, monkeys, leopards, bears and a couple of satyrs looking down on us.

The three chambers of Buontalenti's Grotto were frescoed by Bernardo Barbatelli, a prolific local painter

known as Bernardino Poccetti, 'Little Bernard the drinker', after his habit. The second chamber seems like a ruined Roman villa, with frescoes of Juno and Minerva on the walls, and scenes from the Trojan War, framed by bands of stone vegetation, shells and pebbles that seem to have grown organically through the walls. The subjects of the frescoes were inspired by the sculpture of two naked lovers sitting on the corpse of a wild boar in the middle of the room – Vincenzo de' Rossi's *Paris and Helen*, installed here in 1587. Paris was the handsome son of King Priam of Troy. He attended a wedding banquet on Mount Olympus, where Zeus asked him to say who was the most beautiful of the three goddesses, Hera, Athena and Aphrodite – the Greek counterparts of Juno, Minerva and Venus. Paris selected Aphrodite, who rewarded him with the most beautiful woman in the world, Helen, the wife of King Menelaus of Sparta; he abducted her, thereby provoking the Trojan War. Helen fell in love with Paris, which perhaps explains why her beautiful statue sits on his leg, but she doesn't hold on to him and looks apprehensively away from him, as if she is keeping an eye out for her husband. Paris, who has a worried look on his loving face, has a ribbon across his chest engraved with 'VINCENTIUS DE RUBEIS CIVIS FLOREN. OPUS', 'The work of Vincenzo de' Rossi, citizen of Florence'. Taking his cue from Benvenuto Cellini's *Perseus with the Head of Medusa*, de' Rossi clearly wanted to confirm his citizenship.

The walls of the oval third chamber have niches containing huge stone fountains that appear to have grown organically like stalagmites in a natural cave. The ceiling dome is frescoed with vines growing over a metal pergola, and birds flying past the spaces in the frame, as if we were in an underground garden. In the middle of the chamber a pillar supports a large green marble basin, with four stone satyrs clinging to its corners and gaping up at a *Bathing Venus*, standing on a heap of stones and shells in its centre. Giambologna's beautiful sculpture of a tall woman with smoothly polished skin, twisting sideways as she stands with one foot lifted onto the base

of an amphora, was made for the Boboli Gardens in 1573, and installed here twenty years later.

Vincenzo de' Rossi was born in Fiesole in 1525. He trained as a sculptor apprenticed to Baccio Bandinelli, whom he assisted with the statue of Pope Leo X in the Hall of the Five Hundred. He went to work in Rome in 1546, where he made *Paris and Helen*, which he gave to Duke Cosimo in 1560 to demonstrate his talent. Cosimo clearly appreciated the diversion of art away from its original purpose of religious illustration and from his aim of promoting the prestige of his family to the erotic entertainment provided by the statue. De' Rossi's gift paid off: Cosimo commissioned him to make twelve marble sculptures illustrating events in the story of Hercules to surround a fountain in the Boboli Gardens, which he began two years later. By 1584 de' Rossi had finished seven of the statues. One of them, *Hercules carrying the Sky*, is at the entrance gate of the palatial Villa di Poggio Imperiale on the Arcetri hill south of the city, which Duke Cosimo confiscated from his political opponent Alessandro Salviati in 1565, and gave to his daughter Isabella. The other six were moved to the Hall of the Five Hundred in 1592. While the artistic depictions of the Labours of Hercules of the previous century were been intended to represent the triumph of good over evil, de' Rossi's statues are fiercely violent, embodying heroism, and some have homosexual overtones.

The first of the sculptures standing on a pedestal on the western side of the Hall, close to Bandinelli's statue of Duke Cosimo, is *Hercules and Antaeus*. Unlike Pollaiuolo's version, Hercules does not quite lift the giant

Vincenzo de' Rossi: statues of Hercules in the Hall of the Five Hundred in the Palazzo Vecchio

This page
Hercules and Antaeus, Hercules and the Centaur and *Hercules and Cacus*

Opposite
Hercules and Hyppolita, Hercules and the Erimanthian Boar, and *Hercules and Diomedes.*

off the ground, and seems to be hugging him round the waist rather than trying to crush him to death. The next one is the dynamic *Hercules and the Centaur*. Nessus, the centaur lying on his side, had kidnapped Hercules' third wife, Deianira, and he and Hercules are about to whack each other with the clubs they are waving. The fourth sculpture beside the western wall of the Hall is *Hercules and Cacus*. Cacus also is lying down and about to be beaten vigorously. It was not one of Hercules' labours to kill Cacus, but he stole some the cattle of Geryon, which were Hercules' tenth labour to obtain, so he was killed.

On the eastern side of the Hall the statue opposite *Hercules and the Centaur* is *Hercules and Hippolyta*. Hercules' ninth task was to capture the magical girdle of Hippolyta, the Queen of the Amazon tribe of female warriors, as a present for the daughter of his master,

753 BC Romulus and his followers needed wives to start families. Their neighbouring Sabines, who lived in the mountains north of Rome, refused to allow the Romans to marry their women, so the Roman settlers invited the Sabines to a festival, and abducted their women. The *Rape of the Sabines* still stands today in the Loggia dei Lanzi. The main figure has his back towards the piazza; the dramatic sculpture wasn't intended to be seen from just one point of view, but from all around. A strong young Roman man lifts a woman over his shoulder, and stands astride a crouching bearded older man, perhaps her husband or father, who raises his arm in self-defence. The abductor presses his

fingers into the soft flesh of the Sabine woman's left hip, and she twists back, trying to escape from his grasp.

Duke Francesco also commissioned Giambologna's most famous work, a life-size bronze statue of flying *Mercury*, finished in 1580 for a fountain in the Medici Villa in Rome where his younger brother Cardinal Ferdinando de' Medici lived. Now in the Bargello, *Mercury* is a slender young man balancing on his toes on a column of air spouting from the mouth of Zephyr, the personification of the west wind in Greek mythology. With wings on his helmet and his ankles, he leaps forward carrying his caduceus entwined with snakes in one hand, and pointing his index finger up to

heaven with the other. Two years later Giambologna made another bronze statue, completely different in style and subject, that was also intended for a fountain. His *Nano Morgante riding on a Sea Monster* shows the comical court dwarf riding a creature that looks like a cross between a snail and a dragon, with a spout pointing out of its mouth. This frivolous fountain was made for a garden on the roof of the Loggia dei Lanzi, where there is now a copy in a basin on the terrace of the Uffizi's restaurant; the original is in the Bargello. We would not remember Nano Morgante were it not for Bronzino's portraits and Cioli and Giambologna's fountains, but as they all show him naked he looks like a fat and flabby football – poor fellow!

Valerio Cioli made several more statues for the Medici's Boboli Gardens in the 1590s. Their subjects show how the influence of Classical precedents in the Renaissance was being replaced by informal everyday activities. One statue is of a man digging the earth under his feet with a long-handled spade. One of the fountains, currently being restored, is a of a woman washing a child's hair, and another is of a man pouring a bucket of grapes into a vat held by a young boy.

Although the Medici dominated the arts in Florence in the years of their dukedom, a few other families commissioned significant works. Two of the most notable are the chapels of the Salviati family in the church of San Marco and of the Niccolini family in Santa Croce. Despite Francesco Salviati's involvement in the Pazzi conspiracy, the wealthy Salviati family were closely related to the Medici: Jacopo Salviati married Lorenzo the Magnificent's daughter Lucrezia, and their daughter Maria was Giovanni delle Bande Nere's wife and the mother of Duke Cosimo. There were also several cardinals in the family. They lived in the grand Palazzo Portinari-Salviati at 6 Via del Corso, that Jacopo Salviati bought from the Portinari family.

The Salviati Chapel, on the left side of the nave of San Marco, was designed by Giambologna, along with the huge altar frames of the side chapels of the church, and built between 1579 and 1585. Although Giambologna was primarily a sculptor, the chapel is a most impressive, almost dramatic piece of architecture. The brothers Averardo and Antonio Salviati who built the chapel, following their father's will, are buried in the crypt below it. They were supported by Duke Francesco de' Medici, as the chapel is dedicated to St Antoninus, the Dominican friar Antonino Pierozzi, who was Cosimo the Elder's ally. Although he was a small man, hence his name, 'little Anthony', Giambologna's statue of him standing on a pedestal above the grand Serlian arch that frames the entrance to the chapel seems quite tall. He wears his bishop's mitre and carries a long cross, raising his hand in blessing as he looks down into the nave of the church. Antoninus died in 1459, and his mummified remains, dressed in his archbishop's

robes, lie in a glass coffin behind a grille under the chapel's altar, but Giambologna's bronze effigy of him lying on his back was moved from the chapel to the sacristy of the church in the eighteenth century.

Each of the three walls of the chapel has a large frame, with a protruding broken pediment carried on Ionic columns, around a painting. Colossal fluted pilasters in the corners carry an entablature on their Composite capitals. The gilded inscription on the frieze reads 'AVER. ET. ANT. ALVIATI SANCTO ANTONIO DICARUNT

ANNO DNI M.D LXXXVIII', which translates as 'Averardo and Antonio Salviati dedicated [this chapel] to St Antoninus, AD 1588'. As if this bold message was not clear, a similar inscription, 'AVERARDUS ET ANTONIUS SALVIATI FILIPPI FF. FEC.', 'Averardo and Antonio, the sons of Filippo Salviati, made this', is repeated on the lintels above each of the four doors in the side walls of the vestibule of the chapel, and again, painted in an extended octagonal frame, on the ceiling of the vestibule. The family's involvement is further advertised by their coat of arms in stained glass in the centre of each of the windows of the chapel and the vestibule, and on sculpted shields on either side of the entrance arch. On the left side of the arch, their bright red and white diagonal bands like battlements are

combined with the red and white vertical stripes of the Nerli family for Averardo's wife Alessandra, and on the right with the Gagliano family's emblem, which looks like a scarlet lion prancing behind pairs of diagonal white stripes, for Antonio's wife.

As well as all this promotion of the Salviati family, their splendid chapel does contain some fine works of art, made in the 1580s. There are six statues of saints in niches beside the frames, made by Giambologna with the assistance of his pupil Pierre de Francqueville, a fellow Fleming known to Italians as Pietro Francavilla. St John the Baptist, wearing his ragged camel skin on the left of the altar, looks down at it as he steps up on a block of stone and points his index finger up to heaven, indicating where St Antoninus has gone. To the right of the altar a thoughtful St Philip, commemorating the Salviati brothers' father Filippo, also steps up on a block of stone. Around the corner on the right-hand wall the elderly St Anthony, the Egyptian hermit monk, is accompanied by one of the pigs he looked after when he worked as a swineherd. To the right of the frame, St Thomas Aquinas studies his Bible seriously. On the left wall opposite him, St Dominic also holds an open Bible as well as a lily, but smiles benignly into the centre of the chapel. The statue on the other side of the frame, surprisingly, is St Edward the Confessor. Why on earth was an Anglo-Saxon king of England celebrated in a monastery in Florence? About to step out of his niche, as well as wearing a spiky crown and holding his royal sceptre in one hand, he carries a model of a church in the other. The major building project that he undertook during his reign was the rebuilding of Westminster Abbey, so his presence here reminds us of St Antoninus's involvement in

the rebuilding of the monastery of San Marco.

Above each of the statues in their niches are large bronze bas-relief panels, designed by Giambologna and cast with assistance from Fra Domenico Portigiani, a friar of San Marco. They show episodes from St Antoninus's life, set in scenes with buildings drawn in steep perspective, creating the impression of depth in their shallow relief. In addition to reviving the idea of using sculptural panels to tell stories, that we last saw in Benedetto da Maiano's pulpit in Santa Croce, Giambologna's panels introduce political implications, probably to please his patrons. They show Antoninus's obedience to political authority as well as illustrating his commitments to charity and preaching, and his supernatural power. The first scene, above the statue of St Dominic, shows Antoninus kneeling to receive his habit from Giovanni Dominici, the friar who founded the monastery of San Domenico in Fiesole, which Antoninus entered when he was sixteen years old. The next scene, going clockwise around the chapel, shows him standing on the steps of his archbishop's palazzo, giving alms to a beggar who has lost his leg and to another lying on the ground. Round the corner, on the altar wall, Antoninus is preaching to an eager congregation from a high pulpit in a church that might be San Marco before Giambologna's renovations. On the other side of the altar, Antoninus is identifiable by his bishop's mitre as he addresses the Signoria, gathered in front of the Palazzo Vecchio, surrounded by a huge crowd and several men on horseback, on the occasion of his appointment as archbishop. The next scene shows Antoninus standing on the steps of the Duomo bending forward to forgive the members of the Signoria who kneel or bow in penitence, having been excommunicated because of their political dispute with him. The last scene shows him flying like an angel below the ceiling of a nobleman's home as he miraculously brings a boy back to life, in front of his delighted family.

In the centre of the pediment above the altarpiece a bronze angel stands on one leg as if he has just come through the window behind him, against which his raised arm and wings are silhouetted. The angel's prancing pose, similar to that of his *Mercury*, is typical of Giambologna's style, as are the two chubby cherubs who wave at us as they lie beside him on bronze blankets on the curved segments of the pediment.

The altarpiece below is of *Christ's Descent into Limbo*, by Alessandro Allori. The inscription on the frieze above, 'ECCE FILIUS TUUS', 'Behold your son', explains the painting, which shows Christ returning from limbo and greeting his mother – a more appropriate subject for a family's memorial chapel. Mary wears her usual blue dress, but has a dark brown veil, causing some to suggest that she might be a portrait of the Salviati brothers' mother. Christ wears a pink and blue silk robe, patterned with flowers. The curly-haired angels behind them, one of whom holds a banner signifying Christ's victory over death, and the other a bunch of lilies, symbolising the Virgin's purity, wear dresses made of material with multicoloured stripes. Perhaps their lavish clothes are intended to celebrate the first source of the Salviati family's wealth in the cloth trade, before they set up their banking business. Adam and Eve kneel in the foreground, looking gratefully up at Christ for having saved humanity from their mistake, and Christ stands on a rock, crushing the back of the serpent with a female head who led them astray. A group of saints stand behind Christ, including Moses who rests a hand on his tablets of stone, and St John the Baptist, carrying his cross. In the background, the souls whom Christ rescued in his visit to limbo rush out of a cave and ascend into heaven.

The brightly coloured painting on the chapel's right wall is the *Calling of St Matthew* by Giovanni Battista Naldini, a local painter who had trained with Pontormo and Vasari. Jesus stands in the centre, pointing towards a huddle of partially clothed men, women and children below the steps in the foreground, suggesting to a sceptical St Matthew that they should be his concern, rather than his tax-collector colleagues in the arcade behind him. The scene is set in a city of contemporary architecture, so we are reminded of St Antoninus's calling and his support for

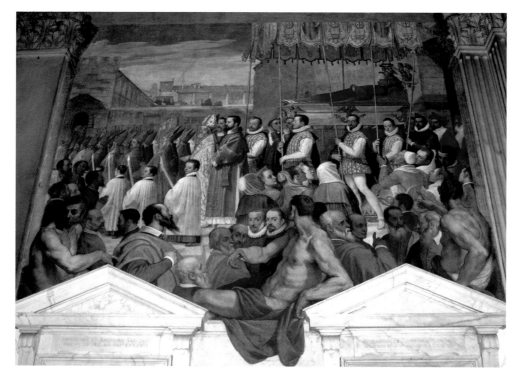

Left and below
Il Passignano: *Funeral Procession
of St Antoninus*, and *Adoration of
the Body of St Antoninus*, in the
Salviati Chapel, San Marco

THE HEART OF THE RENAISSANCE

Left
Alessandro Allori: *The
Assumption of the Virgin*, in the
Niccolini Chapel, Santa Croce

Right
Giovanni Antonio Dosio:
doorway to the Niccolini Chapel,
Santa Croce

fruit and flowers, in front of a long cross and a bishop's crozier tied together by the tassels of a cardinal's hat.

The two paintings by Alessandro Allori in the Niccolini Chapel focus on the dedication of the chapel, and not on the achievements of the family. The *Assumption of the Virgin*, above the altar, has strong contrasts characteristic of the art of the age. The background of most of the painting is dark, almost black, apart from the golden glow around Mary's head at the top. Dressed in dark blue and red, Mary stands calmly on the cloud that takes her up to heaven, towards a golden crown that hangs from the beam above the picture, while the cherubs waving bunches of flowers around her leap about, and the disciples crouching in the foreground, dressed in bright pink, orange and gold, gesticulate vigorously. Stylistically, the *Coronation of the Virgin* at the opposite end of the chapel is similar. Mary prays and kneels calmly while God places a crown on her head, and Christ holds her shoulder as he sits supportively behind her. The dove of the Holy Spirit radiates a golden glow above her, shining a bright light onto the figures in the foreground. One of them, wearing only a laurel wreath and a gold loincloth, tumbles backwards and raises an arm to protect his eyes from the light. Another, probably St John the Baptist as his tunic seems to be made of camel skin, has an even brighter scarlet cloth on his lap that stands out against the black background. The other saints wave their arms and stare upwards appreciatively at the heavenly ceremony.

The frames around Allori's pictures are inlaid with marble of various shades of grey that looks like a slice of a wave. The recesses in the walls in which *Moses* and *Aaron* sit have frames with shoulders like Michelangelo's blank

windows, and are set between columns made of streaky grey and white marble, contrasting with the pale brown of their bases and capitals, supporting segmental pediments. The alcoves behind the statues of the Virtues have curved backs and giant shells at their tops made of marble of darker shades of grey, contrasting with the near-white marble of the pairs of giant fluted pilasters, with delicately carved acanthus leaf capitals, on either side of each alcove. The walls of the chapel are inlaid with panels of naturally patterned polished marbles, in shades ranging from black and white to bronze, dark red, and warm pale brown.

The wide range of colours and articulated surfaces of all the walls would make a strong contrast with the Gothic style of the church, were the chapel not built outside the transept. However, the entrance doorway to the chapel

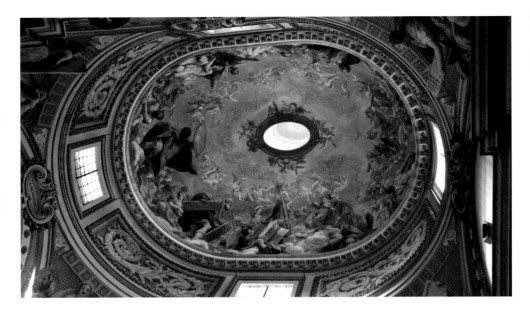

Left
Volterrano: frescoes in Giovanni
Antonio Dosio's dome of the
Niccolini Chapel, Santa Croce

from the transept is framed by a bold Mannerist-style portal with columns and frieze of bright red and white variegated marble, and the surrounding wall is covered with panels of extraordinary black, grey, white and pink marble. Between the two halves of the broken arch pediment, the Niccolini family's coat of arms is made very striking by the crimson, white and blue stripes on the shield. The cherub above the cartouche carries a grand-ducal crown, showing the loyalty of generations of the Niccolini family to the Medici. An inscription on another cartouche with rolled-up ends above the door translates as 'This chapel, unfinished by Giovanni Niccolini, was illuminated, ornamented and finished by Marquis Filippo, his son, in 1664'. Indeed, it was Filippo Niccolini, who was granted the Marquisate of Montegiovi, a small hill town in the province of Grosseto south of Siena in 1625, who arranged for the stretched circle of the dome and its pendentives to be painted by Baldassarre Franceschini in 1653–61.

Franceschini, known as Volterrano after his home town of Volterra, frescoed the dome in a busy Baroque style. The figures shrink in size from those around the lower rim to the cherubs who hold up the lantern in the centre as they fly beneath the golden glow of heaven, creating the impression that the dome rises far higher in the sky than it actually does. Moses and several others seem in danger of slipping over the cornice at the base. He carries his tablets of stone and King David, wearing a crown, carries his harp. St John the Baptist holds his cross with a ribbon tied around it that reads 'ECCE AGNUS', 'Behold the Lamb (of God)'. An Evangelist shows his book, and other characters hold symbols of the Virgin Mary's virtues, like a sheaf of wheat, a sprig of laurel and a bunch of lilies. At the altar end a warrior displays a large shield painted with a child's face radiating light. At the other end, God and Christ put a crown on the Virgin's head, giving the fresco its title, the *Coronation of the Virgin*. Mary and the Holy Trinity sit on a cloud held up by cherubs swarming like bees, while angels fly nearby, playing a violin, a flute, and a lute.

Three of the four pendentives show Sibyls, prophetesses assisted by cupids carrying panels with biblical quotations referring to things that were or will be lifted up – Noah's Ark, a woman, and the fruits of the earth – echoing the chapel's dedication to the Assumption of the Virgin. The fourth fresco shows a prophet staring at the stone slab that a cupid holds up for him to read, so we cannot see what it says. By the middle of the seventeenth century religious

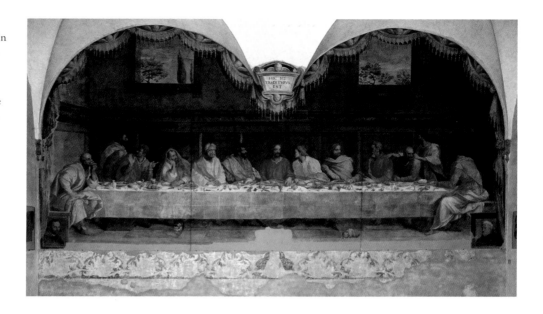

art had altered a lot since it related stories from the Bible.

A fresco that Allori had painted in the old refectory of the church of Santa Maria del Carmine in 1582 shows that traditions had not changed much by then. As usual in a monks' dining hall, the subject is the Last Supper, and Christ sits at the centre of the long table, with six disciples on either side. A panel on the corbel above Christ's head reads 'HIC ME TRADITURUS EST', 'I will be betrayed', provoking the reactions from the disciples. The tablecloth is covered with fruits and leaves as well as plates of bread and glasses of wine, and a couple of cuddly cats sit below it. At the lower corners frames enclose Allori's self portrait looking at us on the left, and on the right a portrait of the white-haired Father Luca, sponsor of the fresco.

Francesco de' Medici and his wife Bianca both died of malaria on the same day in 1587. Ferdinando, Francesco's younger brother, succeeded him as Grand Duke of Tuscany and commissioned a bronze equestrian statue of their father Cosimo, which dominates the part of the Piazza della Signoria between the Palazzo Uguccioni and the Palazzo Vecchio. It took four years to cast the large trotting horse, and three more to add the dignified figure of Duke Cosimo and to make the marble pedestal. While Ammannati's

Left
Pietro Francavilla: bust of Duke
Ferdinando, in the loggia of the
Ospedale di San Paolo

Right
Giambologna: Chapel of the
Madonna del Soccorso in
Santissima Annunziata

Fountain of Neptune celebrated Duke Cosimo's naval power, Giambologna's statue commemorates his military success. Dressed ready for action, Cosimo sits on a saddle with his feet in the stirrups and the horse's bridle in his hand. He wears armour under his cloak and holds his commander's baton in his right hand, while his long sword hangs in its scabbard from a strap by his side. Cosimo's symbols are carved on all sides of the elaborate pedestal. At the ends, his capricorns look as if they are trying to leap out under the rim, pushing their heads out over straps of stone and poking their paws out below them, and his turtles are trapped trying to squeeze out below the stone panels framing bronze plaques. The plaque in the panel at the front of the pedestal praises Duke Cosimo and records that the statue was erected by Ferdinando in 1594. The three bas-reliefs on the other sides of the pedestal record the major events of Cosimo's life. The Latin inscription above the one at the back describes the scene below as the Signoria gathering around Cosimo to tell him that they had chosen him as the Duke of Florence in 1537. The panel on the left side shows Cosimo entering Siena on a chariot after having conquered the city in 1555, below a crowned shield bearing the Medici coat of arms. The panel below a similar shield on the right side shows Pope Pius V crowning Cosimo as Grand Duke of Tuscany in 1570 in a church full of clergymen and soldiers.

In 1594 a portrait bust of Duke Ferdinando made by Pietro Francavilla was placed over an arch in the centre of the loggia of the Hospital of San Paolo, facing the church of Santa Maria Novella across the piazza. Ferdinando had taken over control of the hospital from its nuns, as it was deteriorating under their management, and converted it into a convalescent home. Although it was still a home for the sick, Ferdinando has engraved armour plates around his shoulders. He has a curly tuft of hair on his forehead and a moustache as well as whiskers on his cheeks and a goatee beard. Perhaps because we can only see his face from the ground below, he seems to stare arrogantly over our heads.

Giambologna lived in 26 Borgo Pinti, now called the Palazzo Bellini delle Stelle. Above the front door there's a bust of Ferdinando de' Medici that Giambologna made in 1603, and above the central first floor window the coat of

arms that Ferdinando granted him, combining a cross, the head and shoulders of a Florentine lion holding a ball, and three Medici *palle*. These emblems appear again, gilded with a scarlet background, on a shield above the arch of the chapel at the end of the circular tribune of Santissima Annunziata. The chapel, dedicated to the Madonna del Soccorso, Our Lady of Succour, or Perpetual Help, was acquired by Giambologna in 1594 for his funeral chapel. He was allowed to devise his own decorations for it, provided that he complied with the decrees of the Council

of Trent. With the help of his pupils, he created a smaller version of the Salviati Chapel in San Marco. He made a bronze Crucifix standing on the altar above his tomb, showing a slender athletic Christ looking subdued despite his thick crown of thorns and the big bolts through his hands and feet. Giambologna also designed six bronze bas-relief panels set into the walls, showing scenes from Christ's Passion: being presented to Pontius Pilate, identified as the man to be crucified, mocked, whipped, carrying his cross, and crowned with thorns.

In the niches above these panels on the side walls are stucco statues of angels and Apostles made by Giambologna's pupil Pietro Tacca, who was also buried behind the altar in the sarcophagus between two marble figures made by Giambologna's other pupil, Pietro Francavilla. The lady on the left holding a flask and a dish represents *Active Life*, traditionally symbolised by Leah, Abraham's grandson Jacob's first wife, who gave him seven children; on the right her sister Rachel, Jacob's second wife, who had only two children after several years of infertility, represents *Contemplative Life*, gazing at heaven.

Above the cherubs thoughtfully holding their chins as they lie on the pediment over the sarcophagus, and between these two ladies, the altarpiece is a *Pietà* commissioned by Giambologna from Jacopo Ligozzi, a Veronese painter who had been called to Florence to be a court artist by Duke Francesco. On the left wall of the chapel is a *Nativity* by Giovan Battista Paggi, a painter from Genoa who had also been one of Duke Francesco's court artists. The best painting in the chapel, on the opposite wall, is a *Resurrection* by Passignano, showing Christ floating up to heaven over the heads of the Roman soldiers who collapse in amazement. The design is similar to Bronzino's in the chapel next door, but the figures are less erotic. The cupola of the dome was painted by Bernardino Poccetti with a fresco of *Paradise*, full of flying cherubs, not the verdant mountain top imagined by Dante.

Soon after he had completed the equestrian statue of Cosimo I, Giambologna began work on another

sculpture of a man and a horse, in a very different style. Made from a single block of marble, his huge *Hercules and the Centaur Nessus* is now on display in the Loggia dei Lanzi, behind his *Rape of the Sabines.* When it was finished in 1599 Duke Ferdinando ordered it to be placed in the Canto dei Carnesecchi, the crossroads of the Via Rondinelli and the Via Cerretani, to ornament the route that the dukes' carriages took from the Palazzo Pitti to the Duomo. The gigantic Hercules stands over his lion's skin across the back of the centaur who had tried to steal his wife, crushing him to the ground and beating him with an iron log. He bends the centaur's human torso back so far that his ribs and muscles are stretched tight, as well as the tendons of his horse's legs.

When Duke Ferdinando commissioned Giambologna to make a statue of himself in 1598, Giambologna reverted from the anatomically accurate dynamism of *Hercules and the Centaur Nessus* to the dignified symbolism of his statue of Duke Cosimo. The equestrian statue of Ferdinando I de' Medici in the Piazza Santissima Annunziata was cast in 1602 and completed in 1607, the year before Giambologna died, with help from Pietro Tacca. Ferdinando's horse is almost a mirror-image of Cosimo's, raising its left front leg instead of its right, but its mane is neatly trimmed compared to the thick shaggy curls of Cosimo's horse. Ferdinando is dressed very similarly to his father, wearing armour and prodding his thigh with his commander's baton. He too carries a sword tucked under his cloak, but he gazes calmly to his right, whereas Cosimo leans back a bit as he looks haughtily down to his left. Ferdinando wears a Maltese

Left
Giovanni Caccini: baldacchino in
Santo Spirito

Right
Door of the sacristy of Santa
Maria Novella, designed by
Fabrizio Boschi and made by
Gherardo Silvani

Caccini also designed the façade of the Palazzo Valori-Altoviti, completed in 1604, in an unprecedented way. The façade of the palazzo, at 18 Borgo degli Albizzi, is decorated with fifteen herms, tapering stone pillars supporting portrait busts, five on each of its three storeys. The portraits are of Florentine poets, authors, scholars and philosophers chosen by the scholarly owner of the palazzo, Baccio Valori the Younger, but typically a handsome portrait bust of Duke Cosimo made by Caccini looks down from the broken pediment above the entrance door.

Caccini was assisted in the design and creation of the baldacchino in Santo Spirito by a local architect and sculptor, Gherardo Silvani, who was also involved in making another spectacular but stylistically inappropriate addition, to Santa Maria Novella. In 1629 he made the portal of the door to the sacristy, in the Tuscan Gothic left transept of the church, to the design of 1616 by the painter Fabrizio Boschi. Gently curved stone waves flow sideways in front of the large seashells above the lintels of the two smaller side doors. It is the pediment above the larger central door that is most striking: as in the Porta delle Suppliche the two curved halves of the pediment are reversed, so they rise from the centre like the wings of a giant bird flying out of the window above the door.

Gherardo Silvani made several palazzi with façades decorated by some of the liveliest Mannerist sculptures. The Palazzo Capponi-Covoni, at 4–6 Via Cavour, opposite the Palazzo Medici, has a comical monster's face on the arch above the front door. Bats spread their wide wings beneath the sills of the ground floor windows. There are still two heads of creatures like furious frogs beneath the scrolls under the window to the left of the front door. In the

scrolls supporting the pediments of all the windows on the ground floor there are grimacing faces of monstrous men on animal heads. Up the road at 22–24 Via Cavour, the Palazzo Bartolommei has monstrous monkeys' heads above its doors and bats with human faces below its windows. The beasts below the scrolls under the sills of the ground floor windows look a bit like birds; some of the men on the scrolls beside the top of the windows look more human, and others like lions. The Palazzo Fenzi nearby at 10 Via San Gallo, now the History Department of the University of Florence, was built by Gherardo Silvani from 1628 to 1630 and has the most extraordinary portal. A pair of shouting satyrs made by Raffaele Curradi in 1634 lean out below the corbels supporting the balcony above the front door. A pair of griffins above the arch hold a panel: this shows a locomotive steaming from Florence to Livorno, added in the nineteenth century when the Fenzi family created the railway.

CHAPTER 16

BAROQUE ARRIVES WITH THE GRAND DUKES

Grand Duke Ferdinando commissioned many sculptures, but one of the most striking images of this age, a *Head of Medusa* in the Uffizi, was given to him by his agent in Rome, Cardinal Francesco Maria del Monte, as a present for his armoury in the Palazzo Vecchio. It was painted around 1597 by Michelangelo Merisi, known as Caravaggio after the town in the northern province of Bergamo where his parents lived. This most famous of Italian Baroque painters was working in Rome at the time, until he had to leave after being convicted of murder. *Medusa* is painted on canvas stretched over a convex round wooden shield: Perseus put her head on a mirrored shield to petrify anyone who looked at it. Although her head has been cut off, and blood is streaming out of her neck as in Cellini's statue, she has a horrified expression on her face. Her mouth is open wide as she screams and her eyes look shocked, perhaps by the tangled coil of snakes that replaced her hair.

There are two other memorable paintings by Caravaggio in the Uffizi. His *Bacchus* was also commissioned by his patron Cardinal del Monte as a gift for Duke Ferdinando. Two or three years before, he had painted a portrait of himself as Bacchus, looking pale and sick, but in this version the god of wine is a healthy-looking rosy-cheeked plump young man. He is sitting on a couch, wearing only a sheet wrapped over one of his shoulders and around one of his arms, and leans forward to offer us a huge glass of red wine, poured from the flask on the table in front of him, beside a large bowl of over-ripe fruit. He has a crown of colourful vine leaves and grapes around his curly black hair. Celebrating the pleasures of sensuality and

consumption, he shows how the values of Baroque art came back to earth after the humanism of the Renaissance.

The young man who modelled Bacchus may have been a friend of Caravaggio's, as the model of the bare young boy about to be killed in his *Sacrifice of Isaac* also may have been. In this picture commissioned in 1603 by another Roman cardinal, Maffeo Barberini, who later became Pope Urban VIII, Abraham pushes his screaming son's neck down onto a rock with one hand and holds a sharp knife in the other, but fortunately a sweet-faced young angel grasps his wrist so he cannot cut his son's neck, and points at the

head of a ram to be sacrificed instead. There is a distant rural landscape in the background, but the strong contrast between light and shade and the close focus on the subjects of Caravaggio's paintings make them very dramatic.

In 1608 Ferdinando's eldest son, Cosimo, married Maria Maddalena of Austria, daughter of Archduke Charles II and niece of Cosimo's aunt, Joanna. Ferdinando arranged for the streets that their wedding procession passed through to be embellished with sculptures to celebrate the occasion. Four grand statues representing the Four Seasons were added to the ends of the Ponte Santa Trinita. They were fished out of the Arno in the 1950s and reinstated at the corners of the bridge after it had been

On page 544
Caravaggio: *Head of Medusa* (Uffizi)

On page 545
Caravaggio: *Bacchus* (Uffizi)

Above
Caravaggio: *The Sacrifice of Isaac* (Uffizi)

Above, left to right
Statues at the ends of the Ponte
Santa Trinita: at the northern
end, *Spring* by Pietro Francavilla
and *Summer* by Giovanni Battista
Caccini; at the southern end,
Autumn by Giovanni Battista
Caccini and *Winter* by Taddeo
Landini

rebuilt. Although the statues were made to commemorate
the wedding of the son and daughter of the rulers of
Tuscany and the Hapsburg Empire, they have neither a
religious nor a political significance, and just celebrate the
seasons. The female figures on the north bank are Pietro
Francavilla's *Spring*, holding a basket of flowers, and
Giovanni Battista Caccini's *Summer*, who holds a sheaf of
wheat. The males on the south bank are *Autumn*, also by
Caccini, who holds several bunches of grapes up high, and
Winter, by Taddeo Landini, one of Buontalenti's pupils,
who clutches a blanket to keep himself warm.

A few yards up Via Maggio from the Ponte Santa
Trinita is the sharp corner where Via dello Sprone meets

BAROQUE ARRIVES WITH THE GRAND DUKES

Borgo San Jacopo. On the spur of the junction – the *sprone* – is a small fountain that is one of the most memorable in Florence, made by Buontalenti, probably as part of the wedding celebrations. The Fontana dello Sprone consists of the mask of a middle-aged man with extraordinary stone streaks of water coming out of his mouth, looking like tusks, on either side of the pipe which sprays water into a shell-shaped basin with large spiral volutes at the sides. A pool in the pavement below collects the water which flows over the lip of the basin. As usual, there is the coat of arms of the Medici below a balcony at the top of the wall above.

A year after Cosimo's wedding his father died, so he was only eighteen years old when he succeeded as Grand Duke Cosimo II of Tuscany. He and Maria Maddalena had eight children before he died of tuberculosis at the age of thirty in 1621. He was very fond of children, and supported the Ospedale degli Innocenti as his uncle and father had done. Their help was commemorated by portrait busts above blank portals at the ends of the loggia of the Ospedale, Francesco at the north and Ferdinando at the

south. Cosimo II must have been supportive even when he was very young: he was commemorated by a grander portrait bust above the central arch of the loggia, looking out over the piazza; the lion below him holds a cartouche dated 1612, so the clean-shaven handsome young man was only twenty-two when it was made. Two cheerful cherubs hold a bronze crown above his head. These three portrait busts are the only known works of Giovanni Battista Sermei, another of Giambologna's pupils, born in Fiesole, who worked for the Medici family.

Cosimo's visit to the Ospedale was recorded by Bernardino Poccetti. Poccetti lived there from 1610 for the last two years of his life in exchange for decorating several of the vaults of the loggia and the lunettes at its ends. At the side of his fresco of the *Massacre of the Innocents* in the children's refectory at the back of the Ospedale there is a scene showing Cosimo II, wearing a white ruff around his neck, visiting the Ospedale with its Prior and a couple of other dignitaries.

In 1619 Cosimo II commissioned Giulio Parigi, one of Buontalenti's former pupils, to build a grain market, the

Far left
Bernardo Buontalenti:
Fontana dello Sprone, at the
corner of Via dello Sprone
and Borgo San Jacopo

Left
Giovanni Battista Sermei:
bust of Duke Cosimo II on the
Ospedale degli Innocenti

Above
Chiarissimo Fancelli:
Fontana del Mascherone on
the Loggia del Grano

Above right
Chiarissimo Fancelli:
bust of Duke Cosimo II on
the Loggia del Grano

church, grain was traded under the grand arched vaults of the ground floor, and stored in the floors above. The Loggia was embellished by Chiarissimo Fancelli, a sculptor who had worked for Giovanni Caccini, whose unusual forename means 'Very Clear'. His Fontana del Mascherone, clearly inspired by Buontalenti's Fontana dello Sprone, is named after the grotesque mask that seems to be staring and laughing mockingly at anyone it can see from the corner of the pier facing the piazza. The weird face, out of whose mouth the water spouts, has eyebrows that grow like leaves over the crown of its head, and sideburns that droop as low as its beard. Fancelli also made the portrait bust of Cosimo II above the central arch of the Loggia facing Via dei Neri. There is a large grand-ducal crown above his head as usual, and the head of a lion, holding one of the Medici's *palle* in its mouth, below. Cosimo II wears the Maltese cross of the Order of St Stephen on his chest, like his father in his equestrian statue, but fashion had changed since then: he has a bushy moustache and long curls of hair over his ears, and no beard. The cartouche below reads 'EGENORUM

Loggia del Grano, in the small Piazza del Grano, behind the south-east corner of the Palazzo Vecchio. Eight years earlier Parigi had built the huge palatial portico of the Ospedale di Santa Maria Nuova, around three sides of the piazza in front of the hospital, that Buontalenti had designed before he died, which may have inspired the grand style of Parigi's Loggia del Grano. As at Orsanmichele, which was a grain market before it was converted into a

PATRI', 'By the father of the needy', thanking himself for building the grain market.

Cosimo II had a younger brother, Carlo, who became a cardinal in 1615, at the age of twenty. Carlo was a major contributor to the reconstruction of the church of San Michele in the Piazza degli Antinori at the northern end of Via de' Tornabuoni. The previous Romanesque church was granted in 1592 to the Theatines, a group of clerics who promoted the policies of the Counter-Reformation. Their founders included the Bishop of Chieti (Teate in Latin, hence the name of their order) and Gaetano Thiene, who was beatified in 1571, so the rebuilt church, the most impressive Baroque church in Florence, is called Santi Michele e Gaetano. Don Giovanni de' Medici was also involved in the project. He was the son of Duke Cosimo I and his lover Eleonora degli Albizzi, born five years after Cosimo's wife Eleonora di Toledo died, and was an architect as well as a soldier. They asked Buontalenti to manage the project in 1597, but when building started in 1604 his assistant Matteo Nigetti, whose father had made a wooden model of Buontalenti's design, took over as architect. Nigetti continued in that role until 1633, by when the choir and the transept were completed. Gherardo Silvani, who had been appointed court architect to Cosimo II's son, Grand Duke Ferdinando II, took over, assisted by his son, Pier Francesco, and completed the rebuilding of the enlarged nave and its side chapels by 1648.

Paradoxically, the interior of the church is so grand and richly decorated that it almost has an atmosphere like a palazzo. The design is dominated by triumphal arches, framing the apse and the three chapels on each side of the nave. Built of grey *pietra serena*, they contrast strongly with the fourteen white marble statues of the Evangelists and Apostles standing in niches between the heads of the arches of the chapels, and beside the apse and the balcony above the entrance door. *St Peter* and *St Paul* flanking the apse were made in 1683 by Giovan Battista Foggini, the best Baroque sculptor in Florence, whose *King David* we saw in the Chapel of St Luke at Santissima Annunziata.

Above
Matteo Nigetti and Gherardo Silvani: Santi Michele e Gaetano, looking from the nave towards the chancel

The other statues were made by a wide range of sculptors, several of whom were Foggini's pupils, by the end of the century, as were the relief panels below each of the statues illustrating the martyrdoms of the saints above or other episodes from their lives. The sculpture of the panels is even more vigorous and animated than the statues, all of which are lively and expressive. The colour contrast is strengthened by the bright white balustrades across the fronts of the chapels and around the choir, with inlaid panels of coloured marble. The vaults of the chapels and the transepts and the dome above the apse are frescoed in warm colours, while the white paint of the barrel vault of the nave is illuminated by lunette windows above the chapel arches. The floor of the nave is paved with intricate patterns of multicoloured inlaid marble.

The high altar is even more magnificent. Designed by Pier Francesco Silvani, it has a gilded wooden grating across the front, and behind is a concave wall faced with red, yellow and mottled grey marble. The curved steps above the wall carry an enormous silver ciborium that looks like a miniature chapel. At the ends of the curved wall cartouches bear the coat of arms of the Corsi family, who lived next door in the Palazzo Tornabuoni that they had recently bought. Their emblem is a prancing lion behind a diagonal band, like the Niccolini family's, but it is split horizontally into red and green, with the lion in contrast to the background. The red marble is repeated in the cardinal's hat and tassels around the emblem on the left, and the one on the right is topped by a marquis's crown, commemorating two eminent members of this noble family.

There is a colourful fresco of the Archangel Michael presenting St Gaetano (Cajetan in English) to the Holy Trinity in the dome above the altar, and a large cartouche bearing the Theatines' symbol of a tall cross on the arch in front of the apse. However, the dome is obscured by the arch and the cartouche is made from the same *pietra serena* as the arch, so much more noticeable from the nave is Cardinal Carlo de' Medici's enormous coat of arms on a golden background, surrounded by a crimson cardinal's hat and tassels, on the white-painted vault of the crossing.

Every inch of the chapels beside the nave is decorated. Each chapel has a grand altarpiece with columns and pediments of colourful marbles. The domed ceilings have frescoes and ornamental patterns of stucco. The *pietra serena* walls between the chapels have pairs of fluted pilasters with fancy foliage on their capitals. The arch above each chapel has a cartouche with the coat of arms of its patrician patron family, between lavish stone swags of fruit and flowers held up by swirling ribbons, creating a lively surface. The chapels in the corners between the transepts and the apse were sponsored by the Bonsi family. Their emblem appears above the arches of those chapels as well as at the ends of the transepts, above monuments to Giovanni and Pietro Bonsi. Their golden millwheel against a blue background celebrates the origins of their family's wealth in the wool trade, and their loyalty to the Guelph party. Although both were cardinals as well as bishops of Béziers in southern France, the coats of arms on the ends of Pietro Bonsi's tomb in the right transept are surrounded only by a bishop's green hat and tassels, while those on his cousin Giovanni's tomb in the other transept are more red than green.

The dramatic façade of Santi Michele e Gaetano is as splendid as its interior. It was built between 1648 and 1683 by Gherardo and Pier Francesco Silvani, to a design modelled on Buontalenti's late sixteenth-century façade of Santa Trinita down the road. As at Santa Trinita, the façade is split into three vertical sections by pilasters, but they are made more prominent by being fluted, in pairs on either side of the central section, and attached to projections of the wall behind them. So the main cornice above the first storey is split into seven sections, and the upper one at the top of the nave into five, alternately projecting and recessed. The three doors are more prominent too, having portals with columns carrying pediments that stand forward from the façade. As well as being more vigorous architecturally than Santa Trinita, the façade promotes the Medici more boldly. The frieze has an inscription across

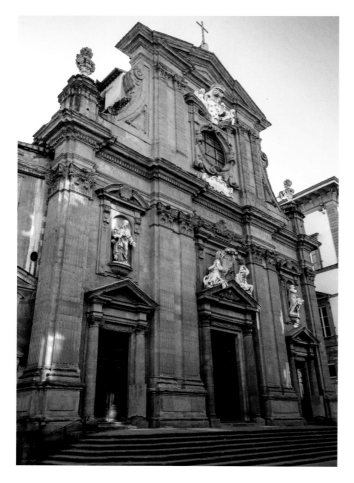

the whole width of the church: 'CAROLUS S·R·E· CARD MEDICES EPIS·SABIN ANNO·SAL·M·DC·XLVIII'. Abbreviated Latin can be confusing, but 'S·R·E' probably stands for 'Santa Romana Ecclesia', and 'EPIS·SABIN' for 'Episcopus Sabinae', so the inscription would translate as 'Carlo de' Medici, Cardinal of the Holy Roman Church, Bishop of Sabina [his diocese in the Sabine hills, north-east of Rome], AD 1648'. Above the cornice there is a cartouche, inscribed with 'DEO ET ANGELORUM PRINCIPI', saying that the church is dedicated 'to God and the Prince of Angels' – that is St Michael, not Cardinal Carlo.

Several sculptures were added to the façade between 1688 and 1693. Made of white marble, they stand out boldly against the brown sandstone of the building. Above

the round window at the upper level, a couple of chirpy cherubs sit on top of a pediment of inverted curved wings like the one that Gherardo Silvani made for the door of the sacristy at Santa Maria Novella. They hold a huge scrolly cartouche with the Medici's coat of arms under the grand-ducal crown. The window has a most unusual frame, carved to look like ropes and scrolls. Further down, two female figures sit on the pediment above the main door. The lady on the left, who holds her hands up to pray, represents Hope, and the one on the right, who pulls her ragged clothes over her head, represents Poverty. Surprisingly, considering the opulence of the chapels of wealthy families inside the church, these were two of the key values of the Theatines, whose emblem wrapped in ribbons hangs between them. In the niche above the left door there is a statue of St Gaetano, and above the right door is St Andrea Avellino, another early exponent of the Theatine order. Both of them gesture expressively, and are accompanied by cherubs. At the ends of the façade above the main cornice, two large pedestals carry urns full of flames, representing Faith. Made to designs by Giovan Battista Foggini, their white marble stands out against the sky.

Pier Francesco Silvani had another project while the façade of Santi Michele e Gaetano was being built. In 1679 he designed the amazingly lavish gilded swirling carvings of the ceiling of the church of San Marco, and the elaborate decorations on the walls of the chancel, completing the transformation of Michelozzo's Renaissance design into an exotic Baroque masterpiece.

The Medici started another major building project in 1604. Duke Cosimo I had wanted to build another chapel

to commemorate his family at the church of San Lorenzo. Although the Medici had become grand dukes, it is known as the Chapel of the Princes, and although it is attached to the back of the church, it is opulently decorated and designed to celebrate the family and display their power. Cosimo's son Grand Duke Ferdinando I commissioned the architect Matteo Nigetti to construct a chapel based on sketches drawn by Don Giovanni de' Medici, who was Ferdinando's half-brother. Nigetti's former teacher Buontalenti was also involved in the project; he planned the low vaulted crypt underneath the chapel.

Nigetti worked on the project until 1640, building an enormous octagonal chapel with the second highest dome in the city centre, with ribs whose curves copy those of the Duomo. The frames of the large upper windows around the outside of the dome are tapered like those of the New Sacristy, but these were added in 1740 to designs by Giuseppe Ruggieri, whose brother Ferdinando designed the small pointed bell tower of the church. The walls and the floor in the enormous and impressive interior of the chapel are covered with panels of coloured marbles, semi-precious stone and coral, of red, green, amber and other colours, so lavish that it is almost gaudy. There are six niches in the walls, each one above a large sarcophagus, with the names of the grand dukes in gold on the frieze above them, although they are buried in the crypt below. Only two of the niches have bronze statues of the grand dukes, made by Pietro Tacca between 1626 and 1642. Ferdinando is to the right of the altar, and his son, Cosimo II, beside him further to the right. In the dado around the walls, below the sarcophagi, there are the crests of the sixteen Tuscan cities governed by the Medici.

With the hope, no doubt, of elevating the status of their family, they intended to obtain Christ's Holy Sepulchre from Jerusalem and place it in the centre of the chapel, but they were unable to buy or even steal it. There is one Christian symbol in the chapel, the Crucifix above the small altar. The octagonal dome is frescoed with scenes from the Old and New Testaments, but these were not added until 1828, by Pietro Benvenuti, a local Neoclassical artist. The original extravagant plan was to line the dome with lapis lazuli and gilded bronze ornament, confirming the aim of making the chapel a place of celebration of the Medici family.

While he was working at the Chapel of the Princes Matteo Nigetti designed the façade of the Ognissanti in

Left
Matteo Nigetti: façade of the
Ognissanti

Below
Pietro Tacca: one of the fountains
with marine monsters in the
Piazza Santissima Annunziata

1637. The interior of the church had been rebuilt in the Baroque style around ten years earlier, but Nigetti's was the first Baroque façade in Florence, built ten years before the façade of Santi Michele e Gaetano. It is elaborately decorated with pilasters and ornamental sculpture around the windows and empty niches, and crowned by a huge coat of arms with the lily of Florence on the gable. A large della Robbia style Renaissance glazed terracotta lunette of the Coronation of the Virgin with rows of saints and angels, attributed to Benedetto Buglioni, was retained over the doorway.

Pietro Tacca also had other projects to work on while was making the statues of the grand dukes. In 1626 he was commissioned to make a couple of fountains with marine monsters. They were intended for the port of Livorno, but Ferdinando II wanted them brought back to Florence and in 1641 they were placed in the Piazza

Santissima Annunziata, one on each side of the equestrian statue of Ferdinando I de' Medici, which Tacca had helped Giambologna to complete. The amazing bronze fountains each have a pair of human-bodied monsters leaning back to back, grasping the ends of each other's long coiled legs. They have spiky crests on their heads, and fins that look like seaweed on their shoulders, and they kneel above creatures that look like a cross between giant seashells and sharks.

Tacca also made a bronze sculpture of a wild boar with a bristly fur coat, crouching in a friendly pose, for the Boboli Gardens around 1633, inspired by a Roman marble copy of a Hellenistic sculpture (now in the Uffizi). Ferdinando II had *Il Porcellino*, 'the Piglet', moved into the Loggia of the Mercato Nuovo and converted into a fountain, with the water coming out of its mouth. Tacca's original is now in the Museo Bardini (in the Piazza dei

Right
Replica of Pietro Tacca's
Il Porcellino fountain in the
Loggia of the Mercato Nuovo

Right, below
Gian Lorenzo Bernini: *The
Martyrdom of St Lawrence* (Uffizi)

Mozzi in the Oltrarno). Its replica in the southern side of
the Loggia is so popular that its snout is polished so much
by admirers' hands that it shines.

By commissioning artists to decorate their palazzi,
ornament their gardens, and glorify themselves and their
family in public buildings and piazzas, the grand dukes
reduced the influence of Classical art and humanism that
had been essential ingredients in the art of the Renaissance.
Although Florence continued to be home to many artists
in the next centuries, it ceased to be the leading centre of
artistic development, partly because the kings of Northern
European countries followed the example of the Medici
in employing artists to promote themselves, and partly
because it ceased to be one of the most prosperous cities in
Europe. Rome was the home of the best Baroque art, and the
Netherlands developed new styles in the Dutch Golden Age,
financed by their domination of world trade. However, there
are a few of the works of leading Baroque artists in Florence.

There are two works in Florence by the most famous
Baroque sculptor, Gian Lorenzo Bernini. He was born
in Naples, where his Florentine father Pietro met his
mother, and his family moved to Rome, where he created a
marble sculpture of the *Martyrdom of St Lawrence* around
1614, when he was just sixteen years old. Now in the
Uffizi, this unusual work shows the saint reclining on a
gridiron, gazing serenely up to heaven, as if he appreciated
his martyrdom, even though he is being roasted by the
flames and smoke carved in the stone below the grill, and
one of his hands touches a flame.

Some twenty years later, when he was still living in
Rome, Bernini made the bust of Costanza Bonarelli, now in

invited to work in Florence. One of the most impressive results is the magnificent long gallery added to the Palazzo Medici by the Riccardi family who bought it from Grand Duke Ferdinando II. Proud of the former owners of their home, they commissioned the Neapolitan artist Luca Giordano to paint a huge fresco of the *Apotheosis of the Medici* in 1682–85 on the vaulted ceiling of the gallery, above walls lavishly covered with gilded carvings around the windows and mirrors.

At the centre of the fresco Grand Duke Cosimo III de' Medici, whose hand strokes a lion's neck, his brother Cardinal Francesco Maria dressed in red, and his sons Gian Gastone and Ferdinando both riding white horses, are being carried up towards Jupiter in heaven on a cloud. In the corners of the ceiling the Cardinal Virtues of good rulers appear again, but this time with their opposing Vices as well. At the far end on the left, *Temperance* sits beside a friendly elephant above figures representing *Sloth*, *Envy* and *Anger*. On the right, *Justice* holds her sword and scales as she sits above an ostrich which has a leg over *Deception*, a man with legs like snakes' tails who wears a mask and carries a bunch of flowers tangled with a snake. Above the entrance on the left, *Prudence* holds her mirror and a wand with a snake coiled around it, above *Fraud* who holds a donkey's head over his own. On the right, *Fortitude* sits on the back of a friendly lion above Hercules who strangles a snake.

Between *Temperance* and *Justice* the figures in front of a cave represent the *Creation of Man* and the huge snake that bites its own tail is an ancient symbol of Eternity. Between the other Virtues there are several scenes from Classical mythology, including the Triumph of Bacchus riding a

the Bargello. He had an affair with Costanza, the wife of his assistant Matteo, and the bust, which he made for himself, displays how much he loved her, with her hair combed back to show her affectionate face, and the neckline of her dress open to reveal her breast. However, two years after he made the bust he discovered that she was having an affair with his younger brother Luigi, and he sent his servant to slash her face. Bernini's behaviour, and Caravaggio's conviction for murder, as well as their works, reflect how much artists had changed since the years of the Renaissance.

Eventually, more artists from other parts of Italy were

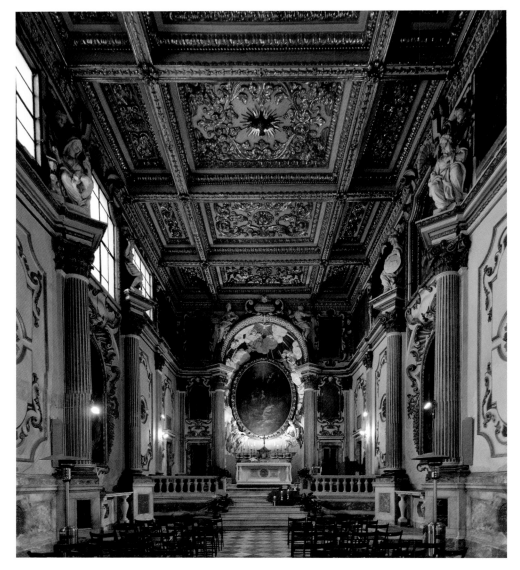

Left
Looking from the nave to the
chancel of San Giorgio alla Costa

Right
Giovanni Battista Foggini: tomb
of Galileo Galilei, in Santa Croce

the distressed dog-like dragon that he has spiked with his long lance. In the nave, the ceiling is decorated with gilded coffers filled with swirling carvings, even more palatial than Pier Francesco Silvani's ceiling of San Marco. The walls are embellished with fluted columns with gilded capitals, supporting statues of saints above diagonal projections of the cornice. These columns are repeated beside the high altar, framing a bustle of white stucco cherubs on clouds around golden rays of light, and angels holding the oval altarpiece. The white dove of the Holy Spirit flies in front of the sun under the top of the arch over the altar, beneath an inscription that translates as 'The Spirit of the Lord came down to me so that by him we can go up to the Lord'. This message is illustrated in the altarpiece, the *Descent of the Holy Spirit*, by Anton Domenico Gabbiani, another Florentine Baroque painter, which shows rays of golden light shining down on the Virgin Mary and the disciples.

Galileo Galilei, Florence's most famous scientist,

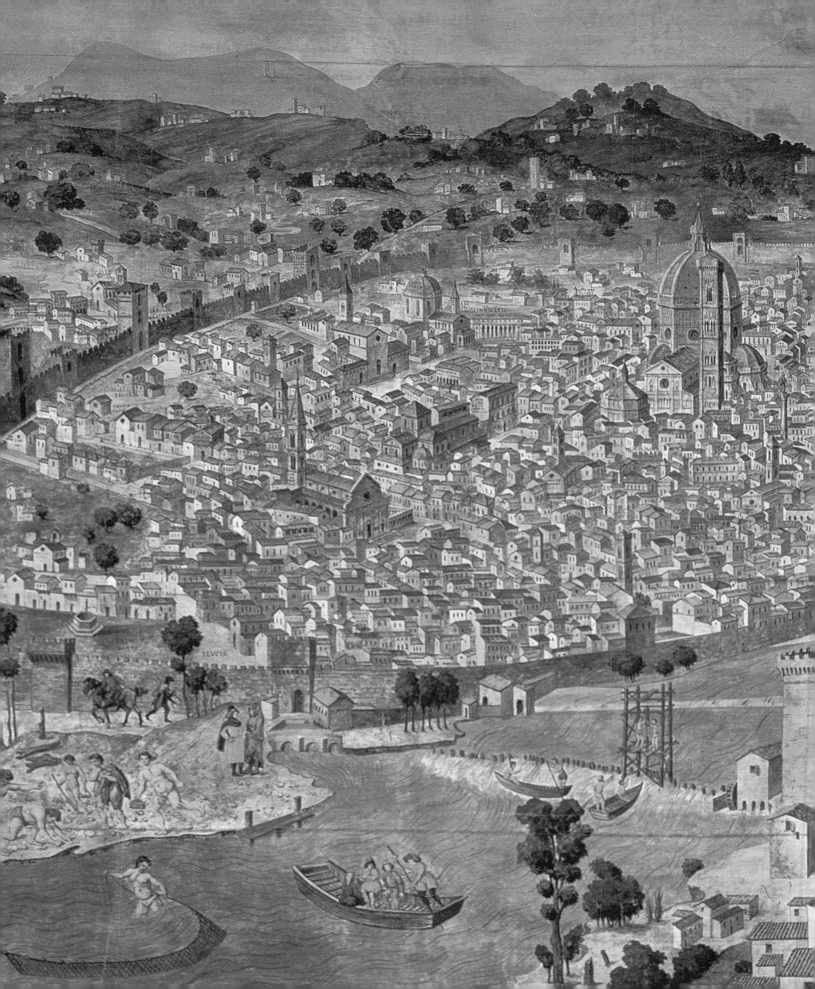